THE CIVILIZATION OF THE AMERICAN INDIAN SERIES

PLAINS INDIAN ART FROM FORT MARION

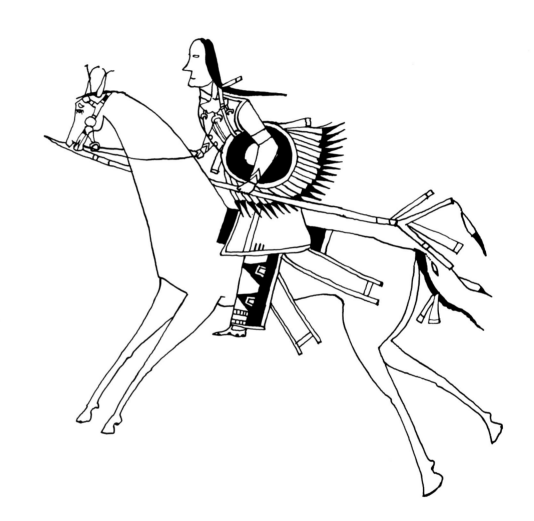

PLAINS INDIAN ART
FROM FORT MARION

By *Karen Daniels Petersen*

UNIVERSITY OF OKLAHOMA PRESS NORMAN

By Karen Daniels Petersen

(Commentary, with E. Adamson Hoebel) *A Cheyenne Sketchbook*, by Cohoe (Norman, 1964)
Howling Wolf: A Cheyenne Warrior's Graphic Interpretation of His People (Palo Alto, 1968)
Plains Indian Art from Fort Marion (Norman, 1971)

International Standard Book Number: 0–8061–0888–6

Library of Congress Catalog Card Number: 70–88146

Copyright 1971 by the University of Oklahoma Press, Publishing Division of the University. Composed and printed at Norman, Oklahoma, U.S.A., by the University of Oklahoma Press. First Edition.

Plains Indian Art from Fort Marion is Volume 101 in *The Civilization of the American Indian Series.*

To Margaret Hawkins Seelye,
a true granddaughter of Captain Pratt

PREFACE

THEY began their days as wandering buffalo hunters; yet the Indians imprisoned at Fort Marion who are the subject of this book were the first exponents of the Contemporary school of Indian art. As a part of their youthful education on the Great Plains, they were taught to draw and paint figures. This is not to say that they were professional artists or even devotees of "Art." Plains drawing was not self-conscious; it was woven into the fabric of the daily life of every Plainsman. This book presents drawings selected from 847 extant pieces of art done by twenty-six Plains Indian warriors under unique circumstances.

Today's era of art-for-everyone has produced a wide audience able to respond with appreciation and understanding to Indian art. It must not be assumed, however, that appreciation will come without preparation. To understand Japanese art, or Egyptian, an accepted prerequisite would be a study of the cultural background that produced it. Plains Indians comprise another foreign culture—actually indigenous, but foreign to the Graeco-Roman tradition of their conquerors. With consummate ethnocentrism, non-Indian Americans have often dismissed Plains drawings as "childlike," implying untutored spontaneity, or—more damning—as "primitive." If an Indian, for instance, places one horse higher on the page than another, to denote distance, this is "primitive," because his perspective is not expressed in the convention of the Graeco-Roman tradition which prescribes a diminution of size and color for distant objects. Yet if a classical Chinese artist places figures in receding clouds of mist for the same purpose, the product of this age-old civilization is, of course, not "primitive"; it is accepted as a convention imposed by the traditions of his culture. Such condescension to the Indian only betrays an ignorance, an unawareness that the Indian was following

a prescribed set of artistic conventions, like the Chinese or the Graeco-Roman artist.

Without a knowledge of the basic rules of Plains Indian drawing, the language of their pictures is a foreign tongue. Two aids to the interpretation of drawings in this volume are furnished by the author: the text examines the painting traditions that the Indians brought with them to prison, and the Pictographic Dictionary interprets conventional devices used by the Fort Marion Indians. It may come as a surprise that few of the devices are what have come to be known as "Indian symbols." Plains drawings usually employed shorthand versions of recognizable objects rather than abstractions with "symbolic" meanings known only to the initiated. This was a matter of expediency, for, just as the sign language was the lingua franca among the diverse tongues of the Plains, picture-writing was the inscribed equivalent thereof. Two more aids to understanding are furnished by the pictures themselves. The Fort Marion drawings were oftentimes provided with captions suggesting the meaning, and the pictures were drawn with a conscious attempt to make them understandable to the white man. Painting from the Plains is more difficult of interpretation because such clues are usually wanting except for the captions frequently recorded for calendric glyphs. Comprehen-

sion of what the imprisoned artists were saying leads to a better understanding of the drawings from the Plains. Indeed, the Fort Marion art may prove to be the Rosetta stone of Plains pictorial representation. As an artistic bonus, an understanding of the Indian drawings illumines such culturally unrelated, yet curiously similar, works as the great tapestry of Bayeux.

When the "Florida Boys," as the prisoners at Fort Marion, Florida, came to be called, became a popular tourist attraction, their drawings gradually found their way to many states of the Union. It would be difficult to assess the extent of the influence of these pictures upon contemporary non-Indian Americans, but there is no doubt that the impact was emotional rather than artistic in nature. Comments on Plains drawings by critics of the day were usually brief and general. One exceptional longer treatment, done with heavy-handed humor by a well-known writer and illustrator, betrays an ignorance of the tenets of Plains drawing exceeded only by ingenuity at improvising. It dismisses the work as "artistic artlessness" and mistakes Sitting Bull's name-symbol, connected to his mouth by a line, for his war-cry, "an imitation of the bellowing of the *Bos urus* . . . poetically symbolized." The brash journalist may be excused for his unfortunate early encounter with Plains drawing, since, nearly a century later, the

same lack of awareness prevails. A recent notable publication shows a fleeing man in whose back is buried an ax which is purported to be a missile thrown by the warrior who rides in pursuit of his victim. By this reasoning, the bow often shown resting unsupported on a victim's head, the floating lance touching his shoulder, or, worse, the discharging gun held close to his body by no hand, would indicate that bow, spear, and gun had been hurled at the victim by an aggressor who is shown on his horse a little distance off, perhaps with both hands occupied with other weapons. In reality, the device is a convention showing two tenses: the moment at which the rider was caught by the artist, and the time before or after when the rider shot his enemy or rode up to him to lance him or to count coup by bravely touching him with spear or empty bow. (See Pictographic Dictionary, VIII, 20.)[1]

Another fallacy was introduced into the concept of Plains drawing at an early date by a man who had abundant opportunity for true understanding. Colonel Richard I. Dodge believed that Indian drawings "were all so essentially alike in character and execution, that they might have been drawn by the same hand." The Fort Marion artists explode this myth. Even the earliest drawings show a wide variation in technical skill and aesthetic sensitivity.[2]

Since the Fort Marion pictures represent the pre-reservation period that ended in the Southern Plains by 1875, they differ from subsequent drawings from this region (and very few earlier ones are extant) in springing directly from the nomadic period with no intervening protracted reservation experience to influence the work. The Fort Marion art affords a unique opportunity to observe the impact of acculturation upon a group of artists in a limited time and under known conditions—a subject deserving of more than the cursory treatment offered here. Therefore, rather than subjective aesthetic evaluations, this book stresses ethnological analysis of the drawings and a historical synthesis of the setting that produced them. Technique and style are considered as they relate to the two cultures which influenced them, Indian and white. For the most part, the drawings as art are permitted to speak directly to the viewer. Interpretation of the content of the pictures attempts to take into consideration the Indian point of view.

The eight detailed biographies of the artists presented herein have a unique quality that is threefold. The subject of all but one is the little man, the common warrior. The one exception achieved chieftainship and manhood almost simultaneously. Each biography begins with the subject's young manhood and

recounts the blows suffered in the struggle between Indian culture and white that shaped the mature man. Most of the material is drawn from contemporary writings by the man himself, his Indian confreres, or sincere and concerned white friends. Throughout the book, whenever feasible, the words of the Florida Boys and their friends have been used in preference to a summary or a paraphrase, in hopes that the reader may experience the *"I was there"* feeling that delights the researcher when he reads the first-hand accounts of a vanished era.

Searching out these accounts and publishing the illustrations would have been impossible without the generosity of many institutions and individuals. Permission to study and reproduce their pictures and other archival material was granted by the Castillo de San Marcos National Monument (Luis R. Arana); Cumberland County Historical Society and Hamilton Library Association (Mary S. Hertzler); Fort Sill Museum, U.S. Army (Gillett Griswold); Hampton Institute (Eleanor A. Gilman, Addie F. Spence, Fritz J. Malval); Historical Societies of Massachusetts (Stephen T. Riley), Missouri (Ruth K. Field), Oklahoma (Mrs. C. E. Cook, Louise Cooke, Rella Looney), and St. Augustine (Doris C. Wiles); Joslyn Art Museum (Mildred Goosman); Richard H. Pratt's descendants (Edgar N. Hawkins); Smithson-

ian Institution, Office of Anthropology (Dr. J. L. Angel, Margaret Blaker, Donald E. Kloster, Dr. S. H. Riesenberg); and Yale University, Beinecke Rare Book and Manuscript Library (Archibald Hanna).

Reproduction of a photograph was permitted by the Butler Institute of American Art (Ed G. Perkins). Authorization to study and list their drawings was given by the American Museum of Natural History (Philip C. Gifford, Jr.), Field Museum (George I. Quimby), Frances Malone, Museum of the American Indian, Heye Foundation (Dr. Frederick J. Dockstader), Mrs. A. H. Richardson, and Roy H. Robinson. Collection data and permission to list their drawings were furnished by Mrs. Maurine M. Boles, L. S. M. Curtin, James Jolly, Mrs. D. W. Killinger, and Howard D. Rodee.

First-hand data was given me by Homer Buffalo, Bert Geikaunmah, Enoch Smokey, Mrs. Samuel Tyler and Laura White Horse.

Material was generously made available for study at the American Baptist Home Mission Society, Valley Forge; Anadarko Agency (Mary Lacer); Concho Agency (James M. Hays, Jr.); Congregational Library, Boston; Episcopal Dioceses of Arkansas (Ven. John Gordon Swope, Jr.), Central New York (Rt. Rev. Walter M. Higley), Massachusetts

(Gladys H. McCafferty), and Oklahoma (Mrs. Harold Belknap); Gilcrease Institute (Mrs. H. H. Keene); Haverford College Library (Marjorie Davis); Historical Societies of Cumberland County, Pa. (Mrs. John T. Brougher), Kansas (F. R. Blackburn), Nebraska (Paul Riley), Pennsylvania (Manuscript Room), Tarrytown, N.Y. (Mrs. L. V. Case); International Military History Institute (J. Hefter); Newberry Library of Chicago; St. Paul Public Library (Gertrude Krugmeier); U.S. Army War College of Carlisle (Jean Cope); U.S. Military Academy Library (J. Thomas Russell); U.S. National Archives (Jane F. Smith, Robert Kvasnicka, Garry D. Ryan); University of Florida, P. K. Yonge Library (Elizabeth Alexander); University of Oklahoma Archives (Jack D. Haley); Utica Public Library, N. Y. (Alice C. Dodge). To all these people and institutions I am deeply grateful.

I wish to express thanks for kind services rendered by Warner F. Clapp, John C. Ewers, Norman Feder, Eloise Wicks Hinkle, Anna Z. Jenks, Dorothy Newcomb, Jean Snodgrass, and J. Peter Spang III. To the staff of the Minnesota Historical Society goes my appreciation for long-sustained patience and thoroughness, particularly on the part of Michael Brook, Patricia Harpole, William J. Schneider, and Eugene D. Becker.

Mrs. S. Clark Seelye has contributed to this work about Indians an unflagging enthusiasm worthy of her grandfather, the Captain Pratt of our story. With a painstaking fidelity to the work of the Fort Marion artists, Lydia S. Wederath rendered in pen and ink the drawings for the Pictographic Dictionary. The considerable travel necessary for the research behind this book was made possible by a generous grant from the Penrose Fund of the American Philosophical Society of Philadelphia. Finally, neither the writing nor the travel could have been done without the faith and co-operation of my husband, Sidney A. Petersen.

[1] Porte Crayon [David Hunter Strother], "Sitting Bull.—Autobiography of the Famous Sioux Chief," *Harper's Weekly*, Vol. XX, No. 1022, 625–28; "David Hunter Strother," *Who Was Who in America: Historical Volume, 1607–1896*, 513. George Catlin to the contrary, George Bird Grinnell implicitly denies ax-hurling on the Plains by naming the hatchet as a weapon that would not do harm at a distance. Catlin, *North American Indians*, I, 266; Grinnell, "Coup and Scalp Among the Plains Indians . . . ," *AA*, n.s., Vol. XII, No. 2, 297.

[2] Dodge, *Our Wild Indians*, 413.

ABBREVIATIONS USED IN CITATIONS

AA American Anthropologist

AAG Assistant Adjutant General

AG Adjutant General

AGO Adjutant General's Office

ARBAE Annual Report, Bureau of American Ethnology (Washington, D.C.)

ARCIA Annual Report of Commissioner of Indian Affairs (Department Edition, Washington, D.C.)

ARSI Annual Report of the Smithsonian Institution (Washington, D.C.)

BAEC Bureau of American Ethnology Collection, Office of Anthropology Archives, Smithsonian Institution, Washington, D.C.

C&A Cheyenne and Arapaho

CO Chronicles of Oklahoma

CT Cheyenne Transporter (Darlington, I. T.)

DAB Dictionary of American Biography, 22 vols. (New York)

DFMS Domestic and Foreign Missionary Society of the Protestant Episcopal Church in the U.S. of America

DSP Daily Sun and Press (Jacksonville, Fla.)

EKT Eadle Keahtah Toh

FP Florida Press (St. Augustine, Fla.)

GMCJ Gospel Messenger and Church Journal of Central New York

K&C Kiowa and Comanche

MMBWA Minutes of the Massachusetts Branch of the Woman's Auxiliary of the Board of Missions of the Protestant Episcopal Church, MS, Library, Episcopal Diocese of Massachusetts, Boston

MSt Morning Star

NA National Archives, Washington, D.C.

OHSIA Oklahoma Historical Society, Indian Archives, Oklahoma City, Okla.

OIA Office of Indian Affairs, Department of the Interior

OITC Oklahoma and Indian Territory Church-man (Guthrie, 1894; Shawnee, 1900)
PP General Richard H. Pratt Papers, MSS, Western Americana Collection, Beinecke Rare Book and Manuscript Library, Yale University, New Haven, Conn.
SM Spirit of Missions
SMC Smithsonian Miscellaneous Collections (Washington, D.C.)
SN School News (Carlisle Barracks, Pa.)
SW Southern Workman
USNMC United States National Museum Collection, Office of Anthropology Archives, Smithsonian Institution, Washington, D.C.
WD War Department

CONTENTS

LIST OF PLATES

PART ONE

INDIANS UNCHAINED

I. FORT MARION'S PLAINS INDIAN PRISONERS

I SAW Seventy two big Indians yesterday: proper men, and tall, as one would wish to behold. They were weary, and greatly worn; but as they stepped out of the cars [of the train], and folded their ample blankets about them, there was a large dignity and majestic sweep about their movements that made me much desire to salute their grave excellencies. Each had his ankles chained together; but managed to walk like a man, withal. They are confined,—by some ass who is in authority—in the lovely old Fort, as unfit for them as they for it. It is in my heart to hope sincerely that they may all get out."[1]

Curiously, this poignant picture of the shackled Indians of the Great Plains as they arrived at Fort Marion in St. Augustine for imprisonment, as well as the first account of their drawing, came from the pen of the Southern musician and poet, Sidney Lanier. Under contract to write, as a potboiler, a travel book on Florida, he was in the city to gather material for what was to become the best section of his book. Like many a writer after him, he found the prisoners "good copy." A few weeks later he recorded in his chapter on St. Augustine: "They seem excessively fond of trying their skill in drawing, and are delighted with a gift of pencil and paper. Already, however, the atmosphere of trade has reached into their souls: I am told they now begin to sell what they were ready enough to give away when I saw them a few weeks ago."[2]

In August, at work on his book in New York, Lanier wrote for "some specimens of the sign writing of the Indians at Fort Marion, and also an account of their sign-system." The first published drawing by one of these Indians was the anonymous wood engraving of a buffalo hunter printed in the travel book.[3]

Lanier saw the prisoners arrive on May 21. By May 27 he had left St. Augustine. In the first days

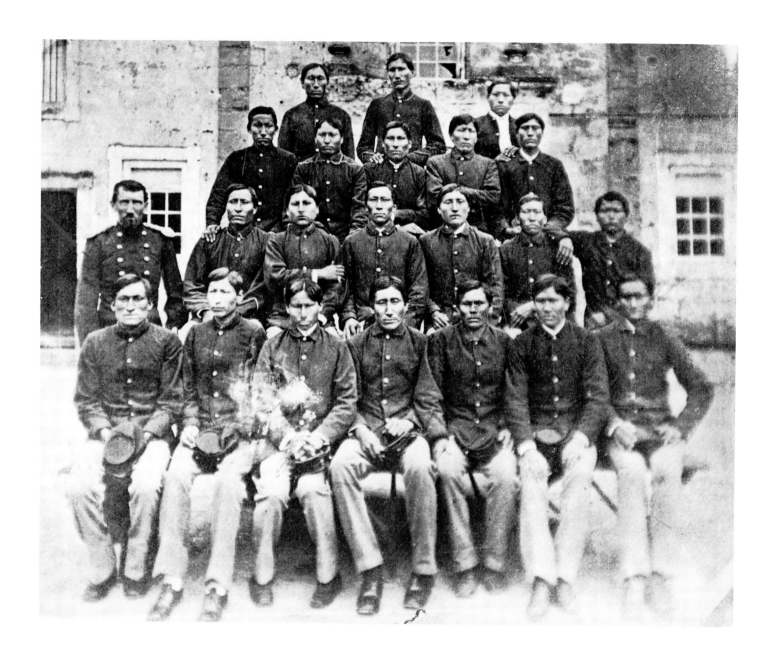

4

after the great walls of Fort Marion closed around the Indians, he saw them busily making drawings of a quality that merited publication, and he found them eager for the white man's pencil and paper. Yet he had described them as weary and greatly worn. He could not know that they were suffering from ills far more profound than fatigue from their journey. Less than a year before, they had been living the free, buffalo-hunting life of their forefathers. Some of them could recall the days before the first treaty with the United States put limits to the ranges which they could travel in search of the buffalo. As the white man pushed into their lands to settle or to slaughter the buffalo herds, and as treaty after treaty eroded away their assigned domain, the Indians' reservations became too restricted to support their accustomed way of life. The allied tribes—Kiowa, Comanche, Cheyenne, and Arapaho —ignored the artificial boundaries of reservations and continued to move at will in order to search for the dwindling buffalo herds, carry off horses, or make raids on their enemies, both red and white. True, a few bands capitulated and settled down near the agency, and in the hunger of winter even the most recalcitrant sometimes came in to accept the agent's beef. But by far the greater number of the allies refused to accept agency life or to become reservation Indians.

By the summer of 1874, the white outcry against the raiding in the Southern Plains became so loud that government officials were determined to end the trouble once and for all. In a great campaign, the military burned camp after camp hurriedly abandoned by the Indians as the troops approached. The fugitives were given no pause to hunt the buffalo and replenish their supply of food and tipi-covers. Ponies died from exhaustion and hunger. The winter was one of unusual severity, and many people per-

Plate 1. Fort Marion prisoners who chose to remain East for further education, March or April, 1878: Left to right, front row: Little Chief, Shave Head, Nick, Buzzard, Koba, Tounkeuh, Ohettoint. Second row: Captain Pratt, Tsadeltah, Matches, Buffalo Scout, Tsaitkopeta, Soaring Eagle, White Bear. Third row: Bear's Heart, Zonekeuh, Roman Nose, Squint Eyes, White Man. Last row: Cohoe, Making Medicine, Zotom. Absent: Etahdleuh. All but Matches and Buffalo Scout were artists. (*Courtesy of Fort Sill Museum, U.S. Army;* identification of individuals by author).

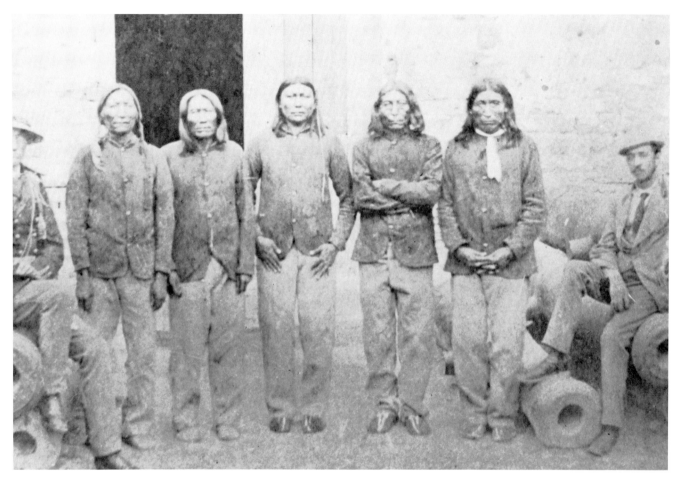

Plate 2. Kiowa chiefs at Fort Marion, May, 1875–June, 1876: Captain Pratt, Lone Wolf, ?, White Horse (the artist), Woman's Heart, ?, George Fox (interpreter). (*Courtesy of Castillo de San Marcos National Monument;* identification of Indians by Mason Pratt).

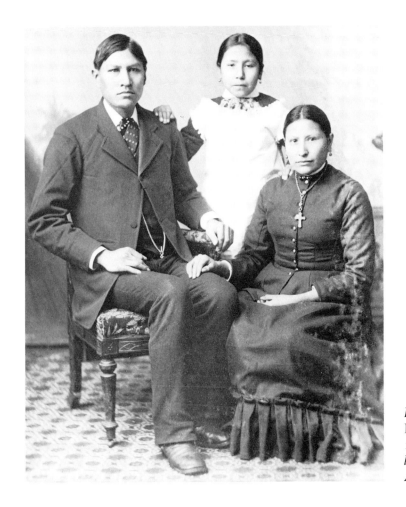

Plate 3. Etahdleuh Doanmoe, his wife Laura, and a Kiowa pupil at Carlisle, Martha Napawat, December, 1884–1887. *(Courtesy of and identification by Cumberland County Historical Society and Hamilton Library Association).*

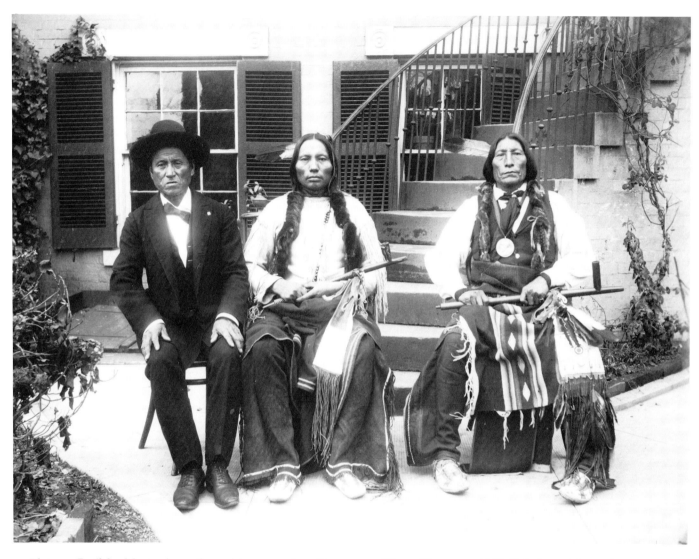

Plate 4. Buffalo Meat, the artist, with two other Cheyennes, Three Fingers and Wolf Robe, at Beveridge's boarding house while they were delegates to Washington, D.C., December, 1898. (*Courtesy of Smithsonian Office of Anthropology;* identification of individuals by Jesse Rowlodge).

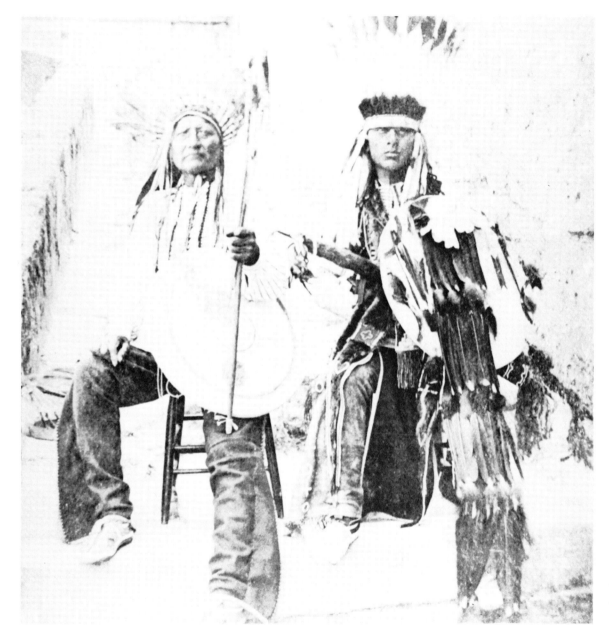

Plate 5. Cheyenne Chief Minimic and son Howling Wolf, the artist, at Fort Marion in costumes from Mrs. Pratt's collection, May, 1875–April, 1878. *(Courtesy of and identification of individuals by St. Augustine Historical Society).*

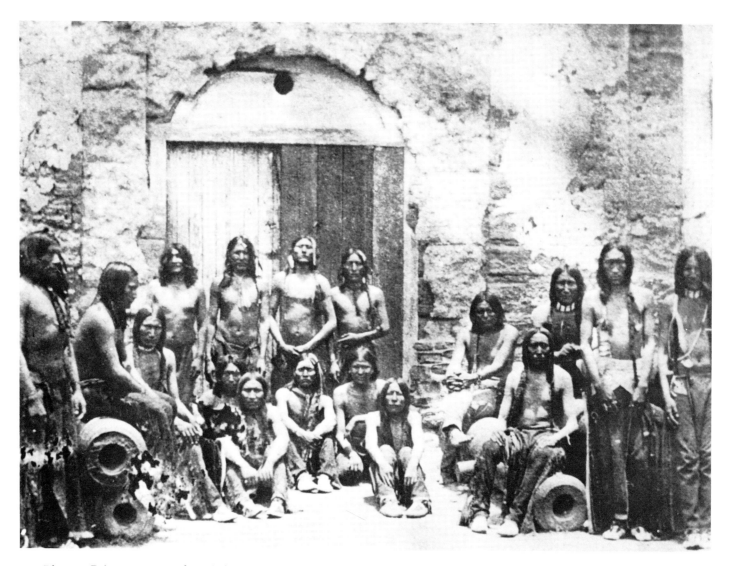

Plate 6. Prisoners soon after their arrival at Fort Marion. Wohaw is the man sitting at center, with hands clasped over his knees, May or June, 1875. (*Courtesy of Yale University;* identification by New York Public Library).

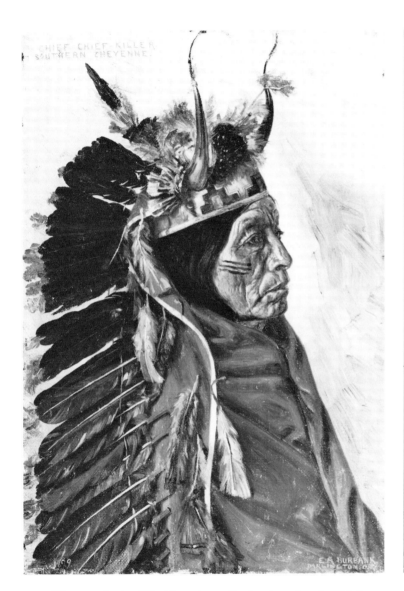

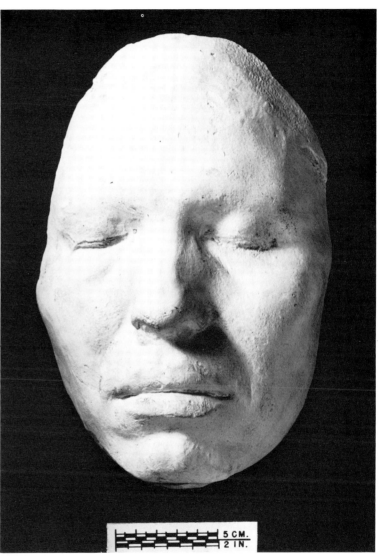

Plate 7. Artist Elbridge Ayer Burbank painted Chief Killer's portrait at Darlington, Oklahoma, 1899. (*Courtesy of Butler Institute of American Art*; identification painted on portrait).

Plate 8. Packer was one of the prisoners of whom a face-mask was made by the noted sculptor Clark Mills, July, 1877. (*Courtesy of and identification by Smithsonian Office of Anthropology*).

11

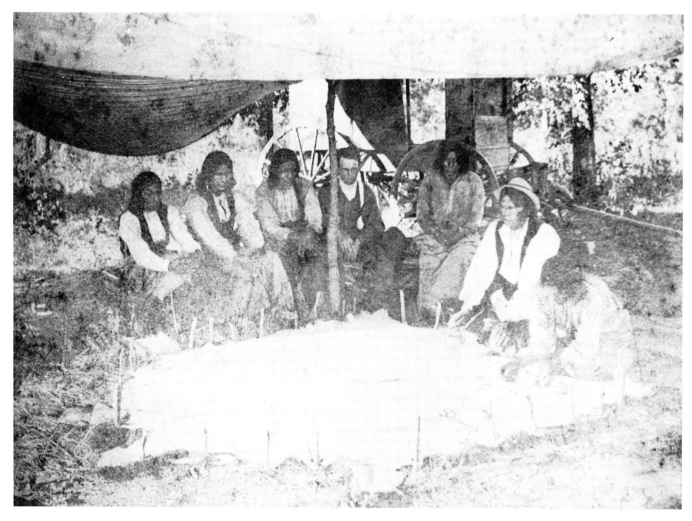

Plate 9. "Comanche and Kiowa Indians painting history on Buffalo Robe Indn Territory 1875." Symbols for star and dragon-fly are visible. (*Courtesy of Oklahoma Historical Society*).

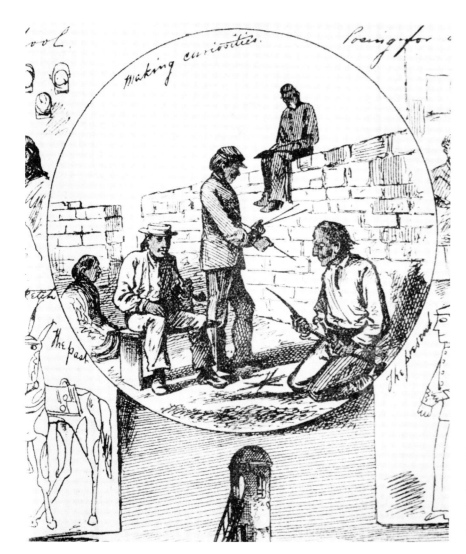

Plate 10. "Making Curiosities." Frank Hamilton Taylor sketched the only known picture of the prisoners making drawings, as the man on the parapet appears to be doing. Below him, two men work on arrows and a bow. (*Courtesy of Yale University*, from *Daily Graphic*, New York, April 26, 1878).

Plate 11. Mary Buffalo, wife of Ohettoint, by the "Tipi with battle pictures," a pattern inherited by her husband from Dohasan. Collected in 1925. (*Courtesy of and identification by Oklahoma Historical Society*).

ished. Then the remnants of the proud and inde-
pendent tribesmen, in small groups or in bands, on
foot, starving, homeless, and freezing, straggled in
to the agency and surrendered.

It had been decided that notorious hostiles from
each of the four tribes should be sent away for con-
finement, in order to assure the complete subjuga-
tion of their people. As the Indians came in, those
considered notably "guilty" were locked up, and the
most hostile were placed in double irons. In April,
seventy-two of them (including one Caddo), with-
out a trial or a hearing, were chained into wagons
and carried away under heavy guard to what the
Indians believed would be their execution.

As they were continuing their long journey by
rail, a Cheyenne head chief, Grey Beard, threw
himself from the window of the moving car one
morning before daylight, preferring death, as he
said, to the humiliation of chains. The train was
halted, and a search was made. One of the guards
discovered the fugitive by the clanking of his shackles
and, contrary to orders, shot him fatally.

Later the same day Lanier saw the despondent
Indians arrive at St. Augustine for an indefinite in-
ternment in Fort Marion. Their afflictions were
many: malnutrition from months of running before
the troops; debility from more months of confine-
ment; apprehension of a summary execution at the
end of the journey; fear of the trigger-happy guards;
homesickness for the land and people they expected
never to see again; and the humiliation of wearing
the chains of total defeat.

Why should this band of warriors, broken in body
and spirit, eagerly fall to drawing pictures? "Cer-
tainly," as John C. Ewers trenchantly observes, "the
men were not selected for incarceration on the basis
of their artistic talent."[4]

Not every prisoner produced pictures. The Co-
manches and the lone Caddo are not represented
by a single drawing. Likewise, there was a line of
demarcation drawn among the prisoners on a basis
of age. According to Plains custom, between the
ages of thirty-five and forty, men retired from such
youthful pursuits as aggressive warfare and dancing.
With dignity they performed the functions of old
men of experience: of generals in war, of instructors
in the military societies, of priests in ceremonies, of
musicians in the dance. Just so, at Fort Marion the
"old men" generally abstained from dancing for the
sightseers and from filling sketchbooks. Making
Medicine, who was about thirty-one on his arrival
at Fort Marion, was the oldest of the prisoners to
engage in the activity of drawing. Also, one of the
seventy-two was a woman, who by tradition could

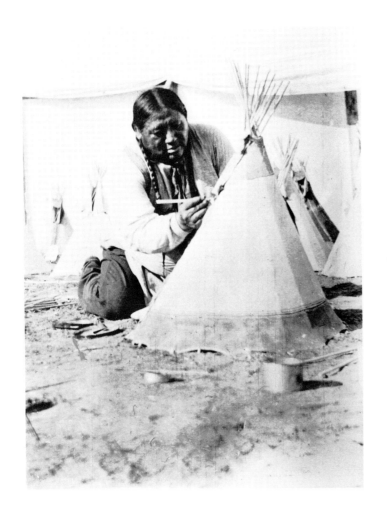

not depict representational figures. Among the forty-two clearly young men, drawings are known to have been produced by twenty-six—and perhaps there were more whose work has not yet come to light from the depths of trunks or museum archives. The high proportion bespeaks a native artistic ability and a rich cultural heritage.

Many Plains Indians utilized the arts as a way to express meanings—whether by music, the dance, or the creations of their hands. One man who for most of his life lived with the Cheyennes and studied them, observed: "The pictorial form of that expression was much used in earlier years, [but] is hardly under-.stood by the younger Cheyenne generation. It was used or expressed in rude drawings and paintings, by arrangements of several colors, with porcupine quills or birds' feathers, with hair or head adornment, with beads, knots, sticks, bones, blankets, and whatnots.

Plate 12. Paul Zotom is painting a model tipi at Anadarko, Oklahoma, 1897, for the Smithsonian to use in displays at expositions. (*Courtesy of Smithsonian Office of Anthropology;* identification by James Mooney, who took the picture).

Thus the Cheyenne have many ways to express themselves without saying a word. In ceremonials, dances and councils this pictorial or symbolic language is greatly resorted to by the Indians. According as one is painted, the others understand what he means to express."[5]

What were the resources in pictorial expression that the Fort Marion artists brought with them? Their work is a lineal descendant of early-nineteenth-century hide-painting on the Plains. The purpose of that painting was to express meanings, and in this sense it might be called pictography, or picture-writing. For many years it was the custom for the Plains Indian warrior to depict his feats of war in paint on his robe of hide. When he wrapped the robe about him all might read his biography and accord him the place that he had earned in the war-based society. Sometimes he spread his exploits as murals on the hide lining of a tipi or on its exterior walls. A few

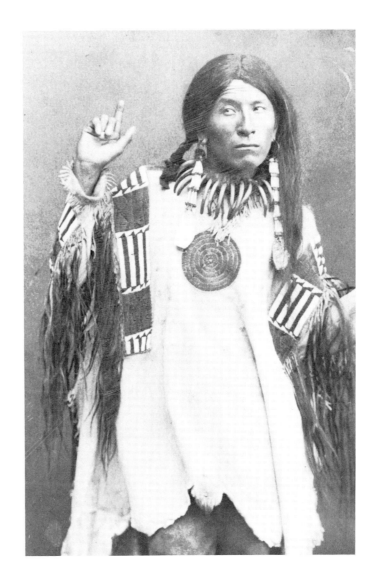

Plate 13. Squint Eyes, in the employ of the National Museum, is wearing a wig and bear claw necklace, 1879–80. *(Courtesy of and identification by Smithsonian Office of Anthropology)*.

men portrayed on shields or lodges the supernatural beings from visions. A very few kept historical records in the form of painted calendars.

Since the purpose of painting was to communicate events or record facts, an economy of expression was employed that amounted to a pictorial shorthand. It consisted of a set of conventionalizations—simplifications of natural forms (see the appended Pictographic Dictionary). "Plains Indian artists continued to repeat the conventional forms over a period of many decades because they must have found more satisfaction in this repetition than they would have experienced had they chosen to experiment with novel forms and arrangements." The meaning conveyed by paintings was readily apparent to the Indians; a knowledge of traditional conventionalizations, as well as a mastery of techniques for their execution, was part of a man's education. "The instructor did the work of painting, and the young men looked and listened to the old man's instruction."

They learned, for instance, that the most distinctive features of animate beings should be emphasized, even exaggerated, while lesser traits were minimized, in the manner of modern cartoons and nature guide books. Thus a Crow Indian might be a stereotyped human figure except for the tribal netlike wig hairdo, which would indicate the Crow tribe in the same way that the Uncle Sam costume universally suggests the United States. Again, an undifferentiated quadruped figure with long widespread legs might be designated a buffalo by the addition of horns, hump, and arching tail. The part might represent the whole: fifteen heads would mean fifteen warriors. A symbol might stand for an abstract idea (a wavy line for sacred) or for a concrete object (many horse tracks to signify a large body of riders). Foot tracks might perform the neat pictographic trick of showing past and present tenses in the same picture.

Technique, too, was simplified in this pictorial shorthand. Color was applied in flat tones, and neither color nor line was manipulated to give figures a third dimension. The clear colors employed might be used to represent subtler gradations of coloring. Thus, in depicting horses, blue or green (equivalent colors, to the Indian eye) might stand for a delicate mouse-gray, or light purple for a roan. Backgrounds and all irrelevant details were omitted; elaborations were employed only to assist in putting the message across. Since realism was no object, proportionate sizes were ignored and the component parts of a standing man were drawn in the easiest fashion—body and arms from the front view, feet and facial features from the side. Aesthetic considerations, be-

fore mid-century, were given scant attention. It is because the Fort Marion drawings were rooted in the old pictography that they were little masterpieces of compaction. Many of the pictures would require the proverbial thousand words for a full translation.[6]

One of the Fort Marion prisoners, Koba, filled five pages with "picture-words" that are like a miniature pictographic dictionary. English words learned in classes at the fort are illustrated by tiny drawings, many of them showing how the concept of the word was portrayed in Plains pictography (e.g., howl, walk, lame). Lists of prisoners' names are similarly illustrated.[7]

[1] Sidney Lanier to Mary Day Lanier, May 22, 1875, Sidney Lanier, "Letters, 1874–1877," *Centennial Edition of the Works of. . . .* (this vol. ed. by C. R. Anderson and A. H. Starke), IX, 198.

[2] Lanier, "Florida and Miscellaneous Prose," *Centennial Edition,* VI (this vol. ed. by Philip Graham), xii, xiii, xv; Sidney Lanier, *Florida: Its Scenery, Climate, and History,* 52–53.

[3] Lanier, *Florida: Its Scenery, Climate, and History,* 53; Lanier to Lt. A. H. Merrill, Aug. 26, 1875, PP. The human figure in Lanier's illustration is strikingly suggestive of Tichkematse's mounted man of four years later (Color Plate 8).

[4] General Richard H. Pratt, "Memoirs," MS, Chapter IX, PP; "The Last Sensation!!," [FP, May 29, 1875]; Brig. Gen. Richard Henry Pratt, *Battlefield and Classroom: Four Decades with the American Indian, 1867–1904* (ed. by Robert M. Utley) (copyright © 1964 by Yale University), 115, 118–19; John C. Ewers to author, Sept. 23, 1958. Mr. Ewers' *Plains Indian Painting* is a pioneer work to which the writer acknowledges great indebtedness.

[5] Thomas B. Marquis (ed.), *Wooden Leg: A Warrior Who Fought Custer,* 118–19; Rodolphe Petter, *Reminiscences of Past Years in the Mission Service among the Cheyennes,* 48–49.

[6] Quotations from John C. Ewers, *Plains Indian Painting,* 61, and George Bird Grinnell, *The Cheyenne Indians,* II, 19. On conventionalized coloring of horses: De Cost Smith, *Indian Experiences,* 124; Matthew W. Stirling, "Three Pictographic Autobiographies of Sitting Bull," *SMC,* Vol. XCVII, No. 5, 54.

[7] Cat. No. 39c, picture-words by Koba, BAEC.

II. WORKS OF MAKING MEDICINE, KOBA, AND WHITE HORSE

In style, the drawings at Fort Marion have many points of similarity to the early nineteenth-century pictorial (as opposed to geometric or abstract) painting on animal-hide robes in the Central Plains. For example, a drawing from the earliest known Fort Marion sketchbook (Color Plate 1), done in August, 1875, by the Cheyenne, Making Medicine, reveals most of the characteristics of early robe painting: figures of horse and man in action; horse conventionalized, with long, arching neck, small head, long body, legs spread before and behind to indicate speed; man conventionalized, with profile view but shoulders broadside, nose but no mouth or eye or hands, elongated upper torso, rigid straight posture; costume details stiffly stylized in a conventionalized pattern rather than a realistic one; distant objects placed behind or above nearer ones, but not made smaller or less distinct; no background; figures outlined and filled in with bright colors; figures two-dimensional in line and color; action flowing from right to left. In addition, this drawing shows "the semi-realistic, yet essentially decorative, style of painting . . . done by the Indians of the central Plains, especially the Teton Dakota and Cheyenne, in the second half of the nineteenth century." This style comprised well-drawn horses, fully clothed men, refined proportions, added details, sureness of line, careful application of color, and a general lack of crudeness. [1]

Yet Making Medicine defied robe-painting conventions in three respects. He departed from the traditional subjects of coup-counting, horse-stealing, and, more rarely, buffalo-hunting, with their mood of self-glorification; his composition was unified instead of random; and his media or drawing materials were made by the white man instead of by Indian hands. What brought about these modifications in traditional forms?[2]

It is frequently assumed that the decline of the painted robe was contemporaneous with the decline

of the buffalo. The Fort Marion drawings demonstrate the fallacy of this assumption for the Kiowas, Arapahos, and Cheyennes. Many buffalo hunts are depicted, roughly for the years between 1860 and 1875. Before 1870, the great herds had only begun to dwindle. Yet the drawings show that the hide robe was obsolescent by 1875. Only three of these wrappers are found among an array of Navaho, Mexican, and commercial blankets in some 460 sketches of Plains life closely examined, and these robes are not ornamented with pictographs. Indeed, except for moccasins, some leggings, or a rare war shirt, cloth had supplanted leather for clothing in the drawings.

As a matter of fact, the hide robe was out of style among many Indians of the Central and Southern Plains as early as 1840. In that year Tixier wrote, "The Osages nowadays seldom wear a buffalo-robe; it is more convenient and less tiring to pay for a blanket than to prepare, paint, and embroider a bison-skin." Of the Patokas (Padokas), or Comanches, he says, "The bleached buffalo robes are ornamented with strange figures and covered with pictures representing war or hunts However, the well-dressed Patoka replace the buffalo robe by a blanket." As to the Cheyennes, at one time they painted upon their robes the records of their deeds and the tracks of animals when they returned from war. But by 1847, Cheyenne beaux were wearing either decorated robes or blankets. By 1865, says George Bent, "our Southern [Cheyenne] Indians all wore cloth blankets, cloth leggings, and other things made by the whites." Although photographs from this time show the Cheyennes wearing buffalo robes with the hair on, they appear to be destitute of ornamentation and to be worn primarily for their warmth. The woolen blanket, whether obtained by gift or by annuity, by trade or in battle, had become a prestige piece. By 1872, white-tanned robes for summer use were antiquated on the Cheyenne and Arapaho agency. The women were tanning hides to trade for gay blankets for themselves and strouding blankets for their men "which were afterwards ornamented with beadwork by women and these they wore in place of the old-time whitened summer robes."[3]

This is not to deny that elaborately decorated buffalo robes were ever produced between 1850 and 1875 (Plate 9). There are many specimens in museums collected within that period. Some of them may have been relics hoarded from an earlier day, yet some were doubtless made for the use of those conservatives, whether dead or alive, from whose backs the robes were "collected." Others were made to order for the white man, with profit as the motive.

One of this type was painted by two top chiefs of the Kiowas, Satanta and Lone Wolf (later to be a Fort Marion internee) between December 20, 1868, and February 23, 1869. For all but the last week of this period, General Philip H. Sheridan held the pair prisoner as hostages for the submission of their people. No doubt the captives painted their pictures in the confines of their Sibley tent, under the surveillance of the guard. Interestingly, Lone Wolf was not deemed too old to portray his exploits on hide, although at Fort Marion six years later he never set pencil to sketch pad. As the man who ordered the robe described it:

The figures represent the encounters of those two worthies with the Utes and Navajoe tribes. Under the circumstances they probably considered the subject of their biographical sketches had better turn to a less direct subject than to killing soldiers. This painting cost the writer a pound of vermilion alone. The elegantly burnished physiognomies of Satanta and Lone Wolf, and their friends, during the production of this work of genius, suggested that the eminent artists did not forget the favorable opportunity of a lavish application of art to their own hides.[4]

Another Kiowa chief painted a robe during captivity; White Horse did the only known hide-painting at Fort Marion. It was done in May, 1877, on a cured buffalo robe received from one of his wives, "which White Horse has ornamented by paintings on the inned [sic] side, representing life scenes on the plains and a battle on the Mexican border, between Kiowas and Mexicans"—once more the tactful solution to a delicate problem. In Florida, White Horse did not feel bound by the tradition limiting robe painting to warlike subjects.[5]

According to the available evidence, the young Fort Marion artists probably had done little or no robe painting on the plains. Few men kept calendric records. Because of the prisoners' youth it is unlikely that they had painted sacred shields. Nor could they, generally, exercise their skill on the exterior of a tipi, as the example of one painted lodge will show (Color Plate 6). The lodge was given by a Cheyenne to the Kiowa chief Dohasan, or Little Bluff, in 1845, five years after a lasting peace was made between their two tribes, chiefly through Dohasan's influence. The gift was in ratification of a bond of comradeship between the two men. On Dohasan's death in 1866, it passed to a nephew, also named Dohasan, who in 1881 gave it to a son, Patain or White Buffalo (the twin of Ohettoint, one of the Fort Marion prisoners), who lived in it—the last painted tipi in the tribe—until his father's death in 1892. Half of this tipi cover was striped in yellow

and black; the other half was decorated with memorabilia of battles. It was a partial record of tribal history. The pattern varied with the painting of each new tipi made when the old one wore out or, as once happened, was burned. Twelve tomahawks were added by Heart Eater to represent his coups upon the Pawnees. A row of lances was added by Sitting in a Tree, representing the coups he had counted with a lance. A "circle picture" of forted-up Indians varied each time it was repainted, as did most of the other battle pictures that were contributed by outstanding warriors including the great Dohasan himself. "The pictures," said anthropologist James Mooney of this tipi, "might be painted by the chief actors in the deeds recorded or by the owner of the tipi, or by some competent artist selected for the purpose who worked under direction." The last alternative was also employed by the Cheyennes. "In former days the [Cheyennes] had certain men and women who were experts in decorating skins, tipis, etc. with drawings." Dohasan's tipi was known as the Dogiagyaguat, literally, Tipi with battle pictures.[6]

Mooney's account brings out several pertinent facts. Among the Kiowas—and the Cheyennes followed the same custom—painted tipis were heraldic and hereditary and specially significant. Limited among the Kiowas, and presumably among the Cheyennes, to prominent families boasting hereditary civil, military, or religious leaders, painted tipis were few in number. And those bearing battle pictures were even more rare, as the name of Dohasan's tipi suggests. Indeed, a study of recorded tipi designs used by the Kiowas and Southern Cheyennes of the pre-reservation era conclusively lays to rest the often-repeated fallacy that Plains Indians in general commonly decorated their tipi covers with pictures of their brave deeds. The statement simply is not true of the Kiowas and Cheyennes of the Southern Plains before 1875.[7]

With these tribes, as we have seen, the painters of the exploit scenes were either great warriors of many coups or artists who had built up a reputation for skill in decorating. Among the young Fort Marion artists only White Horse had risen to the rank of greatness. The others, at best, might occasionally be invited to portray war deeds of the great on the cover of another man's lodge.

The tipi liner, however, was quite a different matter. Among the Cheyennes it resembled in ubiquity and subject matter the pictured robe of an earlier day, but unlike the robe it might comprise tribal history. "Oftentimes it was highly ornamented with pictographs drawn on it by the lodge owner, or by

his friends, or by some young man who painted on it scenes of battle and other adventures representing the deeds of aged men."[8]

Curiously, twenty years after Fort Marion and the end of warfare, our artist Ohettoint was decorating a tipi cover with battle pictures—a small model of his father Dohasan's famous lodge, made at James Mooney's behest. It was proper that Ohettoint should paint it. Mooney vouches for the fact that it was made "by the hereditary Indian owner of the original." Yet Ohettoint did not presume to portray his own undistinguished war record. Except for the prescribed tomahawks, lances, and circle picture, the paintings show battles that are "purely imaginary with the artist." The model tipi is now preserved in the U. S. National Museum.[9]

What incentive was there, then, other than the anticipation of occasionally painting battle scenes on tipis and liners, for young men of our tribes to become proficient in drawing? How did they get the plentiful practice essential to the firm, disciplined hand apparent in the earliest Fort Marion sketches? They did not learn to make richly detailed compositions by drawing with crude native materials on natural surfaces of wood, stone, or bone. As to using tanned hides for doodling—impractical as the idea seems—even the best of the hide paintings made up

to 1875 could not match the detail of some of our earliest Fort Marion drawings (Color Plate 1). What material had they used that was susceptible of such detail?

The answer to all these questions is to be found in drawings on paper. A few dated specimens of these drawings are preserved in collections today. Representing, no doubt, only a token of the total output, the surviving sketches suggest that blank or partly-used ledgers, army rosters, daybooks, memorandum books, and sheaves of paper often found their way into Indian hands through gift, trade, or capture. With them went ink, colored and lead pencils, and water colors. Indeed, the lead pencils, calico bonnet, and ribbons in the possession of Chief Killer, one of our artists, at the time of his capture by Pratt on the plains, were the damning evidence that sent Chief Killer to prison for complicity in the John German family murders.

The new media were much more convenient than tanned hides and vegetable or mineral colors applied with implements of bone, horn, or wood and sized with animal glue. Even while hides of buffalo and other large animals were abundant, warriors adopted the white man's materials for recording the pictographic history of their brave deeds. Cheyenne war-drawing books were captured at the sacking of the

fallen Black Kettle's village on the Washita in 1868, at the burning camp of the slain Tall Bull near Summit Springs in 1869, and after the slaughter on Sappa Creek in April, 1875. The voluminous record of Black Kettle's warriors, drawn in an old daybook, pictured fights with the army. "The colored troops were indeed quite artistically colored, evidently with a burnt stick. The chiefs . . . were also highly illuminated in person and attire, vermilion and blue predominating."[10]

The impedimenta of Indian life perished in the flames of many of the villages. In the decade before 1875 alone, no less than twenty Cheyenne camps or villages were systematically burned—and sometimes plundered first—by attacking United States troops. It may well be that in these fires the era of the cumbersome painted robe was finally consumed, and that from the ashes rose the phoenix of a rejuvenated art—the war-drawing book. Its form was well adapted to the perilous new way of life. The old way, long days in camp or on the hunting plain, punctuated by the lightning-thrusts of warfare, gave way to a perpetual foreboding of attack, to heavy and punishing blows by the army, to stealing away in the night and running before the enemy. A man could give battle or slip away, with the precious record of his bravery securely tied upon his back.[11]

The white man, by introducing the use of the horse and gun, and adding axes, knives, kettles, and beads to the already rich Indian culture, brought about the Golden Age of the Plains Indians. Just so, the evidence suggests, the white man, by introducing into the Central Plains his commercial drawing materials and, presumably, models in the form of pictures in books and magazines, induced the flowering of the native pictorial drawing talent in the second half of the nineteenth century. The relative abundance of materials and the ease of using them allowed the practice necessary for mastery of the technique. The superiority of the new media over the crude native products permitted the elaboration and refinements in technique that produced a decorative style of painting. The use of sheets of paper, by limiting the number of figures, contributed unity to the composition of pictures and thereby enhanced their appeal to the eye.[12]

So much for the unity and the media found in a specimen of the earliest Fort Marion drawings (Color Plate 1) and lacking in traditional painting on hide robes. The third innovation in Making Medicine's sketch marks a departure from Plains Indian pictures either on hide or in war-drawing books. He shows neither the counting of coup, the stealing of horses, nor, as occasionally was depicted, the vanquishing of

a menacing beast. He draws neither esoteric figures nor winter counts. Instead, he captures on paper the nerve-tingling moments preceding attack. Elsewhere in his sketchbook he depicts a study of wild horses, the stalking of the gentle antelope, and a social dance (Plates 14, 15, 16). How did he happen to arrive at Fort Marion equipped to portray so wide a range of subjects and moods?

Although the concept of exploits illustrated on painted robes and tipi-liners is common knowledge, the scope and everyday usefulness of Plains pictography are not generally recognized. Like the gestures of sign-language, the conventional pictographic devices were, for the most part, universally employed and understood throughout the plains. Once a camp of Pawnees wiped out a small party of Cheyennes and memorialized the event with a detailed charcoal drawing on a large white log. "This was well drawn on the log. Whoever made these drawings took pains to make them easy to be understood." So great was the pictographer's skill that the complex Pawnee story was readily grasped not only by the Sioux party who came upon the log but also by the Cheyennes whom they told of their find. The latter sought out the place and read for themselves the fate of their friends.[13]

A very practical use of pictography lay in com- posing everyday messages. In these communications, the subject matter was by no means limited to recitation of the exploits of an individual. A Cheyenne suiter might diplomatically send to the brother of the girl he wanted to marry, a slab of wood on which was drawn the representation of a girl and of the articles which he would give for her. The shoulder blade of a buffalo might become a signboard set up at the site of an abandoned hunting-camp to indicate the new location of the village or the reason for departure to fellow Sioux or Hidatsas absent when camp was moved. A bone might be leaned against a Blackfoot war lodge with a message to the members of a horse-stealing party, saying that one of their number had started home with his booty and enumerating his successes. In 1833 or 1834 a certain Mandan wrote a pictographic letter to a fur trader, setting forth terms for an exchange of goods. In 1824 a safe-conduct pass was painted on a piece of wood by a Pawnee chief. In 1819 or 1820, Omaha warriors on their way home from battle might have left behind a sign for their fellows not yet returned; by writing on a peeled tree-trunk with vermilion and charcoal they could tell of the outcome for their party—the number of combatants, the toll in men and horses, the roll of captured men, horses, guns, and women. Knowing how to read and write the

pictographic language was, for an Indian, a tool for survival.[14]

Contrariwise, for the white man, understanding pictography was a tool for subjugation. Counterintelligence required that a good army scout know how to read more than one kind of "sign." On June 26, 1868, Lieutenants S. M. Robbins and W. W. Cook were escorting a wagon train which Custer had sent for supplies. Not far from Fort Wallace, Kansas, five or six hundred Cheyennes and Sioux under old Roman Nose staged an attack on the train and then withdrew. Where were they to be found?

"Will Comstock, the scout and guide who had accompanied Lieutenant Robbins, had seen what he termed 'Indian letters'—characters cut in the bark of trees. These he declared to indicate that the Indians had moved to the west, and camped somewhere on the head of Beaver Creek."[15]

Comstock, with the good scout's understanding of Indian ways, termed these pictographs "letters." It is not to be doubted that, particularly after the advent of paper and pencil, the widely scattered kindred tribesmen kept abreast of family news by means of picture-letters. Just so, the prisoners at Fort Marion kept up a lively correspondence with their relatives in Indian territory. One letter from home became known on both sides of the Atlantic. The old

Cheyenne chief, Minimic, started things off by writing to his wife, Shooting Buffalo, in Indian Territory. As their agent tells it:

On Saturday last she came to my house after paper to write to 'Manimic' herself.—She and her children now send the enclosed 'letters'—'hieroglyphic' in character yet I presume will be perfectly intelligible to their friends . . . Mrs. Manimic says . . . to tell him that he must write oftener as she had almost come to the conclusion that he was dead but now she knows he is not. . . . The first night after she got his letter she could not sleep from joy and sadness, and said she would get up and look at the letter.[16]

Her reply, addressed to her husband and to their son Howling Wolf and Making Medicine (two of our artists), is reproduced in a recent book, the notable memoirs of General Richard H. Pratt. In 1875 this humanitarian was known as Captain Pratt. He had participated in the campaign against the tribes of the Southern Plains, he had conducted the seventy-two chained captives across the country, and now he had become their jailer, friend, and advocate at Fort Marion. His memoirs use the Minimic message as an illustration of the "crude picture letters from home which, to them, were full of information." When the packet of letters arrived at the fort, Pratt told the Cheyenne agent, John D. Miles, that "the

7.

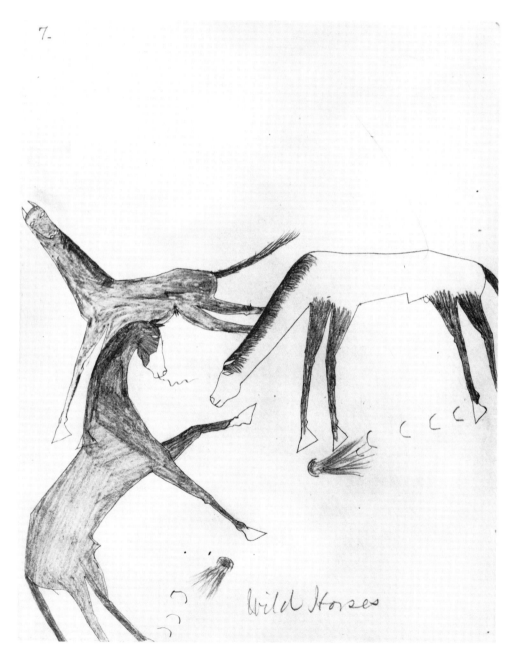

Wild Horses

Plate 14. "Wild Horses," by Making Medicine, Cheyenne, August, 1875. (Courtesy of Smithsonian Office of Anthropology). In the artist's lifetime the Cheyennes obtained few of their horses by catching them in the wild state. Here, in an interesting triangular composition, is portrayed a fight over a mare by two stallions.

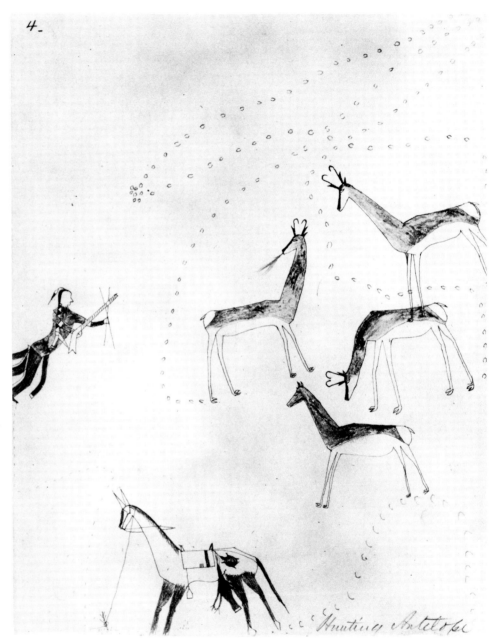

Plate 15. "Hunting Antelope," by Making Medicine, Cheyenne, August, 1875 (*Courtesy of Smithsonian Office of Anthropology*). The story of the maneuvering of hunter and prey is easy to follow from the tracks: the hunter utilizes the innate curiosity of the antelope to lure it within range. The mule, tethered to a small sprig, bears a turtle, a turkey, and a three-point commercial blanket.

contents were quite acceptable to us all, but more particularly to old Minimic. The letters were understood at once, by all the Cheyennes So the Cheyennes are in extra good heart." Indeed, Minimic told Pratt, "When that letter came it made my heart feel glad, and I have been light ever since." He kept the letter for seven or eight months, and then relinquished it to a sympathetic visitor to the fort, Esther Baker Steele. The pictures, their interpretation, and the story of the prisoners were embodied in an article thrice published by Mrs. Steele and her husband, Joel Dorman Steele, a well-known educator whom she assisted in the writing of his many textbooks. The article spread the story of the prisoners and their picture-writing abroad as far as London.[17]

Pratt tells of another picture-letter received by the Cheyennes in the form of an army muster roll with drawings of the battle on the Little Big Horn, 1876. Other letters reported the arrival of the Northern Cheyennes at Darlington in 1877, the flight of some Cheyennes to Canada, and the names of the Southern Cheyennes who were wiped out on the Sappa in 1875. "The Cheyennes have kept up a constant interchange of information in their rude picture way, but the Kiowas and Comanches have not had full response from their people, and have not felt encouraged to write," said Pratt. One message came to the devoted Minimic (Eagle's Head) after he sent his wife a fan and a parasol. It is described by Elizabeth Williams Champney, a popular writer of children's books and wife of James Wells Champney, a well-known artist who painted and sketched the Indians at the fort and told their story in *Harper's Weekly*. Mrs. Champney wrote:

The letter which he received in return, acknowledging their receipt, was simply a drawing of a squaw holding the articles, while over the woman's head was drawn a buffalo and a gun, signifying that this was Shooting Buffalo, Minimic's wife. Over the fan and the parasol was drawn an eagle's head, telling that these articles had been sent by him.

Perhaps [perceptively comments this wife of an artist] it is owing to the use of this picture language that all of the Indians have an aptitude for drawing. Their pictures are very curious, somewhat resembling old Egyptian paintings [Plate 16], and the Indians earn considerable money by selling them to the visitors at St. Augustine.[18]

When the prisoners arrived at Fort Marion, even though they were bilingual (they knew the universal sign language of the Plains as well as their tribal tongue, and some knew the language of other tribes), and although they were literate (in the pictographic language), not one could speak or understand Eng-

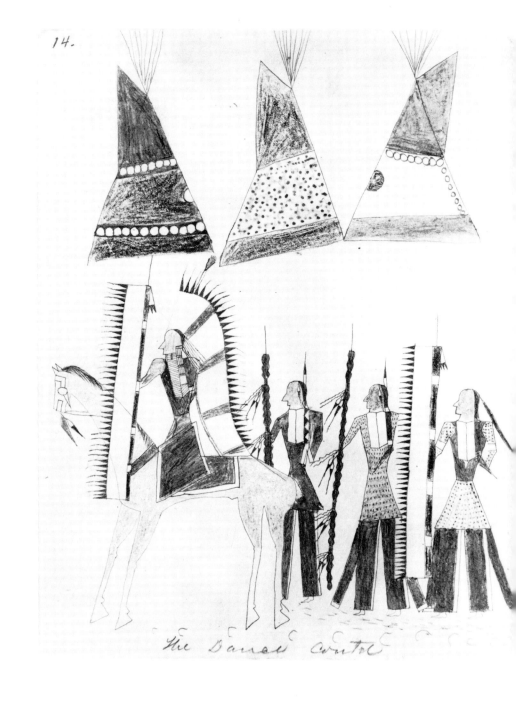

14.

The Damall Counted

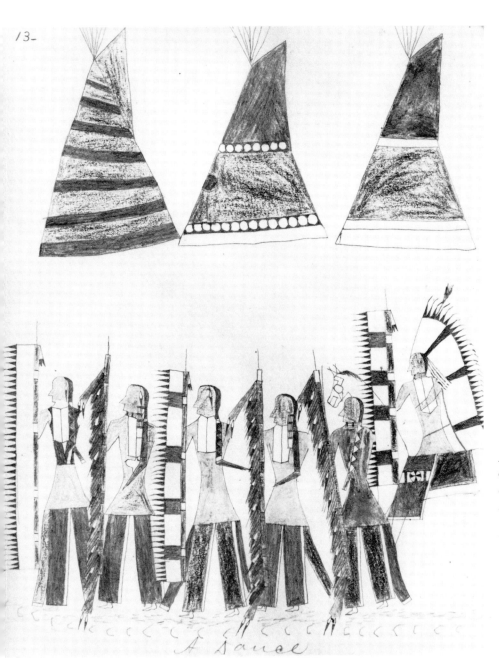

Plate 16. "A Dance," by Making Medicine, Cheyenne, August, 1875 *(Courtesy of Smithsonian Office of Anthropology).* A soldier society is staging one of its dignified, drill-like dances under the direction of its two bravest members, who are mounted. The drawings are shown in reverse order to that of the originals. The horse tracks and the customary position of dance-directors warrant the change.

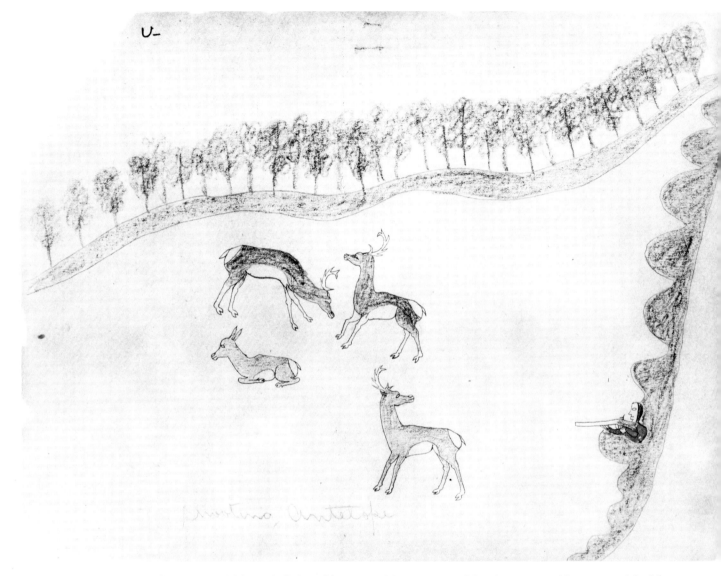

Plate 17. "Shooting Antelope," by Making Medicine, Cheyenne, May 18, 1876–March 26, 1877 *(Courtesy of Smithsonian Office of Anthropology).* From a hilly ridge the hunter stalks the nervous deer as they feed near the stream below. The deer far surpass those of Plates 23 and 40 in naturalism.

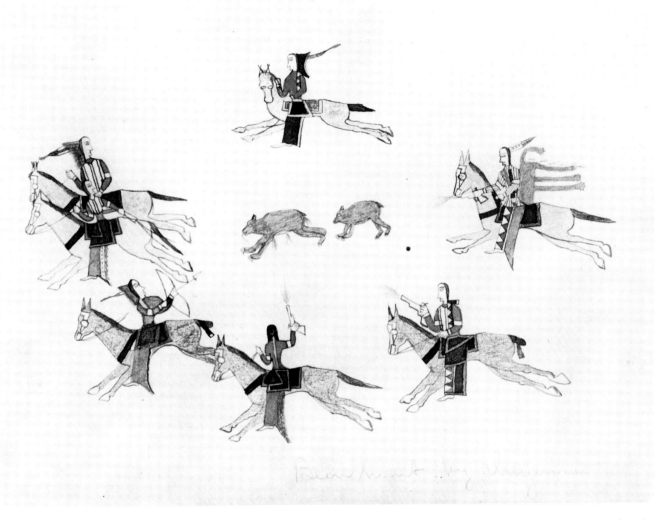

Plate 18. "Bear hunt by Cheyennes," by Making Medicine, May 18, 1876–March 26, 1877 *(Courtesy of Smithsonian Office of Anthropology).* Cheyennes, who avoided the grizzly but prized the black bear's skin for covering their shields, have surrounded a bear and cub. The effective circular composition is unusual.

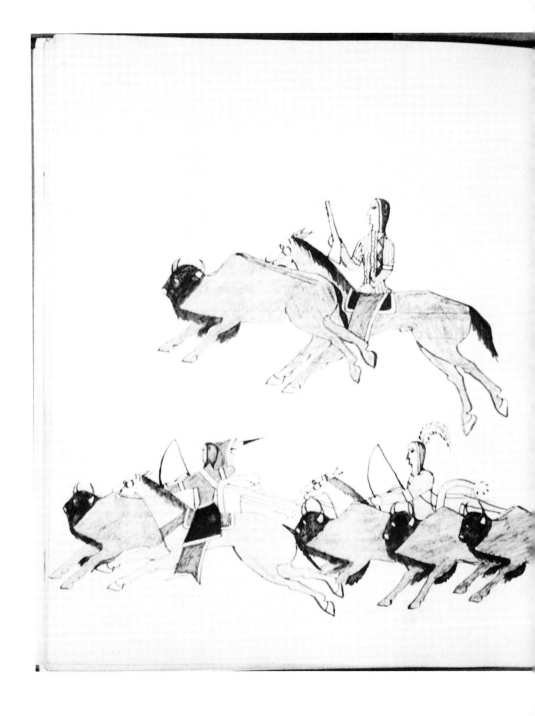

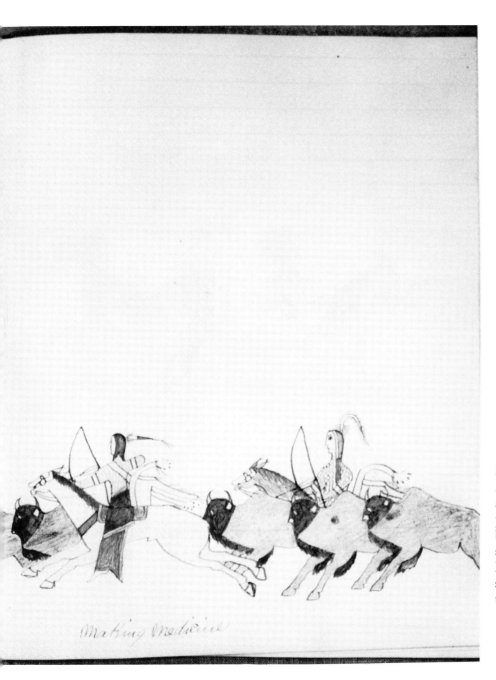

Making Medicine

Plate 19. By Making Medicine, Cheyenne, April 18–July 21, 1877 *(Courtesy of Massachusetts Historical Society).* The artist presents his motif—the approach to the buffalo—by itself and then weaves with it a flying frieze. Although the figures in Plate 32 and Color Plate 8 on the same subject are drawn better, this one is unique in originality of concept.

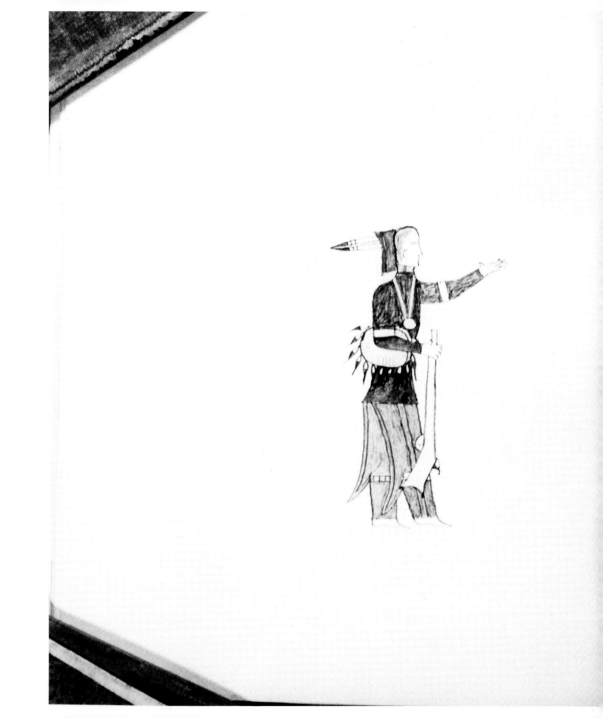

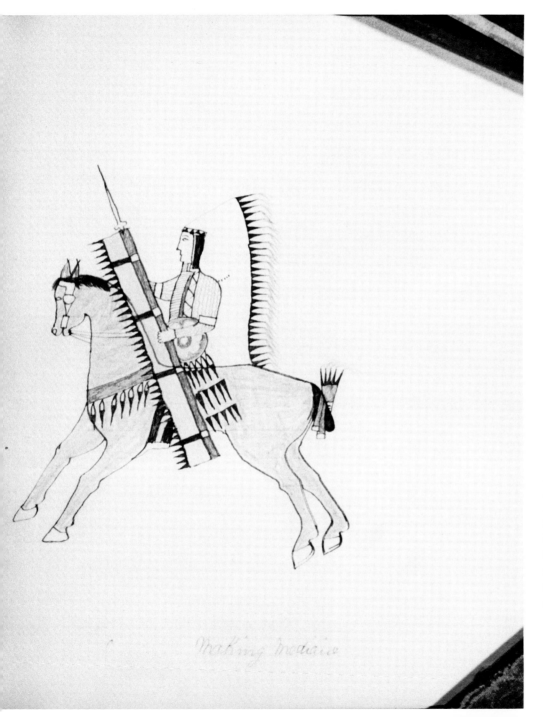

Plate 20. By Making Medicine, Cheyenne, April 18–July 21, 1877 *(Courtesy of Massachusetts Historical Society)*. By extending his palm and grasping his rifle by the barrel, the man on foot, presumably an Osage, shows his peaceful intentions toward the rider, a Cheyenne. Gestures are the only language the men have in common.

Plate 21. "This Indians three man bow and array shoot kill Buffalo," by Making Medicine (and Little Medicine?), Cheyenne, about 1877 *(Courtesy of St. Augustine Historical Society).* The dedication of this fan to Mistohaih (the Indians' name for Miss Annie E. Pidgeon) is probably an Indian joke. Mistohaih is Cheyenne for the dreaded owl, not the pigeon.

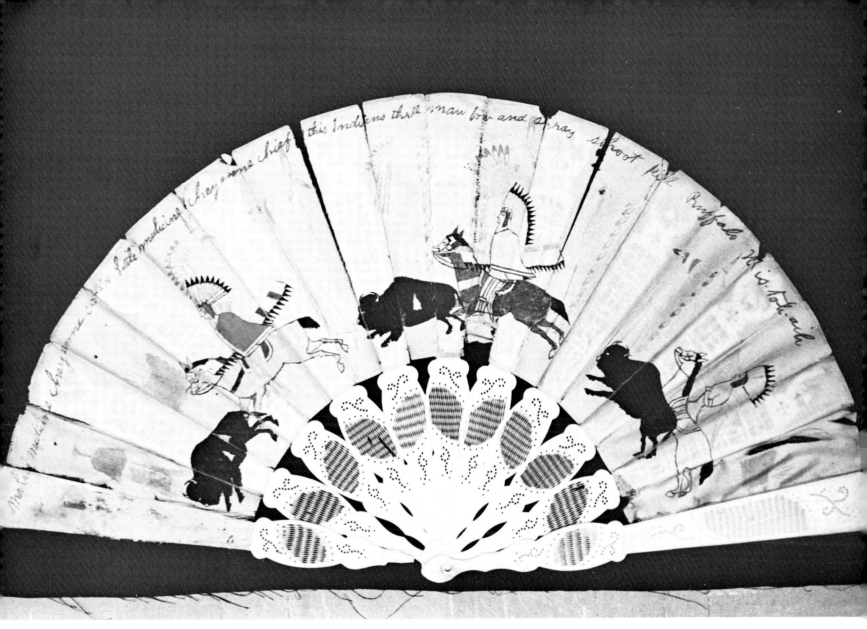

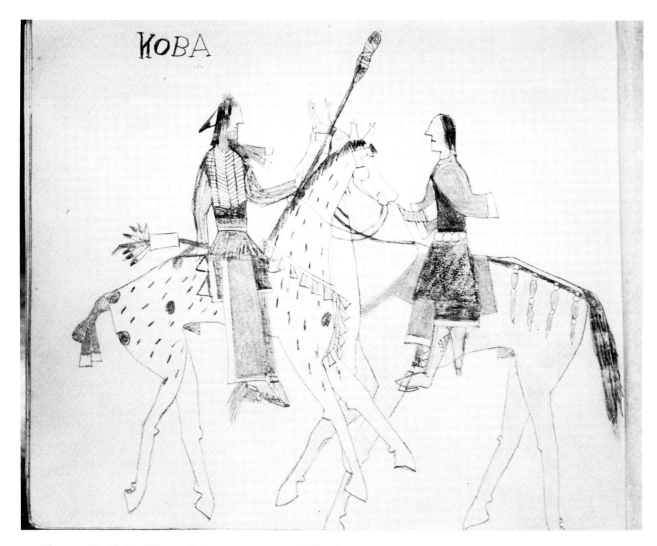

Plate 22. By Koba, Kiowa, February 12, 1876 (*Collection of Karen D. Petersen*). The woman and her horse are in holiday attire. The man has applied paint to himself and his horse and has tied up his mount's tail as if for battle. But instead of weapons and shield, the man carries a harmless club woven of leafy willow withes, for he is off to the sham battle of the Sun Dance.

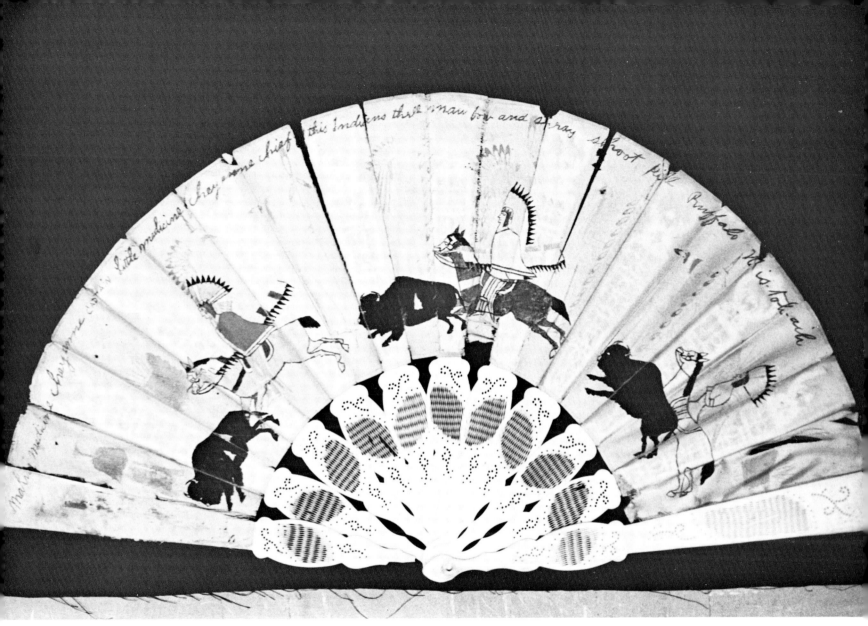

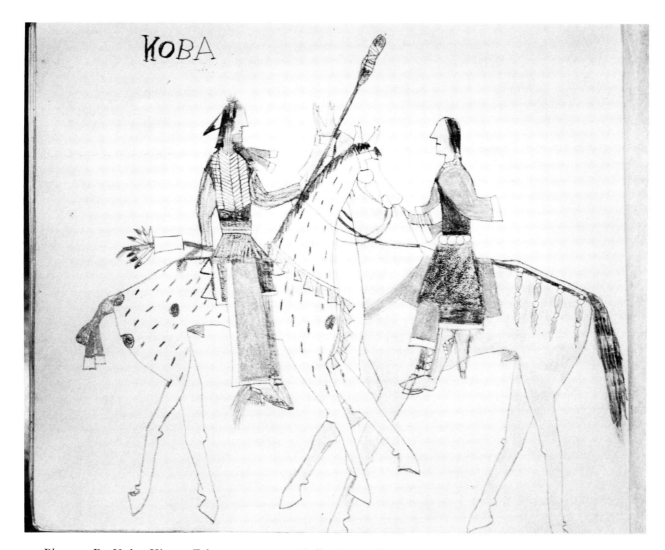

KOBA

Plate 22. By Koba, Kiowa, February 12, 1876 (*Collection of Karen D. Petersen*). The woman and her horse are in holiday attire. The man has applied paint to himself and his horse and has tied up his mount's tail as if for battle. But instead of weapons and shield, the man carries a harmless club woven of leafy willow withes, for he is off to the sham battle of the Sun Dance.

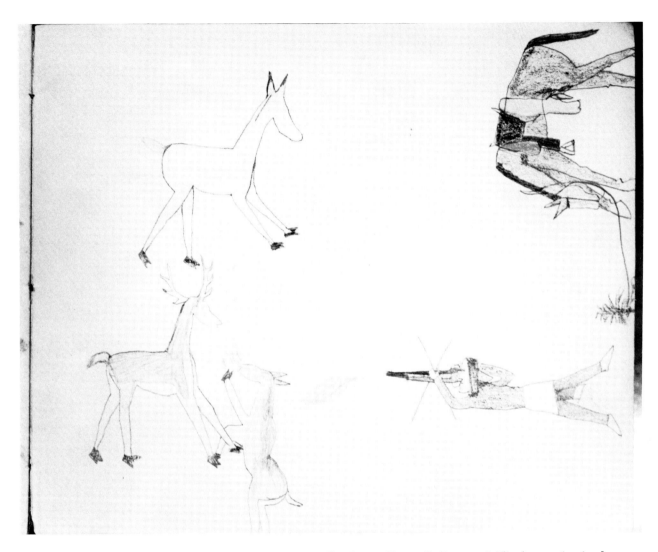

Plate 23. By Koba, Kiowa, February 12, 1876 (*Collection of Karen D. Petersen*). The hunter has broken the back of one deer. Crossing his wiping-sticks to rest his heavy weapon, he concentrates on the next. Slung behind his saddle is the carcass of yet another victim.

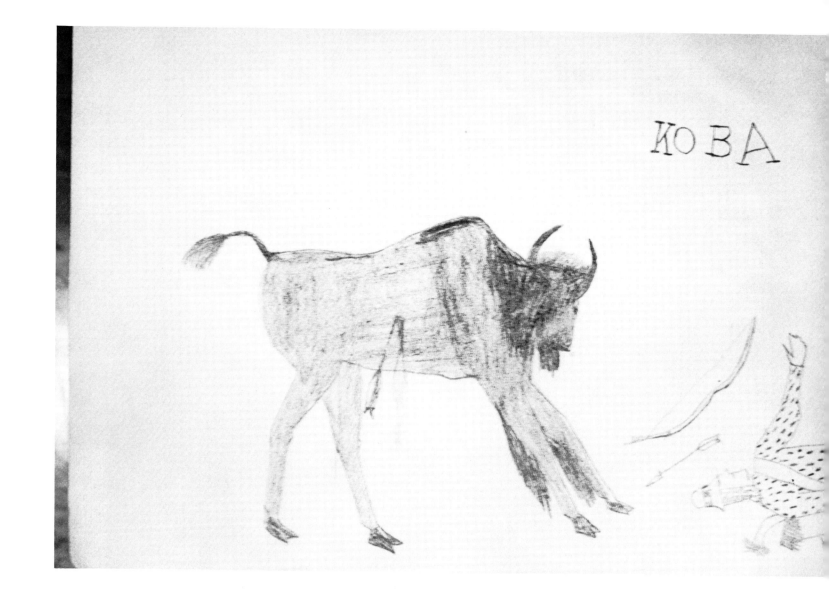

44

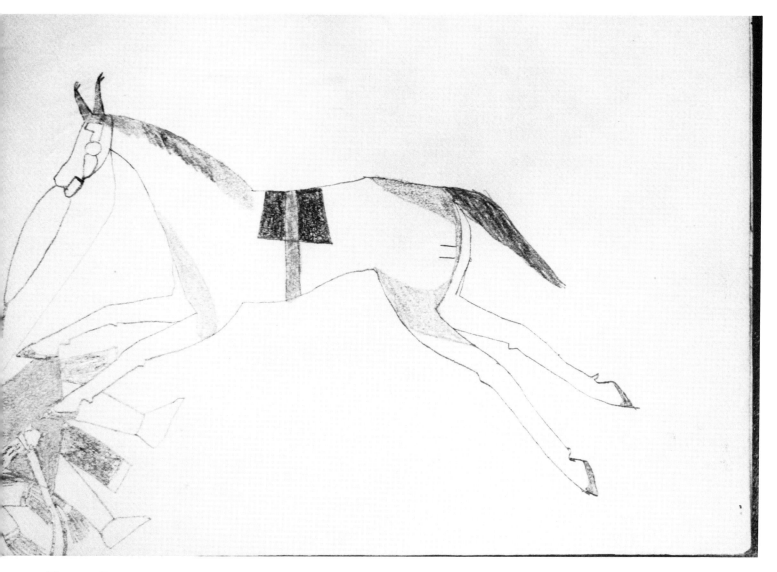

Plate 24. By Koba, Kiowa, February 12, 1876 *(Collection of Karen D. Petersen).* A buffalo is said to attack only if it is seriously wounded. The hunter is pitched over his horse's head just as his well-aimed arrow goads the buffalo into turning on his tormenter.

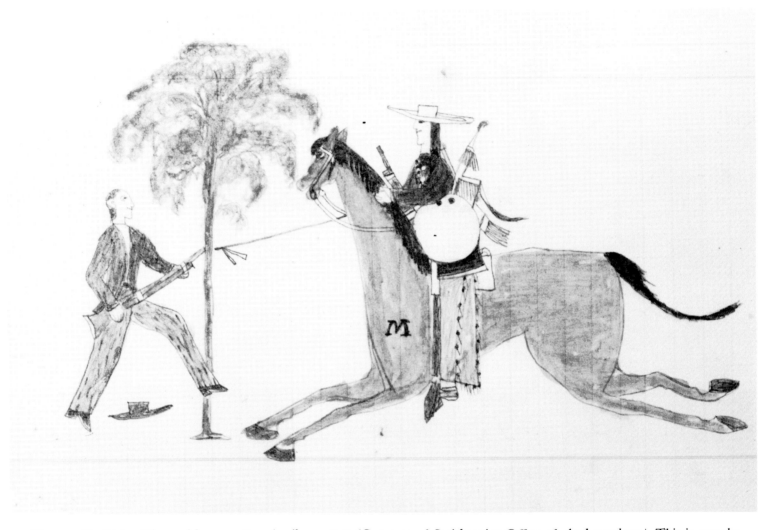

Plate 25. By Koba, Kiowa, May 21, 1875–April 11, 1878 *(Courtesy of Smithsonian Office of Anthropology).* This is not the rider's first encounter with a white man; witness the Army uniform coat, the Mexican stirrup-covers, and the hat on his head. He is performing the ultimate act of bravery—touching his adversary with a harmless coup stick. Comparison with the combat scenes of Plates 56 and 42 (in descending order of technical skill) reveals Koba's artistic superiority.

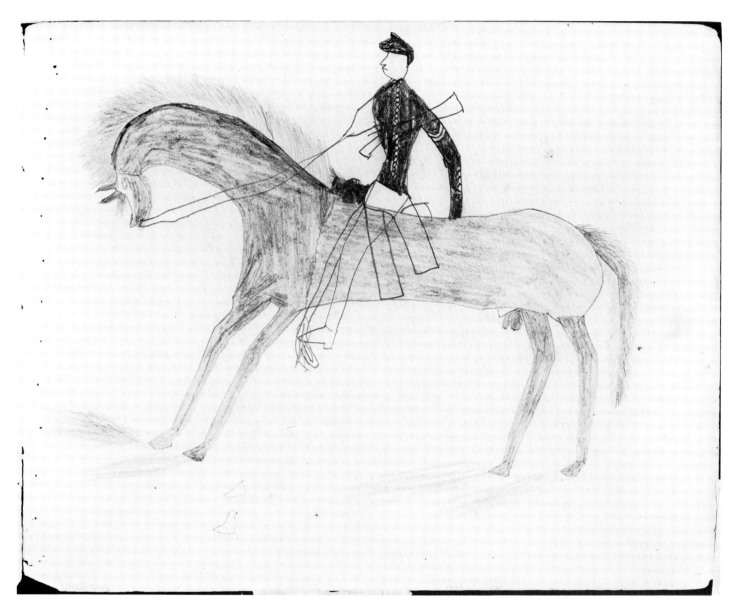

Plate 26. By White Horse, Kiowa, May 21, 1875–November 30, 1876 *(Courtesy of Joslyn Art Museum).* As the Indian Scout rides with reins casually looped over one shoulder, his great stallion shies to a dust-raising halt. The objects in the foreground, hoofs, which the artist sketched and abandoned, suggest that White Horse began his horse drawings with the hoofs and built onto them.

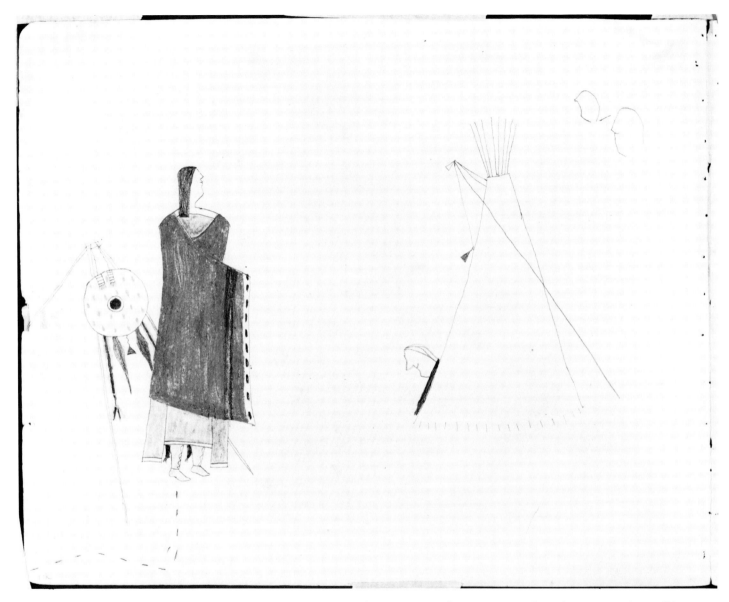

Plate 27. By White Horse, Kiowa, May 21, 1875–November 30, 1876 *(Courtesy of Joslyn Art Museum)*. Walking along, the lady abruptly turns in at the tipi whose owner she knows by his shield on its easel. A head pops out of the door and . . . the reader may wish to supply dialogue for this cartoon.

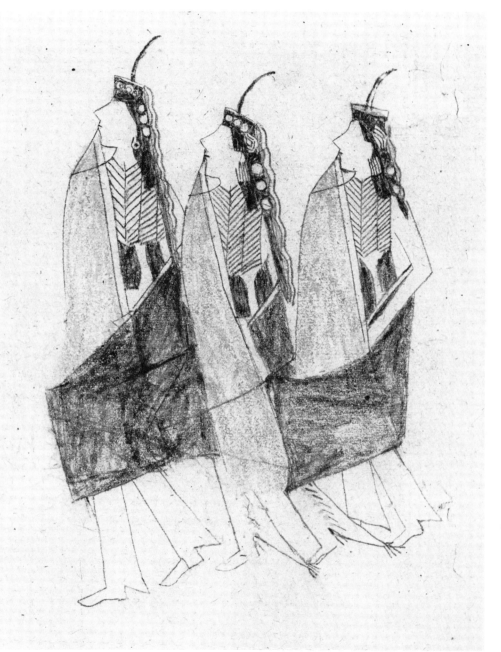

Plate 28. By White Horse, Kiowa, May 21, 1875–November 30, 1876 *(Courtesy of Joslyn Art Museum).* Three men move along in unison, with their robes pulled up, half concealing their faces.

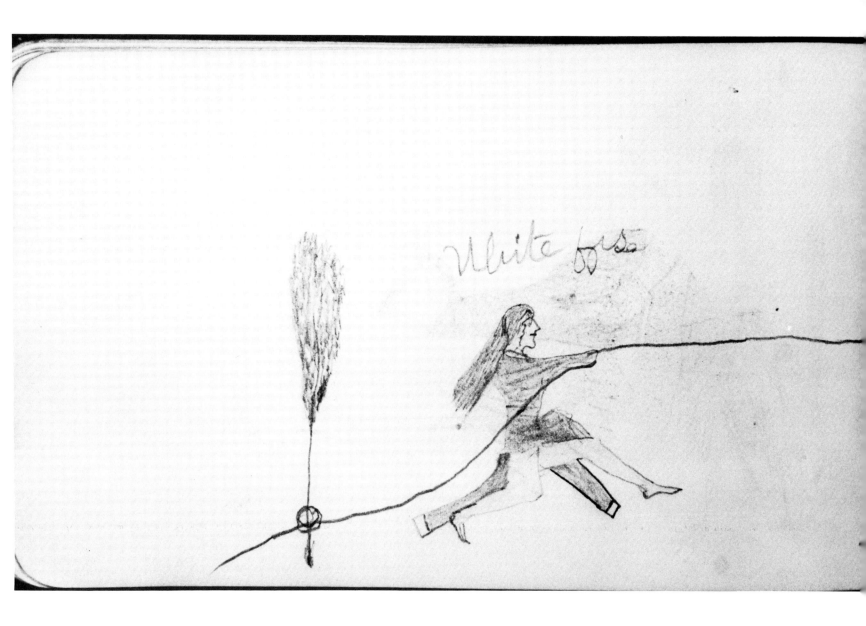

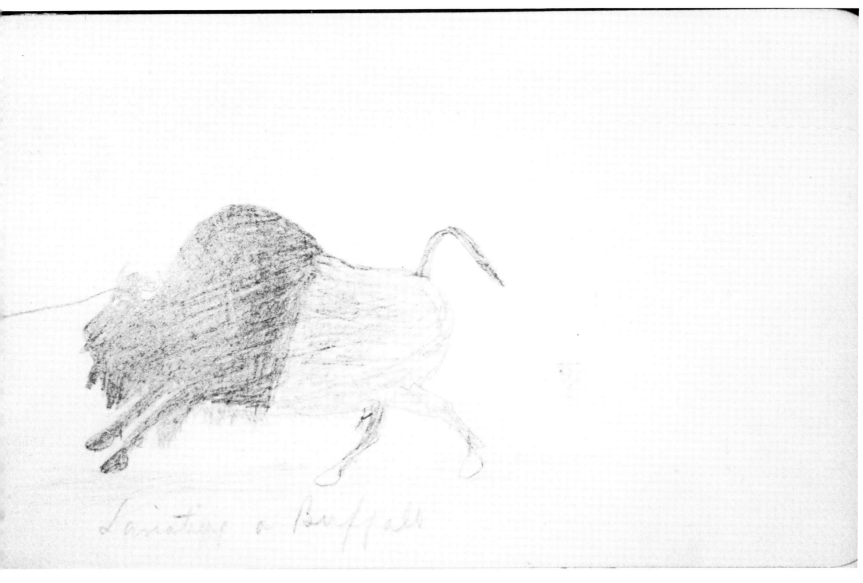

Plate 29. "Lariating a Buffalo," by White Horse, Kiowa, May 21, 1875–April 11, 1878 *(Courtesy of Yale University Library).* To capture without a weapon this grown bull weighing between one and two thousand pounds is an act of sheer bravado.

lish. During their first summer, Pratt began to teach them the language of their captors. With the help of devoted volunteer teachers, his project rapidly grew into a school of the three R's within the dark casemates. By the end of their three years, many of the younger men could write letters in English, but their people on the Plains could not read them without the intervention of an interpreter of questionable ability, and the prisoners avoided writing home in the new language. "Some of the letters sent from the old fort . . . to their friends out west, were mostly in pictures," said Pratt afterwards. Today the Cheyennes remember that when their illustrious principal chief, Heap of Birds (more accurately, Many Magpies), died on October 9, 1877, at Fort Marion, his family learned the grievous news from a picture-letter of "a grave and lots of little black birds." Even Pratt fell into step with the pictorial trend. When he wrote Agent Miles of the prodigious moving job the Indians had done in town (they lifted a chapel four feet above the waters of high tide and carried it 350 yards), he enclosed an Indian's drawing of the event.[19]

Although few of the striking painted robes, tipis and liners, calendars and shields from before 1875 have survived, rarer yet are specimens of the commonplace, unspectacular uses of Plains Indian drawing. Three of the latter still to be seen in collections are letters to or from the Fort Marion Indians. One letter shows the progress made along the white man's road at the Cheyenne and Arapaho Agency as represented by the number of plows, hoes, wagons, and stone pipes owned by each of forty-five men named. Another letter, received by the artist Cohoe and the chief Minimic on June 30, 1877, depicts the last successful buffalo hunt of the Southern Cheyennes. It was "willingly given by Minimic to the Smithsonian Institution at Washington to aid science in the study of his people, which has been explained to and is understood by him." Interestingly, although the old chief's loving wife is depicted, it is their son, White Buffalo Head, who is named as the author of the letter. The suggestion is that the Cheyennes still maintained the division of work from the days of the painted hide robes, when pictorial painting was limited to the male sex. Clark Mills, the noted sculptor who produced the equestrian statue of Andrew Jackson that stands in front of the White House, obtained the letter on a visit to the fort for the purpose of making casts of the Indians' heads at the behest of the Smithsonian.

While he was in St. Augustine several of the Indian chiefs received letters from their wives. . . . He describes

these letters as very peculiar, and succeeded, after much difficulty, in securing one from "White Horse," and a copy of another. The Indians have no letters [alphabet], their communication on paper being entirely by objects such as a house, horse, field of corn, buffalo hunt, &c. Each one of these objects signifies something, and the Indian reads it fluently and rapidly. . . . These "letters" were filled with objects of various kinds, and he intends placing those he has secured on exhibition in the Smithsonian Institute.[20]

Only one of the many picture-letters written by the Florida Boys is to be found today (Plate 43). Once more Minimic is the recipient. His son, the artist Howling Wolf, went by steamer to Boston in the middle of July, 1877, for correction of conditions threatening his vision. He was escorted by Lieutenant Edmund L. G. Zalinski, later to become famous as the inventor of the pneumatic dynamite gun, who was on leave from St. Francis Barracks, St. Augustine. The letter is in the form of a coastal map showing the estuaries and cities along the first part of the route.[21]

In picture-letters, evidently, lies the precedent that gives Making Medicine a wide choice of subject matter and mood for filling his first sketchbook at Fort Marion (Color Plate 1 and Plates 14–16). He is, in effect, writing picture-letters to his white friends in the East, telling of the folks back home. Nevertheless, even his first drawings transcend the realm of pictography. They exhibit a sureness of technique and a developing instinct for composition with such elements as balance, rhythm, and emphasis. Mrs. Dorothy Dunn, in a recent artistic evaluation of Making Medicine's drawings here represented by Color Plate 1 and Plates 14–18, comments discerningly on "the sharp, sure pencil and firmly laid crayon, the strongly individual style in the consistent angularity and economy of line, the selective yet intricate detail."[22]

When the prisoners entered the old stone fortress, their captor quickly struck off their shackles. As swiftly as Making Medicine was freed from the chains on his ankles, he was liberated from the obligation to follow traditional art forms. One convention he all but abandoned was the name-symbol. Since Plains drawing shunned facial expression or portraiture, a small drawing that represented a man's name was the means of identifying him in the traditional pictographs. It was commonly placed just above or below his figure, to which it was usually connected by a line. Within the walls of Fort Marion, the name-symbol device became obsolescent; it was employed in less than a score of pictures out of some 460. Instead, a man was sometimes identified

by what might be termed a costume-symbol—significant features of dress and accouterment. The innovation of the costume-symbol was made possible by the white man's drawing materials; for the first time, costume could be detailed down to the very beadwork pattern of a small bag. With Indian as with eighteenth-century portraiture, the pictured costume might furnish a man's contemporaries with clues to the rank, age, sex, economic status, club affiliations, and previous feats of the subject. In addition, the portrait might show some item of dress which was commonly recognized as distinctively his.

Just how successful was the costume-symbol in disclosing a man's identity to his confreres? Were they able to recognize him at once as "that camp crier who wore the arrowhead on his breast" or "the man who had the captured gold epaulets"? Portrayals of White Horse reveal that while his self-portraits emphasize his blue shield with its distinctive pattern and his blue face paint with a white disk, worn for war and courtship, Koba shows White Horse with not only the disk and shield but also another identifying feature—a double-horned war bonnet from which falls a streamer sparsely hung with feathers (Color Plate 3 and several unpublished drawings). The horns were mentioned in a contemporary account (page 125, below) and in the recollections of a present-day Indian. It would appear that the features identifying a man were not standardized but might vary with the artist.[23]

To take another instance, Making Medicine and Howling Wolf show the great chief Roman Nose, who was killed in 1868. Both illustrate a full tail bonnet on the chief and a flank wound on the horse. Although Making Medicine illustrates the single buffalo horn of the famous protective bonnet, he omits the kingfisher skin behind the horn in plain sight, described by Grinnell, while Howling Wolf omits both horn and bird. Once more it appears that not all artists stressed the same details of personal costume.[24]

On the other hand, identifying details of foreign costume, standardized and universally employed, undoubtedly conveyed to the viewer the tribal affiliation of the subject, or at least narrowed the choices to a few tribes. Thus the Fort Marion artists used a moccasin with flared cuff to indicate either Pawnee or Osage (see Pictographic Dictionary), while Mallery calls it Pawnee. The netlike wig and pompadour for the Crow appear in the sketchbooks (see Pictographic Dictionary) and in Mallery. No doubt the warrior studied tribal costume traits just as a modern soldier learns aircraft identification. Survival might depend on the ability to recognize friend

from foe at a glance, whether from a silhouette against the sky, the litter of an abandoned camp, a piece of clothing dropped along the trail, or a solitary moccasin print. Familiarity with the enemy's costume might have been made possible by the custom of carrying home as battle trophies both captives and pieces of regalia, or from the tales of visitors from neutral tribes. Distinctive details would be readily absorbed by observers as acute as our artists. Indeed, although the Fort Marion drawings sometimes betray a lack of understanding of white men's mechanical devices and a deficiency in artistic techniques, their ethnographic details, under comparative analysis, have proven marvelously accurate. If there is a conflict with white men's records, it does not suffice to say complacently, "The Indian artist must have made a mistake" or "This may be artistic license." It is wiser to say, "This has gone unrecorded by the white man" or "I may not be looking at the picture in the right way."[25]

Since conventionalization was acceptable for depicting the costumes of foreign tribes, the question arises, was it employed in portraying the artist's own people? Undoubtedly, yes. It is common knowledge that the Plains Indian man's clothing for hunting and everyday consisted of moccasins, leggings, and breechcloth, supplemented by a robe in cold weather. Yet the sparely dressed hunter in Plate 15 is in marked contrast to the other hunters in this volume, who are incredibly encumbered with chokers, breastplates, armbands, shirts, vests, capes, robes, assorted headgear, and even full-feathered lances, a stone pipe worn at the waist, and a yard-long pipe bag. The horse-racers in Plate 58 are similarly overdressed.

While such an ornate costume on a hunter or a racer is clearly an artistic convention, war dress equally elaborate is a different matter. Although stripped-down dress was of advantage to the former, regalia with medicine or power was helpful to a warrior in battle. For this reason he might carry a shield or a particular lance, or wear an amulet or a protective bonnet. In addition, the Cheyenne or Kiowa warrior paused just before battle to dress himself in his best as a preparation for possible death. He painted himself and his horse, combed his hair, and put on his finest clothing. These customs could account for the dress in our battle scenes, except for one item. Eagle-feather war bonnets were worn only by a few outstanding men of the tribe; yet our war drawings run heavily to these headdresses. The pictures might be explained as faithful depictions of war leaders if it were not for a series of drawings in one sketchbook of which Plate 47 is an example.

The series clearly identifies seven of our artists and shows these young, undistinguished warriors wearing eagle-feather crowns. We are forced to conclude, then, that many of these bonnets, and perhaps other elaborations of costume, were an artistic convention for depicting warfare.[26]

Just as a man selected certain regalia for battle, he chose items appropriate to the occasion for a social or ceremonial function. The elaborate costumes shown for soldier society ceremonies, the Sun Dance, and other formal occasions are fitting and proper; yet their extreme elaboration suggests conventionalization—an ideal state in which every man owns every article of dress he would wish for.

Since on all the other miscellaneous occasions represented, our drawings show men well clothed, we may conclude that again this practice was an artistic convention, a carryover from the fully-clothed men of the art traditions on the plains in the second half of the century.

Although Making Medicine discarded the name-symbol, he chose to retain the old symbols when they served a narrative purpose. The symbols for a hole and for dust rising add to the action. Foot tracks show the route taken, but the tracks of men and antelopes are symbols and not literal drawings of footprints. Symbols for the whistle of the antelope and the whinny of the horse add sound to the pictures.

Liberated from the strictures of tradition, he was free to add backgrounds that were simply decorative, to show figures in naturalistic rather than conventional postures, and to substitute for the asymmetric right-to-left flow of action a triangular composition (Plates 14–16). More subtly, the new freedom extended to mood. The artist could express a range in emotions from excitement to grave dignity.

Making Medicine compromised on one problem that has troubled many an artist in many a culture—perspective, or the handling of the more distant objects in a scene. The painter on the plains found a solution to the problem that satisfied him. He placed a farther object above and sometimes partially behind a nearer one. When a number of gradations of distance occurred, the effect was that of looking down on the scene at an angle of forty-five degrees. He made the distant horse of the same size and clarity as one in the foreground, for, as everyone knew, a horse was of the same size and description whether at one place or another, and the Indian drew things as he knew them to be, not as they appeared to the eye. Making Medicine's greatest concession to the art of the white man in his first sketchbook was in the matter of perspective. Upon the traditional means of suggesting distance he superimposed linear per-

spective, or making distant figures smaller (Plate 16). However, he reversed the process for the giraffe-like antelopes.

Besides this sketchbook by Making Medicine, the Cheyenne, only one other dated book from the first year of imprisonment is known to have survived. Most of the output stems from the second year. The other early book is signed by Koba, the Kiowa, and dated February 12, 1876. Ewers has commented that the few dated specimens of representational Kiowa painting from the plains in the late 1860's are "roughly delineated, with poorly proportioned figures in indefinite outline such as are the marks of the unskilled draughtsman lacking complete control of his technique." In this connection, it is interesting to compare Koba's book with that of Making Medicine, done six months before, taking as a basis the specimen of each artist's work that most resembles traditional robe-painting (Color Plates 1 and 2).[27]

Koba's drawing retains, in part or entirely, most of the nine characteristics of the early nineteenth-century representational robe-painting of the Central Plains that were observed in the Cheyenne picture: figures of horse and man in action; horse conventionalized, with long, arched neck, small head, long body, legs spread before and behind; man shown in profile but with shoulders broadside (in

most instances); costume details stiffly stylized; distant objects placed behind or above nearer ones, but not progressively smaller or less distinct (in most cases); no background; figures outlined and filled in with bright, flat colors; action flowing from right to left (for the most part). He also shares with Making Medicine all the developments of the later nineteenth century and the new freedom from tradition in regard to unity, media, and subject matter (the purport is not a battle but a peace-making). Yet, undeniably, he surpasses the earlier artist in certain refinements not inherent in traditional painting. Koba excels in naturalism: his animals are more realistic; his men have eyes, mouth, hands, better proportions, and a relaxed posture; he shows front and rear views. He has learned how to give his horses a third dimension by manipulation of line, and he experiments with the problems of foreshortening, or rendering the more distant parts of a figure smaller. A comparison of Plates 15 and 23, from the same two sketchbooks and, again, on similar themes, elicits much the same comment. Between the drawings of these two earnest and conscientious young men stand six months of practice and opportunity to learn from companions. Who is to say whether it was this lapse of time, a superior artistic development back home, or natural ability that gave Koba's drawing a margin

over Making Medicine's? Within a year after Koba's book, Making Medicine was producing a deer-hunting scene more skillful than Koba's (Plates 17 and 23).

Koba's work (Color Plate 2 and Plates 22–24) is nearly free from the pictographic shorthand devices often intelligible only to the initiated. He forsakes the unbalanced right-to-left convention. The rhythm is pleasing in Plate 22, as is the subtle asymmetrical balance in Color Plate 2. For "background" he confines himself strictly to essentials (Plate 23). The portrayal of some unwonted emotions seem to be attempted—dogged determination on the part of the deer hunter, irony in the dilemma of the assailant assailed.

Koba, too, has his technical problems. He has not mastered the rendering of facial features except in profile views. Yet he is capable of an individualized profile on his determined hunter. In the same picture, he is not entirely adjusted to the limitations of the paper page; the hunter appears to be shooting while waving one leg in the air. Somewhere in the neighborhood of the hunter's hips, the artist turns the corner in his point-of-view. By turning the book, it can be seen that the hunter is lying prone. Koba gives his buffalo the legs of a horse, yet his startled deer are convincing. If Koba entered the fort as a typical un-

skilled Kiowa draughtsman of the late 1860's, he came a very long way in nine months. A drawing from a later date appears in Plate 25.

Although Koba's is the earliest Kiowa book bearing a date, White Horse, the Kiowa raider, produced an undated one that appears to have been done very early in the imprisonment and hence warrants further attention. Once more beginning with the drawing most like the exploit-robe paintings of the early nineteenth century (Color Plate 3), we find figures of horse and man in action; horse conventionalized, with long, arched neck and small head; man conventionalized, with shoulders broadside, elongated upper torso, rigid straight posture, nose, no eyes, and, unless the hand is employed, no hands; costume stylized; distant objects placed higher on page; no background; figures outlined and filled in with color; figures almost entirely two-dimensional; action from right to left; and a mood of self-glorification. To these, White Horse adds the later-nineteenth-century traits discussed above that produce a decorative style of painting.[28]

Like Making Medicine and Koba, he achieves unity through use of the new media and he explores a fresh phase of warfare, the long journey to find the enemy. For this subject the horse-convention for speed would have been unwarranted; his horses

are walking instead of galloping. He departs still farther from tradition by introducing into the theater of war a woman, albeit in the subordinate role of lance-carrier.

White Horse was taking no chance that his hero might go unsung. He made identification doubly sure by resorting to the old name-symbol and also introducing elements of costume-symbol, his well-known shield and medicine paint. In this and other drawings he used the conventional symbols for dust and the tracks of horse and man (Color Plate 3 and Plates 26–27). Indeed, he departs from the basic pattern of Plains hide-painting but little, although his subjects range from a bit of camp gossip to a quiet, pleasantly rhythmic study of three muffled figures (Plates 27 and 28), and his moods from the glorification of war to the adulation of brute horse-flesh (Color Plate 3 and Plate 26). His other departure is in adding such background details as a tipi and an identifying shield on its easel, when they are essential properties for his little comedy. He was not a meticulous draughtsman; in two instances, "transparent" figures are obviously afterthoughts. Koba could make a more pleasing composition with much the same figures (Plate 22 and Color Plate 3), although at a date that may have been nine months later or earlier. Given the opportunities afforded at

Fort Marion, White Horse had little desire to innovate or experiment in techniques. For the most part, he was content to draw in the way he had learned on the plains. How much his technique gained in refinement can be seen by comparison with Plate 29. His forte, however, lay in another direction. Among his peers, he was pre-eminent in the field of humor. His technique was adequate to his purpose of rendering cartoon-like situation comedies (Plate 27).

Of the three early Fort Marion artists analyzed in some detail above, Making Medicine affords the opportunity for observing his development over the longest period of time. Drawings done at most two years after the first book show the direction taken by his art during his captivity (Plates 17, 18, 19, and 20). Realism rather than conventional stylization has become the keynote. Men and animals have eyes, hands, and mouths, and have all but lost their transparency. Pictographic symbols have vanished. The stiff horses have become naturalistic. The representation of the man in the gesture of peace is admirable. Animate figures have become three-dimensional in line. The buffaloes have lost their angularity. The deer (mislabeled antelope) are delightful.[29]

The background landscape in Plate 17 produces a boldly angular, asymmetric balance that points up

the delicacy of the deer. Especially noteworthy is the circular rhythm of Plate 18. It is in Plate 19 that the artist makes a clear break with tradition in favor of art. Some of his hunters commit the unthinkable blunder of approaching the buffalo on the left side. With the rhythmic alternation of left-right-left-right, Making Medicine creates a flowing frieze of grace and beauty.

In sum, so great was Making Medicine's technical development in two years that only by close study can his two books be recognized as the work of the same hand.

[1] Cat. No. 39a, sketchbook by Making Medicine, BAEC; Ewers, *Plains Indian Painting*, 17–21, 34. All the criteria are Ewers' except for the arching neck and small head of the horse, the rigid straight posture and stylized costume of the man, and the action flowing from right to left.

[2] Ewers, *Plains Indian Painting*, 3–4, 17, 22.

[3] Victor Tixier, *Tixier's Travels on the Osage Prairies* (ed. by John Francis McDermott), 138, 166; Grinnell, *The Cheyenne Indians*, II, 7, 19; George E. Hyde, *The Life of George Bent: Written from His Letters* (ed. by Savoie Lottinville), 195; Lewis H. Garrard, *Wah-to-yah and the Taos Trail*, 97; John H. Seger, *Early Days among the Cheyenne and Arapahoe Indians* (ed. by Stanley Vestal), 32.

[4] De B. Randolph Keim, *Sheridan's Troopers on the Borders: a Winter Campaign on the Plains*, 223–24 and *passim*; Wilbur S. Nye, *Carbine and Lance: The Story of Old Fort Sill*, 116.

[5] *FP* quoted in *Weekly Floridian*, May 29, 1877 (copy).

[6] James Mooney, MS 2531, Field notebooks, I, 50–51, BAEC; Mooney, "Calendar History of the Kiowa Indians," 17th *ARBAE*, 1895–96, Part I, 180, 336, Pl. LXXIX; Rev. Rodolphe Petter, *English-Cheyenne Dictionary*, 793; "Dohasan," *Handbook of American Indians North of Mexico* (ed. by Frederick W. Hodge), Bureau of American Ethnology *Bulletin 30*, I (Washington, D.C., 1907), 394. See "James Mooney," *AA*, n.s. XXIV, No. 2 (Apr.–June, 1922), 209–14, for Mooney biography and bibliography. It could not be ascertained whether Sleeping Bear, the Cheyenne who gave the tipi to Dohasan and was said to have died in 1867, was the Sleeping Bear, reported slain in 1864, who was the father of artist Cohoe. See Cohoe, *A Cheyenne Sketchbook* (with commentary by E. Adamson Hoebel and Karen D. Petersen), 4n.

[7] Mooney, 17th *ARBAE*, 1895–96, Part I, 336; Mooney to H. Browne Goode, Jan, 29, 1895, as quoted in Althea Bass, "James Mooney in Oklahoma," *CO*, Vol. XXXII, No. 3, 257; Grinnell, *The Cheyenne Indians*, I, 233–34. Among Mooney's thirty-four model Kiowa tipis made for the U.S. National Museum, Washington, D.C., in 1893–98, representing the painted tipis of the tribal circle for the year 1867, the Dohasan is the only one portraying warlike deeds (S. H. Riesenberg to author, Mar. 29, 1966). Of Mooney's eighteen model Cheyenne tipis collected at Darlington, Oklahoma, for the Field Museum, Chicago, in 1904, only one shows exploits in battle, Cat. No. 96958. Among the many tipis illustrated in the Fort Marion drawings, none show exploits and few show animate figures.

[8] Grinnell, *The Cheyenne Indians*, I, 225.

[9] Mooney, MS 2531, Field notebooks, I, 50–51, BAEC; Cat. 254,001, Model tipi by Ohettoint, USNMC; Mooney, "The Indian Congress in Omaha," *AA*, n.s. Vol. I, No. 1, 146.

[10] Pratt, MS, Data on prisoners at Fort Sill, PP; Jack D. Filipiak, "The Battle of Summit Springs," *The Colorado Magazine*, Vol. XLI, No. 4, 343–54; Lt. Austin Henely to Post Adjutant, Apr. 26, 1875, 44 Cong., 1 sess., *House Exec. Doc. No. 1, Part II* (Serial 1674), 91; Keim, *Sheridan's Troopers on the Borders*, 223. Similar records were kept by two Dakotas, Sitting Bull (1870) and Running Antelope (1873), Stirling, *SMC*, Vol. XCVII, No. 5, 3–34, and Garrick Mallery, "Pictographs of the North American Indians," 4th *ARBAE*, 1882–83, pp. 208–214.

[11] Donald J. Berthrong, *The Southern Cheyennes*, 178, 183, 217, 276–78, 327, 343, 393, 395, 396; Joint Special Committee Ap-

pointed under Joint Resolution of Mar. 3, 1865, "Condition of the Indian Tribes," 39 Cong., 2 sess., *Sen. Report No. 156* (Serial 1279), 69; [Gen. Philip H. Sheridan], *Record of Engagements with Hostile Indians within the Military Division of the Missouri from 1868 to 1882*, 22.

12 Elman R. Service, "The Cheyenne of the North American Plains," *Profiles in Ethnology*, 117.

13 George Bird Grinnell, *By Cheyenne Campfires*, 33–34.

14 Grinnell, *The Cheyenne Indians*, II, 27; Royal B. Hassrick, *The Sioux, Life and Customs of a Warrior Society*, 156; John C. Ewers, "The Blackfoot War Lodge: Its Construction and Use," *AA*, n.s. Vol. XLVI, No. 2, Part I, 190; Maximilian, Prince of Wied-Neuwied, *Travels in the Interior of North America*, II, (in Reuben Gold Thwaites, ed., *Early Western Travels, 1748–1846*, XXIII, 285, 287–88); Garrick Mallery, "Picture-writing of the American Indians," 10th *ARBAE*, 1888–89, 214, 336; Edwin James (comp.), *Account of an Expedition from Pittsburgh to the Rocky Mountains, Performed in the Years 1819 and '20 . . . under the Command of Major Stephen H. Long*, I, 296–97.

15 Berthrong, *The Southern Cheyennes*, 286; [Theodore R. Davis], "A Summer on the Plains," *Harper's New Monthly Magazine*, Vol. XXXVI, No. 213, 303.

16 John D. Miles to Pratt, June 27, 1876, PP. See John Murphy, "Reminiscences of the Washita Campaign and of the Darlington Indian Agency," *CO*, Vol. I, No. 3, 273n., for short biography of John De Bras Miles.

17 Pratt, *Battlefield and Classroom*, Plate 18 following 337, and 180–81; Mrs. J. Dorman Steele, "The Indian Prisoners at Fort Marion," *The National Teachers' Monthly*, Vol. III, No. 10, 289–92; Pratt to Miles, July 24, 1876, Minimic to Cheyennes, July 22, 1876, both in OHSIA, C&A, Indian Prisoners; J. D. S. [J. Dorman Steele], "An Indian Picture-Letter," *The Leisure Hour*, Vol. XXVI, No. 1351, 730–32; Ethel Webb Faulkner, "Joel Dorman Steele," *DAB*, XVII, 556–57.

18 Pratt, *Battlefield and Classroom*, 183; Pratt to Lt. Col. James W. Forsyth, Aug. 20 and 25, 1877, Pratt to Col. Mackenzie, Aug., 1877, PP; Lizzie W. Champney, "The Indians at San Marco," *The Independent*, XXX, 27; Robert J. McKay, "Biography," *James Wells Champney, 1843–1903*, 12, 16; "Indian School at Fort Marion," *Harper's Weekly*, Vol. XXII, No. 1115 (May 11, 1878), 373, 375.

19 "A New Era for the Indians," *Daily Times*, Feb. 1, 1879; Mrs. Mary Inkanish, oral communication to author, May 30, 1959; Pratt to Miles, April 5, 1877, OHSIA, C&A, Indian Prisoners.

20 Picture-letter, Huntington Library, Hampton Institute, Hampton, Va.; Catalog No. 30740, picture-letter, USNMC; Adeline Adams, "Clark Mills," *DAB*, XIII, 4; "Curiosities for the Smithsonian Institute," *News*, July 23, [1877].

21 Picture-letter by Howling Wolf, Massachusetts Historical Society; "Edmund Louis Gray Zalinski," *National Cyclopedia of American Biography* (13 vols.) (New York, 1897), VII, 248.

22 Dorothy Dunn, *American Indian Painting of the Southwest and Plains Areas* (copyright © 1968 by the Univ. of New Mexico Press), 173. This book, the first major survey of Plains painting in nearly thirty years, speaks with authority on the aesthetic aspects of the art from prehistory to the future. It reproduces in color three drawings from Fort Marion.

23 Sketchbooks by White Horse, Joslyn Art Museum, and Koba, 39c, BAEC; George Z. Otis to author, Aug. 5, 1965.

24 Sketchbooks by Bears Heart and others, Massachusetts Historical Society, and Howling Wolf, Mrs. A. H. Richardson; Grinnell, *The Cheyenne Indians*, II, 120.

25 Sketchbooks by Bears Heart and others, Massachusetts Historical Society, and Making Medicine and others, PP; Mallery, 10th *ARBAE*, 1888–89, 320–21, 380.

26 Marquis, *Wooden Leg*, 83, 85; Nye, *Carbine and Lance*, 286, 288.

27 Sketchbook by Koba, Karen D. Petersen; Ewers, *Plains Indian Painting*, 34.

28 Sketchbook by White Horse, Joslyn Art Museum.

29 Cat. No. 39b, sketchbook of Making Medicine, BAEC; sketchbook of Bears Heart and others, Massachusetts Historical Society.

III. THE ARTISTS EARN A MEASURE OF FAME

On the plains, at least in the first half of the nineteenth century, drawing seldom rose to the height of true art. "The mere attempt to represent something, perhaps to communicate an idea graphically, cannot be claimed to be an art It becomes a work of art only when it is technically perfect, or when it shows striving after a formal pattern." In mid-century, as pointed out above, utilization of the white man's materials made for a notable improvement in technique. The result was the well drawn, highly decorative conventionalization of horse and rider frequently found on hides as well as on paper. When the Indian ventured afield into representations of other subjects, it was another matter. He was still communicating his ideas, but he betrayed a deficiency in mastering either the technique of execution or the arrangement of the parts into a pleasing pattern of form, showing balance, rhythm, emphasis, and other artistic qualities. Moreover, the purpose of his drawing was to fill social needs. It contributed to the stratification of society by means of heraldic tipis and records of exploits; to the recording of history, with annual counts; to the invoking of supernatural aid, with tipi and shield insignia; to the preservation and solidarity of the tribe, with written messages. The custom of society decreed that the drawings should be brief and to the point.[1]

Three dated sets of drawings on paper from the close of the quarter 1850 to 1875 provide an indication of the height of technical proficiency achieved in Plains drawing before the prisoners set out for Fort Marion. All three sets originated among the Cheyennes and Dakotas of the Central Plains, the tribes rated highest in technical skill at this period. A detailed study of these drawings lies outside the province of this book, but it should be noted that, although the subject matter generally is limited to traditional battle scenes, the style of the earliest, col-

lected from the Southern Cheyennes in 1869, greatly resembles a sketchbook by the Kiowa White Horse from the first year at Fort Marion, discussed above. And the technique of the two Dakota books from 1870 and 1873 is very like the other two produced in the first year at Fort Marion by Making Medicine, the Cheyenne, and Koba, the Kiowa, respectively. Unlike the Florida art, the Plains drawings' only claim to aesthetic appeal lies in their renditions of the classic horse and rider.[2]

In 1875, the Dakotas of the Plains were yet to be subjugated; their great chiefs were persisting in the struggle to maintain the old way of life. Undoubtedly the pictorial representation of the Dakotas—and of other tribes of the Central and Northern Plains—was still bound by the strictures of tribal traditions. True, in widely separated instances, individual Indians had broken away from the pattern and emulated the style of white artists who had come among them bringing their new drawing materials. Yet their innovations made no perceptible permanent change in the style of Plains painting. In Fort Marion, with the old societal structure shattered, drawing passed from the social to the personal. A new concept entered pictorial drawing—self-expression, art for art's sake. The artists had begun to explore the aesthetic possibilities of their media on the plains; at Fort Marion they were free to concentrate on pictures appealing to the eye and to the emotions. (See Plates 43 and 42 for drawings by one man showing pure pictography versus the beginnings of artistic expression.) The Plains Indians, who had begun the century as draughtsmen writing a pictographic shorthand, crossed over the bridge to the era of modern Indian art when the prisoners in irons shuffled across the drawbridge to shed their chains at Fort Marion.[3]

The preoccupation of the prisoners with reproducing their life on the plains down to the smallest detail suggests a homesickness sublimated to pictorial representation. This emotion, combined with the new freedom, leisure for drawing, and an admiring public, was triggered by a ready supply of drawing materials into an artistic explosion. So abundant was the outpouring that, after ninety years of near-obscurity, some 745 original pictures drawn at Fort Marion are known to have survived. The number still in existence suggests a staggering total production during the time of the Indians' imprisonment. (See the Chronological Catalogue of Art Appendix, on page 309.)

In considering the causes for this output, Sidney Lanier's charge that "the atmosphere of trade has reached into their souls" cannot be ignored. When

Lanier wrote this comment, his greatest poem had just been published, beginning:

> O Trade! O Trade! would thou wert dead!
> The Time needs heart—'tis tired of head.

With the sale price running at two dollars a sketchbook, concern for the Indians' souls appears unwarranted. The charge smacks of being a subliminal plug for Lanier's masterpiece. Moreover, the astute warden, Captain Pratt, had the economic aspect well in hand. In sanctioning the sale of "what they were ready enough to give away" on their arrival, he seized upon the Indians' talent as a means to further his plan for their future. Pratt was an anomaly of his day, a man who believed that Indians could be educated, could learn a trade, and could be absorbed into the white man's world. He left no stone unturned in implementing this belief. He encouraged his charges to work at any useful task that prison life afforded, and spurred their efforts by giving them passes to go into St. Augustine and spend their earnings for small luxuries. A curious artistic by-product of this practice was the price current, a price list of sundry small articles that might be purchased by the Indians, illustrated in color by Buffalo Meat (Plate 44). A demand for the quaint memorandum arose, and Buffalo Meat capitalized on it by making copies for visitors to the fort. Doubtless the profit motive contributed to the copious artistic fare served up to tourists to satisfy the easterners' hunger for Plains Indian lore.[4]

No doubt the publication of Lanier's *Florida* in November, 1875, served to popularize the Indian prisoners and create a demand for their art. Their drawings became dispersed far and wide over the eastern half of the country. After Lanier, a three-year procession of journalists, notables, and curiosity-seekers filed under the Spanish coat-of-arms that bore the date of 1756. To thousands of northerners in search of a milder winter climate, St. Augustine was ultima Thule. By whatever combination of railroads and steamboats they chose to make the tedious journey down the coast, this old Spanish town was literally the end of the line, and hence fashionable as a destination. Many of the visitors were people of means, education, and position, and many were in the forefront of the ranks of eastern Indian-sympathizers. Since for most of these philanthropists this was their first opportunity to hobnob with a "wild Indian," or perhaps even to see one in the flesh, they cultivated the prisoners with enthusiasm. A number of them wrote about the Florida Boys and took home a book of their drawings.

The J. Dorman Steeles, well known in educational

circles, were mentioned above for their sympathetic articles on the Indians. The venerated humanitarian Harriet Beecher Stowe, of *Uncle Tom's Cabin* fame, sometimes visited the fort, and was so taken with a sketchbook by Zotom that she ordered another just like it. However, a new medium of artistic expression had become the fad among the tourists—the painting of Indian scenes on ladies' fans. A month later Pratt wrote to Mrs. Stowe, "Zotom is very slow with the duplicate book because the lady visitors have flooded us with fans to paint, and his reputation gives him the lion's share." One of the fans done at about this time may be seen today in the St. Augustine Historical Society collections (Plate 21). It was painted by Making Medicine for Miss Annie E. Pidgeon, on her farm. In curious contrast to the delicate white silk and carved ivory of the fan are the gaudy warriors, feathered lances, and lumbering buffaloes. Some of the Indians, no doubt utilizing similar themes, took up the painting of pottery, "which they have learned to do very neatly," said Pratt. Miss Stowe published an account of what she saw as she walked through the Indians' barracks in March, 1877.

This is a structure more than a hundred feet by forty or fifty, covering the top of a portion of the old fort A double row of rough board bunks occupies each side of the building, and the blankets and mattresses were rolled up and disposed in each with perfect neatness and precision. The barracks were perfectly clean

All along we saw traces of Indian skill and ingenuity in the distinctive work of the tribes. Bows and arrows skillfully made and painted, sea beans nicely polished, paper toys representing horses, warriors and buffaloes, showing a good deal of rude artistic skill and spirit in the design and coloring, were disposed here and there to attract the eye and tempt the purse of visitors. Capt. Pratt said that during the time of their stay [two years] not less than five thousand dollars had been taken in by the whole company from the sale of these curiosities to visitors.[5]

The production of Indian craftwork had begun soon after the gates closed behind the prisoners, but the seeds of such a project had long lain dormant in Pratt's fertile brain. In 1874 he had tried to promote the making of bead-and-buckskin dolls among the Tonkawa women in his charge, for sale to the military personnel at Fort Griffin, Texas. After three months at Fort Marion, Pratt reported that the Indians were making considerable pocket money not only from bows and arrows and sea beans, but also from polished alligators' teeth and beadwork, to which canes were added the next year (Plate 10).

The beading was no doubt the work of the two women, one a prisoner and one the wife of a prisoner. Six weeks after arrival it was reported, "The squaws make fancy work, and dress deer and bear skins." A caustic lady writer was more explicit: "The women worked over old bead moccasins, and freshened them up with new soles and buckskin linings, all of which were bartered to visitors."

So successful was the first year's sale of crafts that their second tourist season found the prisoners prepared. "Spurred on by past winter's experience they have accumulated a large stock of material for sale to visitors this winter." Some of the more enterprising took to peddling their wares on the streets of St. Augustine, and this stirred up a hassle. The city council issued a complaint against these unlicensed peddlers of "trinkets and curiosities." Pratt protested that "possibly the Indians may have picked up 50¢ or 75¢ a day in this way." The Post Commandant firmly closed the matter by ordering that the Indians' personal purchases, frequently amounting to fifteen or twenty dollars a day, should be made thereafter in Jacksonville and that the prisoners should confine their selling to the fort. "They have a stand under the archway at the entrance, to sell pictures, curiosities, &c.," observed a journalist. One of our artists, Roman Nose, recorded, "Indians sold sea beans each at twenty five cents and bows and arrows one dollar and a half Some two dollars and a half and best bows and arrows for five dollars."[6]

Like Lone Wolf on the Plains, the Indians in prison practiced the "application of art to their own hides." Six weeks after their arrival it was reported, "The Indians upon rising in the morning perform the necessary police duties of the fort, after which they perform their ablutions, paint themselves, and after breakfast proceed to pass the time as best they may." Apparently the wearing of face paint was frowned upon; this is the only mention of it except in conjunction with dances put on for the entertainment of visitors. Another celebrity, artist James Wells Champney, was so taken with the paints worn at the final dance on March 9, 1878, that he recorded nine of them for posterity. At least six of the subjects were our artists. His hasty sketches, which lay unrecognized for many years, were recently located and identified. Among the drawings is one done in Plains Indian style, showing a buffalo hunt. It is signed "Etahdleuh." Champ's own account of the episode reads:

Desirous of learning how the Indians decorated their faces for the war dance, I easily obtained permission to go with them to their quarters and make several sketches of the lines with which they had tried to render

themselves hideous. The scene was wild enough as they crowded about me, each anxious to be the first to be sketched, that he might get off his toggery and go to his bunk, for the evening performance had been fatiguing, and they were weak from long confinement in the fort. One after another passed in review, and hasty diagrams of the position and shapes of the black and red lines were made, until the crowd had all vanished from the court below and the captain and I were left alone with the Indians.[7]

While Champ was at the fort, a fellow-artist who was also a journalist and lithographer called there. In the closing days of confinement, Frank H. Taylor, pioneer in photo-lithography on the short-lived New York *Daily Graphic*, the "first illustrated daily newspaper in America," found the Indians still laboring in their barracks upon various articles for sale to visitors. He bought a few drawings, and his comments on them reveal an artist's point of view. "You will observe a caustic humor pervading them. The first shows the chief, in all the glory of his war-paint, with his horse's bridle upon his arm [Plate 45]. That horse was a terrible task for the dusky artist. The second portrays his present condition as a soldier—just like the others, all in a row."[8]

George Hunt Pendleton, a man politically prominent in Ohio, visited Jacksonville early in 1876 for a round of politicking, parades, and oratory. At nearby St. Augustine his wife, the daughter of Francis Scott Key, became interested in the Indians who as freemen had made a stand "between their loved homes and wild war's desolation." Two years later, she pledged the tuition by which Making Medicine (who thereupon took the name David Pendleton) could remain in the east three years for further education. A year afterward, the newly elected Senator Pendleton introduced in Congress a bill to assist Pratt in launching Carlisle Institute. Possibly some part in these acts was played by the drawing books Making Medicine sent to the lady after her visit to the fort.[9]

A sketchbook was completed on July 31, 1876, by Bear's Heart and Ohettoint, and four more in September, by Etahdleuh, Ohettoint, Bear's Heart, and Cohoe (Plate 40). The preservation of these five early books was due to the visit of yet another notable Indian sympathizer who came to St. Augustine in 1876. The history of the five books has been told in another volume in which twelve of Cohoe's drawings are reproduced in color. There, too, is related the story of the affection that arose between Pratt and his charges, on the one hand, and the great reformer of the Indian policy of the United States, Bishop Henry B. Whipple of the Episcopal Diocese of Minnesota.[10]

68

Not all the collectors of Fort Marion art were known to fame. Two young men from St. Augustine fraternized with the young men from the Plains. One was the son of Presbyterian clergyman Charles O. Reynolds, who had come from New York soon after the Civil War. Before Burnet S. Reynolds was twenty years old, as his widow said much later, "he used to go to the Fort to teach the younger Indians, and formed friendships with some of them about his own age. [¶] These drawings were made by some of those young Indians and given to my husband as an expression of their friendship and affection for him" (Plate 25). Some of the drawings bear notes which Burnet and Koba wrote to each other. Noel Atwood was the son of George W. Atwood, Sr., who brought his family from New Jersey in the 1860's, quickly bought up real estate in St. Augustine, and soon rose to be County Clerk. Noel acquired a sketchbook from White Horse. The twenty-three-year-old man took it as a gift to a cousin in New York, after stopping off at the Philadelphia Centennial Exposition (Color Plate 3 and Plates 26, 27, 28).

A third young man, George W. Fox, the interpreter who was beloved by the Indians, sent as a gift to his cousin the drawing book by Making Medicine which is analyzed on page 59.[11]

Sightseers from many states returned home with Fort Marion drawings as souvenirs. This was apparently the case with a pair of St. Louis honeymooners, Frances Angela and John F. Grady, in January, 1877 (Color Plate 9), as well as with an artist, Elizabeth Wyer of St. Paul, Minnesota, who became interested in Pratt's policy of encouraging the artistic impulses of the Indians while she was vacationing with her sister, Mrs. George L. Farwell, in 1876. A painter, Eva Scott, sent to New York for blank sketchbooks and suggested many of the subjects for the drawings that were to fill them. Zotom complied with her requests, but Howling Wolf preferred to choose his own subjects. Delegates to a convention of railroad conductors visited St. Augustine with their wives in November, 1875, and "traded" for Indian drawings. Knowledge of the Fort Marion art was spread abroad by Indian sympathizers. Dr. Horace Caruthers illustrated a lecture at Tarrytown, New York, with specimens of the prisoners' handiwork and art, while William E. Doyle showed drawings in Washington, D. C.[12]

Captain Pratt quickly saw the efficacy of his drawings in public relations and used them to this end. He sent a collection of drawings to the United States National Museum (Plate 39) and others to ranking Army officers to demonstrate the industry of his men. A very early book went to the headquarters of Gen-

eral Philip H. Sheridan, commanding the Division of the Missouri, and two others to General William T. Sherman, commanding the Army. The books that Pratt selected indicate his high estimate of the work of certain artists: for the gifts to his superiors—Bear's Heart and Zotom; for his mentor Bishop Henry B. Whipple—Etahdleuh, Ohettoint, Bear's Heart, and Cohoe, "the best books I could find"; and for his own use, an Etahdleuh book which the captain gave to his son Mason (Plates 31 and 32), and Zotom drawings entitled "Red skin fancies and sketches" that Pratt bestowed on his daughter Nana (Plate 37). Years later, telling Zotom of the many good pictures being drawn by Zotom's brother Otto at Carlisle, Pratt commented, "His talent for drawing is much like yours in the Old Fort."[13]

The completion of at least four books in September, 1876, must have depleted the drawing materials at the fort, for on the sixth of the month Captain Pratt ordered a new supply. His letter answers for us the question of what materials the artists used.

> Please send me by express . . .
> 7 Dozen Crimson Pencils AEP. Co. Sharp, bright
> 9 Dozen Light Blue Pencils AEP. Co. colors suit
> 10 Dozen Chrome Yellow Pencils AEP. Co. best
> 10 Dozen Green Pencils AEP. Co.
> and samples of all the colors you have.

2 Dozen bottles, assorted colored inks . . .
Please send me a dozen each of 8 and 12 leaves, Drawing books, that I may know your prices &c . . .
Send also ½ Gross Pen points like enclosed, *but with finer points.*[14]

Pratt's order emphasizes the fact that Fort Marion drawings were in no sense "ledger art." This term is sometimes applied, for want of a better name, to all representational Plains drawing between the end of hide painting and the beginning of the contemporary era. On the plains, although ruled account books of various kinds were often used, many times the pages of notebooks were unlined, or the drawings were made on loose papers or canvas. At Fort Marion, drawing was sometimes done on sheets from ruled ledgers, loose papers, small autograph books, fans, and even hide. But the bulk of the drawings are in bound sketchbooks manufactured for the use of artists.

Generally speaking, the fine pens dipped in colored inks were used in outlining the figures, drawing the smallest details, and filling in black areas. Colored pencils, and sometimes lead pencils, served for most of the filling in and some of the detail. The pencils provided a variation in intensity ranging from the pastels of light strokes to the brilliance of a heavy application of pencil. In the absence of color-model-

ing, the mottled pencil-strokes yielded a welcome variety in texture. Some of the artists used water colors alone or in combination with the other media. The technique at Fort Marion was derived directly from the traditional method of outlining with a pointed instrument dipped in color and spreading the color over larger areas. As one student of Plains painting observes, "It is significant that very few drawings were done with the white man's brush and paint."[15]

The adaptation to new media produced a unique art form akin to both drawing and painting. Regrettably, only a single specimen of this remarkable product from Fort Marion has been found in a museum of art—that in Joslyn Art Museum. Otherwise, the preservation of the sketches has been relegated to manuscript libraries, non-art museums, or private collectors.

An early professional critique of the drawings comes from an artist for the New York *Daily Graphic:* "One of them, a young man, is an expert with his pencil. I obtained some of his sketches . . . for reproduction in THE GRAPHIC. The other Indians, who are very imitative, are all drawing colored pictures, which are in great demand by visitors."[16] Unfortunately, the identity of this artist's artist cannot be determined, because the drawings never appeared.

The casual phrase, "they are very imitative," raises a number of questions about the originality and development of the artists. Did they copy from each other? Did they imitate pictorial devices seen in magazines, books, or the picture-cards of everyday objects used by their English teachers? Did these zealous teachers instruct them in drawing, or did visiting artists give them coaching? How much of their development can be attributed to diligent practice? Were they influenced by the Victorian penchant for narrative art and the current belief that historical painting was the "highest" kind of art? The popular Currier and Ives prints called to the attention of the white man many facets of his own everyday life hitherto unexploited in art. Did this genre painting inspire the Indians to do likewise for Indian life? Did the vigilant Captain Pratt censor the subject-matter? How much were their modifications of traditional style an accommodation to the customer, to the "atmosphere of trade"?

Inasmuch as only half the output at Fort Marion can be dated within a month of its origin, many of these questions cannot be answered with certainty. The general quality of the drawing rose during the internment, just as it was to improve on the Plains when the tribes were subjected to relative peace, a fixed abode, and closer contact with the white man.

Several Fort Marion artists improved conspicuously over a period of years; presumably, practice did its share in making perfect. Certain scenes by different artists bear a resemblance that suggests that one man was looking over the shoulder of another as he drew. Very probably, their preoccupation with drawing would lead them to analyze white men's pictures that came their way and to observe the artist's solution to problems in technique. As to narrative and historical art, there was precedent enough on the Plains, where a series of drawings sometimes portrayed historic events. The Plains, too, had its own genre painting in the form of the picture-letters that showed everyday happenings. It was these letters that had trained the hands of our artists to draw more than war and the chase even before they encountered Fort Marion and its sightseers.

Out of a random sampling of three hundred drawings, less than ten per cent are warlike in tenor, and few depict war against white Americans. It is likely that Captain Pratt, the Indian "civilizer," frowned upon the favorite subject-matter of Plains art, the celebration of valiant acts of war. Again, we may be sure the artists held in the bailiwick of the white man were sensitive to the imprudence of flaunting their victories over white adversaries in the late wars on the Plains.

On the question of white teachers we are on firm ground. An inscription in the sketchbook from the collection of the historian, Francis Parkman, dated 1877, notes that the Indians "had not been instructed in drawing." George Fox commented, "With a little instruction, I think they would draw nicely." Mrs. Horace Caruthers, one of the dedicated women who taught the prison classes, went further. She wrote in the fall of 1877:

The drawings of the Indians, which are in great demand by visitors, are entirely original, none of those who make them having received any suggestions even. They fill many books, the best of which are eagerly bought up, most of the pictures in them representing some scene in their past lives, some experience they have had or journey they have made.[17]

As to the question of conscious tailoring of the Indians' art style to fit the understanding of white customers—be that as it may. It is this modification, the added detail, the unity of composition, the more realistic proportions, whether conscious or no, that give the drawings their great value. The old Plains pictography is like a locked door with its key hidden. Unless a contemporary explanation is produced to reveal the meaning behind a pictograph, it is all but unintelligible to the modern viewer. The Fort Marion drawings frequently bear informative captions

in English and are themselves couched in a pictorial language not too foreign to be understood today.

In summary, the prisoner artist sought rapport with innovations from the white man as well as with tribal tradition, and he partook of the power that flowed from both. He turned his face toward the new life and set his foot upon the white man's way; yet he preserved an identification with the art of his people (Color Plate 9). The result is an original style, uniquely Indian.

[1] Franz Boas, *Primitive Art*, 64.

[2] Filipiak, *The Colorado Magazine*, Vol. XLI, No. 4, cover and pp. 343–53; Stirling, *SMC*, Vol. XCVII, No. 5, plates 1 through 55 after p. 8; Mallery, 4th *ARBAE*, 1882–83, Figs. 124–34 on pp. 208–13.

[3] John C. Ewers, "Plains Indian Painting: The History and Development of an American Art Form," in Karen Daniels Petersen, *Howling Wolf: A Cheyenne Warrior's Graphic Interpretation of His People*, 9–11.

[4] Lanier, "Poems and Poem Outlines, *Centennial Edition*, I (this vol. ed. by C. R. Anderson), 343, 46; Pratt to H. B. Whipple, Dec. 21 [1876], Minnesota Historical Society, St. Paul, Minn., Bishop Henry B. Whipple Papers; Henry [Pratt] to Marion [Jennings], n.p., n.d., PP.

[5] Pratt to Stowe, Apr. 30, 1877, PP; fan by Making Medicine, St. Augustine Historical Society; [Helen W. Ludlow], "An Indian Raid on Hampton Institute," *SW*, Vol. VII, No. 5, 36; Harriet Beecher Stowe, "The Indians at St. Augustine," *The Christian Union*, Apr. 18 [1877], as quoted by *FP*, (May, 1877). Sea beans are tropical seeds susceptible of a high polish and used in making jewelry.

[6] Pratt to Chambers, June 22, 1874, PP; Pratt to Covington, Aug. 15, 1875, OHSIA, C&A, Indian Prisoners; Pratt to Gen. Sheridan, May 25, 1876, PP; "A Glimpse at the Indians," *FP*, July 3, 1875; Silvia Sunshine [Abbie M. Brooks], *Petals Plucked from Sunny Climes*, 231; Pratt to ADC, Dec. 18, 1876, PP; Sleeper [pseud.], "About St. Augustine, Mostly," *Daily Florida Union*, Mar. 15, 1877, 3; J. D. Lopez, Clerk of Council, to Pratt, Jan. 23, 1877, enclosed in Pratt to Gen. Dent, Jan. 24, 1877, PP; Dent to Pratt, n.d., PP; *FP*, (n.d.), in Scrapbook, p. 194, PP; [H. C. Roman Nose], "Experiences of . . . ," *SN*, Vol. I, No. 7, [1]. Sea beans polished by the Florida Boys are in the possession of Mrs. S. Clark Seelye and, thanks to her generosity, in the possession of the author, also.

[7] "A Glimpse at the Indians," *FP*, July 3, 1875; drawing by Etahdleuh in sketchbook by J. Wells Champney, Miss Frances Malone; "Champ" [J. Wells Champney], "Home Correspondence" (dateline, St. Augustine, Mar. 18), *Weekly Transcript*, Apr. 2, 1878.

[8] Drawings by Buffalo Meat and Buzzard, Oklahoma Historical Society; MS, folder, Frank Hamilton Taylor, Historical Society of Pennsylvania, Philadelphia, Manuscript Room, Autograph Collection; F. H. T. [Frank H. Taylor], "Indian Chiefs as Prisoners" (dateline, Philadelphia, April 25), *Daily Graphic*, Apr. 26, 1878.

[9] Pratt, *Battlefield and Classroom*, 217; Mary Selden Kennedy, *The Seldens of Virginia*, 188; "Hotel Arrivals," *Tri-Weekly Florida Sun*, Jan. 29, 1876; Alice Key Pendleton to Pratt, July 19, 1876, and Apr. 5, 1878, PP.

[10] Cohoe, *A Cheyenne Sketchbook*, 7–13; sketchbooks by Bear's Heart and Ohettoint, Etahdleuh, Ohettoint, and Bear's Heart, Roy Robinson; sketchbook by Cohoe, Mrs. Karen D. Petersen; Grace Lee Nute, "Henry Benjamin Whipple," *DAB*, XX, 68.

[11] "United States Census, 1870, St. Augustine, Fla.," No. 12 and No. 7; Mary B. Reynolds to Librarian, Library of Congress, Aug. 1, 1945 (copy), BAEC files; Cat. No. 39c and No. 39b, sketchbooks by Koba and Making Medicine, respectively, BAEC; Mrs. Samuel Tyler, oral communication to the author, Apr. 29,

1966; Mrs. Doris C. Wiles to the writer, Jan. 17, 1966; sketchbook by White Horse, Joslyn Art Museum; memo by Mrs. S. H. Burnside, BAEC files.

[12] Mrs. Dana O. Jensen, "Wo-Haw: Kiowa Warrior," Missouri Historical Society *Bulletin*, Vol. VII, No. 1, 77, with seven reproductions; two sketchbooks by Wo-Haw, Missouri Historical Society; Malcolm G. Wyer to E. A. Hoebel, June 19, 1965; sketchbook by Ohettoint, Mrs. D. W. Killinger; sketchbooks by Zotom and Howling Wolf, L. S. M. Curtin; *Weekly Floridian*, Nov. 23, 1875, 2; *Argus*, May 19, 1877; *Daily Call*, Apr. 25, 1877.

[13] Drawings by Wo-Haw, U.S. National Museum; Bear's Heart and Zotom, Museum of the American Indian; Etahdleuh, Ohettoint, and Bear's Heart, Roy H. Robinson; Cohoe, Mrs. Karen D. Petersen; sketchbooks by Etahdleuh and Zotom; AAG Drum to Pratt, Nov. 17, 1875; Pratt to Zotom, Mar. 9, 1883—all in PP; Pratt to Whipple, Dec. 21 [1876], Minnesota Historical Society, St. Paul, Minn., Bishop Henry B. Whipple Papers; Margaret Sidney. "The Carlisle School for Indian Pupils," *Sights Worth Seeing. By those Who Saw Them.*

[14] Pratt to A. S. Barnes and Company, New York, Sept. 6, 1876, PP.

[15] Howard D. Rodee, "The Stylistic Development of Plains Indian Painting and its Relationship to Ledger Drawings," *Plains Anthropologist*, Vol. X, No. 30, 225. This study analyzes in gratifying detail the chronological stages of pictographic development that culminated in a drawing by Bear's Heart, one of the Fort Marion artists.

[16] E. [Ed.] R. Townsend, "A City of the South" (dateline, St. Augustine, Feb. 29), *Daily Graphic*, Mar. 30, 1876.

[17] Sketchbook by Bear's Heart and others, Massachusetts Historical Society; Cat. No. 39b, sketchbook by Making Medicine, BAEC; Mrs. Horace Caruthers, "The Indian Prisoners at St. Augustine," *The Christian at Work*, Vol. XI, No. 554, 678–79. For biographical data on Dr. and Mrs. Caruthers, see Curtis Carroll Davis, "Tardy Reminiscences: Some Recollections of Horace Caruthers 1824–1894," *Westchester County Historical Bulletin*, Vol. XXIV, No. 3, 77.

IV. FORT MARION AFTER THE PLAINS INDIAN PRISONERS

In 1886 some five hundred Apache prisoners arrived at Fort Marion, the aftermath of the long campaign against Geronimo in the Southwest. They are not known to have produced any art in their year at Fort Marion except for some drawings found at St. Augustine. A folio at the St. Augustine Historical Society is attributed to them, and rightly so, judging from two facts. The signatures on three of the drawings, Noche and Bazina (Batsinas, Betzinez), appear to signify two well-known Apache prisoners; and the highly acculturated rendition of the horses resembles none of the work by the prisoners from the Plains. Similar to the Apache drawings in style are three undocumented sketches in the files of what was once called Fort Marion. The putative Apache work is so widely divergent from the large body of Plains drawing from the fort in quality and quantity, subject matter and technique, tribal origin and accul-turation, as to exclude it from the drawings spoken of in this book as Fort Marion art.

In the interval between the last warriors from the Southern Plains and the holdout fighters from the Southwest, Fort Marion stood vacant. Vacant, with one exception. "Green lizards swarm in its sunny corners," observed an English lady-sightseer. Regarding the prisoners from the Plains, she said:

They have left their sign-manual upon the walls—specimens of Indian art in the shape of sundry sprawly sketches of man and beast. . . . Crude and out of all proportion as their productions are, they illustrate the minds and peculiar proclivities of the people. An Indian never represents himself as standing, dancing, or walking; he is always on horseback, and always fighting against fabulous numbers, and always a conqueror, riding victorious over a score of prostrate foes.[1]

The wall-drawings described by Lady Hardy do

not accord well with the bulk of the subjects in this volume, wherein the men do stand, dance, and walk, with scarcely a prostrate foe to be seen. The riders counting their coups may have represented some of the first work of the captives, done while they were yet in chains, below in the damp casemates. Again, they may have been the mainstay of some hapless White Horse languishing in solitary confinement, who preserved his self-respect by rehearsing his great deeds of days past. Or they may have been merely the doodlings of an Ohettoint while his bread was baking, reverting to the favorite subject on the Plains —the mounted warrior in his glory. All that was visible on the walls by 1950 were six or seven crude, uncolored outlines scratched in the rough plaster with a sharp instrument, and less than this remains today. What can be discerned—and there is no reason to attribute it to the Plains prisoners—is the semblance of a spider web and the crude outlined bust of a human figure wearing a diagonal breast-strap and a headdress with horn-like projections. The murals of Lady Hardy, in which the warrior of the Plains is always a conqueror, have been covered by wall fern and lichen or have crumbled away.[2]

[1] Folio of drawings by Apaches, St. Augustine Historical Society; Jason Betzinez, *I Fought with Geronimo* (ed. by Wilbur Sturtevant Nye), 167, 154; catalog No. B-19, No. B-20, and No. B-33, anonymous drawings, Castillo de San Marcos National Monument, St. Augustine; Lady Duffus Hardy, *Down South*, 170, 168.

[2] Albert C. Manucy to John C. Ewers, July 19, 1950 (copy), files of the Missouri Historical Society, St. Louis.

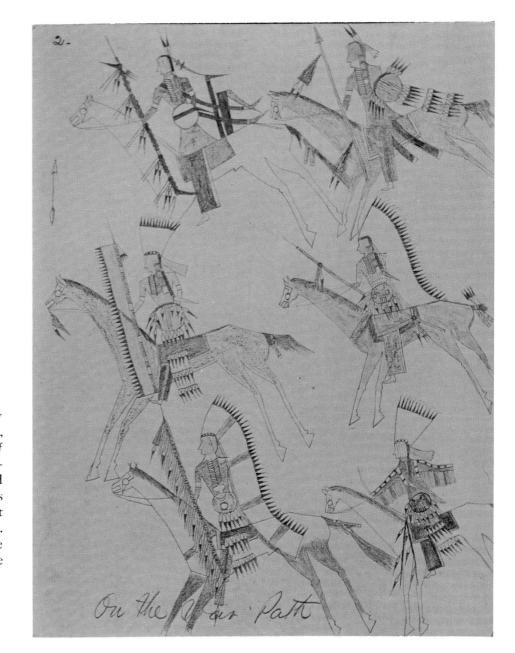

Color Plate 1. "On the War Path," by Making Medicine, Cheyenne, August, 1875 *(Courtesy of Smithsonian Office of Anthropology)*. Each man rushing to battle bears appropriate regalia—a fringed warshirt or a feathered bonnet that shows his bravery in other battles, a lizard amulet or a sacred shield that gives him power. A spear or a saber—each a short-range weapon—proves him ready to risk the dangers of infighting.

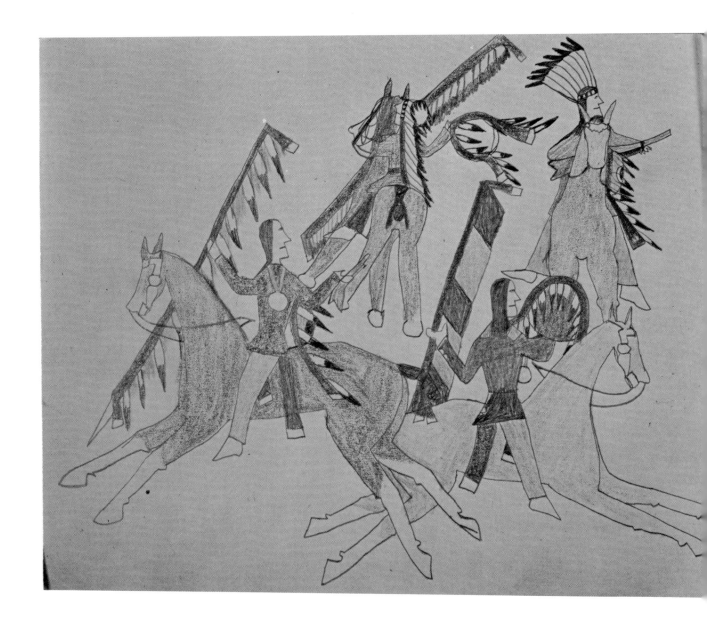

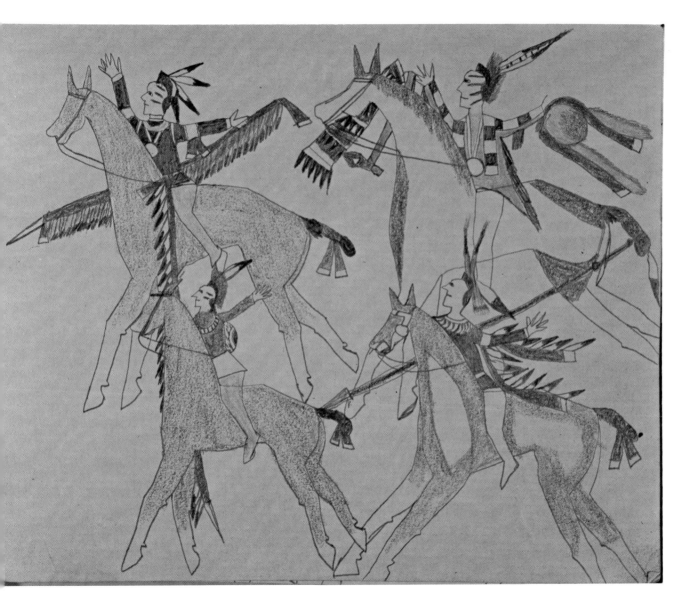

Color Plate 2. By Koba, Kiowa, February 12, 1876 *(Collection of Karen D. Petersen).* The Osages at the right hold up their hands in surrender, while the Kiowas keep their weapons in ready position.

Color Plate 3. By White Horse, Kiowa, May 21, 1875–November 30, 1876 *(Courtesy of Joslyn Art Museum).* White Horse, the famous raider, is riding forth to war. His spotted war horse is led to conserve its power for actual combat. The warrior has brought his wife to carry his traditional armaments, while he keeps his firearms close at hand for emergencies.

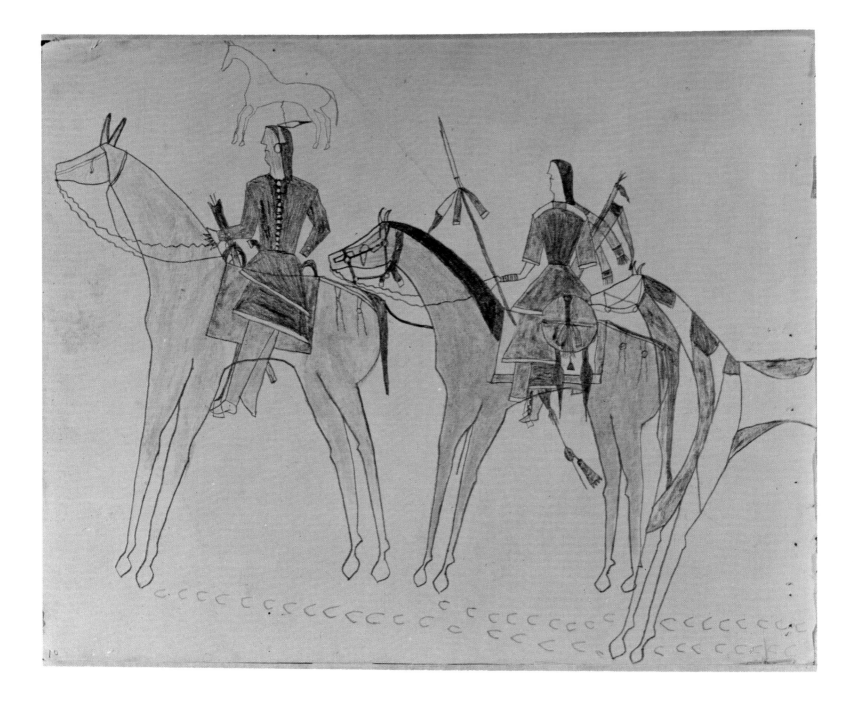

Color Plate 4. "Stealing Horses drawn for C. M. Folsom," by Jas. Bears Heart, Cheyenne, December, 1880–March 31, 1881 *(Courtesy of Hampton Institute).* The pair are working in unison at a task calling for bravery and skill. It can earn them material wealth and a place among their peers.

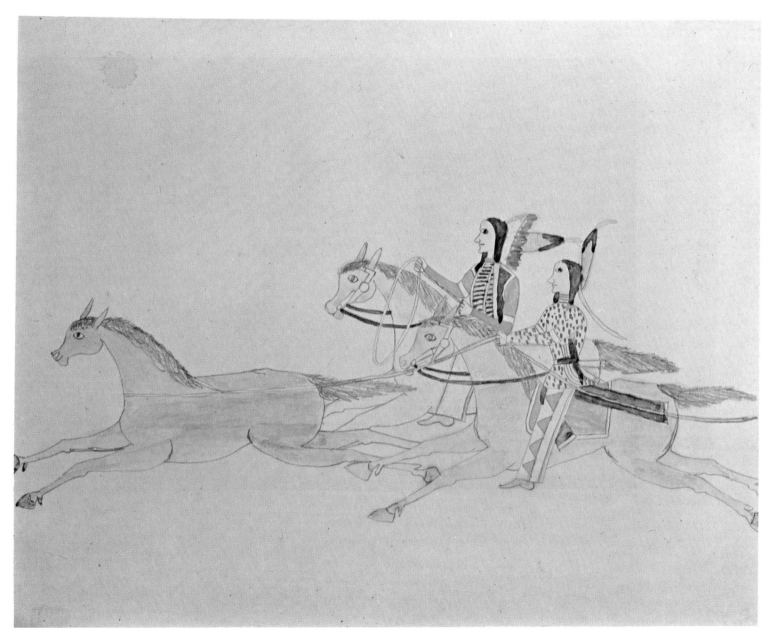

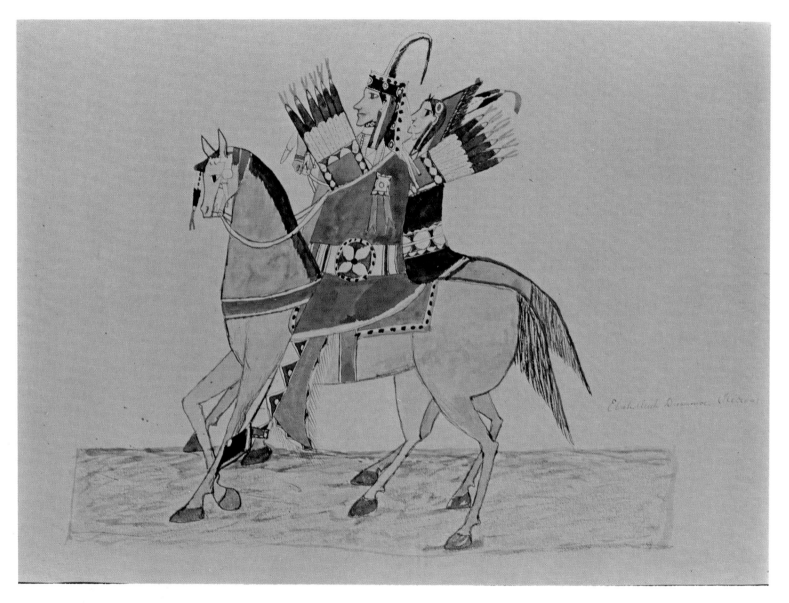

Color Plate 5. By Etahdleuh Doanmoe, Kiowa, February 21–April, 1880 *(Courtesy of Smithsonian Office of Anthropology).* These dandies on prancing ponies are probably young; not a single honorific emblem of bravery have they earned the right to display. Nevertheless, from the otterskin crown-hat to the Mexican tapadero stirrup, they are calculated to dazzle the eye of the beholder.

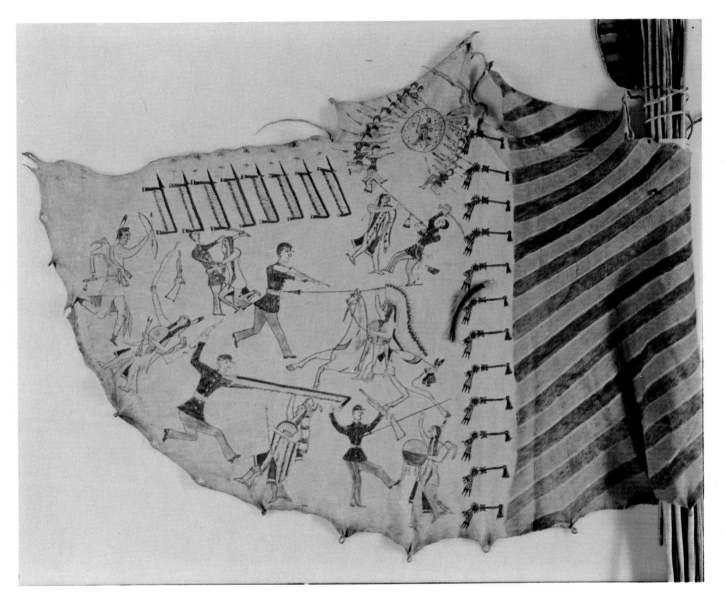

Color Plate 6. By [Ohettoint], Kiowa, 1893–1898 *(Courtesy of Smithsonian Office of Anthropology).* "Tipi with battle pictures" was the name of this model tipi's hereditary pattern. The "north" side, photographed rolled around the tipi poles with the oval door above them, was traditionally striped, while the "south" side depicted the brave deeds of Cheyenne warriors.

Color Plate 7. By Zotom, Kiowa, May 21, 1875–April 11, 1878 *(Courtesy of Hampton Institute)*. The warrior with shield, coup-stick, rifle, looped-up breechcloth, and feathers in his hair, is ready for combat, but his skittish horse is reluctant.

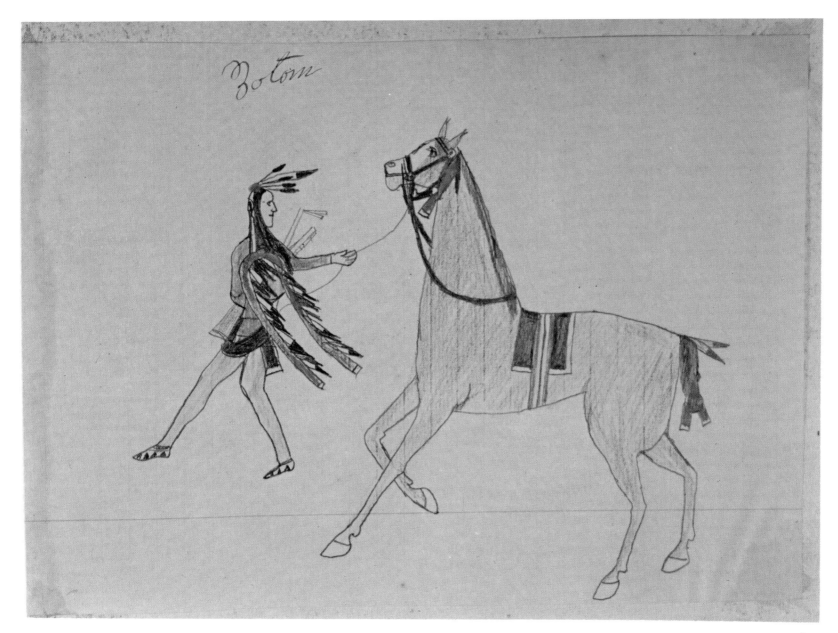

Bo-tom

87

Color Plate 8. "Cheyenne," by Tichkematse [Squint Eyes], Cheyenne, March, 1879–February 21, 1880. *(Courtesy of Smithsonian Office of Anthropology)*. After four years in the East, the artist successfully added water colors to the combination of ink and pencils commonly used at Fort Marion. This drawing marks the high point of Tichkematse's achievement in technique and composition.

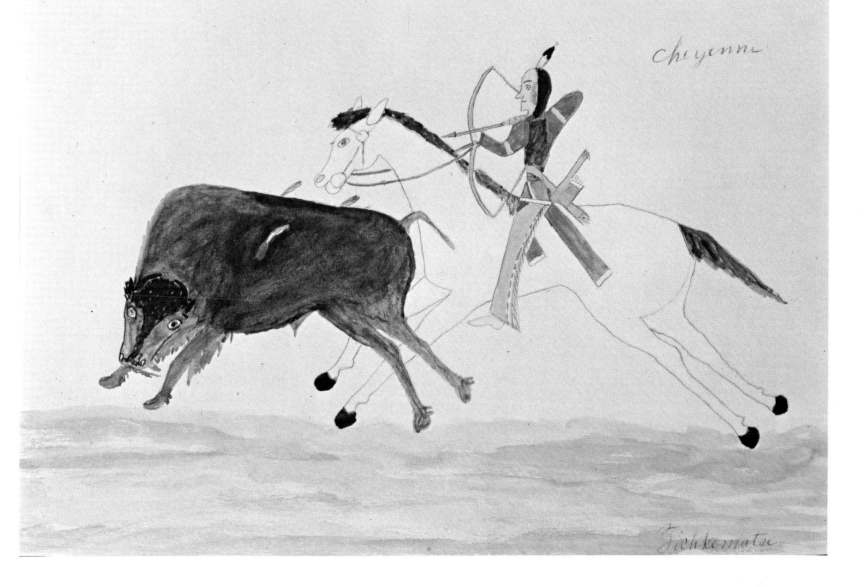

Cheyenne

Tichkematse

Color Plate 9. By Wohaw, Kiowa, January, 1877 *(Courtesy of Missouri Historical Society).* The Indian stands at the meeting of two cultures, the old on the left and the new on the right. Near one foot stand the myriad buffalo and tipi—the old food and lodging—while beneath the other foot lie the cultivated fields with a frame house adjoining, symbols of the new subsistence. In the traditional gesture of respect, the man offers the sacred pipe equally to the revered buffalo—the prairie cattle of the Indian—and to the *wohaw*, the white man's spotted cow for which the artist was named. The emanations from the animals' mouths envelop the Indian, while his mother the earth and his father the sun, together with the moon and the flaming meteor, act as witnesses to the solemn ceremony. By this drawing, pre-eminently rich in symbolism among those from Fort Marion, the artist appears to show his acceptance of the inevitable: he has turned his face to the new life and set his foot upon the white man's way.

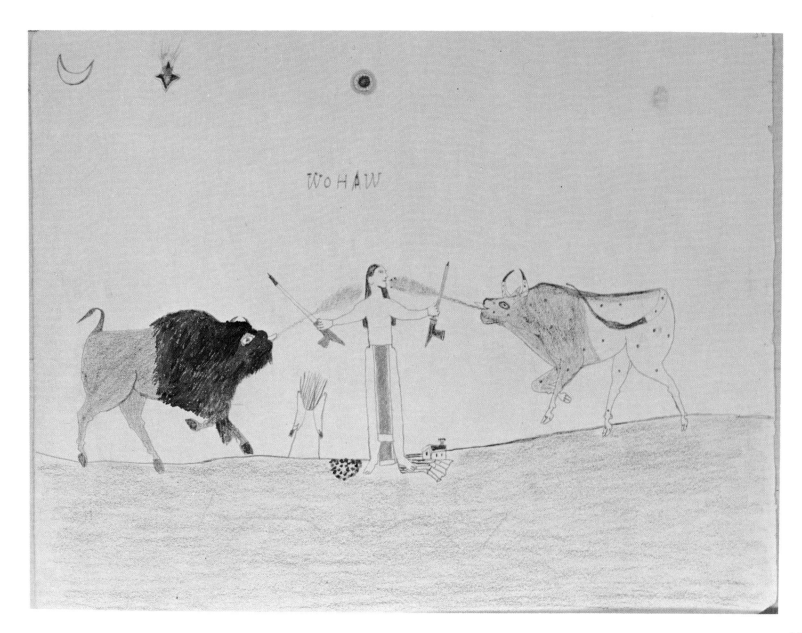

WOHAW

PART TWO
THE ARTISTS

V. MAJOR ARTISTS

THEY were arranged on either side of a wide aisle extending the whole length of the building upon cots, which served as beds at night, and as chairs or sitting quarters during the day, as well as counters to display their goods and chattels, which they are constantly manufacturing for sale. I was surprised to see them so quiet and contented. . . . They were busy making bows and arrows, polishing sea beans, and painting pictures in a crude way. The only one . . . reticent and grum was chief 'Lone Wolf.' "[1]

Thus one journalist saw the Indians practicing their arts and crafts in the wooden barracks which they helped to erect high on the terreplein as a welcome change from the dripping stone casemates. Because Lone Wolf was a familiar name, the reporter took special note of him and discovered that he had personality traits that set him apart from all the others. In a similar way, in this part of the book most of the major artists are singled out for a close look. They emerge, not as faceless, generalized "Indians" but as individual men, each in his own manner meeting the challenge of a new way of life and responding to the impact of a new art tradition.

The artists have been categorized as major or minor largely on the basis of quantity of output rather than of quality. A major artist produced at least one sketchbook of his own, or a folio of equal scope. The 11 major artists produced 94 per cent of the 749 identified drawings, for an average output of 64 drawings apiece. In choosing drawings to represent the artists in this book, it has generally been the intention to select some of their most aesthetically pleasing works as well as to show, for every major artist, drawings made at two different periods or at least, if undated, from two different sketchbooks. Except for Color Plates 1, 5, and 6, the drawings have never before been published.

[1] Jack Plane, n.d., n.p., PP.

BEAR'S HEART, The Color-bearer

Names on drawings: Bears Heart, Jas. Bears Heart.[1]

Names on Pratt's list: Bear's Heart [translation of Cheyenne name], Nockkoist.

Tribe: Cheyenne.

Date of birth: 1851.

Charge listed against him: Accomplice (pointed out by Big Moccasin and Medicine Water) in Germain [*sic*] murder [1874].

Other incidents of early life: Fought Utes and Texans and the U.S. troops.

Dependents at time of arrest: None.

Rank at time of arrest: Warrior.

Place and date of arrest: Cheyenne Agency, Indian Territory, April 3, 1875.

Height and weight, July 9, 1877: 5′ 9″; 136 lbs. 8 oz.[2]

At Fort Marion, Florida: Arrived for imprisonment May 21, 1875.

At Hampton Institute, Virginia: Arrived for schooling, April 14, 1878; baptized "Bear's Heart," March, 1879; expenses paid by Mrs. William Smith (Ann D.) Brown of New York City; spoke at anniversary; color-bearer at inaugural; adopted first name "James."

At Lee, Massachusetts: Arrived for work on farm in early summer of 1880.

Departure for reservation: April 1, 1881; was carpenter and wagon driver there.

Death: Died at the Cheyenne-Arapaho Agency, January 25, 1882, of scrofulous tuberculosis. Interred at

the agency cemetery, beside the old chief, Minimic. *Number of pieces and location of extant art:* 1 BAEC; 1 Hampton Inst.; 12 Mass. Hist.; 24 Mus. Am. Indian; 15 PP; 51 Robinson, including 26 jointly; 1 Rodee. Total, 105, including 26 jointly.[3]

IN MAY OF 1880, in a school auditorium in Virginia a Cheyenne Indian rose to speak before a capacity audience that included President Rutherford B. Hayes, Secretary of the Interior Carl Schurz, Governor John D. Long and former Governor Alexander H. Rice of Massachusetts, and a party of sixty from Boston. The Hampton Normal and Agricultural Institute was celebrating its twelfth anniversary as a school for negro children. The Indian speaker was one of seventeen young men from Plains Indian tribes to whom Hampton had opened its doors in 1878, upon their release from a three-year imprisonment in Fort Marion, Florida, as an aftermath of the Indian wars on the Southern Plains. The words of Bear's Heart are deceptively simple and sound like the composition of an elementary-school pupil. Indeed, the academic education received by Bear's Heart—two or three hours a day, in season, at Fort Marion, and four days a week for two years at Hampton—was probably near the third-grade level. Yet the story he tells reveals that in the twenty-four years before he learned a word of English or caught

a glimpse of the white man's world, he had achieved the full stature of manhood on the Plains. His account is rare indeed. It is the autobiography of a true buffalo-hunting nomad who had never settled on a reservation, recorded without the intervention of an interpreter, and seen not with the dim eyes of old age but with the clarity of young manhood.

A Boston newspaper correspondent who heard him at Hampton saw in Bear's Heart a living manifestation of a new idea dawning upon the white world, the idea that Indians were susceptible of education. He reported:

He is a tall, unpleasant looking fellow of thirty-five years, with high cheek bones, and he spoke in imperfect English, which he supplemented now and then with gestures He spoke with hesitation and nervousness, but straight on, without repetition or any doubling back on his course. . . . The audience listened with intense attention to his simple story, and I wish it was possible to reproduce it in his own broken words, and with his expressive gestures, for it seemed to me a very impressive "object lesson" as regards the possibility of Indian education. There could scarcely have been a more unpromising subject than this hard-featured young brave, fresh from waging war on the whites when he was taken to St. Augustine. The teachers say he is well disposed and tractable and anxious to learn.[4]

Here is the "Indian talk" of Bear's Heart, as printed in the school paper "by request," with the comment, "It is entirely original":

When I was a little boy, I got out of bed, may be six o'clock every morning. I go out Wigwam, wash face, go back in Wigwam. My father comb my hair and he tie it then he paint my face good. Then my father said you go shoot; my little friend come and I said to him let us go and shoot. When finish cooking, my mother say Come here, Bear's Heart, breakfast. Then I told my friend after breakfast you come again we go shooting again. I had buffalo meat just one [only?] for breakfast. I will tell you how my home look, Indian bed just on ground. My father and my mother have a bed one side of the wigwam; I and my brother other side, and my sister another side, and the door on one side. The fire is in the middle. My people sit on bed, and my mother she give us a tin plate and cut meat, we have one knife no fork hold the meat by the hand, eat with knife. After breakfast I go shooting with my friend. I eat three times every day. Sometimes two times when not much meat. All the time meat, that is all. I no work, I play all the time.

After a while I big boy. My father he said, Bear's Heart you try kill buffalo now, I say yes. When Indians went buffalo hunting I go too. One time I shoot twice and kill buffalo. I skin buffalo and put skin and beef on my horse. I took to my wigwam. My father he

say Bear's Heart, how many times you shoot. I say one time. He say good. When I big boy my father give me gun and I shoot deer. All the time I shoot, I done no work.

When my father died I was a bad man.[5] By and by about twenty Indian young men went to fight Utes.[6] I told my mother I want to fight to, and she said yes. I go and fight all day first time, we killed one Ute and four Cheyenne. Sundown we stop. In Texas I fight again. In Texas all time fight no stop, some fight, some take horses [Color Plate 4]. In the summer I fight, in the winter no fight. I fight then I got tired, I say my two friends let us go back to agency; my friends they say yes.[7] We went to Agency, the Capt. take [talk] to us, he say, Bear's Heart what you want to do, fight or stay here. I said stay here; all right say he "go to wigwam." About one month after, Cheyenne chief he tell agent Bear's Heart had been fighting so he is bad, then the Captain put me in the guard house. By and by the Captain he sent my two friends to tell all Indians to stop fight and come to agency.[8] All Indians come back then Cheyenne chief he looked at all Indians and told Captain what Indians fight,[9] the Captain put bad Indians in guard house, and colored soldiers put chains on their legs. One man he got mad and run, the soldiers shoot but no kill him.[10]

By and by good many soldiers come from Fort Sill [Plate 30] and took us to Fort Sill, where I saw Capt. Pratt. Good many Kiowas, Comanches, and Arapahoes,

Cheyennes all together with soldiers and Capt. Pratt take us to Florida.[11] When I ride to Florida all the time I think by and by he kill me. When I been to St. Augustine some time and womans and mans come to see me and shake hand, I think soldiers no kill me. After awhile Capt. Pratt took off all Indian chains, but not too quick. Capt. Pratt he see boys no have money. He got sea beans, he say make sea-bean shine, he told us how and when we make sea-bean good we take to him, he give us money. First time we make sea-beans, then bow and arrows, then paint pictures. By and by teacher she come with pictures of dog, cat, cow and tell us every day nine o'clock morning we go to school stop at twelve o'clock, afternoon just make sea-beans.[12]

Before Indians went to school, Capt. Pratt he gave Indians clothes just like white men, but Indians no want hair cut. Sunday Indians go to church St. Augustine: down from head, Indians same as white men; but heads, long hair just like Indians. By and by after Indians go to church, they say I want my hair cut; my teachers very good.

Two years I stay at St. Augustine, then come Hampton. At Hampton I go to school and I work. I like school and work. I don't want to go home just now. I want learn more English, more work and more of the good way. When I finish my school here, I go home to teach my people to work also, I want my mother and sisters to work house, and I and brother to work farm. When they put chains on me to take me from my home, I felt sorry, but I glad now, for I good boy now.[13] [Paragraphing added for ease in reading.]

Bear's Heart's narrative gave due credit to Captain Pratt and the visitors and teachers at the old fort, but it was at the school for freedmen that he found full acceptance and approbation. He was endowed by nature with hard, unpleasant features, marked by a scrofulous form of tuberculosis. In the fishbowl existence at the fort, his personal appearance did not fit the pattern of the "noble savage" that visiting Indian-sympathizers expected, and he was apparently passed over in favor of other more glamorous captives. Yet, after two years at Hampton Institute, it was Bear's Heart who was chosen to make the "Indian talk" at the anniversary day exercises, albeit as understudy to a younger pupil from the Northern Plains who had succumbed to stage fright. Speaking in a foreign language to his erstwhile enemies and conquerors, including "Washington" himself, Bear's Heart betrayed understandable nervousness. But with firm presence of mind he pushed straight on to the conclusion, for he had the confidence born of self-respect. As a newspaperman reported, "He is not prepossessing. He admits this, but protests that he has a 'fine heart'." One of his teachers commented on his talk, "Bears Heart distinguished himself—and brought down the house several times."[14]

At the anniversary celebration two years before, Bear's Heart had demonstrated the same ability to think under fire. Most of the Fort Marion prisoners arrived at the school April 13, 1878. While the majority left for their reservations within a few days, fifteen of them, later augmented by two more, remained at Hampton for further education, among them Bear's Heart (Plate 1). At the celebration of May 23, the new Indian students were the center of attention for a large body of distinguished guests and many of the Northern friends from whom the school derived most of its financial support. Down Chesapeake Bay by steamer came President Rutherford B. Hayes and an entourage that included Secretary of War George W. McCrary and Attorney General Charles Devens. They made a holiday of visiting the campus with the lovely view of the bay, two rivers, and Fortress Monroe. The President and his party sat on school benches with the former warriors at a school session demonstrating the revolutionary concept that Indians could be educated. The students were quizzed in geography by their brisk Quaker teacher, Eunice Dixon.

The little school ma'am, with amusing confidence and with audacity that was rather startling, treated her scholars as if they were children in a primary school. She would encourage them, invite them to "speak up," reprove them for forgetfulness and give her approval in a manner that seemed to gratify the Indian heart, while it provoked the smiles of astonished spectators. When she invited Soaring Eagle [another of our artists] to explain the peculiarities of a peninsula, and Soaring Eagle's intellect would fail to soar to the necessary extent, she would appeal sharply from him to Bear's Heart, who would unfold the mysteries of a peninsula in a manner that seemed to make Soaring Eagle wish he was dead.[15]

The Hampton curriculum placed equal emphasis on academic and vocational training. For nine months, pupils spent four days in the classroom and two in the workshop. The summer days were divided with two on lessons and four on farm work. Before Bear's Heart had been in attendance four months he was declaring, "Now me, White man, no Indian." He labored diligently at carpentry, in which he acquired "fair skill." He had put behind him the Plains division of work by which the cultivation of crops, as well as the heavy domestic labor, fell to the lot of women. As a convert to the white man's road, he was preparing to furnish the women of his family with a convenient house, and to support them by farming. As he said in his autobiographic speech, "I want my mother and sisters to work house, and I and brother to work farm."[16]

Religious instruction, begun at Fort Marion, was continued at Hampton. In March, 1879, Bear's Heart and ten others, "by their own desire and by the earnest desire of their captor and guardian, presented themselves to be admitted to the Christian church." They were baptized by Chaplain John H. Denison in the non-denominational Bethesda Chapel of the school. Bear's Heart, showing the piety characteristic of his tribe, said of the fifty-first Psalm, "I read it every night."[17]

His companions from Fort Marion kept dwindling in number. Eleven of them chose to join Pratt at his new Indian school at Carlisle, Pennsylvania. One went to the Smithsonian to work; one returned home; two succumbed to the dread consumption. On March 2, 1880, his last confrere from Fort Marion, Zonekeuh (one of our artists), was moved to Carlisle in a condition that quickly became hopeless. "I don't know whether Bear's Heart has heard of it and is dispirited by that," wrote his teacher, "or by a cold he has lately taken himself—in this last cold rain storm. He seems very dismal, and coughs a good deal. . . . He has always seemed to have some scrofula about him." The Cheyenne alone was left at Hampton. "I can not go away. I stay here in Hampton," he told his agent.[18]

It was in a letter in October, 1880, that the Cheyenne first signed his name with the prefix "James." The letter told of his introduction to the white man's way, in particular through the "planting out" of Indian pupils at the homes of friendly farmers in the Berkshire Mountains for the summer, under the direction of Deacon Alexander Hyde, a trustee of Hampton residing at Lee, Massachusetts.

. . . First they took us to Florida; they first teach us the good way and I find Indian road very hard, so I thought, I will never walk the Indian road any more; I find that the white people and colored people are very good friends to the Indians. I think I will be kind to every body and work for white people I am trying very hard to do well; I want to be the best Indian here Now I must tell you about my vacation and my visit at Lee, Mas. I was very glad to learn up there the farm. I stayed with Mr. Frank Merrill, he is very kind man, he learn me how to work with a mowing machine. I work on the farm, I cut corn stalks, and pick potatoes, and pick apples; Mr. A. Hyde, who has charge of all the Indian boys, want us all work on the farm and learn; he is very kind to me, and of all the Indian boys. We stayed there four months.

They returned to school by way of Boston, where they went sight-seeing and met General Samuel C. Armstrong, principal of Hampton. As animated specimens of the civilizing work of Hampton, they

U. S. Cavalry

Plate 30. "U.S. Cavalry," by Bear's Heart, Cheyenne, May 21, 1875–March 31, 1881 *(Courtesy of Yale University Library).* Like the gesture of the sign language for the concept "white soldier," this drawing states with beautiful rhythm that white soldiers, unlike the individualistic Indian warriors, are monotonously "all in a line." Contrast another frieze-like composition (Plate 19) that stresses the unconstrained freedom of the buffalo hunter.

accompanied the dedicated General when he spoke in behalf of his negro and Indian school—in a church and a school in Boston and at a meeting of the American Missionary Association in Norwich, Connecticut. The Indian youths demonstrated their progress by singing a hymn at the last-named place and again for the General Convention of the Episcopal Church in New York City.[19]

At Fort Marion, Bear's Heart was numbered among the most prolific and technically advanced of the artists, creating jaunty little horses drawn as if for a children's book (Plate 30). At Hampton he took up the fad of decorating pottery and his drawings on paper reached their zenith (Color Plate 4). In February, 1881, he went to Carlisle Institute on a visit. He found only two of his old friends from Fort Marion. Pratt selected four youths, his own protégé, the artist Etahdleuh, Bear's Heart, and two younger Carlisle pupils, to appear at a meeting at Baltimore on February 3. All five spoke, and the program was repeated at another location that evening.[20]

Bear's Heart won recognition under the strict military regimen of Hampton. It was said of this steadfast warrior, "Sergeant Bear's Heart and Corporal Yellow Bird are as proud of their command, and as careful to maintain the honor of their stripes, as any West-Pointer." Quite probably the Cheyenne youth

took the name James in compliment to Hampton's "oldest trustee," James A. Garfield. At Garfield's inauguration as President, Bear's Heart had his hour of glory.

An official invitation was received . . . and at 3:40 P.M. Mar. 3, the battalion (four companies, aggregating 101 men, with addition of band, thirteen pieces) left the grounds of the institution and embarked on steamer 'Mosely,' at Fortress Monroe
The passage up the [Chesapeake] Bay was very rough, and many of the students were sea sick, making the time of arrival at Washington very late, (8:40 A.M.) The morning was very cold and stormy
The battalion . . . moved down Penn. Avenue in 'column of companies,' headed by the band . . . and during the march it attracted much attention, and drew forth its full share of cheers and applause.[21]

A newspaper described the students as uniformed in blouse and pants of cadet gray and gray caps with black bands. "Both races are represented in the officers, and the United States colors are carried by a Cheyenne Indian, formerly a warrior, and for three years a prisoner of war at Fort Marion, Florida."[22]

Bear's Heart's three-year stay at Hampton was supported by a scholarship furnished by an Indian sympathizer, Mrs. William Smith (Ann D.) Brown of New York City. As the days remaining for his

stay at Hampton diminished, the old scourge of the Indian burgeoned within his body. Miss Folsom wrote Hampton's valedictory to the young Cheyenne:

Earnest, industrious, and deeply religious, his influence over the wild young Sioux from the West was especially helpful, and he would have been glad to remain longer had not a scrofulous trouble made a change seem advisable.

For weeks before his return, his mind and hands were busy preparing surprises and pleasures for the friends at home, especially the old mother to whom he seemed most tenderly attached. On April 1st, '81, he started bravely homeward with a large trunk full of gifts, a warm and complete outfit for his mother and many articles of household use that he had learned to appreciate here.

He wears back a neat suit of the school gray uniform decorated with a sergeant's and color-bearer's stripes which he has well earned. . . .

He takes back a chest of carpenter's tools [purchased by Mrs. Brown for $35.70], . . . the bible and many other good volumes. . . .

He goes back a strong, decent, Christian *man*, with the rudiments of an English education, and hands trained to earn himself a living at the carpenter's bench or on the farm. . . .

Bears Heart was one of the most obedient and kind hearted students that ever entered this school. He was always ready to inconvenience himself to please others.

On the day of his departure, he said that he would like to speak to the Indian boys and girls before leaving. They gladly assembled to hear his parting words. He was a great favorite among the students, although not one of them belonged to his tribe. . . .

When he had finished, "I am sorry"—"I am sorry" echoed from all parts of the room.[23]

Bear's Heart and a Pawnee, Jonathan Huestri, or Heustice, went by boat to Washington, D.C., thence by train to Caldwell, Kansas, with a stopover of a day or two at Carlisle, and the rest of the long journey by wagon. At the end of the month Agent Miles reported:

Bear's Heart reached home in due time, and after visiting his friends in camp for a few days *only*, applied at my Office for work; said he could not be idle, and had no desire to remain idle in camp—but was anxious to show his people that he had been taught to work, and that it *pays* to work, and that it is honorable to work. He told his people the first Sabbath in Sabbath School that "the *Bible religion has work right along with it.*" I put him in the Carpenter shop, where he seems quite at home, and I am confident his example and influence will be on the right side.

Send us more such men.[24]

By June, Bear's Heart was carrying passengers to

and from Caldwell by covered wagon drawn by four ponies. In September Agent Miles said: "Bear's Heart is at present on the sick-list, having overheated himself in helping unload a [wagon] train. His whole heart is for progress among his people, and both by preaching and practice he endeavors to help his people forward."[25]

Like many a returned Fort Marion prisoner, Bear's Heart was finding the going difficult. He came home filled with the noble dreams of Captain Pratt, General Armstrong, his teachers, and Indian sympathizers—dreams soon dissipated by the hard light of reality. On the reservation he met the opposition of the conservative leaders of his tribe to any innovation, conditions unsuitable for farming,-the bitter irony of a paternalistic government that forbade him to go out in search of food but neglected to provide a ration to alleviate hunger, an understaffed agency, the hostility of cattlemen, the inroads of liquor smugglers, and inadequate appropriations by Congress to implement the "civilizing" upon which he and other returnees were primed to embark. Bear's Heart's pay of twenty dollars a month must have shaken his faith in his declared precept, "It *pays* to work." He kept in touch with his friends at Hampton by letter. Miss Folsom recalled, "His letters were always bright and cheerful, tho' one could read between the lines the struggle he was making with poverty, sickness and lack of sympathy in his new life; yet in spite of all, he succeeded in his determination to make his home comfortable and his mother happy for two years [*sic*] or until his death in 1882."[26]

His obituary, written by the Episcopal missionary at the Cheyenne and Arapaho Agency, said in part:

Entered into rest at Darlington, January 25, 1882, James Bears Heart

While in the East, he became a member of the Church, and from that time to his death, lived a singularly pure and gentle life I was much pleased with his quiet gentle ways, and particularly with his reverent demeanor at our morning and evening devotions. He was always present at the services of the Church until he became too feeble to attend. . . .

His disease was the dreaded lung trouble of the race, and at times he suffered severely

Industrious, faithful, kind, affectionate, genial Bears Heart. . . . we buried him [in the agency cemetery] by the side of the old chief Minimic, who learned the good road at old Fort Marco [Marion].[27]

Said his agent, "Bear's Heart was a good man and his influence was excellent among his people. It is very discouraging to see so many of those who have had educational advantages dying with 'consumption.' "[28]

Within the life span and the means allotted to him, Bear's Heart had fulfilled the promise he made before President Hayes on a May day in Virginia less than two years before: "When I finish my school here, I go home to teach my people to work."

[1] The symbol above the name of each artist has been taken intact from Koba's Picture Words, BAEC, with these exceptions: White Horse, his sketchbook, Joslyn Art Museum; Howling Wolf, anonymous drawing, Hampton Institute; Buffalo Meat, Ohettoint's book, PP; Packer, one of his drawings, Hampton Institute; Shave Head, one of his drawings in book by Making Medicine and others, PP. All but the Buffalo Meat, Soaring Eagle, and Tounkeuh were intended by the makers to be name-symbols for our artists.

The name Bear's Heart is spelled without an apostrophe in all of the artist's sketchbooks and handwritten signatures. In printed matter, the usage varies. In this book the apostrophe is used in the interest of grammatical accuracy.

[2] Names on Pratt's list, tribe, date of birth, charges, rank, place and date of arrest, and height and weight for all the artists are derived from R. H. Pratt, "Catalogue of Casts Taken by Clark Mills, Esq., of the Heads of Sixty-four Indian Prisoners . . . , Feb. 9, 1878," United States National Museum, *Proceedings*, I (1878), *SMC*, XIX, 204–14. The statistical data was recorded July 9, 1877.

The tribal designations suggest a question concerning the purity of blood-strains. All the fourteen Cheyennes and Arapahos about whom there is information for some or all of their near relatives were of unmixed blood. All of the six Kiowas about whom information could be found had close relatives—mother, father, wife, or adopted son—with "foreign" blood: two of them Mexican, two Comanche, and one each Navaho, Sioux, Crow,

Kiowa-Apache, Pawnee, and Cheyenne. Of the six Kiowas, five were major artists. This is not to imply that inter-marriage with foreign tribes improved the quality of Kiowa art. Rather, the fact bears out the reputation of the Kiowas for absorbing foreigners into their culture.

[3] More complete addresses for locations of art pieces are given in the chronological Catalog of Art, Appendix, pages 309–11.

[4] (Dateline, Hampton, Va., May 20, 1880), *Journal*, May 24, 1880.

[5] Among the Plains tribes, a survivor frequently was subject to "a bad heart" that could be pacified only by taking a life.

[6] The Utes lived west of the Southern Cheyennes, in the mountains of Colorado.

[7] The U.S. Army staged a broad and punishing campaign against the Cheyennes, Arapahos, Kiowas, and Comanches, beginning in July, 1874. On Dec. 12, the Cheyenne-Arapaho agent, John D. Miles, reported the arrival at the agency of Bear's Heart and his two friends, all of whom surrendered their arms to Lieut. Col. Thomas H. Neill and were placed in the prisoners' camp. On Jan. 3, 1875, Miles reported that Big Moccasin "has *pointed out* 'Bear's Heart' and 'Limpy' [Cohoe, another of our artists] who arrived here from 'Grey Beard's' camp on 19th [*sic*] ultima as being two of the twenty-two (22) under 'Medicine Water' who murdered the survey party embracing Capt Short, his son, and four others, and also the *Germain* [German] family —They have been placed under a strong guard." Miles to Commissioner Smith, Dec. 12, 1874, NA, OIA, Central Superintendency, Field Papers, C&A Agency, 1874; *ibid*, Jan. 3, 1875, NA, OIA, Letters Received, C&A Agency, 1875.

[8] Miles continues, " 'Big Moccasin' also says that 'Little Shield' who came in with these two men [Bear's Heart and Limpy] on the 19th Dec. was one of the party [in the Short and German raids]—Gen Neill has sent 'Little Shield' with two others to the main Cheyenne Camps, with a message to 'Stone Calf' requiring the immediate return of the two German girls and the terms on which he with his Band may come in and surrender. At the time 'Little Shield' was sent out it was not known that

he was connected with the murders."—Miles to Smith, Jan. 3, 1875, NA, OIA, Letters Received, C&A Agency, 1875. Little Shield apparently did not return, for he was not sent to Fort Marion for his part in the raids.

9 The main body of the Cheyennes surrendered March 6. Lieut. Col. Neill reported, "On yesterday, March 12, I paraded all the men of the Cheyenne Tribe, and made Medicine Water [the alleged leader in the two raids] point out those who were identified with him in the German and Short murders." Neill to AAG Williams, Mar. 13, 1875, NA, WD, Letters Received, U.S. Army Commands, Department of the Missouri, 1875. Bear's Heart was one of those implicated in the German raid by Medicine Water. Pratt, *SMC*, XIX, 207.

10 This is the famous Sand Hill fight of Apr. 6, the last battle between the Southern Cheyennes and the Army. It occurred when a prisoner fled while his legs were being ironed by a negro soldier. The Cheyenne was officially reported as killed by the guard, but actually, as Bear's Heart says, he escaped from captivity. James Mooney, "The Cheyenne Indians," *American Anthropological Association Memoirs*, I, 394n; Theodore A. Ediger (ed.), "Chief Kias," *CO*, Vol. XVIII, No. 3, p. 296.

11 The Cheyennes were taken from Darlington by night on Apr. 23, and arrived in St. Augustine in chains May 21.

12 Volunteers taught the prisoners to read, write, and speak English by using pictures and primers.

13 "Indian Talk," *SW*, Vol. IX, No. 7 (July, 1880), 77.

14 "The Work at Hampton, Va." (dateline, Hampton, May 20), *Daily Advertiser*, May 24, 1880; Helen M. Ludlow to Pratt, June 3, 1880, PP.

15 "The Hampton Institute," *Evening Transcript*, May 29, 1878; "More about the Hampton Institute" (dateline, "Old Virginia," May 25), *Daily Courant*, May 30, 1878; Max Adeler [Charles Heber Clark], "Negro and Indian" (dateline, Fortress Monroe, May 24), *Evening Bulletin*, May 25, 1878.

16 Pratt to Commissioner Hayt, Aug. 23, 1878, NA, OIA, Letters Received, Miscellaneous; Bear's Heart to Miss Mather, July

29, 1878, NA, WD, AGO, APC File 6238, 1878, Statement and Appeal in Behalf of Indian Education; Miles to Pratt, Apr. 21, 1881, *EKT*, Vol. I, No. 11 (June, 1881), [1].

17 Rev. John H. Denison, "A Supplement to the Last Smithsonian Report," *The Congregationalist*, Vol. XXXI, No. 21, 162. For a biographical sketch, see "John Henry Denison," *Who Was Who in America* (5 vols.) (Chicago, Ill., c1942), I, 314.

18 Ludlow to Pratt, Mar. 26, 1880, PP; Bears Heart to Miles, June 2, 1879, OHSIA, C&A—Deaths.

19 James Bear's Heart to J. R. Murie, Nov. 1880, "A Letter," *SW*, Vol. IX, No. 12 (Dec., 1880), 129; "General Convention," *Churchman*, Vol. XLII (Oct. 23, 1880), 460. Murie was a younger Hampton pupil now remembered for his anthropological works on his tribe, the Pawnees. For a biography of Armstrong, see Edith Armstrong Talbot, *Samuel Chapman Armstrong*.

20 "From the Indians," *SW*, Vol. X, No. 3 (Mar., 1881), 35; Etahdleuh Doanmoe, "Communicated," *EKT*, Vol. I, No. 9, [3].

21 [Helen W. Ludlow], "Indian Education at Hampton and Carlisle," *Harper's New Monthly Magazine*, Vol. LXII, No. 371, 666; [Capt. Henry Romeyn], "The Hampton Institute Cadets at the Inauguration," *SW*, Vol. X, No. 4, p. 44.

22 *Daily National Republican*, Mar. 4, 1881, as quoted in *SW*, Vol. X, No. 4 (Apr., 1881), 44.

23 [Cora M. Folsom], "Instantaneous Views," *Twenty-two Years' Work of the Hampton Normal and Agricultural Institute at Hampton, Virginia*, 329; "Incidents of Life at Hampton: Bears Heart Returns to the West," *SW*, Vol. X, No. 5 (May, 1881), 55.

24 Acting Commissioner Marble to Gen. Armstrong, Mar. 31, 1881; and Capt. Henry Romeyn to Miles, Mar. 31, 1881, both in OHSIA, C&A—Hampton Institute; *CT*, Nov. 25, 1881, [1]; Miles to Romeyn, Apr. 29, 1881, "Bears Heart's Return," in *Report of the Principal for 1881*, Hampton Normal and Agricultural Institute, 32.

25 Rev. J. B. Wicks, "Story of the Indian Territory Mission," *OITC*, Vol. IX, No. 12, 69; Miles to Pratt, Sept. 28, 1881, *ARCIA*, 1881, 194.

[26] Roster of Agency Employees, 1880–1881, NA, OIA, Statistics Division; [Folsom], "Instantaneous Views," *Twenty-two Years' Work*, 329.

[27] Rev. J. B. Wicks, "Obituary," *CT*, Feb. 10, 1882 [1].

[28] Miles to Pratt, Jan. 27, 1882, PP.

White Horse, the Notorious Raider

Name on drawings: White Horse.

Names on Pratt's list: White Horse [translation of Kiowa name], Isatah.

Tribe: Kiowa.

Date of birth: 1847.

Charges listed against him: Led the party killing Manuel Ortego and Lucien Munós, near Dr. J. J. Sturms, on the Little Washita River, Indian Territory, Aug. 22, 1874. Participated in the Howard's Wells Texas massacre, 1872. Led the party killing the Lee family and abducting the Lee children, near Fort Griffin, Texas, 1872. Led party killing Mr. Koozier [Koozer], near Henrietta, Texas, and carrying his wife and four children in captivity, 1870. Led the party attacking the mail stage, dangerously wounding the driver, robbing the stage, killing, wounding, and robbing the stage of its mules, near Johnson's Station, 25 miles west of Fort Concho, Texas, July 14, 1872. Notoriously a murderer and raider.

Other incidents of early life: Member of Young Mountain Sheep Society; led many raids against Navahos and whites; defied white authorities; enrolled as a friendly; imprisoned in guardhouse; defended by agent, opposed by Pratt.

Dependents at time of arrest: Two wives.

Rank at time of arrest: Chief.

Place and date of arrest: Fort Sill, Indian Territory, December 17, 1874.

Height and weight, July 9, 1877: 5′ 11″; 197 lb. 8 oz.

At Fort Marion, Florida: Arrived for imprisonment May 21, 1875; leader in abortive outbreak; active in entertainments.

Departure for reservation: April 11, 1878.
Death: Died in 1892.
Relatives: Sister, wife of Man Who Walks above the Ground (Mahmante), a Fort Marion prisoner. Adopted son (Navaho captive), husband of Giagihodle.
Number of pieces and location of extant art: 19 Joslyn Mus.; 4 PP. Total, 23.

IN THE FREE DAYS on the plains, White Horse was the only man of all our artists whose name already resounded on the frontier and on the Eastern seaboard—whose reckless deeds were recounted with pride by the red man and with horror by the whites. He inspired in men either an ardent loyalty, or a lasting enmity. When he was but twenty years old, he was performing legendary feats of strength and daring. It is said that in a raid he lifted a Navaho boy by his hair, set the youth behind him on his horse, and carried him back to camp and adopted him. Anko's Kiowa calendar records for the same year, 1867, the killing of a Navaho by a party led by White Horse. Anko was a member of this party. In 1870, at the unusually early age of twenty-three, White Horse ranked near the top of the Kiowa tribe. He was a leader of raiders and a chief—the head of his band. He was tall, strongly built, and open and smiling of countenance. As befitted his rank, by 1875 he had two wives—sisters, in accordance with custom. Doubtless, one of them is portrayed in Color Plate 3. Because of his bravery White Horse was chosen as one of the two warriors who brought up the rear in dances of his soldier society, the Young Mountain Sheep. As an emblem of office he carried a long, flat stick with a pendant coyote skin attached to the handle. With a blow from the stick he would prompt a laggard dancer to get on his feet.[1]

Not every man had the ability to qualify as a leader of raids. He had to be able to inspire men to enlist in his cause. He had to have a reputation for success on his raids and for skill in organization and strategy. He was the magnet that held together his little group of undisciplined individualists. During the years 1870–1872 White Horse was the *enfant terrible* for the civil and military officialdom of his reservation. Many of his raids were characterized by atrocities and extreme brutality. He began on June 12, 1870, with an insolent raid on the Fort Sill corral that netted seventy-three government mules for the Indians. Ten days later, White Horse and his friends attacked the guard for a Texas woodcutting party south of Four Mile Crossing near Medicine Bluff Creek, and a group of Texas cattle-herders on the road a few miles south of the fort. One man was

shot and scalped in each attack. Next he led a war-party which killed a farmer, Gottleib Koozer, and carried off the wife and several children in Texas. The Kiowas then asked for, and were granted, the opportunity to counsel with Agent Tatum.

In the council they said they wanted pay for women and children held by them before they brought them in. . . . They were very overbearing and impudent. . . .

The Kiowas brought White Horse in and set him upon a barrel, and pointed him out to General Grierson and Mr. Tatum, the Indian agent, as the man who killed and scalped three persons and stole all the stock around this post, and who captured the family in Texas. They spoke of him as the most dangerous man among them, and, in presence of General Grierson and Mr. Tatum, they all shook him heartily by the hand, and asked him to consent to make peace for the poor white people's sake.

They said that after they left they would not disturb us any more; that we need not be sitting trembling in our tents, and peeping out to see if the Kiowas were coming, but that we could now send our horses out to graze, and send men out to chop wood.[2]

With the approval of the Department of the Interior, Tatum paid White Horse a hundred dollars for each Koozer he surrendered. On September 30, White Horse killed a stagecoach guard in revenge for the slaying of a Kiowa warrior. On the eighteenth of May, 1871, he had a part in the cruel Warren wagon-train massacre at Salt Creek Prairie, Texas. On the twentieth of April, 1872, he was shot in the arm at a raid on another wagon train, this time at Howard Wells, Texas. Here he acted as second in command.[3]

In June of 1872 White Horse's brother was killed in Texas in a fight with surveyors. White Horse organized a party of six other men and a woman for a revenge raid into Texas. The Kiowa, George Hunt, tells the story as he heard it first-hand: "They came to a house with the two rooms connected by a long, roofed porch. A man in a white shirt was sitting in a rocking chair on the porch, reading a newspaper [it was Sunday]. The Indians sneaked up a gulch. White Horse took aim and shot the man. Then they rushed the house, took several children, and perhaps a woman."

Adds Nye, "This revenge raid took place on Sunday, June 9, at the home of Abel Lee. . . . Mr. and Mrs. Lee and one daughter were slain and three other children taken captive." On July 14, White Horse led a party in attacking and robbing a mail stage with a military escort only twenty-five miles west of Fort Concho, Texas.[4]

The Kiowa agent, Lawrie Tatum, characterized

White Horse as "daring, vile, and treacherous," and the feeling of contempt was reciprocated. Early in August, at a conference held at old Fort Cobb, the raider bragged of his intention to shoot "Bald-head," Agent Tatum. "Lone Wolf and White Horse recounted their depredations with all the nonchalance of a sophomore telling about a hazing escapade." When the subject of peace was broached, White Horse flaunted his defiance, saying that "the old chiefs might make peace, but he and the young men did not wish it, but should raid when they chose."

After delivering his ultimatum, he did not choose to raid for nearly two years, as far as the records show. In the fall, Washington issued an ultimatum of its own. If the Kiowas wanted their chiefs, Satanta and Big Tree, released from a Texas prison the next year, they must remain at peace and give up their captives and their stolen stock. The Kiowas complied with the conditions, but when June of 1873 came, the governor of Texas refused to release the prisoners. The Kiowas grew resentful and restless. They hatched a plan fantastic in concept, and delegated its execution to White Horse.[5]

The doughty Tatum, before he resigned and left the agency on April 1, was disillusioned with Grant's Peace Policy. He replacement was another Quaker, James N. Haworth, who remained firm in a belief in the efficacy of kindness and moral suasion in controlling the Indians. White Horse took to visiting the agency frequently and became acquainted with the new agent. As the summer wore on and the chiefs were not released, the Kiowas reasoned that they, too, were entitled to hostages. They sent White Horse and four daring and resourceful men into the agency to kidnap Haworth and the erstwhile teacher of the Kiowas, Thomas Battey. The pair were to be held far out on the plains in the Kiowa camp until their chiefs were set free. Accordingly, one evening in mid-July, the five picked men arrived at the agent's house. Haworth had been secretly informed of the plot, and outdid himself in brotherly love. White Horse surrendered his revolver as a gesture of good faith, but as he sat down, he inadvertently exposed another gun beneath his blanket, much to his mortification. Haworth plied his kidnappers with supper, and the wicked were put to confusion. The guests postponed the kidnapping for another day, but that day was no more propitious. The third day they left for camp, and the agent heaped coals of fire on their heads in the form of gifts of beef, sugar, and coffee. On one thing both sides were agreed, in essence. To Battey, this was the work of Divine Providence; to the Indians, the white men's "medicine was too strong."[6]

On October 8 the Kiowas received their chiefs back and began raiding again. By midsummer of 1874, depredations by the Kiowa, Comanche, Cheyenne, and Arapaho Indians had reached proportions that called for rigorous action. For these tribes, the peace policy was modified late in July by Secretary of War William W. Belknap. Guilty Indians no longer were to be protected from the military, once they had gained the boundaries of their reservations. Friendly Indians who took no part in recent forays and who lived close to the agency would be exempt from military action. White Horse promptly enrolled as a friendly and took up residence in camp near the agency. Nevertheless, nearly five months later, on December 21, Lieutenant Colonel John W. Davidson had him arrested and placed in irons in the guardhouse at Fort Sill. But White Horse had a friend at court; Haworth rejoiced to turn the other cheek. The agent was outraged at this injustice to his repentant sinner. Haworth's superior, Superintendent Enoch Hoag, with Quaker zeal for Indians' rights, backed him up firmly. He implied that he agreed with the Indians' charge: the government had broken its promise made in a telegram of Secretary of the Interior Columbus Delano on March 21, 1874, "Promise all Indians who remain on reserva-

tions, and are peaceful, that the government will exert all its power to protect and defend them."[7]

The point was well taken. The ground rules in this game of war were changed so often that not only the Indians were hard pressed to keep abreast of them. Delano's statement of March was superseded by Belknap's orders of July 20. Because of the dual chain of command, military and civil, a like directive went out from the commissioner of Indian affairs July 20. These orders raise questions. What constituted a peaceful or guilty or friendly Indian? If classification was to be made on the basis of alleged depredations, what were "recent" forays or "late" outrages? Further, in the case of conflicting allegations, whose testimony should be accepted, that of a hardened army officer or of a sympathetic agent; of an Indian turned informer or of a loyal friend of the accused?

The enrolling officer, Captain G. K. Sanderson, weighed only offences committed in 1874, and he passed the responsibility of vouching for White Horse to a chief well known as friendly to the whites. Said Sanderson on August 8: "I also enrolled White Horse who presented himself for that purpose. I did it on Kicking Bird's swearing that he knew White Horse had not been engaged in any hostile act this year, he was also assured that it would

go worse with him than the others if we hereafter could prove any hostile act on his part."[8]

When White Horse was arrested in December, said Haworth, "The General informed me it was for depredations committed in Texas some years ago, the murder of part, and capture of others of the Lee family," in 1872. The agent insisted that Captain Sanderson, when he enrolled White Horse, had promised "that he would not be disturbed for offences committed previous to the commencement of the troubles of 1874"—apparently true, judging from Sanderson's own comment above. Haworth also declared that immunity had been promised to all who had been at peace since the Adobe Walls fight of June 27, 1874, and that this date had been set by a council held in the post. He further charged that White Horse had been cleared by his tribe of any part in the hostilities at Anadarko on August 22. In view of the last charge, there would be serious ground for doubting the validity of White Horse's arrest were it not for the evidence gathered by the man who was to serve as jailer to White Horse for three years.[9]

If White Horse had his champions in Haworth, Hoag, and the Kiowas, he also had a stubborn adversary in Richard H. Pratt, a lieutenant in the Tenth Cavalry. On December 14, Pratt was detailed to in-

vestigate the records of the internees at Fort Sill by taking testimony from both Indians and whites regarding each turbulent Indian. It was just one week after Pratt entered upon his new duties that White Horse was arrested, and the officer took satisfaction in writing to his wife that he held in the guardhouse, awaiting trial by military commission, "the notorious Kiowa chief White Horse who disturbed us so in 1870 . . . a worse man than Lone Wolf." At first the intention was to try before a military commission those Indians against whom there was evidence of depredations during the two years previous. For White Horse, Pratt charged up raids going back to 1872—the Howard Wells fight, the Lee family raid, and the mail stage attack—with the Koozer murders of 1870 included for good measure. When it became apparent that the trials should cover only the short period of active warfare that began August 22, 1874, at Anadarko, there was still the charge that White Horse had led a party killing two noncombatants on the first day of the war. (Somehow this incident had escaped the knowledge of Haworth and the Kiowas.)

For the most part, Pratt's witnesses were reputable white men: a doctor, the mail escort, and former agent Tatum. Curiously, the only Kiowa who informed against White Horse was the man with

whom Pratt had compared him—as many more were yet to do—the man who was to vie with young White Horse for leadership of the Kiowas at Fort Marion, the aging chief, Lone Wolf. Old Horse Back and his wife, Comanche friendlies, added their testimony regarding the murders of 1874 to that of a near-victim, Dr. J. J. Sturm. The story runs:

A party of Indians went to Dr Sturms house about 15 miles from here [Fort Sill], and between here and Wichita Agency, and threatened to and deliberated about taking his life, but was saved by the intervention of old Horse Back and a man sent by Kicking Bird for that purpose. Some of the party pursued two white men, Hauser and Sam Holly, mail rider—who hid in bushes. White Horse was there and acted in a manner calculated to alarm Sturm. He wanted to take his gun, and when refused it said that he wanted to kill White men at Wichita Agency with it. The bodies of two Mexicans Lucien Munos and Manuel Ortego were found six miles from Sturms on the road to Sill, some days afterward but there is reason to believe that they were killed same day and by some of the Indians who left Sturms, to pursue the two white men. White Horse is implicated.[10]

In the mind of the judge advocate general of the military Department of Texas, the evidence against White Horse did not place his case among "the cases of those Indians who had committed crimes within two years that rendered them amendable [sic] to trial by a military commission," to the regret of that worthy officer. Instead, he relegated him to Pratt's list of "turbulent men." The raider forfeited his immunity and earned a punishment by committing a proven "hostile act," against which he had been warned by Sanderson. Pratt believed that imprisonment in the East was too lenient a punishment for the raider. He told General Philip H. Sheridan, "White Horse should go to Texas for trial as he can be convicted (and would be) in both the Koozier [sic] and Lee family cases." He was indicted for murder by the grand jury of Clay County, Texas, but he never stood trial.[11]

Captain Pratt deprecated the handling of the Koozer and Lee murders by the "present management," which rewarded White Horse instead of punishing him. In Pratt the Kiowas met their master. "The Man Who Walks Above the Ground [Mahmante], being of an insolent, swaggering, braggadocio disposition is working it off in solitary confinement. White Horse being attacked some time ago with the same disease was completely cured by being dosed a couple of weeks [beginning January 29] with that medicine."[12]

A year later, in Florida, the Man Who Walks

Above the Ground, the husband of White Horse's sister, lay in his grave, and Pratt had White Horse confined in a dark-cell. When the Fort Marion years were over, a wise and venerable woman who had taught the prison classes said of White Horse, "We were great friends, though Capt. Pratt never liked him." The teacher on the plains whom White Horse had attempted to kidnap and who, in full acknowledgement of the raider's crimes, called him "the terror of the frontier," added, "Though terrible as an enemy, I think [he] is capable of warm friendship." These two teachers knew the White Horse who broke down in tears at the death of his comrade, Sun, in Florida.[13]

An eye-witness to the confinement of White Horse at Fort Sill in January was yet another who succumbed, in spite of his preconceived judgment, to the charisma of the great leader of raiders.

The more guilty and dangerous [of the imprisoned Indians] were placed in irons and confined under strict surveillance in the post guard-house The principal was White Horse, a Kiowa chief, a murderer, ravisher, and as great a general scoundrel as could be found in any tribe.

I told the interpreter I should like to begin by a visit to White Horse.

"Then," said he, "we shall have to see the officer of the day; for the sergeant of the guard has orders to let no one visit White Horse without special instructions." . . .

The officer then conducted us to a private room, into which he ordered White Horse to be brought. A clanking of chains was heard along the corridor, and White Horse, doubly ironed, stood in the door-way. He entered, not without a certain untutored majesty of gait, maugre his irons. He put out his manacled hands, and energetically went through the ceremony of hand-shaking, beginning with the officer of the day, and giving him an extra shake at the end.

White Horse was a large, powerful Indian. He wore a dark-colored blanket which covered his entire person. I could discern no indications of ferocity in his countenance. His face, on the contrary, had rather what I should call a Chadband [indulging in the good things of life] cast. His flesh seemed soft, oily, and "puffy."

White Horse's mother and aunt [who applied to visit him] were now permitted to enter. The mother rushed to her son, threw her arms around him, kissed him on both cheeks, while the tears rolled down her face; but she uttered not a word. The aunt kissed him in like manner. White Horse submitted to their embraces, but made no motion of responding affection. He seemed a little nervous under their caresses, and probably under our observation. The mother took hold of his chain, looked at it for a moment, and then came another paroxysm of silent grief, revealing itself in tears alone. They

sat on a rough wooden bench, White Horse in the centre, his mother on his right, his aunt on the left, each holding one of his hands in both of hers. White Horse uttered no sound; no gesture betrayed any emotion, yet I thought I could detect a moistening of the eye. This made me feel that I had no business there, gazing on his grief and that of the poor Indian women. I suppose I ought to be ashamed to say it; but the truth must be told, and I must confess that, villain as he was, I could not help feeling for him. . . . I believe I should have pleaded for mercy towards him, though he showed little mercy to others.[14]

After months of uncertainty as to what disposition to make of the culprits, seventy-two Indians were shipped off to Florida. The most prominent Kiowas were Lone Wolf, the Man Who Walks Above the Ground, Woman's Heart, and White Horse (Plate 2). Man Who Walks died only two months after his arrival at the fort, and Woman's Heart withdrew into mourning. From the first, the acknowledged head of the hostile element in the Kiowa tribe and the notorious leader of raids were prominent at Fort Marion. The local press reported, a week after their arrival, that " 'Lone Wolf' is a tall, spare, dark Indian, quite advanced in years, seems quite depressed in spirits on account of his confinement, and is sulky and sour. 'White Horse,' the tallest of his party

[Kiowas] is younger, more lively, . . . seems in good spirits, and is in better physical condition."[15]

A year later, Pratt noticed a suspicious evasiveness about the Kiowas. Once more they had hatched a fantastic scheme with White Horse as its vital element. The captain detailed his interpreter, George Fox, to interrogate one of the tribe whose loyalty was not to be doubted.

I questioned Ah-ke-ah–Kiowa Pris. about the actions and disposition of Lone Wolf–and White Horse (Kiowas) and as to their influence with the Kiowas "here as prisoners"–He said that Lone Wolfs influence amounted to very little, but his talk at all times was for bad. White Horse to the contrary had great influence over them all, they had all been associated with him, in the Indian Country–in all his raids, and depredations, and looked up to him here as a kind of a Leader. He told me of a plan being devised to escape . . . White Horse being one of the principal schemers."[16]

And, according to Fox, the "Chiefs White Horse, Lone Wolf, Woman's Heart and To-zance [Double Vision] have become satisfied that their release from captivity would never take place and that they would with their tribe escape and endeavor to reach the plains. They would travel day and night and never allow themselves to again be captured. . . . The young warriors did not want to take part in the

escape, nor did the talk of their chiefs, with the exception of White Horse, appear to have any effect upon them. This chief urged it and demanded it."[17]

As Captain Pratt tells the events of that crucial April 4, 1876: "White Horse, who had been one of the worst of their leaders in frontier lawlessness, attracted special attention. He asked permission to go over alone to the coast to a particular sand dune in sight of the old fort to perform some religious ceremony. To disarm any suspicion that he was being observed, his request was granted."[18]

Pratt quietly arranged for support from St. Francis barracks in St. Augustine, and, if needed, from his ever-reliable Cheyenne prisoners. He closed the great doors of Fort Marion to visitors, and when the Indians marched in to dinner, he required the cooks and guards to come, too—every prisoner. "The Kiowas realized that something was up, and Lone Wolf and White Horse were last and hesitated about going into the dining casemate." The officer announced that a bottle of poison was missing from the medical supplies (which was a fact). He called in soldiers from the post to search the men's quarters carefully and then, after finding nothing, to search each man, tribe by tribe.

Finally came the Kiowas, and as they were searched

the two leaders were put in one casemate and bolted in. Then Lone Wolf was searched and put in a cell by himself. As we opened the door to bring out White Horse he stood at the far end of the casemate, head erect, and arms folded. Evidently realizing the futility of his plans, he said to the interpreter: "Tell the captain it is all right. I understand and I want him to kill me now." I told Fox to ask him "who said anything about killing anybody," and he was silent. After searching he was put in a casemate by himself and the door bolted.

A blacksmith was called to replace the shackles and handcuffs on the two ringleaders. After dark Lone Wolf was blindfolded and marched back and forth around the courtyard by two stalwart soldiers. "In a very little while he . . . had to be supported back to the cell. Then White Horse was taken out in the same manner, but he, with head erect and firm step, marched throughout the prolonged treatment and went back to his cell without having shown fear." The post surgeon, Dr. Janeway, gave Lone Wolf a hypodermic injection in his arm to produce unconsciousness.

We went to White Horse's cell, and as he watched the doctor using the hypodermic he said something. Mr. Fox interpreted: "Captain, he wants to know what you are doing to him." I said: "Tell him that I know the Indians have strong medicine and do some wonderful

things, but the white man has stronger medicine and can do more wonderful things, and I am having the doctor give him a dose of our strong medicines." White Horse immediately asked, "Will it make me good?" I said: "Tell him I hope so. That is the object." In a little while they were unconscious.

The Kiowas, except for their leaders, were confined in casemates under arrest for periods up to two weeks. White Horse was given dark-cell confinement at St. Francis barracks. After two weeks in the post guardhouse he was joined by Lone Wolf for another fortnight. On their return to the fort they were kept in a casemate, still in irons, until their releases on May 11 and 8, respectively. As the captain recalled long afterward, he gave them both good talks. His parting words to White Horse concluded:

"I want you to see that I can still trust a man of your character in spite of what you had planned to do, and you will return to duty in the company and will again help guard the fort, but as a private and not as a sergeant." He and Lone Wolf said they were sorry for what they had planned to do and White Horse was especially grateful that I still trusted him. Later he was again made a sergeant and to the end of his imprisonment rendered most satisfactory service.

What about the lonely visit to the sand dune, and the missing bottle of poison? The newspaper of the rival city of Jacksonville set forth under lurid headlines a highly imaginative account of a near-massacre, adding, "Poisoned arrows were the weapons to be used." Pratt says only, "They had prepared bows and arrows so as to kill game and protect themselves on the way."[19]

After his second dose of confinement administered by the hand of Captain Pratt, the ebullient White Horse had to find more acceptable outlets. He attended the classes in the fort long enough to learn to write his name with difficulty (Plate 29) and to speak a few words of English. Once his teacher, Miss Mather, brought to class her friend, Harriet Beecher Stowe. Pratt relates:

The casemate Miss Mather occupied as her schoolroom was next to the casemate in which I had my office. One day, while the classes were in session, there was quite a commotion in Miss Mather's schoolroom, and two of the Indians were outside and looking back when I went to see what was the matter. Mrs. Stowe was sitting near the blackboard by Miss Mather and both were laughing heartily. The Indians were quiet. To keep from looking at Miss Mather, White Horse had his arm up in front of his eyes when I went in, and said to me, "Miss Mather no good." This renewed the ladies' amusement. Then Miss Mather told what had happened. She was trying to teach them to pronounce words ending in *th*

and was using the word *teeth*. She had them well along in the concert pronouncing and then, wanting to show them what "teeth" are, removed and showed them her complete set. She closed her jaws, which made a remarkable change in her facial presentation.[20]

The Indians thought she was coming to pieces.

No doubt it was White Horse's relish for clowning that helped to win Miss Mather's firm friendship. His few extant drawings sparkle with situation-humor. He was not bound by the Plains convention of showing himself of heroic stature; he was not afraid to make a joke at his own expense. He drew what is apparently one of the first of the Fort Marion sketchbooks. One of his wives sent him a cured hide in May, 1877, which he adorned with pictures. Perhaps he sold it, for in June he sent five dollars to the devoted mother who had visited him in the Fort Sill guardhouse. That summer he camped with other prisoners on Anastasia Island for several weeks in August.[21]

In the entertainments given by the prisoners the flamboyant White Horse was in his element. In "an evening with Mother Goose and the children," staged by local residents to raise money for the education of some of the Indians, it was our raider who provided dramatic relief by a demonstration of the Indian war whoop. Only a month and a half after

his arrival at St. Augustine he had the leading role in a production that played to hundreds. St. Augustine's celebration of the Fourth of July was held that year at the picturesque fort. The feature of the afternoon was billed as

"A BUFFALO CHASE

in which Mounted Indians, in full war paint, will pursue and kill a bullock after their fashion of killing Buffalo on the Great Plains." The local paper described the events with gusto and appropriate classical allusions:

Long before the hour appointed for the opening of the festivities, crowds of people hastened towards the old fort, in and around whose walls the sports were to take place.

Promptly at 3 o'clock, the first gun of the salute boomed out over the placid waters of our bay, and ere the reverberations of the last had died away, another and another discharge announced the existence of one, and each of the several States in the combined nationality. The salute having been fired, (after the manner of the 1st Artillery—in unexceptionable style), the balloon was inflated, and sent aloft, but from some unforseen cause, exploded when about thirty feet above the ramparts of the fort. Universal regret was expressed at the failure of this part of the programme, and Pvt. Coleman had the sympathy of all. Col. Hamilton then

ordered the gates of the fort to be thrown open to the public, and soon the ramparts were lined with a densely packed throng; every one seeking the best vantage ground from which to view the grand feature of the day.

Emerging from the fort, four Indian warriors, dressed and painted in all the barbaric splendor of their tribes, are seen to mount

"Four steeds that spurn the rein, as swift as shy," and armed with bows and arrows, they appear like fabled Centaurs, and look the perfection of manly grace and strength. These have been selected on account of skill, and are Quo-yo-uh [Pile of Rocks], a Comanche brave, Moconista [Bear Killer], a Cheyenne, and White Bear, an Arrapahoe, all under the leadership of White Horse, the celebrated Kiowa Chief. Capt. Pratt and Mr. Fox were also mounted, and exercised a general supervision of the chase. But hark!

"Thrice sounds the clarion; lo! the signal falls
The den expands, and expectation mute
Gapes round the silent circle's peopled walls.
Bounds with one lashing spring the mighty brute,"
and stands not upon the order of his going, but at a furious pace rushes down Charlotte street. After him, pell-mell, with whoops and yells which startle the propriety of the "ever faithful City," fly the braves, and for a little while the race seems a doubtful one. Strict orders had been given the Indians not to shoot until at a given signal, but when opposite the FLA. PRESS of-

fice, Moconista espied a little child in the street, and seeing the imminent danger, drew bow and let fly his unerring shaft. This checked the bull in his mad career, and quickly four arrows were seen sticking in the back of the beast; but still there was life in him, when White Horse, at full speed, and knife in hand, administered the coup de grace. The bull fell in the yard of the St. Augustine Hotel, and upon examination it was found that each of the four arrows had struck a vital part, two penetrating over eighteen inches.

As this sport was not witnessed by the crowds at the Fort, Mr. Willie Sanchez very kindly agreed to supply another animal, and in company with the Indians rode off to drive him up. Some little delay ensued, but soon the announcement was made that they were coming, and every eye was strained to catch a glimpse of the heroes of the day. From the direction of the St. Sebastian, shortly after 4 o'clock, the Indians were seen driving their destined game, and from the difficulty they experienced in keeping Number two in the right direction, the spectators were led to expect that he would prove as mettlesome as the first. While getting the animal into position, the braves displayed some excellent feats of horsemanship, and their riding was universally pronounced perfect.

Finally, the bull was driven across the road, and set off with lightening speed towards the Fort, with the warriors in hot pursuit. The situation was beginning to grow critical to those who were standing outside, and

a general stampede was checked, just in time too, by Capt. Pratt's giving the signal to kill. Quo-yo-uh discharged an arrow, which had the effect of turning the brute, and before he had run fifty yards, the Indians had dispatched him. The Butchers, (one from each tribe), then appeared upon the scene, and with remarkable celerity and skill, dressed the carcass, stopping now and then to eat some delicious morsel *au naturel*. In the meantime busy preparations had been going on outside of the fort for the grand feast. Each tribe had a separate fire, and the chiefs and braves cut, cooked and eat, to their hearts content. Leaving them to the hearty enjoyment of meats, such as their souls delighted in, we went inside, where Mr. Geo. M. [*sic*] Atwood was reading the Declaration of Independence. This part of the proceedings having been concluded, Col. Hamilton introduced the Hon. Judge Stickney,

THE ORATOR OF THE DAY . . .
Nothing more ornate or appropriate to the occasion could have been offered

Those at a distance can form no idea of the spectacle presented by the Indians in their chase of the bulls; their wonderful feats of horsemanship and their skill and dexterity with the bow and arrow. Think of throwing themselves on their knees, their horses at full speed, thus standing over the bull and piercing him to his vitals. Think of White Horse throwing his leg under the horse's neck, whilst horse and bull were going at a furious rate, leaning over and stabbing him to the heart.

We doubt if anything in Barnum's Hippodrome could compare with them.[22]

There is a footnote to this story. Captain Pratt staged the Fourth of July celebration not only to cheer his dejected charges but also to liven the dull off-season for the native residents of St. Augustine. His trial balloon exploded like Private Coleman's, albeit on a delayed fuse. The captain made all the arrangements for the full-scale program, from the artillery salute to an evening of Indian dances. "The citizens sent in upon invitation a steer and several horses, and next day sent in their bills," to the sum of $28, paid out of Pratt's own pocket.[23]

In the second and final buffalo chase, nearly six months later, White Horse again played the hero. At the last public entertainment put on by the prisoners, only a month before their release, he was the leader of the "old men" singing around the drum during the dance-drama. Like the conductor of an orchestra, he acted on behalf of his musicians. He was not above "hamming it up" and stealing the scene. The other singers wore paint and feathers; White Horse wore a replica of the famous horned headdress that was his trade-mark in many a fight on the Plains. One of the spectators at the dance, an authoress, drew a vivid word picture of the tall, pow-

erfully built Indian, again embellished by the classics:

Chief White Horse, the leader of the orchestra, wore two enormous horns, giving him the appearance of the representation of Moses, as handed down to us by some of the earlier painters and sculptors, and also calling to mind one of the features of the burlesques which amused the Spanish people on the occasion of the marriage of the Cid:

> "For the king had hired the horned fiend,
> For fifteen maravedis;
> And there he goes, with hoofs for toes,
> To terrify the ladies"

During the performance a feather-duster was sent up from the audience to White Horse, as though it were a floral tribute to a favorite actress; and just as the prima donna might have come before the curtain, at the close of the opera, to bow her acknowledgments to the audience, with the bouquet pressed to her heart, old White Horse appeared, holding the feather-duster, to make a farewell speech. It consisted of the most friendly sentiments, delivered, however, in his native tongue, with the exception of the closing words: "Goodnight! Go 'long!"[24]

This is the last favorable report on White Horse. When the prisoners were released the next month, he went back to the reservation—the recommendations of the military notwithstanding. The commanding officer of Fort Sill said of the Kiowa prisoners, "There are some among them of the very worst character, who should never again be allowed at this Agency:—notably 'White Horse' and 'Lone Wolf.'" Pratt commented bitterly, eight months after the release, "Strength in every way would have been added to the Fla. experiment had such bad Indians as Medicine Water, White Horse, Lone Wolf, Long Back and Tozance, and perhaps one or two others, met a fate more in keeping with their crimes. I recommended to the Commissioner the release of all 'except the very bad,' having these in mind. My information from the Ind. Ty. confirms my judgement, and condemns me for so feebly expressing it." The blunt General of the Army, William Tecumseh Sherman, agreed on the futility of "the costly experiment of imprisoning and instructing old and vicious Indians like Lone Wolf, White Horse, Medicine Water &c at St. Augustine or any where else—Such Indians should be tried and hung for murder soon after the commission of their crimes, instead of wasting sympathy and money upon them as was done at St. Augustine."[25]

White men had tried their good medicine on White Horse. George Fox, the interpreter at St. Augustine who had been loved and trusted by the prisoners and had preceded them in returning to Fort Sill, extended his help to the more recalcitrant re-

turnees. "I have worked with them at my house and fed them, but all to no purpose. . . . White Horse is the same big lazy Indian that he was in Augustine; he has forgotten how to put his civilized clothing on any more; he is very low." A solicitous Miss Mather attempted to bridge the distance from St. Augustine to the reservation with friendly letters. At the fort, Pratt had administered the medicine of even-handed punishment and rehabilitation. "Will it make me good?" "I hope so. That is the object." The era of raiding was over, but White Horse was the wild White Stallion of the Prairies, a leader of his own kind that would not be broken to workaday living. As Tsaitkopeta, a fellow prisoner-artist, summed him up, "White Horse promised great things but he no sure and I feel sorry. He tell me he throw away all bad and keep the straight way, but he don't keep." He died of a stomach ailment in 1892, leaving no heirs but the family of the adopted Navaho son. Colonel Wilbur S. Nye tells of a remarkable operation performed on White Horse late in life by a Kiowa healer. He concludes, "White Horse recovered fully, to die in bed some years later unrepentent for the many atrocities he had committed in his young days."[26]

[1] Wilbur S. Nye, *Bad Medicine and Good*, 143–47; Mooney, 17th *ARBAE*, 1895–96, Part I, 320; Bernard Mishkin, *Rank and Warfare Among the Plains Indians*, 54–55, No. 9; Pratt, *SMC*, XIX, 204; Thomas C. Battey, *Life and Adventures of a Quaker Among the Indians*, 150; Elsie Clews Parsons, *Kiowa Tales* (*Memoirs* of the American Folk-lore Society, XXII), 92–93.

[2] Nye, *Carbine and Lance*, 137–38, 140–42, 144, 148; "From the Indian Territory," *Army and Navy Journal*, Vol. VIII, No. 5 (Sept. 17, 1870), 74.

[3] Lawrie Tatum, *Our Red Brothers*, 44; Pratt to wife, Oct. 22, 1874, PP; Nye, *Carbine and Lance*, 152, 167, 196–97.

[4] Tatum, *Our Red Brothers*, 125; Nye, *Bad Medicine and Good*, 170–71; Pratt to Post Adjutant, Apr. 24, 1875, NA, WD, Letters Received, U.S. Army Commands, Department of the Missouri, 1875, S4/168/23.

[5] Tatum, *Our Red Brothers*, 169; Nye, *Carbine and Lance*, 201; Rupert N. Richardson, *The Comanche Barrier to South Plains Settlement*, 351; Tatum, Report, Sept. 1, 1872, *ARCIA*, 1872, 248; Battey, *Life and Adventures of a Quaker*, 197.

[6] Battey, *Life and Adventures of a Quaker*, 150–51, 251–52.

[7] Sec. of War Belknap, telegram to Gen. Sheridan, July 20, 1874 (a copy), in Sheridan to Pope, July 21, 1874, NA, WD, Letters Received, U.S. Army Commands, Department of the Missouri, 1874, M 438; Haworth to Commissioner Smith, Feb. 22, 1875, NA, OIA, Central Superintendency, Field Papers, K&C Agency, 1875; Hoag, Report, Oct. 19, 1875, *ARCIA*, 1875, 264–65.

[8] Commissioner Smith to Haworth (telegram), July 20, 1874, OHSIA, Kiowa–Military relations; Sanderson to Post Adjutant, Fort Sill (a copy), Aug. 5, 1874, NA, OIA, Letters Received, Kiowa Agency, 1874.

[9] Haworth to Commissioner Smith, Jan. 1, 1875, NA, OIA, Central Superintendency, Field Papers, K&C Agency, 1875; *ibid.*, Feb. 22; Haworth to Hoag (a copy), Sept. 30, 1875, NA, OIA, Letters Received, Kiowa Agency, 1875; Haworth, Report, Sept. 20, 1875, *ARCIA*, 1875, 273.

[10] Pratt, *Battlefield and Classroom*, 104–105; *ibid.*, Lt. Col.

Davidson to Pratt, Dec. 14, 1874; 91–92; Pratt to wife, Dec. 24, 1874, PP; Judge Advocate General Emory to Gen. Mackenzie, Mar. 30, 1875, NA, WD, Letters Received, U.S. Army Commands, Department of the Missouri, 1875, S6/168/23; *ibid.*, Pratt to Post Adjutant, Apr. 24, 1875, S4/168/23.

11 Emory to Mackenzie, Mar. 30, 1875, NA, WD, Letters Received, U.S. Army Commands, Department of the Missouri, 1875, S6/168/23; Pratt to Sheridan, Apr. 26, 1875, NA, WD, AGO, AG's Letters Received, File 2815, 1874; Belknap, Secretary of War, to Secretary of Interior, Apr. 14, 1875, NA, OIA, Letters Received, Kiowa Agency, 1875.

12 Pratt to Capt. W. McK. Dunn, Mar. 30, 1875, NA, OIA, Letters Received, Central Superintendency, 1875; Pratt to Miles, Mar. 11, 1875, OHSIA, C&A–Indian murders; Post Guard Book, Jan. 10–Apr. 13, 1875, Jan. 29 entry, Fort Sill Museum, U.S. Army, Fort Sill, Okla.

13 Pratt to AG, July 19, 1875, OHSIA, Kiowa–Indian prisoners of war; S. [Sarah] Mather to Hunt, Jan. 27, 1880, OHSIA, Kiowa–Carlisle Indian School; Horace E. Mather, *Lineage of Rev. Richard Mather*, 194–95 n; Battey, *Life and Adventures of a Quaker*, 149–51; "The Last Sensation!!" *FP* [May 29, 1875].

14 "A Day among the Kiowas and Comanches," *Catholic World*, Vol. XXIII, No. 138 (Sept., 1876), 838–40.

15 Mooney, 17th *ARBAE*, 1895–96, Part I, 199, 215; "The Last Sensation!!" *FP*, May 29, 1875.

16 Fox to Pratt, Apr. 4, 1876, PP.

17 Interview with George Fox, quoted in "About the Indians," *FP*, Apr. 8, 1876.

18 In the following account of the attempted escape, all quoted matter is taken from Pratt, *Battlefield and Classroom*, 147–52. A few facts of chronology are added from Pratt, Report of Indian Prisoners Confined in Fort Marion, St. Augustine, Florida, during the month of April, 1876, NA, OIA, Letters Received, Central Superintendency, 1876; *ibid.*, May, 1876.

19 "Indians Rising in St. Augustine! Plot Discovered! Cheyennes in Irons!" *Florida Sun*, Apr. 6, 1876, p. 3; Pratt, *Battlefield and Classroom*, 148.

20 Pratt, *Battlefield and Classroom*, 154–55; Mrs. Samuel Tyler, oral communication to author, Aug. 13, 1959.

21 Haworth to Pratt, June 20, 1877, PP; C. M. Bevan, letter to Editor (dateline, St. Augustine, Aug. 27, 1877), n.p., n.d., PP.

22 Pratt, *Battlefield and Classroom*, 189; "Fourth of July Celebration in St. Augustine," *FP*, July 10, 1875. The George Atwood mentioned presumably was the father of Noel Atwood, who procured the drawings by White Horse now in Joslyn Museum, of which four are here reproduced. The father, his daughter Fannie, and Noel died of a virulent form of yellow fever that struck St. Augustine in the winter of 1877–78, a score of years before Dr. Walter Reed pinpointed the mosquito as the carrier of Yellow Jack. Pratt to Bro. Carroll, Jan. 11, 1878, PP.

23 *Weekly Floridian*, July 27, 1875, 2.

24 "Excitement in St. Augustine," n.p., n.d., PP; Lizzie W. Champney, "The Indians at San Marco," *The Independent*, XXX, No. 1541, 27–28; George Z. Otis to author, Aug. 5, 1965.

25 Col. Mackenzie to AAG, Sept. 5, 1877, PP; Pratt to AG, Dec. 4, 1878, and endorsement of Gen. Sherman, NA, WD, AGO, APC File 6238, 1878.

26 [Fox] to Pratt, Dec. 15, 1878, *SW*, Vol. VIII, No. 2 (Feb., 1879), 19; S A M [Sarah A. Mather] to Pratt, Feb. 11, 1884, PP; Paul Caruthers [Tsaitkopte] to Pratt, Jan. 5, 1879, PP; Mooney, 17th *ARBAE*, 1895–96, Part I, 428; Wilbur Sturtevant Nye, *Plains Indian Raiders: The Final Phase of Warfare from the Arkansas to the Red River*, 228; Mrs. Laura White Horse, oral communication to author, Mar. 28, 1967; Nye, *Bad Medicine and Good*, 147, 109–110. The familiar photographs in Mooney, Fig. 47, p. 191, taken about 1870, and Pl. LIX, opp. p. 190, from 1892, appear to be the first and last portraits of White Horse.

Koba, the Hoer of Onions

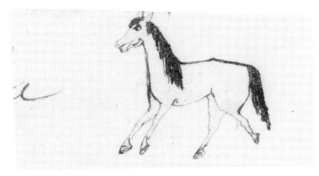

Name on drawings: Koba.
Names on Pratt's list: Wild Horse [translation of Kiowa name], Koba.[1]
Tribe: Kiowa.
Date of birth: 1848.
Charges listed against him: Was with Mah-mante [Man Who Walks above the Ground] stealing a lot of mules in the Brazos country in 1872. Participated in the attack on General Davidson's command at Wichita Agency, August 22, 1874.

Other incidents of early life: Raided for horses in Mexico and Texas; fought the Navahos; witnessed the peace between Kiowas and Pawnees; surrendered to Asa Habba and to Captain Pratt.
Dependents at time of arrest: None.
Rank at time of arrest: Warrior.
Place and date of arrest: Salt Fork, Red River, Indian Territory, February 18, 1875.
Height and weight, July 9, 1877: 5′ 7¾″; 153 lbs.
At Fort Marion, Florida: Arrived for imprisonment May 21, 1875.
At Hampton Institute, Virginia: Arrived for schooling April 14, 1878; baptized "Koba" in March, 1879.
At Lee, Massachusetts: Arrived for work on farm early in June, 1879.
At Carlisle Institute, Pennsylvania: Arrived for education October 7, 1879.
Departure for reservation: September 10, 1880.
Death: Died at the Kiowa-Comanche Agency, September 24, 1880, of consumptive tuberculosis.

Number of pieces and location of extant art: 31 BAEC plus Picture-words; 4 Hampton Inst.; 2 Mass. Hist.; 17 Petersen; 3 Yale. Total, 57 plus Picture-words.

EARNEST young Koba might be remembered for his quaint picture-words, some of which introduce a number of our biographies, or for the glimpses of Kiowa life in his sketches. Instead, his small fame rests on a succinct summary of life at Hampton Institute, often quoted: "I pray every day, and hoe onions."

What heinous crimes sent Koba to prison for three years, without a hearing or a trial? First, he was an ambitious young man zealously carving out his niche in Kiowa society and acquiring a backlog of capital in the manner most approved by his fellows: "Was with party stealing horses in Salt Creek Valley Texas —summer of 1873. Was with Mah-Mante [Man Who Walks Above the Ground] stealing a lot of mules in the Brazos country 1872.—One of the mules spotted."

Second, he was caught up in the excitement of a day of mass rioting and looting when a skirmish ignited the dessicated hopes of the Kiowas: "Participated in the attack on Gen Davidsons command at Wichita Agency I. T. Aug. 22–1874."[2]

The man who recorded these indictments against Koba knew, better than any other white man, who deserved banishment and who did not. With compassion Pratt wrote, "Most of the *young men* going up [to imprisonment] have been governed by the leadership of their chiefs, much as soldiers are, and are not so culpable as at first seems." Of Man Who Walks, the leader of the mule-raid in which Koba and three others were alleged to have assisted, Pratt had quite a different opinion, summed up in the phrase, "Notoriously a leader of murdering and raiding parties." For this raid and other lesser crimes of Man Who Walks, one of the accusing witnesses was Kicking Bird. Twenty other Kiowas, including Koba, bore the indictment of the "friendly" chief. When he died suddenly a few days after the departure of the prisoners, many of the Kiowas believed that the mystic Man Who Walks had conjured him to death in revenge for the exile of the Kiowas.[3]

The drawings of Koba (pronounced Ko'bay) in this volume show his early life as a hunter and warrior on the Plains (Color Plate 2 and Plates 22–25). (See also pages 57–58, above.) A number of his drawings at Fort Marion owe their inspiration to Koba's friendship with a St. Augustine boy in his late teens who frequented the fort. Burnet S. Reynolds and Koba together annotated the pictures with captions,

comments, or touching dedications and acknowledgments. In several loose pages collected and preserved by Reynolds, Koba betrays an original and quick mind with his lists of illustrated names and other words and a practice letter to "my dear father." The first assessment of Koba, made in a news story commenting on three of the Florida Boys who wanted to go North for further education, rings true. "Koba, . . . one of the brightest and most promising among the scholars, came and earnestly asked Captain Pratt if he might not come too."[4]

His boon was granted (see Plate 1) and Koba went to Hampton Institute, thanks to the generosity of eastern philanthropists.

The "Hampton idea" was a challenge to even the most earnest Indian students. It balanced academic learning in the foreign English tongue with manual labor equally foreign to the Indians, administered with military discipline and assuaged by Christian teaching and practice. More than foreign, it was abhorrent to the pureblood Plainsman to violate ancient custom by taking up woman's work— fashioning clothing, serving food, erecting dwellings, and digging in the ground. Yet each pupil was assigned to learn the trade of tailor, waiter, carpenter, or the like, and all worked on the school farm. Small wonder that even Koba, called unusually earnest and

conscientious by one of his teachers, sometimes rebelled. During an arithmetic class he failed at working an example on the blackboard and gave up without correcting his mistake. Sulkily he sat down and turned his back on the board, making no response when the teacher called his name. That evening he knocked at the teacher's door and was admitted. "'Miss B———,' he began as soon as the door was shut, 'to-day you said, "Koba," and I did not say anything. By and by, I think maybe Miss B——— feel bad because I did not speak, maybe she think I don't like her; so I have come to tell you I am sorry.'" A few days later Koba again failed, gave up, and sat down. "A few minutes passed, but they seemed as so many hours to the anxious teacher; then throwing his feet high into the air in a wild demonstrative way, Koba exclaimed, 'I know, I know,' and going to the board, gave the correct answer at once."[5]

Sustaining the young men in their struggle with the new life at Hampton was the Christian faith in which they were instructed. Koba, with eleven others, was baptized into the church in March, 1879. The school chaplain wrote of these new Christians, "One point in theology they understand, and one only. It is to walk the new road in the help of Jesus; and they show their faith by their works. Digging in the earth is not the chief joy of an Indian

warrior; but Koba writes: 'I pray every day, and hoe onions.' "[6]

In June, Koba left Hampton for work on a farm at Lee, in the gentle, green-clothed Berkshire Mountains of Massachusetts. The farmers were understandably apprehensive of their "wild Indians," and the feeling was mutual. "I did not know anybody at Lee," wrote Koba in the first month, "and did not to talk with them much because I am a little afraid of them, and they afraid of me. . . ." "I am doing the best I know how to do and also learning how to work on farm. Sometimes I get tired then I knee down to pray to God and he make me strong and happy. . . . I like to see the beautiful Mountains and the green nice trees among the mountains." In another month he said, "They are kind to me and are my friend and I like . . . this plase Mass."[7]

In the fall he was enrolled in Pratt's new Indian school at Carlisle, Pennsylvania, where he rendered "invaluable help" in its organization. He took up the tinsmith's trade with another of our artists, Roman Nose, and received high praise from his teacher. Koba, one of the last three Florida Boys to remain at Carlisle, wanted to return home for a short time in September, 1880. "His health has not been good for two months," wrote Pratt, "but there is nothing serious in his case. . . . He too is a thoroughly good boy, and I consider that his influence will be valuable amongst his people, equal to the cost. He is very anxious to complete his trade of tinner in which he has made most creditable progress, and says he will come back if he has to save the money and pay his own way."[8]

On September 10 Koba set out for Indian Territory with the Cheyenne Matches and the artist Shave Head. Said the Carlisle school paper, "They left the Territory savages, and manacled for safe keeping. They return examples to teach their people civilization." Koba did not go back to Carlisle to finish learning his trade. He was very feeble when he reached home September 21, and he died of consumption three days later. "His people did not want to bury him after their custom, but were quite willing that he should have a coffin and grave like a white man."[9]

[1] Present-day Kiowas consulted deny that Koba is a Kiowa word, yet the Kiowa Delos K. Lonewolf rendered the prisoner's name as Gobe, Wild-horse, Mooney concurred, and the artist himself gave the same English translation, accompanied by a sketch showing the flowing mane and tail of the wild horse. The author believes the word may have been borrowed from the Comanches, among whom the name appears in phonetic variations such as Coby and Cobay, always translated as Wild Horse. A recent publication quotes Col. W. S. Nye as confirming the Comanche

name Co-bay as Wild Horse and Joseph Balmer as preferring a Comanche informant's version, Wild Mustang. Lonewolf, List of Kiowa Prisoners, [1943], PP; Mooney, 17th *ARBAE*, 1895–96, Part I, 215; Picture Words by Koba, BAEC; G. Derek West, "The Battle of Adobe Walls (1874)," *Panhandle-Plains Historical Review*, XXXVI, 34 n.

[2] Pratt to Post Adjutant, Apr. 24, 1875, NA, WD, Letters Received, U.S. Army Commands, Department of the Missouri, 1875, S4/168/23.

[3] *Ibid*.; Pratt to Gen. Sheridan, Apr. 26, 1875, NA, WD, AGO, AG's Letters Received, File 2815, 1874.

[4] Sketchbook and Picture Words by Koba, BAEC; Mrs. Mary B. Reynolds to Librarian, Library of Congress, Aug. 1, 1945 (copy), BAEC files; "The Indian School at St. Augustine, Florida," *Evening News*, n.p., n.d., PP.

[5] Samuel C. Armstrong, *Indian Education in the East, at Hampton, Virginia, and Carlisle, Pennsylvania* . . . , 3; [Folsom], "Instantaneous Views," *Twenty-two Years' Work*, 325; "The Penitent," *SW*, VIII, No. 7 (July, 1879), 77.

[6] Denison, "Supplement to Last Smithsonian Report," *The Congregationalist*, Vol. XXXI, No. 21, 162.

[7] "Indians in Berkshire County, Massachusetts," *SW*, Vol. VIII, No. 8 (Aug., 1879), 85; Koba to Pratt, June 22, Aug. 9, 1879, PP.

[8] "Our Carlisle Friends," *SW*, Vol. IX, No. 8 (Aug., 1880), 86; Pratt to Acting Commissioner Marble, Sept. 9, 1880, NA, OIA, Letters Received, P1112–80.

[9] "Home Items," *EKT*, Vol. I, No. 6 (Sept. 1880), [3]; Albert Howe, "Notes on the Returned Indian Students of the Hampton Normal and Agricultural Institute, December 1891," 52 Cong., 1 sess., *Sen. Exec. Doc. No. 31* (Serial 2892), 36–37; Hunt to Pratt, Sept. 27, 1880, OHSIA, Kiowa letterpress copy book, XII, 13.

ETAHDLEUH, the Protégé of Captain Pratt

Names on drawings: Etahdleuh, Etahdleeuh, Etadeleuh, Etahdleuh Doanmoe [translation, Boy Hunting].

Names on Pratt's list: Boy [translation of Kiowa name], Etahdleuh.

Tribe: Kiowa.

Date of birth: 1856.

Charges listed against him: Was with Lone Wolf killing buffalo-hunters (Dudley and Wallace) [1874]; was in the party attacking buffalo hunters at Adobe Walls early in the spring of 1874.

Other incidents of early life: Fought Utes, Texans, Navahos, Army; surrendered to Asa Habba and to Captain Pratt.

Dependents at time of arrest: None.

Rank at time of arrest: Warrior.

Place and date of arrest: Salt Fork, Red River, Indian Territory, February 18, 1875.

Height and weight, July 9, 1877: 5' 10"; 166 lbs.

At Fort Marion, Florida: Arrived for imprisonment, May 21, 1878; was quartermaster sergeant under Pratt; taught archery.

At Hampton Institute, Virginia: Arrived for schooling April 14, 1878; sent to Syracuse and Paris Hill, New York, to convalesce; took name "Etahdleuh Doanmoe"; baptized "Etahdleuh" March, 1879; called on President; spoke at anniversary; expenses paid by Mrs. Quincy A. Shaw of Boston.

At Lee, Massachusetts: Arrived for work on farm late in May of 1879; spoke at Lee to recruit farmers to take Indians; went to Indian Territory to procure pupils.

At Carlisle Institute, Pennsylvania: First arrival, October 27, 1879; spoke at Philadelphia and Baltimore; baptized February 20, 1880; employed at Smithsonian Institution; treated at Syracuse for illnesses; employed at school; married to Laura. Second arrival, December 15, 1884; employed at school. Third arrival, 1887; trained as Presbyterian missionary.

Departure for reservation: First time, August 7, 1882; employed at school; farmer; ill with chills and fever. Second time, spring of 1887; employed at school; farmer. Third time, January 2, 1888; employed as missionary.

Death: Died April 20, 1888, at his home near Anadarko, from congestion of bowels. Interred on high hill across the river.

Relatives: Father, Tsoyonety, a Kiowa. Mother, Tsadlebeahky, a Mexican, presumably a captive. Brother, Mobeadlete. Sister, Mabel (Little, Soondy). Wife, Laura (Lame, Tonadlema), half Sioux, married 1882, survived him. Children, Edwin, born July, 1884, Richard Henry, born 1886, and Etahdleuh, born 1888.

Number of pieces and location of extant art: 1 Hampton Inst.; 1 Malone; 2 Mass. Hist.; 29 PP; 32 Robinson; 4 USNMC. Total, 69.

WHEN fifteen-year-old Etahdleuh caught a glimpse of Captain Richard H. Pratt during a parley on Sweetwater Creek near the western border of Indian Territory in 1871, it would have been inconceivable to either of them that the white officer would become in turn jailer, friend, would-be guardian, patron, and employer to this half-Mexican youth. It was because of the close relationship between them that Etahdleuh spent over ten years in the east, three years longer than any of the other Fort Marion prisoners were able to endure life among an alien people.[1]

Before an eastern audience in 1879, Etahdleuh (pronounced Ee tod' lee oo) told of "My Home in Indian Territory" in a speech "partly written by himself, and partly drawn from him in conversation and then written out for him to commit to memory" —written, no doubt, by the hand of Captain Pratt. The narrative goes:

I am a Kiowa Indian boy twenty-three years old. My home is in the Indian territory. My people are not much civilized. They live in houses made of skins of the buffalo. They like to hunt and fight. When I was a little boy I did not see many white people. The Kiowas moved camp often to keep near the buffalo, and we lived on buffalo meat and berries all the time. We had no bread, no coffee or sugar.

We boys talked all the time about hunting the buffalo, going to fight the Utes, Navajoes or Pawnees, and most about fighting the white people or stealing horses. The old Kiowas talked all the time to us about fight or hunt the buffalo. Sometimes the men would go off and bring back scalps of white men and women, or Indian men and women; then we had a big dance. This was all I heard and all I saw, and I thought it was good, so I will be a big fighter and a good hunter too, and may-be I get to be a big chief. When I was about fifteen years old [later amended to ten] I killed my first buffalo, with a bow and arrow. I had no gun. Then I was called a man, because I could kill buffalo [Plates 32 and 35]. Then I went with the young men to fight the Utes and Navajoes and to steal their horses. I was in three fights with the Utes and two with the Navajoes. We did not get many horses; too much fight. I went to Texas about ten times, with young Kiowas and Comanches to fight the whites and get their horses.[2] We fought the soldiers most, and a good many Indian men got killed, but I did not get hurt, only sometimes my horse got killed.

All this time I wore a blanket or a buffalo robe, and liked to have my hair long, and paint my face and wear big rings in my ears [Color Plate 5]. I did not know anything about God, or churches, or schools, or how to make things grow from the ground to live on.

Four years ago there was a big war. The Kiowas, Comanches and Cheyennes fought the soldiers all winter. The buffalo were nearly all gone, and the Indians got very hungry. The horses worked hard, and it was so cold the grass was poor, so they got very weak, and we lost many in fights with the soldiers. Then the soldiers came to our camps and we had to run away and leave our lodges, then the soldiers burned them. We all got very tired and hungry, and the women and children cried, so the chiefs said we will go in to Fort Sill, and give up. We met Capt. Pratt in the Wichita Mountains. He had some Indian soldiers and two wagons loaded with bread, sugar and coffee. He gave us plenty, and we gave him all our guns, pistols, bows and arrows, shields and spears. That night we had a big dance because we had plenty to eat.[3] In three days more we came to Fort Sill, and all the women were taken away, and the men put in the guard house. In two months some of the men had irons put on their ankles, and were sent to Florida. The other men were turned loose. I went to Florida.[4] [Paragraphing added for ease in reading.]

In St. Augustine, Captain Pratt arranged to have the Army guards—scorned by him and feared by the Indians—removed from Fort Marion. To take their place, he relied on a company he organized among the Indians, and on the executive ability of two men he had selected as outstanding among all the prisoners.

One of these Indians [Etahdleuh] was my quartermaster sergeant in charge of the government property

connected with the prison. It was his duty to take care of all the stores for which I was responsible to the government, to keep memorandum of issues of food and clothing, and to know that tools were properly restored to their place after being used and that nothing was left around promiscuously. He also drew these stores from the army commissary and issued to the cooks the food supplies in proper quantity daily, keeping record of the same. He and the first sergeant of the Indian company [Making Medicine] were also intermediaries next to me in command and particularly responsible when I was absent from the fort. They had freedom to come to my house with messages. I had had much to do with white, colored, and Indian soldiers, and among all these experiences there are none that showed finer manhood and fidelity to duty and ability than these two Indians.[5]

When he came to Pratt, Making Medicine was a man of thirty-one years, an experienced and respected leader of Cheyenne war parties. Etahdleuh, nineteen, was a nobody in the Kiowa tribe, who thrived and developed under the wise tutelage of Captain Pratt. In 1878, Pratt selected his two trusted sergeants to instruct the children of a prominent New York City woman, Mrs. Joseph Larocque, in Indian-style archery. In 1876–77 Etahdleuh produced the bulk of his drawings.[6]

After the Florida Boys had spent two years in prison, Mrs. Horace Caruthers, one of the philanthropic women who conducted classes for the Indians, set out to raise money for two prisoners she wished to educate further after their release. In March of 1878, to round out the needed sum, she staged an entertainment in which Etahdleuh contributed an Indian love song and became an impromptu star. Captain Pratt recalled it long after:

When Etahdleuh came out to sing his song, he was dressed in the old way. He had saved his Indian garb and the braids of his long hair, which he fastened on each side of his face. He had a big eagle feather which projected above the back of his head and his face was painted liberally; he wore his moccasins, buckskin leggins, and beaded coat. He stood erect before the audience, folded his arms, and began to pat the floor with his left foot, and then in loud clear tones he sang: "Ho-Nan-Ke-Ah-Bo-Mo, Ho-Nan-Ke-Ah-Bo-Mo, Ho-Nan-Ke-Ah-Bo-Mo, Ho-Nan-Ke-Ah-Bo-Mo." This he repeated about a dozen times. The audience was very quiet and like myself was waiting for a change in the words and music. As none came, I said to him, "Subick," which means, "stop." Etahdleuh quit instantly and hurried behind the curtain. The audience exploded and he had to go out and repeat it. He was the hero of the occasion anyway, and his song added greatly to his notoriety.[7]

The show was so successful financially that after

A Kiowa Banquet in the good old days back home.

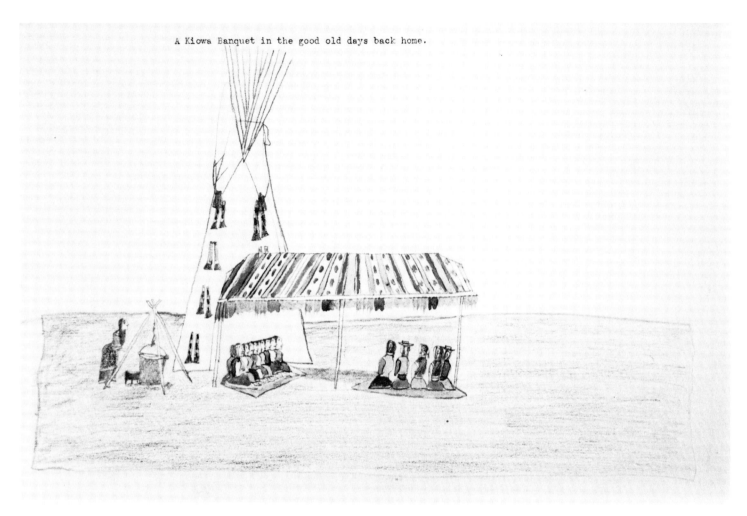

Plate 31. "A Kiowa Banquet in the good old days back home," by Etahdleuh, Kiowa, April 26, 1877 *(Courtesy of Yale University Library).* The guests sit sedately under an awning of blankets on the open plains near the savory kettle. Comparison with the similar Plate 46 demonstrates the gains in both realism and composition derived from greater mastery of technique.

the two Indians were provided for, forty dollars remained. With this money as a down payment, Captain Pratt secured Etahdleuh's acceptance as a student at Hampton Normal and Agricultural Institute, Hampton, Virginia. Only in this negro school did Pratt find the doors open to his Indians to pursue a combined vocational and academic education. The balance of Etahdleuh's tuition of $115 a year was supplied by a woman philanthropist, Mrs. Quincy A. Shaw of Boston. On the eve of the Indian's departure from Fort Marion, Pratt applied, inconclusively, for guardianship over him for two years.[8]

The seventeen Florida Boys were so satisfactory at Hampton that in the fall of 1878 the War Department lent Captain Pratt to the Interior Department so that he might first recruit young Indian pupils for Hampton in the west and then assume charge of them at the school. Pratt requested that his two stalwarts from Fort Marion—Etahdleuh of Hampton and Making Medicine, who was being educated near Syracuse, New York—might go with him as "assistants en route and to influence to come." Etahdleuh and the Captain apparently went to Syracuse to meet the other young man, but plans had to be quickly revised because of the illness of Etahdleuh. Pratt went on without the Indians and Etahdleuh stayed at Syracuse under the care of Deaconess Mary D. Burnham, house-mother of an Episcopalian hospital for needy persons in the city, the House of the Good Shepherd. When he had recovered sufficiently, Etahdleuh spent more than a month at nearby Paris Hill with the four Florida Boys who were in the home of the Reverend John B. Wicks to be educated to become Episcopalian missionaries. Etahdleuh reported on his visit in a letter to his patron. Pratt was so proud of his protégé's literary acquirement that he forwarded the letter to Secretary of the Interior Carl Schurz. It is noteworthy for the signature "Etahdleuh Doanmoe," the first occurrence of the full name, which was usually used thereafter, sometimes prefixed, as in 1882, by "Edwin."[9]

In the spring of 1879 Pratt took Etahdleuh and several other examples of "civilized" Indians to the White House to call on President Rutherford B. Hayes. Each May, Hampton had a gala day combining the commencement exercises with the anniversary celebration. That year such distinguished guests as Daniel Coit Gilman, the first president of Johns Hopkins University, and Dr. Mark Hopkins, former president of Williams College, sat in the audience of some nine hundred persons, while Secretary of the Interior Carl Schurz delivered the principal address. From the same platform, Etahdleuh gave the talk on "My Home in Indian Territory" quoted

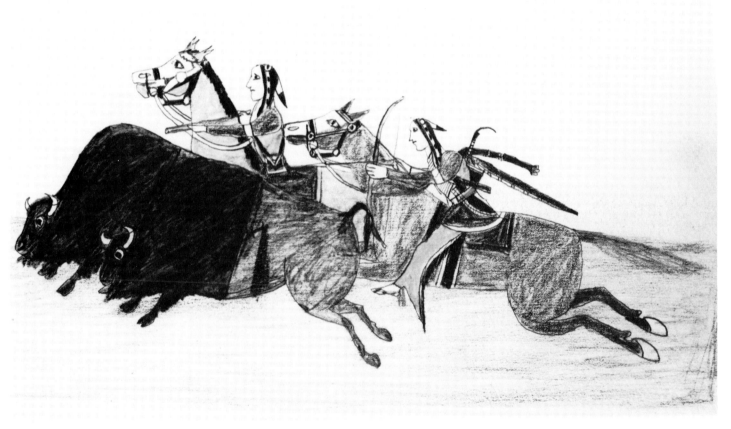

Plate 32. "Killing Buffalo (Kiowas)," by Etahdleuh, Kiowa, April 26, 1877 *(Courtesy of Yale University Library).* Well-drawn figures characterize a portrayal of the classical approach to the buffalo.

above. Among the spectators was a delegation of Indians in blankets and feathers, on their way home from a visit to Washington. Six Northern Cheyennes under the redoubtable Little Chief heard Etahdleuh beat the drum for the white man's way. They heard him with their eyes, for there was a running translation in sign language. Once more Etahdleuh captivated his audience. As the "pleasant faced Kiowa" was described by a newspaper correspondent, "His modest smile of pleasure at the cheers was very winning."[10]

The speech was to stand Captain Pratt in good stead a few days later. The officer was determined to procure farm homes for the Florida Boys for the summer. Here they might learn to work, and learn to farm as they worked. A trustee of Hampton, Deacon Alexander Hyde, lived in a farming area at Lee, Massachusetts. He endeavored to persuade some of his neighbors to employ the Indians as summer farmhands—but to no avail. Pratt rushed Etahdleuh to the scene "as a sample." The Captain wrote to his wife, "We had an Indn meeting last evening in the Congregational Church, when E-tah-dle-uh got off his Hampton speech with much effect."

The three spent a day or two driving about the borough in a carriage and talking to the farmers. Places were found for twelve Indians. The deacon, who for many years had conducted a "family school" in his spacious and stately residence in town, as well as practicing "scientific agriculture," took Etahdleuh into his own home to work for the summer, and the young man was as conscientious as ever about the work he did. "I am haying for three weeks and am working very hard every day except on Sundays and also mowing. I am very sorry to say I am not very strong to do hard work, but I would not tell Mr. Hyde about it." Etahdleuh acted as the liaison man for the group and reported to Pratt frequently. In a week Tsadeltah, the Kiowa on the Goodspeed farm and one of our artists, was ailing with what proved to be terminal tuberculosis. "Etahdleuh staid with him last night," Hyde told Pratt, "and Miss Goodspeed says Etahdleuh makes a good nurse. . . . Etahdleuh is taking his first lessons as a practitioner of medicine. I think Mrs. Hyde's idea of making a physician of E. is a good one. Shall we mould him for an M. D.?"[11]

The proposal must have touched an answering chord in the youth, for he was beginning to formulate plans for his life.

I has got a letter from home and it very nice letter, it from my brother, Mobeadlete and Kiowa Agent too—and they want me to come there. Capt. Pratt I wish

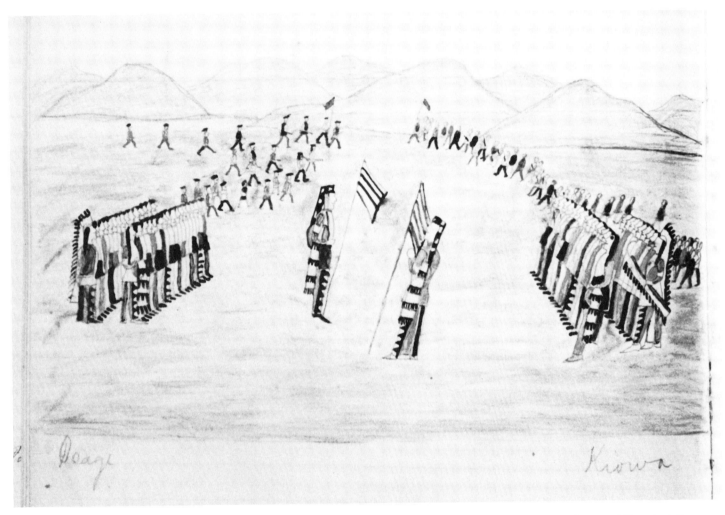

Plate 33. "Osage, Kiowa," by Etahdleuh, Kiowa, April 18–July 21, 1877 *(Courtesy of Massachusetts Historical Society)*. In this peaceful encounter between two great warrior tribes, the chiefs, dressed in their best, are drawn up in formal array for speech-making. However, the common people in the background do not stand on ceremony. Friend strides forward to greet friend.

I go with you when you goes that way and talk with them, what can be done for them.

When I think that way then I feel hurry—about doing something for the Indians. Capt. Pratt you know what I am trying to doing—I am coming to the light and never want to turn away from that light I have seen. I will do something for Christ that he died for everybody and for me.[12]

Etahdleuh had responded willingly to Christian teaching at Fort Marion and at Hampton. He had a moving religious experience while he was yet a prisoner. He took a leading part in the prayer meetings conducted, for the most part, by the Indians. In March, 1879, he was baptized "Etahdleuh" in the non-denominational chapel of Hampton Institute. Now he wanted, in some way as yet unformulated, to bring the light he had received to his people. His aspirations dovetailed with his patron's own plans. Pratt had gained permission to establish a separate school for Indians at the deserted barracks at Carlisle, Pennsylvania. Most of the Florida Boys would transfer to this school from Hampton in the fall, to serve as a nucleus around which to gather a body of younger, more teachable Indian pupils. Time was short; Pratt himself went to the tumultuous Northern Plains to recruit, while he arranged to send Etahdleuh and Making Medicine to their own sub-jugated tribes for the same purpose. Since Pratt had already left for the west, it fell to the capable management of Deaconess Burnham to summon the two boys to Syracuse and brief them for three days. On September 22 they started on their fifteen-hundred-mile journey for what she called "a month of missionary work among their respective tribes." The railroad ended at Wellington, Kansas, and they went the remaining 160 miles to the Cheyenne Agency by stage, riding day and night. After two days of rest, Etahdleuh proceeded to his own agency. As he tells it:

When I got there I saw a great many Indians around the Agent's house. They looked at me but they could not tell who I was. Well, I went in the house and I found the Agent there. Afterwards they knew that I am a Kiowa, and they asked me what I am come for, and I told them what came there for, and they said, well we will let you take our children, quite a number of them, but after disappointed, so I got only fifteen. They are now at Carlisle Barracks, at school. When I was at Fort Sill, I seeked all about what the Kiowas, Comanches and Apaches doing, and I found them very poor, and hungry. The reason is because they dont know how to make things grow from the ground.[13]

Captain Pratt met the little party at Wichita, Kansas, to escort them east. Making Medicine returned

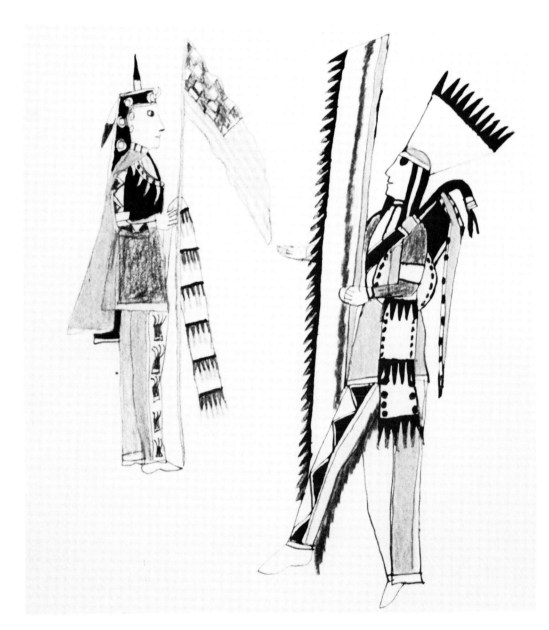

Plate 34. By Etahdleuh, Kiowa, April 18– July 21, 1877 *(Courtesy of Massachusetts Historical Society).* This scene looks almost like a close-up from the previous one. A comparison with Plate 20, by Making Medicine, from the same sketchbook, reveals that the latter, given the same theme and equal technical competence, has learned how to make a picture more aesthetically pleasing than Etahdleuh's.

to Syracuse, bringing his wife and young son from the agency. When Etahdleuh came to Carlisle Institute on October 27, he had in tow his sister Little (Soondy), aged eleven or twelve, who soon came to be called Mabel. Long afterward, the story of Mabel's recruitment was recalled by Lucius Aitson, a youth who had determined to slip off to Carlisle unbeknownst to his father and had gone to the Kiowa agent to enroll.

While we were in the office Hunting Horse [Etahdleuh] came in with his little sister and said: "I have my little sister but I want to send her to school," and then the tears fell on their cheeks. I looked at her and said: "No use to send her away to school for she is such a little bit of a girl." I felt sorry for her. . . . Her mother was sitting outside crying. There were eleven of us wanted to go to school.

Etahdleuh escorted the group as far as the Cheyenne Agency, and then returned to the Kiowa Agency. "We were sent to Arkansas City to the railroad with some men who were freighting for the school," recalls Aitson. "When Soonday kissed her brother good-bye she cried and I thought: 'No use send that poor little girl away to school.' "[14]

Needless to say, Etahdleuh was one of the Florida Boys who followed Pratt to Carlisle. Yet he was afterward remembered with kindness at Hampton.

During the year he was in the Hampton School, it was said of him that no one ever saw him do what was wrong. Indian as he was, and Indian fighter as he had been, he was a Christian gentleman, and his simple, manly, conscientious and consistent life, his earnest endeavor to walk in the new road as fast as he found it, was an example that might put many a "civilized" Christian to the blush. As he sat one evening at Hampton, with the other Indians, playing the letter game that was used to practice them in English, a visitor present spelled out, for him to answer the question, Why did you come to Hampton? His face flushed and slowly there grew before the eyes of his questioner the striking answer, "BECAUSE I WANT TO BE A MAN."[15]

Like the other ten Florida Boys, Etahdleuh helped orient the bewildered young pupils at Carlisle, but in addition he contributed his special talent—the making of speeches. He accompanied Pratt to a Philadelphia meeting "of those interested in the solution of the Indian problem" on November 25, 1879. Former Governor James Pollock presided at the meeting in the Sunday School Union and introduced General Armstrong and Captain Pratt, while the former mayor, Daniel M. Fox, the uncle of George Fox, brought up the rear of this parade of imposing titles bearing fitting resolutions in support of Indian edu-

cation. The tenor of Etahdleuh's talk suggests his tried and true "My Home in Indian Territory." For the third time in six months he brought it off well.

He is twenty-three years of age, with a candid, pleasant expression on his copper-colored face, and possessing all the physical characteristics of the typical Indian. Of neat personal appearance and a highly agreeable address, he was attentively listened to as he gave, in broken, gutteral English, a brief account of his life and adventures. He expressed his appreciation of the advantages to be derived from education, and assured his hearers that he did not want to live again as his poor people lived in the Indian Territory. He hoped to be a physician.[16]

This is the last we hear of his medical aspirations.

When Etahdleuh had gone west for pupils, he had enrolled not only a nephew and a sister; this pleasant and attractive young man had recruited an eighteen-year-old girl who became known as Laura, after Mrs. Kingsley Beatty (Laura Williams) Gibbs, a beloved teacher in Fort Marion. Yet Laura was not the kind of girl to be recruited. It might be more accurate to say that Laura volunteered, and Etahdleuh's own statement should be placed in evidence. Pratt was given this explanation of the special consideration tendered one girl by the young man at Carlisle:

Long time ago, in my home, Indian Territory, I hunt and I fight. I not think about the girls. Then you take us St. Augustine. By-and-by I learn to talk English. I try to do right. Everybody very good to me. I try do what you say. But I not think about the girls. Then I go Hampton. There many good girls. I study. I learn to work. But I not think about the girls. Then I come Carlisle. I work hard; try to help you. By-and-by you send me Indian Territory for Indian boys and Indian girls. I go get many—fifteen. I see all my people, my old friends. But I not think about the girls there. But Laura, she think. She tell me she be my wife. I bring her here, Carlisle. She know English before. She study and sew. Now Laura's father dead, since come here. Now I think all the time, I think, who take care of Laura? I think, by-and-by I find place to work near here; I work very hard. *I* take care of Laura.[17]

Thus it came about that Pratt packed his protégé off to Washington in February, 1880, and told the Kiowa agent, "He is quite in love with Red Otter's girl, hence his absence." Ostensibly, Etahdleuh was filling the place of Squint Eyes, who had returned to the reservation after working at the Smithsonian Institution for some months. It was at this time that, with an artistic talent now matured, Etahdleuh drew his remarkable panorama and a handsome study (Plate 35 and Color Plate 5). For Albert S. Gatschet of the Bureau of American Ethnology he recorded

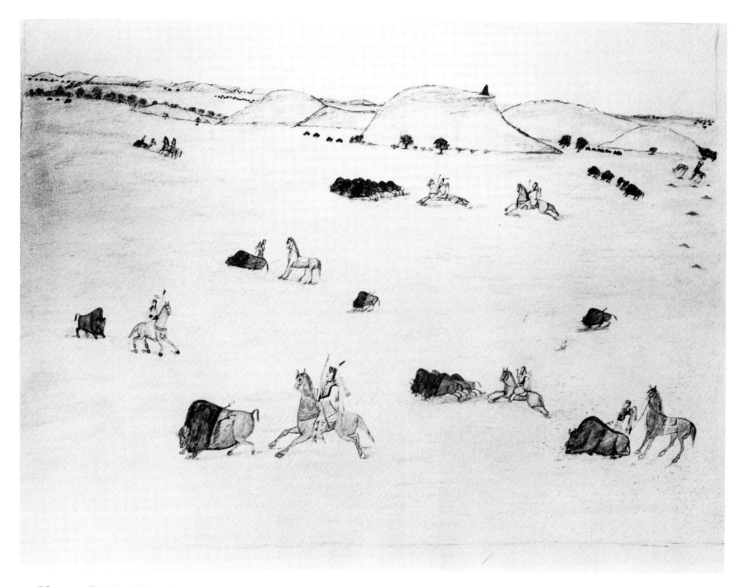

Plate 35. By Etahdleuh, Kiowa, February 21–April, 1880 *(Courtesy of Smithsonian Office of Anthropology)*. The hunters attack only a flank of their perambulating larder lest they stampede the great herd scattered as far as the eye can see about the cairn-topped mesa. Even the mercurial antelope, feeding in the prairie-dog village, have failed to take alarm.

ten pages of Kiowa linguistic material. A few days after his arrival the youth asked Pratt for "Laura's picture and Mabel's too, please" and reported, "I am trying to keep away from bad people. . . . I am goes to Church and Sunday School and goes to the young men's prayer meetings too. and I am enjoy very much."

A month later, still in Washington, Etahdleuh confided to the sympathetic Cheyenne agent that "I am doing the best all I could and try very hard to get Education. so I be able to teach my own people when I return to them. Oh I do wish. How could I learn a great deal of good way and keep my perishing people up to make them better. I remembered pretty well when I was out on plains among my tribes and distroy all over the country and white people were my enemies but now they are at peace with me."[18]

He contracted "a lingering eye and throat trouble" and Pratt was probably relieved for more than one reason to be able to send him back to Syracuse soon after May 7. Etahdleuh must have recovered from his illness by fall, for then he won a dollar premium in a shooting competition at the Cumberland County Fair, Pennsylvania. Just before the Christmas vacation he spurred the Carlisle students on to greater efforts with an address on education. He contrasted the white child's training for work with the Indian child's free youth and manifested disenchantment with the latter.

When I was a boy the Indians did not want education and they lived in their camps and hunted the buffalo and ran horse races and went off to fight the other tribes or the whites, and many went to Texas to steal horses. The children ran about the camps without much clothing summer or winter. Their mothers never washed them or combed their hair and they were dirty. . . . If our good friends among the whites do not get tired of trying to educate us and teach us something, I think we may become good, civilized men and women.[19]

In February of 1881 Pratt took Etahdleuh and Bear's Heart and two younger pupils to Baltimore for two meetings at which all of them spoke. "After the meeting was over," said Etahdleuh, "all the people came to us to shake hands with us, we became very tired of shaking hands because there were so many of them." By March Etahdleuh was working at Carlisle, proving himself. By June all the other Florida Boys had returned home. In March, 1882, he spoke in Philadelphia again.[20]

That spring, Laura Tonadlema (Lame) graduated from Carlisle. As for Etahdleuh Doanmoe, "His course of instruction finished, and having found work to do, he decided to assume the support of the Prairie Flower as promptly as possible." On June 17

they were married. The bride was no ordinary twenty-one-year-old girl. Her father was Chief Red Otter; her father's brother, Lone Wolf, the Kiowa head chief who went to prison in Fort Marion; her father's mother, Kodalpanti, a Sioux captive prominent among her own people; her brother, Apiatan, who was to become a Kiowa chief. "The family from which she comes is one of the strongest among the Kiowas, of superior caste." She attended the local government Indian school at Anadarko before going to Carlisle. The young couple was surely the best educated of any Kiowa pair to date. Both had the advantages of three years of Carlisle's vocational and academic training after earlier schooling in the three R's. They had set their feet firmly on the white man's road.[21]

The school and community alike were determined that this first Carlisle wedding should "teach the Indian the sacredness of the relations of man and wife." Ladies of West Chester and Germantown "furnished the means" for the "wedding feast" (ice cream and cake), but tactfully refrained from intruding upon the ceremony themselves. Neighbors donated quantities of flowers from their gardens. Boy students ran back and forth carrying benches, tables, and baskets of dishes. The older girls assisted in baking the wedding cake, after having helped to sew the bridal dress and make wedding gifts to furnish the room which the new couple was to occupy. A merry group of smaller girls could be seen "down in a meadow, through which flows Le Tort Springs, filling their arms with daisies, which they bore to their quarters, and proceeded to draw their stems through the meshes of a large square of burlap, which lay upon the floor. When no space was left for another daisy, it lay there in the white and gold, a thing of beauty," embellished with a fringe of grass. At 6:30 of a fine summer evening, "at the ringing of the chapel bell the school assembled, curious and expectant."

"Massed against the wall of the chapel in which the ceremony took place, in presence of the school, a few invited guests from town and Secretary [of the Interior Henry M.] TELLER and his wife . . . was a bank of green and flowers, artistically arranged by two of our ladies, and peeping from out the green leaves were the initials 'E–L,' wrought of roses." Carpeting the floor beneath the bride and groom was the daisy mat. "The 'Swedish Wedding March' signalled the approach of the bridal party. The young couple were accompanied by twelve attendants selected from the various tribes." After the ceremony before the Reverend George Norcross of the Second Presbyterian Church and Professor J. A. Lippincott

of nearby Dickinson College, the group moved out onto the grassy mall bordered by the school buildings and centered by a pagoda-like bandstand. "While cheered with music from the band, all were served with cake and ice cream, after which the bride and groom closed the ceremonies by cutting their cakes—rare gifts from friends in town." Two others present were worthy of note: one, a symbol of the old ways on the Plains, come to appraise the progress of his son Luther; the other, the proud "father" of the groom. "Standing Bear, a Sioux chief, was distinguishable for that dignity of mien native to his race—omnipresent was Captain Pratt himself, hospitable and attentive."[22]

On July 24, the Kiowa agent wrote to offer the Doanmoes employment at the agency school. Etahdleuh, called an interpreter, was to receive $300 a year and Laura, as assistant seamstress, $180. On August 7 they left with Dr. Horace Caruthers of Tarrytown, New York. His wife had put on the benefit show four years earlier that had provided the $40.00 that began Etahdleuh's education. By pre-arrangement, near Caldwell, Kansas, they met Dr. Lippincott, who had assisted at their wedding and who was to become Chancellor of the University of Kansas the following year. The two white men were to spend eleven days in persuading reluctant parents to

let them take Cheyenne, Arapaho, Kiowa, Comanche, and Wichita children back to Carlisle.

Etahdleuh's first duty as a school employee was to assist in the recruiting, but this time he failed utterly with his sister Mabel. She had experienced some difficulties at Carlisle, and Pratt wrote to the agent about her particularly, "Do send Mabel back so we may carry her forward to a maturer condition. Now that we know her peculiarities so well, we can do much more for her." Etahdleuh found himself in the spot where Pratt had stood three years before. Fifteen-year-old Mabel was more interested in marriage than in education. It was Lucius Aitson (Cute) who, as a boy of sixteen, had felt such compassion when "that poor little girl" was sent off to school by her brother. Now Lucius had finished the three-year course at Carlisle and, like Mabel, had been sent home on July 1, 1882. As he told it, "It was on the train coming back that I found out that I loved Mabel. Mr. Weeks [Rev. John B. Wicks, Etahdleuh's benefactor at Paris Hill who had since accompanied his charges to Indian Territory] was an Episcopal minister at Anadarko and I went forward and had water put on my head and afterwards Mabel and I were married before him and Zotom [one of our artists who was ordained a Deacon in New York]."

However, Etahdleuh had the satisfaction of seeing

both Mabel and Lucius continuing their education at the agency school and doing well. The couple helped found the Saddle Mountain Baptist Mission in 1903, and Lucius acted as interpreter for the missionary. The Aitsons had six children before Mabel died in 1906. In 1913 Lucius became the first ordained pastor at his church. In keeping with the Kiowa custom of importing captives and incorporating them into the social structure, Lucius, son of a Kiowa woman and a Mexican captive (Mokeen, the adopted son of the great Taime Keeper, Ansote or Long Foot), married Mabel, daughter of a Mexican mother and a Kiowa father; while Etahdleuh, of the same parentage as Mabel, married Laura, daughter of a Kiowa chief and a Sioux captive.[23] Etahdleuh left an account of his two years at the troubled agency:

In the year 1882 I was at Carlisle School and had fully made up my mind to remain at the school for a few years longer, but in early summer I got a letter from Col. Hunt, the Kiowa, Comanche and Wichita Agent, asking me to come home and assist about the agency school. I accepted and went home, with a strong purpose to do some good for my people.

Soon after I got home they employed me to assist the Superintendent of the school and in this, I done all the best I could. It is very discouraging sometimes about our work, but the more we considered the matter, the more we got courage to bear the trials and troubles.

Sometimes I went out to camps to spend a few days with them. In this way, I had more opportunity to talk with greater numbers and relate to them the old, old story of Jesus and his love, and they always listened very attentively.

Numbers asked me to attend their councils and most of the time they asked me to say something.

I have heard many times that the Indians make fun of those who have been at school in east and returned home. I think the reason the Indians make fun of those returned is because some of them do not try to exercise their influence and the experience they had East at school, or set their example of living right and doing right. I thought the Indians had a great respect for me, when I was at home.

They would come to me to hear the ways of civilization, religion and salvation, and they said that they were wrong to live in such low estate. . . .

The Kiowas, Comanches and Apaches are having quite a time about leasing the grass. . . .

They are getting uneasy and restless.

They are advised by different people and so get confused and don't know what to do and now the matter stands before them, dark.

They see no way to carry it out. I hope that this great difficulty may be carried out the right way by direction of the Almighty. I am glad to say that some of the old Florida prisoners are doing remarkably well, they

have built small log-cabins on their farms, and they raise cattle, horses, pigs, chickens, and attend to their own business.[24]

It is no wonder if the Doanmoes, educated in their Eastern ivory tower, sometimes grew discouraged. Etahdleuh wrote of the poor health of his people, the scarcity of food, the dearth of employment opportunity, the lack of farm implements, the dissension over leasing the grass lands, and the poor condition of the horses that prevented the Indians from hauling freight for pay. "I think the Indians are doing all their best they can, to get to the Standing-point of civilization, but you know it takes a good deal of time to civilize the Indians. . . . The good, patient christian man and woman ought to be employed among the Indians so he or she can help the Indians along in the right track."[25]

Laura's work at the school was as assistant seamstress. Etahdleuh went out "talking to the Indians, explaining them what the school is and what the white people want the Indian children in school for, and all the other importance of the school." His agent said of him, "He is a noble young man, deeply interested in the welfare of his people, particularly in education."[26]

Within four months Etahdleuh had taken the first steps toward living like a white farmer. "I starting

my farm not far from the reservation. I got six Indians 'cutting rails,' plant corn and some other vegetables for the first starting." The following year the very prevalent "chills and fever" brought him close to death. His staunch friend, Captain Pratt, paid for the services of the post surgeon at Fort Sill, who pulled Etahdleuh through with the best treatment available. A baby born to the young couple in July, 1884, and given his father's name, Edwin, soon sickened and died. Once again Etahdleuh's eyes failed. Weak and despairing, he applied for work at Carlisle Institute.[27]

So it was that Laura gave up her position as assistant matron, to which she had been promoted six months earlier. On December 15, 1884, she and Etahdleuh fled the reservation for Carlisle. They brought with them a new Kiowa pupil, Martha Napawat, presumably the daughter of the "medicine chief," Napawat, who had supported Pratt in the surrender of the Kiowas at Rainy Mountain Creek in 1875 (Plate 3). Captain Pratt found work that his protégé could do, and Etahdleuh quickly regained his strength. On July 23, 1886, a son was born and named Richard Henry, after his father's patron. The little family lived in a tent on the school grounds. Etahdleuh helped with the three hundred boys at Carlisle, was responsible for the stables and

stock, and was paid twelve cents a day "as assistant teamster, assisting in care of public animals." Of his conduct in Carlisle, his home for six years, all told, the school paper said:

He was kind to all, and much loved by those who knew him best. His earnest words in the Sabbath and weekly meetings were a constant help to us all.

As a pupil he was always obedient and diligent in his studies; as an employe of the school he was industrious and efficient. As an employe he was always at his post and held the respect and esteem of all. As a husband and father, he was kind, cheerful and self-sacrificing.[28]

By June of 1886 Etahdleuh had been able to save only eighty dollars, and the little house he hoped to build on the Kiowa reservation seemed unattainable at the paltry wages prevailing at Carlisle. He would, he decided, "go home and seek for my fortune." The next spring, he set out alone for the reservation to start once more on the white man's way. He took up a claim of 160 acres and wrote to his patron:

Capt., if I have a little home put up, I shall be a happiest man in the world. . . .

My brother, Moab-beedle-ty, and myself had done all the work that required to be done this spring, and he don't need me any more so I came to the Agency and got the work to do, here, at the Kiowa School, I am assistant Industrial teacher. Our corn about 1½ foot high now and every other things coming up fast. But I am afraid the Indians will not make much of anything, great many of them, for they are away behind in working in their fields by some interferes of their foolishness

I am feeling well and working hard every day.

I can see that God is with me all the time and helping me. I am praying more stronger and earnestly now that I ever did before. There are no single man or woman here to tell the Indians about God. Oh! it is a sad thing to me, sometimes my tears run. I do wish, that I could do anything for my people. A missionary is badly needing here.[29]

On September 19, poor health again brought about his resignation at the agency. On his return to Carlisle, Etahdleuh's church began training him for missionary work. Finally, he was appointed by the Presbyterian Board as a missionary among the Kiowas, and with Laura and Richard he left on January 2, 1888, for a last, four-month try at living like a white man among the Indians. As at Hampton, so again at Carlisle he had been baptized, this time by the Reverend George Norcross on February 20, 1880, and he had become a member of the Second Presbyterian Church. At Carlisle, "he was a most consistent and faithful Christian, ever willing and

ready to do all in his power to advance his Master's cause among the pupils." Of his work on the reservation he said, "I am endeavoring to teach our people the new way, preaching the blessed Gospel in the fields as well as in the church." As a missionary he experienced a hostility that he had not felt three years earlier. A colleague who represented the Methodist Episcopal Church South left records of his brief interfaith mission with Etahdleuh Doanmoe. From two of his accounts we learn:

After training under Presbyterian care for religious work among their people, they [the Doanmoes] came back well equipped for such work.

They began the establishment of a home about two miles east of Anadarko. I never knew a more sincere man than Etalye Dunmoe, nor one more humble and earnest. He readily aligned himself with the writer in an effort to enlighten his people, and together we labored for their uplift. We held group meetings in teepes in winter, and larger crowds under summer arbors and out under the trees on the river bottom in the summer.

One afternoon, near where the old commisary building now stands we had a great crowd to listen to us as we read and explained appropriate portions of the Scriptures to them. As we broke up, some went away approving, but the great crowd went away angry and predicting "bad medicine" against us for trying to get the Indians on this new way. Confirming, as they thought, the medicine man's prediction of evil against us, the next afternoon, about the same hour of our meeting the evening before, Etalye Dunmoe died very suddenly.

Old Stumbling Bear came in great haste for me. He said, "Docte, hudley (hurry) Etalye heap sick, maybe-so die." I mounted my horse and hurried to the place two miles away where I knew he camped. Before I reached the place I met the Government doctor who informed me that Etalye was already dead.

I hurried to his home. There were perhaps two hundred men and women at the place.

The women had stripped themselves down to the waist and with butcher knives sharpened on whetstones held in their left hands were cutting arms from the point of the shoulder down to the wrist and the blood was running down over their bodies, a sickening sight to see, and a number had cut off the ends of several fingers. The men also were torturing themselves and all howling like demons from the world of fiends. They began to gather up all the property belonging to the deceased preparatory to burning, as was their custom, but calling for the government police I prevented that till next morning. When we went away to bury the body, the police left the camp and the Indians remaining set fire to the goods and all went up in smoke. We gave him Christian burial singing as he requested "When the Surges Cease to Roll," at his grave.[30]

It was from the same missionary that Captain Pratt

heard of his protégé's untimely death from "congestion of the bowels," on April 20, 1888, at the age of thirty-two. He died at his home near Anadarko, resigned to his Lord's will, and his last words were directions "for some things necessary for the future comfort of his wife and child. He was surely a great blessing to the Indian people. He had the courage of his convictions and in the face of the prejudice of the Indian people against the 'white man's road' he had gone steadily on and was endeavoring to lead them into the light of the Gospel. He had inspired confidence by his steady upright, Christian course."[31]

What of Laura? When the funerary flames died down, she was not destitute. She had her two-year-old Richard, and she bore Etahdleuh a posthumous son whom she named after his father, Etahdleuh. Apparently the property burned by the mourning villagers consisted only of the personal effects of the deceased. When an aroused Captain Pratt, believing that Etahdleuh's hard-won home and farm equipment had been destroyed, demanded restitution by the tribe, he received a reassuring letter from the agency: "The report of Etahdleuh's property being destroyed by the Indians is not true. I have seen the house and wagons, corn field, fine as it is, harness and trunks. Laura is just as firm in her new life and she should be encouraged."[32]

All her long life Laura was true to the "superior caste," both Kiowa and Sioux, from which she sprang. She worked in the Indian Service for many years, progressing from assistant seamstress and laundress to field matron and interpreter. She was the principal informant for anthropologist James Mooney in regard to her famous uncle, Lone Wolf. In 1898 she went to Washington as interpreter and delegate for the Kiowas. In 1894 she was married to the white agency farmer, William E. Pedrick; but by 1911 she was again a widow, this time endowed with a son Albert William, an adopted daughter, Lillie M. or Ruby May, some property in Anadarko, and several farms. In 1917 she held a reunion at her home for those who had attended the school where as a young girl she had arrived in her native dress to enlist in the radical experiment in education, where she was married against a floral wall embellished with the initials "E–L" wrought of roses, and where she reared her baby in a tent—Carlisle Institute, soon to close its doors for the last time.[33]

1 Sketchbook by Etahdleuh, No. 3, PP.

2 He was officially accused of accompanying Lone Wolf, another future Fort Marion prisoner, in killing two buffalo hunters—a charge also brought against nine other men. It was further alleged that he took part in the famous battle of Adobe Walls—as one of several hundred Indians involved. Pratt to Post Adjutant, Apr. 24, 1875, NA, WD, Letters Received, U.S. Army Commands, Department of the Missouri, 1875, S4/168/23.

3 The end of Kiowa armed resistance was marked by the surrender of this large party of holdout fighters on Feb. 18, 1875. It included nineteen future inmates of Fort Marion, among them Chiefs Lone Wolf and Man Who Walks Above the Ground (Mahmante). In order to win for himself immunity from punishment, Big Bow first undertook to persuade this party to come in from their camp far to the west and then, in the next two months, testified to charges that sent many of them to prison, among them Etahdleuh. En route to the agency, the party of 250 people, with some 400 head of stock, surrendered to thirty Penateka Comanches under their "friendly" leader, Asa Habba, accompanied by interpreter Philip McCusker. The Comanches had been sent from the agency to look for lost horses and to intercept hostile bands. On February 23, when the surrendering party reached Rainy Mountain Creek, forty-eight miles northwest of the agency, it was officially received by Pratt. With the aid of his Scouts he took over the surrendered arms, made a census, and gave out rations to supplement the Indians' supply of meat. His own account enlarges on his part in the surrender and the dance that followed. Ibid.; Agent Haworth to Commissioner, Feb. 22, 1875, NA, OIA, Letters Received, 1875, Kiowa, H372; Pratt to Agent Miles, Feb. 1, 1875, OHSIA, Indian warfare; Pratt, Battlefield and Classroom, 94–97; sketchbook by Etahdleuh, Roy H. Robinson; Pratt, MS, Memos, PP; Haworth, Report, Sept. 20, 1875, ARCIA, 1875, p. 272.

4 "Anniversary Exercises at Hampton," SW, Vol. VIII, No. 6 (June, 1879), 71–72. Agent Haworth says that five, including Lone Wolf and Man Who Walks, were put in the guardhouse in irons, on their arrival February 26, while fifty-eight others were interned in the newly finished ice house. Haworth to Com-

missioner, Feb. 27, 1875, NA, OIA, Central Superintendency, Field Papers, K&C, 1875.

5 Pratt, Battlefield and Classroom, 119, 185.

6 Ibid., 184–85; "Joseph Larocque," Who Was Who in America (5 vols.) (Chicago, 1942), I, 706.

7 [Helen W. Ludlow], "An Indian Raid on Hampton Institute," SW, Vol. VII, No. 5, 36; Pratt, Battlefield and Classroom, 189.

8 [Ludlow], "Indian Raid on Hampton Institute," SW, Vol. VII, No. 5, 36; Pratt to Bishop H. B. Whipple, March 27, 1878, Minnesota Historical Society, Whipple Papers; [Folsom], "Instantaneous Views," Twenty-two Years' Work, 326; Pratt to Commissioner, Mar. 6, 1878, PP.

9 Pratt to Armstrong, Aug. 12, 1878, enclosed in Armstrong to Schurz, Secretary of Interior, Aug. 13, 1878, NA, OIA, Letters Received, Miscellaneous, 1878; L.R.B., "Mrs. Mary Douglass Burnham," Churchman, Vol. XCI, No. 2 (Jan. 14, 1905), 66; Etahdleuh Doanmoe to Pratt, Nov. 18, 1878, enclosed in Pratt to Schurz, Nov. 26, 1878, NA, OIA, Letters Received, Miscellaneous, P1093–78; photograph, Doanmoe to Pendleton, 1882, in author's possession. See "John Bartlett Wicks," Lloyd's Clerical Directory, 1913 (Chicago, Ill., c1911) for facts on Wicks.

10 "Indian Students at the White House," n.p., n.d., PP; "Anniversary Exercises at Hampton," SW, Vol. VIII, No. 6 (June, 1879), 71–72; "The Hampton Institute," Daily Union, May 28, 1879, 2.

11 Pratt, Battlefield and Classroom, 193–94; Pratt to wife, June 1, 1879, PP; "Died," EKT, Vol. I, No. 8 (Dec., 1880), [3], quoting Republican (Springfield, Mass.), [n.d.], a short biography of Hyde; E. Doanmoe to Miss Mather, Jan. 6, 1880, EKT, Vol. I, No. 1 (Jan., 1880), [4]; Etahdleuh to Pratt, July 4, 1879, PP; Hyde to Pratt, June 13, 1879, PP.

12 E. Doanmoe to Pratt, June, 1879, "Indians in Berkshire Co., Mass.," SW, Vol. VIII, No. 8 (Aug., 1879), 85.

13 SW, Vol. XVII, No. 7 (July, 1888), 79; M.D.B. [Mary D. Burnham], "An Evening at San Marco," GMCJ, Vol. III, No. 29, 229; ibid., "Our Indians at Paris Hill," IV, No. 48, 386;

H.W.L. [Helen W. Ludlow], "Record of Indian Progress," *SW*, Vol. VIII, No. 5, 55; E. Doanmoe to Miss Mather, Jan. 6, 1880, *EKT*, Vol. I, No. 1 (Jan., 1880), [4].

14 E. Doanmoe to Miss L [Ludlow?], Oct. 29, 1879, *SW*, Vol. VIII, No. 12 (Dec., 1879), 124; Pratt to Commissioner, Nov. 13, 1879, NA, OIA, Letters Received, Miscellaneous, P1182–1879, pp. 13–14; Isabel Crawford, *Kiowa, the History of a Blanket Indian Mission*, 37–38.

The erroneous name Hunting Horse no doubt derived from the fact that Etahdleuh Doanmoe (Boy Hunting) was in the band of Chief Tsatoke (Hunting Horse). P. B. Hunt, Names of Children who go to Carlisle School . . . , Oct. 9, 1879, OHSIA, Kiowa letterpress copy book, VII, 389; Guy Quoetone to author, Dec. 13, 1967.

15 *SW*, Vol. XVII, No. 7 (July, 1888), 79.

16 "The Indian Educational Question," *Public Ledger*, Nov. 26, 1879, 1; "The Young Indian," [n.p.] (Philadelphia, Pa.), [1879], PP.

17 Mrs. George W. Gibbs, "Data about the Indians who came from the West," typescript, 1932, St. Augustine Historical Society, St. Augustine, Fla.; [Ludlow], "Indian Education at Hampton and Carlisle," *Harper's New Monthly Magazine*, Vol. LXII, No. 371, p. 674.

18 Pratt to agent, Feb. 27, 1880, and enclosure, E. Doanmoe to Pratt, Feb. 24, 1880, OHSIA, Kiowa–Carlisle Indian School; *EKT*, Vol. I, No. 2 (Apr., 1880), [3]; Gatschet in James C. Pilling, "Catalogue of Linguistic Manuscripts in the Library of the Bureau of Ethnology," 1st *ARBAE*, 1879–80, 567; E. Doanmoe to Miles, Mar. 22, 1880, *CT*, Apr. 24, 1880.

19 *EKT*, Vol. I, No. 3 (May, 1880), [3]; No. 7 (Nov., 1880), [4]; No. 8 (Dec., 1880), [2]; Pratt to Commissioner Trowbridge, May 7, 1880, NA, OIA, Letters Received, P649–80.

20 Doanmoe, *EKT*, Vol. I, No. 9, [3]; Pratt to Commissioner, May 30, 1881, NA, OIA, Letters Received, 9224–81; "Native Americans," *Evening Bulletin*, Mar. 2, [1882].

21 Pratt to Commissioner, Nov. 13, 1879, NA, OIA, Letters Received, Miscellaneous, P1182–79, 13; Pratt to agent, Feb. 27,

1880, OHSIA, Kiowa–Carlisle Indian School; Rev. J. J. Methvin, *In the Limelight or History of Anadarko and Vicinity from the Earliest Days*, 58, 74; Methvin, "Apeahtone, Kiowa—A Bit of History," *CO*, Vol. IX, No. 3, 336; James Mooney, MS 2531, Field notebooks, I, 67a, BAEC.

22 "Doaumoe-Toealemah," (Boston, Mass.), June 20, 1882, PP; *SN*, Vol. III, No. 1 (June, 1882), [3]; *MSt*, Vol. II, No. 11 (June, 1882), [3]; No. 12 (July, 1882), [3]; Lt. Col. Thomas G. Tousey, *Military History of Carlisle and Carlisle Barracks*, 314.

23 Hunt to Etahdleuh, July 24, 1882, OHSIA, Kiowa letterpress copy book; OHSIA, Kiowa–Employees and K&C Boarding School, 1882–1883; Lippincott to Pratt, Sept. 5, 1882, "Dr. Lippincott's Report," *MSt*, Vol. III, No. 2 (Sept., 1882), [1]; Pratt to Hunt, Aug. 2, 1882, OHSIA, Kiowa–Carlisle Indian School; Crawford, *Kiowa*, 40, 222, 46; Mabel Aitson, No. 1851, Kiowa, Allotment files, Anadarko Agency, Anadarko, Okla.; E. Doanmoe to Pratt, Dec. 25, 1882, *MSt*, Vol. III, No. 6 (Jan., 1883), [4]; James Auchiah, "Statement of Fred Botone on Isabel Crawford," MS, June 4, 1967, Fort Sill Museum, U.S. Army, Fort Sill, Okla., files; Carlisle School Records, NA, OIA, Mabel Doanmoe and Lucius B. Aitson; Mishkin, *Rank and Warfare*, 43n.; Nye, *Bad Medicine and Good*, 54, 55, 66; Pratt to Commissioner, Nov. 13, 1879, NA, OIA, Letters Received, Miscellaneous, P1182–79. For Lippincott biography, see "Joshua Allen Lippincott," *National Cyclopedia of American Biography* (New York, 1899), IX, 494.

24 Doanmoe to Pratt, Mar. 14, 1885, "His two Years' Home Experience," *MSt*, Vol. V, No. 8 (Mar. 1885), 5.

25 E. Doanmoe to Pratt, Sept. 14, 1882, *MSt*, Vol. III, No. 3 (Oct., 1882), [4] *ibid.*, Dec. 25, 1882, No. 6 (Jan., 1883), [4].

26 Reports for quarters ending Sept. 30, Dec., 1883, OHSIA, Kiowa–Kiowa School; E. Doanmoe to Pratt, Dec. 25, 1882, *MSt*, Vol. III, No. 6 (Jan., 1883), [4]; Hunt, Report, Sept. 1, 1882, *ARCIA*, 1882, 71.

27 E. Doanmoe to Pratt, Dec. 25, 1882, *MSt*, Vol. III, No. 6 (Jan., 1883), [4]; OHSIA, Kiowa-Employees, 1883; Pratt to Etahdleuh, June 21, Oct. 22, 1884, PP; "Etahdleuh Doanmoe," *MSt*, Vol. VII, No. 8 (May, 1887), 8; OHSIA, Kiowa–K&C

Boarding School, 1884; [Folsom], "Instantaneous Views," *Twenty-two Years' Work*, 326.

28 Carlisle School Records, NA, OIA, Field Office Records; OHSIA, Kiowa–K&C Boarding School, 1884; *MSt*, Vol. V, 1885; Pratt, *Battlefield and Classroom*, 94; MS, Record of Returned Indians, Hampton N. & A. Institute, Hampton Institute files; Pratt to Commissioner, Reports of Irregular Employees for months ending Sept. 30, Aug. 31, Dec. 2, 1886, NA, OIA, Letters Received, 26277–86; *SW*, Vol. XVII, No. 7 (July, 1888), 81, reprinted from *Red Man*.

29 E. Doanmoe to Pratt, June 17, 1886, PP; [*Folsom*], "Instantaneous Views," *Twenty-two Years' Work*, 326; "Etahdleuh Doanmoe," *MSt*, Vol. VII, No. 8 (May, 1887), 8.

30 OHSIA, Kiowa–K&C Boarding School, 1887; Carlisle School Records, NA, OIA, Field Office Records and Student Attendance Record 5885; *SW*, Vol. XVII, No. 7 (July, 1888), 81, reprinted from *Red Man*; Methvin, *In the Limelight*, 58–59; Rev. J. J. Methvin, "Reminiscences of Life among the Indians," *CO*, Vol. V, No. 2, 171.

31 Methvin to Pratt, Apr. 22, 1888, PP.

32 Mrs. James B. Ritter, family documents transmitted to the author, March 25, 1965; Pratt to Commissioner, Apr. 30, 1888, NA, OIA, Letters Received, 11363–88; Joshua Givens to Pratt, July 28, 1888, PP.

33 Carlisle School Records, NA, OIA, Student Attendance Record 2508; Mooney, MS, Field notebooks, I, p. 67a, BAEC; Family Record Book, Kiowa, Camanche [*sic*] and Apache Tribes, 1901, 85, Anadarko Agency, Anadarko, Okla.; Card Index, OHSIA; Notes with photographs, Negative Nos. 1410-a and -b, 1411-a and -b, BAEC; Notes with photograph of Laura Pedrick, USNMC.

OHETTOINT, the Police Officer

Names on drawings: Ohettoint, Chas. Ohettoint.

Names on Pratt's list: High Forehead [more accurate translation of Kiowa name, Shingled Hair], Ohettoint.

Aliases: Charley Buffalo, Padai (Twin).

Tribe: Kiowa.

Date of birth: 1852.

Charges listed against him: Was with Mah-mante [Man Who Walks above the Ground] when he killed the man in the wagon [1870]; was with Lone Wolf killing two buffalo hunters [1874].

Other incidents of early life: In Battle of the Washita and attack on Lyman's wagon train; surrendered to Asa Habba and to Captain Pratt.

Dependent at time of arrest: Wife [?]

Rank at time of arrest: Warrior.

Place and date of arrest: Salt Fork, Red River, Indian Territory, February 18, 1875.

Height and weight, July 9, 1877: 5′ 9″; 151 lbs. 8 oz.

At Fort Marion, Florida: Arrived for imprisonment May 21, 1875; was baker at fort.

At Hampton Institute, Virginia: Arrived for schooling April 14, 1878; was baptized "Ohettoint" in March, 1879; expenses paid by Mrs. Annie S. Larocque, New York City; went to Washington to meet the president.

At Carlisle Institute, Pennsylvania: Arrived for education Sept. 10, 1878; recruited for Carlisle.

Departure for reservation: June 29, 1880; there he was student, teacher, recruiter for school, timekeeper for

Indian employees, farmer, stock-raiser, assistant carpenter, policeman, informant for ethnologist James Mooney; called "Charley Oheltoint," "Charlie Buffalo," and "Twin, Padai."

Allotment number: 82.

Death: Died on May 15, 1934, at his home twelve miles west of Anadarko. Interred at Red Stone Baptist Cemetery.

Relatives: Paternal great-grandfather, Dohasan I (Little Bluff). Paternal great-uncle, Dohasan II (Old Wagon). Maternal grandfather, Dancing Bear (Sitemgoonmah). Maternal grandmother, Boatsaddlety. Uncle, Poor Buffalo (Pautaudlety). Father, Donepi (Shoulder Blade, Dohasan III). Mother, Sapoodle. Brothers, White Buffalo (Konad), his twin, Silver Horn (Haungooah), and James Waldo (Kokoytodle). Sister, Keintaddle. Wives, Alice Eonety, married, 1880–82, divorced 1912; Mary (Thrusting the Lance to Both Sides, Yeagtaupt), a Comanche and former wife of artist Zotom, married by 1901 by Indian custom and 1914 by court, survived him. Children, Millie (Emaugobah), born 1883, George, born 1891, and Andrew, born 1893.

Number of pieces and location of extant art: 58 PP; 57 Robinson, including 26 jointly; 1 USNMC; 26 Killinger. Total, 142, including 26 jointly.

OF ALL the Kiowa prisoners, Ohettoint preeminently made his mark after his return home. To the few of his tribesmen who still remember the men exiled to Florida for valiant defense of their land and their way of life, Ohettoint is a name to be spoken with respect and admiration.

At the age of sixteen, Ohettoint (accented on the first syllable) was in a little party of men, women, and children who fled before the onslaught of Custer's forces at the Battle of the Washita in 1868. The pursuit of this party by Major Joel H. Elliott culminated in the annihilation of Elliott and his men. Two years later, it was alleged, Ohettoint and two future prison-mates were partisans of the Man Who Walks Above the Ground when the latter ambushed and shot one of two white men driving a lone wagon south of Fort Griffin, Texas. Ohettoint was one of ten named as members of Lone Wolf's party that killed Dudley and Wallace in 1874. After the Anadarko fight of August 22, 1874, as the Kiowas were fleeing to Palo Duro Canyon in constant apprehension of attack by pursuing troops, Ohettoint was one of the young warriors continually out among the surrounding hills scouting for soldiers. Another scout tells of the part played by Ohettoint (later known as Charley Buffalo) in events leading to a well-known fight:

About halfway to the next rise in the plains, I met two other fellows, Sai-au-sain and Charley Buffalo. They agreed to go with me.

The next hill was grassy and had a few low mesquite trees on top. We could see from there without being seen. It was lucky for us that this was so, for there in front of us, about a mile and a half away, was a line of wagons guarded by soldiers! There were twenty or thirty white-topped wagons, each drawn by four mules, coming slowly in single file, preceded by ten to fifteen cavalrymen spread out ahead. About twenty-five walk-soldiers were marching in a single file on either side of the wagons. In the morning light we could plainly see the blue of their uniforms.

Sai-au-sain said "Botalye, you go back to the village with the news. We will stay here to watch the enemy. Tell the chiefs to bring up a big crowd of warriors."[1]

Thus commenced the unsuccessful four-day siege of the Kiowas against a wagon train which was guarded by Captain Wyllys Lyman's company and carried supplies and ammunition to General Nelson A. Miles in the field. After the fight, Ohettoint joined the resistance fighters whose capitulation terminated Kiowa warfare on February 18, 1875. The first list of charges against Ohettoint summed him up as he appeared to the white man: "Foolish and bad all the time."[2]

While he drew pictures prolifically at Fort Mar-ion, Ohettoint had other interests, too. He studied in the class taught by Mrs. George Couper (Julia Williams) Gibbs of St. Augustine. She gave him a new name; beginning with July 11, 1878, he called himself Charles Ohet-toint. When writer Harriet Beecher Stowe told of her tour of the fort in March, 1877, she mentioned seeing "Charley" at work baking bread.

A large oven was constructed in one of the vaults of the Fort, and the Indians assisted the mason in preparing the brick and mortar, and much interested in watching the process they were. After the oven was ready, a baker was for some time hired, and two Indians were given as his assistants. In a very short time these Indians learned the trade, and now all the bread of the Fort is made by them. We saw and tasted the bread, which is white and light, and of a superior quality, to the great delight of Charley, the head baker, who said: "Me make. By and by, out there, will make bread, and get money." Already the idea of a profitable trade has opened before him.[3]

Ohettoint was one of the Florida Boys who elected to remain in the east for further education after their release in April, 1878 (Plate 1). Before he had attended Hampton Institute for three months he had a new goal, disclosed in a letter which he signed "Ohettoint." "When I go home . . . I can teach all

the Indians and try to do good. . . . I am white men now. . . . I am going in the Straight good road."[4]

The following March he was baptized "Ohettoint" in the chapel at Hampton. Soon afterward he was in a party of seven young men whom Captain Pratt, lobbying for an Indian school of his own, selected to meet President Rutherford B. Hayes in Washington. Ohettoint was so pleased by this trip that, many years later, the event became one of his favorite stories. "Pratt told us each what to say to the President—that we wanted a school for just Indians. And we said it."

Ohettoint and a Cheyenne, Nick, were maintained at Hampton by a New York City matron, Mrs. Joseph (Annie S.) Larocque. In St. Augustine she had given them gold rings, which they had lost, and these she replaced at Christmas and sent each a trunk the next month. On the basis of letters she received from Ohettoint and Captain Pratt, Mrs. Larocque observed, "Ohet-toint appears to be almost without fault." In March, too, his father Dohasan invoked a venerated Kiowa tradition. In a letter written by Agent Hunt he said, "The Tobacco & pipe I send you is a request for you to come home . . . and see your old Father, mother and Sisters." Poor Buffalo, half-brother of Ohettoint's mother, thought the student had all the education he needed. "The reason

you wanted to stop at School was to learn something, and I think you can now learn us something. I feel like we need some person among us to teach us the white man's road as I think you could."[5]

On September 10, 1879, Ohettoint and Matches, a Cheyenne, became the first arrivals at Pratt's new Indian school in Pennsylvania, and Ohettoint was entered as number one on the school records. The pair made themselves useful in preparing deserted Carlisle Barracks for the reception of young pupils from the west and nine more of the Florida Boys. The interest of Ohettoint's generous patroness followed him to Carlisle, but now she found him remiss in acknowledging the good watch she had sent him. That same month he was experimenting with water-color drawings in the only sketchbook stemming from Fort Marion and done at Carlisle. Although the perspective of the back rest in Plate 36 gave the artist trouble, the painting, done after five years in the east, perhaps represents the furthest departure from pictography reached by any of the Fort Marion artists. In its subjectivity it goes far beyond the communication of events or the recording of facts.

On March 2, Ohettoint left for his agency in company with three other artists, White Bear, Tounkeuh, and Cohoe. While the others settled down at

Plate 36. By Chas. Ohettoint, Kiowa, January, 1880 *(Courtesy of Yale University Library)*. Three men, viewed from the rear, sit companionably on a bed, one lounging against a willow back-rest. The central figure has drawn his white-striped blanket well up over his head.

home, he returned to Carlisle with new pupils whom he had helped to recruit. He seized the opportunity to learn more of the "straight good road" in the newly established tinshop as well as in a demonstration of electricity given by Professor Charles M. Himes, of nearby Dickinson College, for the Indian girls and boys. "The stroke of lightning that knocked the miniature house to pieces was so real that all were startled, and the girls gave the usual little civilized screech. The most amusing thing was when the spark of electricity passed from Roman Nose's nose to High Forehead's [Ohettoint's] knuckle; while they two were badly shocked, the remainder of the party were convulsed with laughter."[6]

Ohettoint left Carlisle for the last time on June 29, 1880, but first he gave a farewell speech in the chapel. He told the younger pupils of two good things he had learned from the white people: "Do not walk in the Indian road any more" and "to love and to pray to God in all of your thoughts."[7]

Before Ohettoint had been at home three weeks, the Kiowa agent started him on the new road at wages of $15.00 a month. He employed the youth at an office job which utilized the skills learned in the east. Hunt reported to a concerned Captain Pratt four months later: "Ohettoint is everything I could ask, and is quite useful to me. I have him keep the time of Indian employes, and remain at the office when not on this duty, except to recite his lessons at school." Nearly a year later the agent said, "At times he is ready to take a step backwards, and needs a paternal, watchful, and sustaining hand to urge him forward and up to his best capabilities. Last year I gave him a room in the school as teacher, and he did well. I use him now going out and working among his people, collecting children for school. . . . He has a well-balanced mind, and I am quite sure he wants to do right, as I have always found him truthful, and can trust him without fear of having my confidence misplaced."[8]

The journey on the new road came to a halt two months later. Ohettoint was discharged on November 15, 1881, "for want of funds," and by the next year had left the agency proper for the Indian camps. He had not, however, returned to the "Indian road." He tried his hand as laborer at the agency in 1883 and as assistant carpenter in 1882 and 1887, when he was described as industrious by Etahdleuh. When Ohettoint resigned that year, it was "to return home to look after his cattle." His diligence was rewarded, for the following year, although he was "dressed in Indian," he was said to have a splendid farm. The Carlisle paper told of him in 1890:

Charles Ohetoint . . . is now at work at the agency at 10 dollars a month. He lives in a tepee. He has been suffering with sore eyes for years and has not been able to do much. He has 23 acres of land under cultivation, but has seen pretty hard times. He has four children, two of whom are at school. The others are too small. In the way of stock, he has six horses, one mule, four head of cattle, and three pigs."[9]

Ohettoint had persevered on the white man's road in spite of hard times; he was on his way up. The ten dollars a month mentioned was his pay as a private in the Indian Police. He was enrolled in the force April 1, 1889, and in five years progressed to lieutenant at fifteen dollars. He held this office, outranked only by the captain, until his discharge on October 31, 1902. In following this vocation, Ohettoint successfully bridged the gap between the Indian's road and the white man's. The position of Indian policeman was one respected both by the white officials, who appreciated the need for a law-enforcing arm on the lawless reservation, and by the Kiowas, whose ancient tribal system incorporated the concept of police in their soldier societies. "Agent's soldiers," they called the new Indian Police. True, the pay was pitifully small. In return for the cash wage and two suits of uniform a year, the police had to furnish their own ammunition, ride their own horses, and feed their mounts. Yet their service to their people in fending off the encroaching white man was invaluable. War on the Southern Plains had come to a nominal end in 1875; the warrior Ohettoint by his own choice continued the dogged struggle in the cold war of the '80's and '90's. The year he joined the police force, the agent said:

The reservation being large and, unfortunately for the Indians, bounded on the west by Greer County, Texas, makes it absolutely necessary that the police be kept constantly in the saddle, to prevent the utter destruction of the timber on the western border, and also to prevent trespassing stock from being grazed on the reserve and the stock owned by the Indians from being stolen. The men comprising the force at this agency are honorable, truthful, and can be relied on to faithfully perform any duty assigned them. I consider their services indispensable to the successful management and maintenance of good order on the reservation.[10]

Meanwhile, in accordance with the time-honored custom for a Kiowa of high position, Ohettoint had acquired a plurality of wives. This circumstance terminated his fifteen years's government service with his discharge by an agent who was duty-bound to enforce the white man's professed code of monogamy. Between 1880 and 1882, Charles was married by In-

dian custom to Alice Eonety, by whom he had a daughter, Millie (Emaugobah), born in 1883, and two sons, George in 1891 and Andrew in 1893. In 1901 or before, he was married by Indian custom to Mary (Thrusting the Lance to Both Sides, Yeagtaupt), a Comanche and a former wife of the artist Zotom. Not until April 9, 1912, did he surrender his first wife, divorcing her both by court and by Indian custom. He confirmed his marriage to Mary Buffalo by a civil ceremony February 16, 1914.[11]

At home, Ohettoint personified that phenomenon of Kiowa culture, the favorite-son trait. "Charley was the prince of the family—always given the best of everything." In addition, he was a scion of the prominent Dohasan family which held membership in the band called Kata (Biters), "the largest and most important division, occupying the first place in the camp circle, immediately south of the door or entrance. . . . At present [1896] the Kata may be said to constitute the aristocracy of the tribe."[12]

There was more than one artist in Ohettoint's family. A brother, Silver Horn, became well known for his drawings. Their father, Dohasan III or Donepi, for a long time kept a calendric record of the Kiowas, which he surrendered in 1892. Since Donepi had begun the record in his youth, no doubt

Charles, by precept and example, had learned pictography at an early age.

After his father's death, Ohettoint revived his own latent talent to reproduce his father's lodge pattern. With it he decorated a miniature model for ethnologist James Mooney in the 1890's (Plate 11 and Color Plate 6). He was instrumental in reproducing it in a full seven-and-a-half-foot size between 1916 and 1918.

Like his father and his great-uncle, the noted Chief Dohasan, Ohettoint invited eminent warriors to record on the sides of the tipi their coups counted in the days of warfare. Many people—100 to 150—came to watch the work of the old warriors camped at Charles's house west of Anadarko, near Red Stone Mission. With swift and sure strokes the row of tomahawks was added to the tipi cover spread on the ground, each tomahawk exactly like the other. Tanetone (Eagle Tail), Old Man Hummingbird (Rising Wolf, Guimha), and Old Man Sankedota (Howakon) illustrated their brave deeds. The "circle picture" at the top showed Kiowas surrounded by Osages in a slough with a creek running through it. Pauahty (Walking Buffalo, later called Tanehaddle, Running Bird) showed a daring rescue. Tanedoh had taken his nephew Pauahty on a war expedition. The party was attacked by Texas Rang-

ers and Tanedoh fell from his horse, wounded. As Pauahty retreated toward a woods, he saw a horse running loose and recognized it as his uncle's. Turning back, he found Tanedoh and dismounted, put the wounded warrior on his saddle, climbed up in front of him, and rode off with the rescued man. Ohettoint, by making his replicas, preserved for posterity the look of the one Kiowa tipi from the old, pre-reservation days that flaunted in pictures the battles of the heroes of his people.[13]

The name Ohettoint, with which many a typesetter and agency clerk had wrestled, was undergoing metamorphosis. Charles was enrolled in the police under an Irish-Kiowa version, Charles O'Hetowit. After several variations of this theme, he emerged as Oheltoint in 1894, and the name stuck. In 1901 he was allotted as Oheltoint (Charley Buffalo); he signed his will in 1930 as Oheltoint (Charley). Because he and White Buffalo were the only twins in a tribe in which dual births were almost unknown, he was sometimes called Padai (Twin). In 1908 he spent seven hundred dollars for a four-room house on his allotment. In 1914 he reported that he was farming near Anadarko. He died May 15, 1934, at his home twelve miles west of Anadarko, and was buried in the Red Stone Baptist Cemetery. He was survived by Mary.[14]

[1] Homer Buffalo, No. 64, MS, Statement on Charles and Mary Buffalo, Kiowas, Dec. 27, 1962, Fort Sill Museum, U.S. Army, Fort Sill, Okla., files; Berthrong, *The Southern Cheyennes*, 327; Pratt to Post Adjutant, Apr. 24, 1875, NA, WD, Letters Received, U.S. Army Commands, Department of the Missouri, 1875, S4/168/23; Nye, *Bad Medicine and Good*, 189–190.

[2] Pratt to Post Adjutant, Apr. 24, 1875, NA, WD, Letters Received, U.S. Army Commands, Department of the Missouri, 1875, S4/168/23.

[3] Ohet-toint to Pratt, July 11, 1878, PP; Stowe, *The Christian Union*, Apr. 18, 1877, as quoted by *FP* (May, 1877).

[4] Ohet-toint to Pratt, July 11, 1878, PP.

[5] [Ludlow], *SW*, Vol. VIII, No. 5, 55; Denison, "Supplement to Last Smithsonian Report," *The Congregationalist*, Vol. XXXI, No. 21, 162; "Indian Students at the White House," n.p., n.d., PP; Homer Buffalo, oral communication to author, Mar. 28, 1967; Annie S. Larocque to Pratt, Dec. 15, 1878; Apr. 28 [1879]; Jan. 16, Apr. 4, 1879, PP; Snaumy [?] tohosit to Ohettoint, Mar. 31, 1879, OHSIA, Kiowa letterpress copy book, VII, 201; *ibid.* (Poor Buffalo) Pautaudlety to Nephew, n.d., 202.

[6] Carlisle School Records, NA, OIA, Field Office Records; "The Indians Arrive," *Mirror*, Oct. 7, 1879; A. S. Larocque to Pratt, Jan. 14, 1880, PP; Miles to Pratt, Feb. 12, 1880, PP; Homer Buffalo, No. 64, MS, Statement on Charles and Mary Buffalo, Dec. 27, 1962, Fort Sill Museum, U.S. Army, Fort Sill, Okla., files; J. N. Choate, *KW, No. 42, Tinner's Apprentices, Carlisle Indian Training School, photograph, New York Public Library, New York, N.Y.; *EKT*, Vol. I, No. 2 (Apr., 1880), [3].

[7] Carlisle School Records, NA, OIA, Field Office Records; "A Speech Delivered by Chas. Ohettoint, before the Students, in Our Chapel," *SN*, I, No. 1 (June, 1880), [4].

[8] Changes in Employees, July 31, 1880, OHSIA, Kiowa–Employees; Hunt to Pratt, "Report from one of the Florida boys returned to his agency," *EKT*, Vol. I, No. 7 (Nov., 1880), [2]; Hunt to Pratt, Sept. 30, 1881, *ARCIA*, 1881, 192.

[9] Employment records, 1882, 1883, 1887, OHSIA, Kiowa–Employees and Carpenters; Etahdleuh to Pratt, Sept. 14, 1882,

MSt, Vol. III, No. 3 (Oct., 1882), [4]; "Etahdleuh Doanmoe," *MSt*, Vol. VII, No. 8 (May, 1887), 8; Joshua Given to Pratt, July 28, 1888, PP; *Red Man*, Vol. X, No. 5 (June, 1890).

[10] Record of Indian Police, NA, OIA, Statistics Division, 1888–1904; Proposed changes in Indian Police Force, Nov., 1902, OHSIA, Kiowa–Police; Agent E. E. White, Report, Aug. 18, 1888, *ARCIA*, 1888, 99; Agent W. D. Myers, Report, Aug. 27, 1889, *ARCIA*, 1889, 190; Agent Charles E. Adams, Report, Sept. 16, 1890, *ARCIA*, 1890, 188.

[11] Bert Geikaunmah, oral communication to author, Oct. 23, 1960; Allotment file No. 82 Kiowa and Family Record Book, Kiowa, Camanche [*sic*] and Apache Tribes, 1901, 4, both at Anadarko Agency, Anadarko, Okla.

[12] Homer Buffalo, "Statement on Relationship of Charles Oheltoint to Tohausen," MS, 1967, Fort Sill Museum, U.S. Army, Fort Sill, Okla., files; James Mooney, 17th *ARBAE*, 1895–96, Part I, 228, 263; Mooney, MS, Field notebooks, I, pp. 50a, 51a, BAEC.

[13] Gillett Griswold, "Tohausen III, MS compiled from notes of Gen. Hugh L. Scott on Tohausen Calendar, Fort Sill Museum, U.S. Army, Fort Sill, Okla., files; *ibid.*, Homer Buffalo, oral communication to author, Mar. 28, 1967, and Rev. Linn Pauahty, Sept. 29, 1969; James Mooney, MS, Field notebooks, I, pp. 50a, 51a, BAEC.

[14] Record of Indian Police, NA, OIA, Statistics Division, 1888–1890, 1894–1896; Allotment file No. 82 Kiowa, Anadarko Agency, Anadarko, Okla.; Homer Buffalo, "Statement on Relationship of Charles Oheltoint to Tohausen," MS, 1967, Fort Sill Museum, U.S. Army, Fort Sill, Okla., files; James Mooney, 17th *ARBAE*, 1895–96, Part I, 216; Agent Ernest Stedler [?] to Commissioner, Dec. 1, 1908, OHSIA, Kiowa–Indian houses; Carlisle School Records, NA, OIA, Student Attendance Record 744; George Zotom Otis to author, Apr. 20, May 8, 1966.

ZOTOM, the Headstrong and Heartstrong

Name on drawings: Zotom.

Names on Pratt's list: Biter [more accurate translation of Kiowa name, Hole-bite], Zotom.

Aliases: Snake Head, Podaladalte.

Tribe: Kiowa.

Date of birth: 1853.

Charges listed against him: Was in party headed by Mah-mante [Man Who Walks above the Ground], killing two colored men on Salt Creek Prairie, between [Jacksboro] and Belknap, Texas [1871]. Participated in the attack on buffalo hunters at Adobe Walls, early in spring of [1874].

Other incidents of early life: Raided in Texas and Mexico for horses; took part in a killing on Signal Mountain; involved in attack on Lyman's company guarding wagon train; surrendered to Asa Habba and to Captain Pratt.

Dependents at time of arrest: None[?]

Rank at time of arrest: Warrior.

Place and date of arrest: Salt Fork, Red River, Indian Territory, Feb. 18, 1875.

Height and weight, July 9, 1877: 5' 7"; 175 lbs.

At Fort Marion, Florida: Arrived for imprisonment May 21, 1875; insubordinate at first; became bugler.

At Syracuse, New York: Arrived for orientation for education about April 17, 1878.

At Paris Hill, New York: Arrived for education in clergyman's home about May 20, 1878; expenses paid by Dakota League of Episcopal Diocese of Massachusetts; baptized "Paul Caryl" October 6, 1878; confirmed October 20, 1878; visited Carlisle in December, 1879; ordained deacon June 7, 1881.

Departure for reservation: June 7, 1881; assisted in founding Episcopal mission at Kiowa agency; deposed from ministry; assisted with founding of Baptist mission; painted model tipis for Omaha Exposition; practiced peyote religion; medicine man.

Allotment number: 1,403.

Death: Died on April 27, 1913.

Relatives: Maternal grandfather, Rib Piercer (Gwookawtay). Maternal grandmother, Holding a Child (Yeitoty). Father, White Shield (Keintikeah). Mother, Owl (Sahpooly), half Crow. Brothers, Yellow Hair (Audlequoeko), Charles, Patterson (Paddlesay), Gun No Smoke (Honahtay), and Otto. Wives, Prepared Meat (Keahpaum), divorced; Mary (Thrusting the Lance to Both Sides, Yeagtaupt), a Comanche, married 1882, divorced; Mary Aungattay (Standing in Track), married 1893, survived him. Children, Otis Cozad (Toehay), born 1871, and several who died while small.

Number of pieces and location of extant art: 37 Boles and Jolly; 29 Curtin; 2 Hampton Inst.; 15 Mus. Am. Indian; 25 PP. Total, 108.

"THIS MAN for months after his capture was so perverse and insubordinate that it was almost determined to shoot him as an example to his companions of the necessity of submission to authority. Strong, self-willed, passionate, he has fought many a hard battle with self in his upward climbing, and has doubtless many a one yet to fight. . . . ardent, impulsive, fearless, of diversified and brilliant gifts."[1]

So the Kiowa Zotom (pronounced Zo'tahm) was described when he returned to his people after six years in the east. In the former days of war on the plains, his combination of traits ideally fitted Zotom for his first vocation, that of a warrior among the unregimented tribesmen.

The battles in which he is reported to have had a part resounded among the last desperate struggles of his people to perpetuate their own way of life by driving out the invader. At the age of eighteen, it was charged, Zotom took part in a raid on Salt Creek Prairie between Jacksboro and Belknap, Texas, for which seven men were sent off to prison.

On January 24 a group of Kiowas under Maman-ti (Sky-Walker) and Quitan appeared on the Butterfield

Trail two miles south of Flat Top Mountain, in Young County, Texas. Here they attacked four Negroes who were hauling supplies from Weatherford to their homes near Fort Griffin. . . . Though the colored men defended themselves bravely, they all were killed and scalped. On their way home the playful Kiowas amused themselves by throwing the kinky-haired scalps at one another. Finally they threw them away, as the hair was too short to be of value. They had little to show for their efforts when they arrived home, but bragged about the fight nevertheless.[2]

At about the same time, the leader of the attack, Man Who Walks Above the Ground (Mahmante) led a horse-stealing raid on the Clear Fork of the Brazos in Texas, and again Zotom is said to have followed him. Zotom is also alleged to have joined in the general attack on the buffalo hunters at Adobe Walls in June of 1874. He was one of the small war party who killed a white man living in Fort Sill's blockhouse on Signal Mountain the following August 19. The next month, as the Kiowas fled to Palo Duro Canyon in the Texas Panhandle after the Anadarko fight, it was Zotom who—even before Ohettoint—first caught sight of the wagon train guarded by Captain Lyman's company which the Kiowas besieged. He was in the last group of Kiowa warriors to surrender, February 18, 1875. One of his draw-

ings reproduced for this book is a scene full of movement showing a warrior in battle readiness (Color Plate 7).[3]

Elsewhere there are two other drawings by Zotom showing an early confrontation with the army in September, 1871, on the Sweetwater near its confluence with the North Fork of Red River. In all probability it occasioned the first glimpse of Captain Pratt for both Zotom and Etahdleuh. As Pratt told it:

A very large portion of the Kiowas were off their reservations, west of the Wichita Mountains. . . . [Brevet Major] General [Benjamin H.] Grierson took a portion of the Fort Sill cavalry and went after them. We had crossed the Sweetwater and were among the buffalo looking for the Indians. . . . We saw Indians in large numbers on a rise of ground in front and, forming line of battle, continued our advance. The Indians were massed, and as we came nearer we discovered, with our glasses, that they had on their war bonnets and were evidently inviting a contest. All the conditions warranted a fight. They were off their reservation in violation of their treaty and plainly defiant. Why not charge at once and punish them for their insolence?

The Army wagons were corralled in a circle with horses and mules inside and the Cavalry dismounted in companies outside ready for fighting when an Indian came forward with a flag of truce. Captain Pratt, Ad-

jutant of the Command, was sent forward to see what was wanted. After some parleying the professions of friendship the Indian offered were accepted. It was then found the Indian demonstration had been made to hold our command back while the women moved their camp across a stream (the Sweet Water) and onto their reservation where we dare not attack them. It was our duty to attack and destroy them off their reservations, which we would have done but for the moving of their camp.[4]

At Fort Marion, the resourceful Captain Pratt found in rehabilitation an answer to the current cry for Indian extermination. He kept Zotom in the "dungeon" of the dank stone fortress until the Indian came to terms. Even afterwards Pratt had to resort to heroic measures in controlling him.

One night Mrs. Pratt and I were away from home until late, visiting military friends at the lower end of town. When we returned, I found on the stand at the head of my bed this note:

Captain Pratt
His Zotom heap sick. You come see him quick.
Etahdleuh

I hastened to the fort and found Zotom lying on his bed moaning and all the Indians anxiously gathered about. His face was livid and his eyes set in a stare. The doctor was a mile away at the lower end of town. I had many experiences with soldiers under emergencies and at once asked what he had been eating. Etahdleuh replied, "He go down town today and buy big piece beef. He cook and eat and cook and eat just like with old times out west." This was the clue to the situation. I shook Zotom and called his name loud and louder, but he did not respond. . . .

I . . . sent my handy Indian Pedro to our medical supplies for a can of mustard and some muslin, made a fat plaster, placed it over the stomach and bowels of Zotom, appointed four Indians to hold him by the arms and legs, and waited the result. . . .

Zotom was one of the most powerful of the Indians and tested the strength of his holders greatly. He talked Kiowa with rapidity and the Kiowas laughed. When the burnt district was near blister, I removed the poultice and had the Indians let go. Zotom got on his feet at once and, holding his clothes away from the irritation, walked up and down the room, continuing to talk Kiowa and evidently abusing me. I asked if he was swearing, and they said: "No. Indians have no swear words."

Next morning at inspection Zotom's countenance was still dark; but he soon renewed our friendly relations. . . . A good lesson on gormandizing was not lost.[5]

Zotom was indeed a man of diversified gifts. The strong young warrior was so perfect a physical specimen of manhood that when the sculptor Clark Mills

took casts of the heads of the prisoners he made a cast of Zotom's entire body for the Smithsonian Institution. Zotom mastered the bugle and was one of the two "who sounded all the calls to service and duty for the prisoners." After only a year at the fort he produced Pratt's sketchbook from which Plate 37 was taken, a collection showing a remarkably consistent high quality of workmanship. He produced other books and became a popular painter of ladies' fans.

He was an unusually gifted dancer. It was this talent that embroiled Pratt in a hair-raising episode on the plains which the captain long afterwards recounted with an obvious relish for its irony. Early in 1875 Pratt was sent into the Wichita Mountains to accept the surrender of the remnant of the defeated Kiowa tribe. The business completed, the Indians put on a dance in the evening. Pratt and his interpreter, the only white men in that remote camp, were included among the guests of honor. The program, however, got off to an ominous start, with strenuous drumming and loud talk incomprehensible to the white men, but without any dancing.

Finally, when the situation began to be quite oppressive, a powerful young Indian near the chiefs took from his belt a large butcher knife and stuck it in the ground.

Then intense interest was manifested by the whole company, and all began to sing. The music started with new energy; the tom-tom beaters used more vigor, and the singers' voices rose higher and were echoed back from the mountains. Then the young Indian who had stuck the knife in the ground got up and threw off his blanket. He was almost nude and his face and body hideously painted. . . . He danced wildly with grotesque crouching, swaying, and posturing in excellent time to the music.

When he had finished, he reached down and seized the knife as though to use it in stabbing and in the most threatening manner stepped over on to the blanket where I was and leaned over me. On the instant it seemed certain that harm was intended, as all the Indians were excited and the chiefs were urging him on. There was a struggle between this Indian and an Indian sitting just back of me. Then the dancer stepped back into the open space and held up a blanket. He thrust his knife into it several times and cut it into pieces, making it worthless, threw it on the ground, and there was general approval. Replacing the knife in its sheath on his belt, he picked up his blanket, wrapped himself up, and sat down.

Months later, at Fort Marion, Pratt learned the meaning of this episode. In an effort to divert his depressed Kiowa charges, he told them a dramatic version of the story, omitting names and places.

When I said, "I almost felt the knife enter my body," the Kiowas laughed and one of them said, pointing to Zotom, sitting over there, "he was the man who had the knife," and [that] Awlih, sitting by Zotom, was to have danced first because he was the best dancer, but that when the time came Awlih refused to dance and that was why the chiefs scolded. Failing to get Awlih to obey, the chiefs told Zotom to dance first and then take Awlih's blanket and cut it to pieces as a punishment.

Probably many other tales of Indian treachery, and of thrilling adventure, may have originated from just as safe and innocent "horse play" as this I experienced.[6]

Zotom did not lose his talent for dancing at Fort Marion. When the respected "old men" selected the best dancers for a benefit performance at the Magnolia Hotel, they selected Howling Wolf and Zotom. The latter was also chosen to sing a love song and a song "written by a lady," the burden running:

> In this genial happy land
> Chiefs of many a nation,
> We find the welcome friendly hand,
> We find the true salvation.[7]

Zotom studied in the classes in the dark casemates. When the prisoners were released in April, 1878, and moved on to Hampton, he made a short and broken speech for the welcoming ceremonies at the school, beginning, "I to-night came. Because my head don't know. St. Augustine, one year—my don't know—A, B, C, I can't talk"[8]

Language difficulties notwithstanding, Zotom was near the top of his class, and he received his reward. "Three young men, among the brightest and most promising of these Indians—Zotom, Making Medicine, and Tay-a-way-ite, a Kiowa, a Cheyenne, and a Comanche [later augmented by another artist, Shave Head, a Cheyenne]—have been selected, at their own most earnest desire, to become Christian teachers and ministers to their people, and they are to enter upon their studies and training in Central New York."[9]

As a consequence of this plan for his future, Zotom did not linger at Hampton, but went on to Syracuse, New York, for a few weeks' stay under the care of Deaconess Mary D. Burnham, who had envisioned and implemented the education of the four. Thence they were sent to rural Paris, south of Utica, for three years of training for the ministry under the aegis of the Episcopal Diocese of Central New York. Surrounded by the pastoral beauty of Paris Hill, which climbed steeply from the broad valley of the Mohawk, the four Florida Boys lived as sons to the Rev. and Mrs. John B. Wicks. They alternated school sessions in the big room upstairs in the rectory

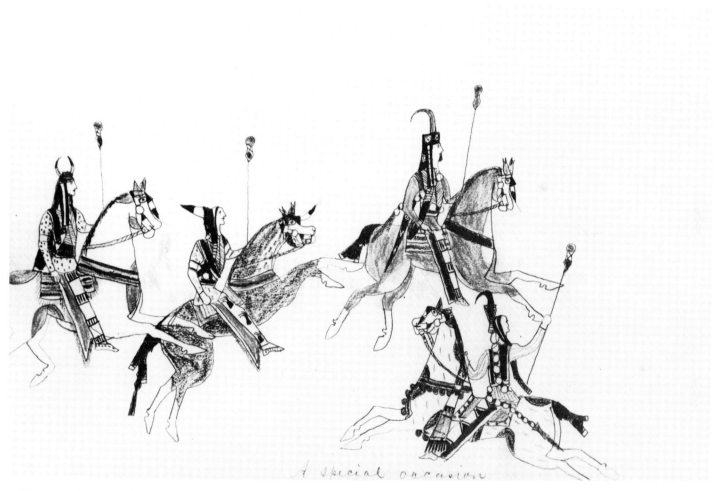

A special occasion

Plate 37. "A special occasion," by Zotom, Kiowa, June 13, 1876 (*Courtesy of Yale University Library*). Capering horses and jingling bells, festive paint and sportive weapons set the mood for the sham battle prefigured by Koba in Plate 22.

with farming and participation in community affairs. After three months Zotom wrote haltingly to Pratt, "do not forget you. I loves you. . . . School good I think. . . . I not sorry and happy every day I study hard any thing Books." In three more months he told Pratt more coherently, "I want be pure in heart and holy man. . . . I learn a better way. I remember all my Indian friends."

Ten months later he was keeping a fairly legible journal telling his daily activities. "9 oclock. I go to school 11 oclock school is out. . . . David and Henry John and I assist Mr. Wicks dig up the potatoes. . . . Evening I go visit little while Miss Alice [step sister of Mr. Wicks] house we have very nice visit In the Evening very good prayer meeting"[10]

He signed his journal "Paul Caryl Zotom." He always included the first two names in his signature after his baptism on October 6, 1878, at the hands of Bishop Frederic D. Huntington. Present at this impressive service at Grace Episcopal Church, Syracuse, were a number of Indian families from the Onondaga reservation ten miles away. The name "Paul" was adopted by Zotom to honor the great pioneer missionary from whom St. Paul's Church, Paris Hill, took its name. The "Caryl" was, presumably, a tribute to Harriet E. Caryl, a long-time officer of the Dakota League of Massachusetts. This organi-

zation of Episcopal women, which had its beginnings in 1864, antedated by fifteen years the Women's National Indian Association, and by eighteen the Indian Rights Association. In accordance with its goal of aiding Indians, the association provided the annual support of $225 for Paul Zotom during the next four years and continued to subsidize him through 1885.[11]

On October 20, at St. Paul's, the bishop confirmed the four young candidates. He preached on the Prodigal Son: "This my son was dead and is alive again; he was lost and is found." Deaconess Burnham said, "The single purpose of these regenerated hearts is to tell of the love of Christ to their poor people, now sitting in the darkness and shadow of death."[12] In taking an assessment of their progress in the first year, their mentor reported:

Tribal characteristics appear in them, and sharp distinctions in personal character. The Cheyenne is most retiring, and evidences the greatest native refinement. The Kiowa, stronger in body, has a rugged force about him that the Cheyenne is a stranger to. . . .

The Kiowa, after his own kind, quick to see, apt to learn, sometimes headstrong and sometimes *heartstrong*, is growing in his own way. Of the four, he will be the voice which shall tell out with all the grace of Indian eloquence the good tidings that are now coming to him, and through him to his people.[13]

Some persons who talked with him spoke of Paul's gentle behavior or of his tender and affectionate heart. After the passage of eighty years, the daughter of the wagonmaker who lived across the street from the church vividly recalled the other side of the coin: "Paul Zotom had a terrible disposition. Some people from away had come and were having a picnic in the grove. Paul ran into our house and threw himself on the couch and put his head down on the pillow. He lay there a good while and then he said he got mad at Mr. Wicks and was afraid he was going to kill Mr. Wicks. . . . He had a terrible temper. You would hardly have known his face, it was so terrible."[14]

Midway in his three years Zotom enjoyed a break in the daily routine. He visited Captain Pratt's Carlisle Institute in Pennsylvania to see his brother Owen Yellow Hair who had come with Etahdleuh from the agency with the first group of young Indians two months before. There Paul "daily exercised his skill as a bugler." In a letter to his agent, he said he taught three boys to blow the bugle, who "learn very fastly blow." One of them was probably the subsequently famous Luther Standing Bear, a Sioux pupil. With an eye to the future, Paul called the agent's attention to his improvement in language skills. "Now Mr Hunt I learn neglish way very nicely. Writin good

neglish talk first rate right all right. . . . I like to aid you some things by and by I got home there. I no want stay Indians camp I like to stay always in white man house."[15]

On June 7, 1881, came the culmination of six years of captivity and study. Paul Caryl Zotom and David Pendleton Oakerhater (Making Medicine) were ordained into the ministry as deacons. "The ordination service was one of peculiar interest and solemnity. The church of modern times presents no parallel case of savage men captured in war, fierce and revengeful, returning in a few short years as missionaries of Christ and His Church to their heathen people. . . . Paul was appointed to read the Gospel. His clear, rich voice filled the church, and every listener's heart thrilled with emotion."[16]

That very evening a small party left Syracuse by train for Indian Territory: the two new deacons, Henry Pratt Taawayite or Buffalo Scout (the fourth candidate, Shave Head, having died), and their teacher and spiritual father, the Rev. John B. Wicks. Their goal was to establish two Episcopal missions. Among the Cheyennes, David would serve as deacon under Mr. Wicks; among the Kiowas, Paul as deacon and Henry as catechist. There was not a single missionary among the Kiowas, Comanches, and Kiowa-Apaches when Paul reached the agency on June 17.

The field, it seemed, was ripe for the harvest, the one requisite being the application of prudence and zeal to the ingathering. The first crucial test for Paul and his mentor was immediately forthcoming, for they found the Kiowas feverishly preparing to move out to the Medicine Grounds. The course chosen by the new arrivals blew up a tempest.[17]

"Medicine" was the term used by the white man to describe any trait of Indian culture partaking of the supernatural: Medicine Lodge (Sun Dance), Arrows, or Hat, and, by extension, any appurtenances thereto, such as medicine man, bundle, or (as above) grounds. To the white man of that day, who neither understood nor sought to understand, and particularly to the missionary, anything "medicine" was odious, smacking of superstition, idolatry, devil-worship, and worse. In their aversion to the Sun Dance lay the seeds of the governmental ban that was placed upon the great religious ceremony of the Kiowas only six years later. For coping with "medicine" ceremonies, the Rev. Mr. Wicks was not unprepared. Before he left the Cheyennes on June 22 to rejoin Paul, who had gone on ahead to the Kiowa agency, Wicks walked boldly into the very environs of the Sun Dance. For a council with Mr. Wicks, David Pendleton Oakerhater had called together a hundred or more of the band which he had led to war in the days gone by. Even as the two men mounted to the high ground selected for the council, most of the Cheyenne tribe were gathered on the plain below, singing and dancing the Sun Dance ritual in their most colorful attire. Accompanied by the pounding of the Sun Dance drum, the little group held their "quiet Christian talk."[18]

Paul Zotom, too, had caught a glimpse of the confrontation to come. At Paris Hill a month earlier, he had confided to his bishop, "I know how we have great hard work up there in Indian Territory, and I know the Indian. Some not hear me what I say because I speak to put away the images and put away sundance. I reckon the Indians not like to hear me."[19] As Agent P. B. Hunt begins his version of what occurred at the Kiowa agency:

Zotom . . . returned to his people in May last [actually June 17] at a very unfortunate time, just upon the eve of their departure to the annual medicine-dance, when all was excitement and more than ordinary interest was felt in the ceremony this year, because it was to be supplemented by a great influx or return of buffalo, promised them by one of their young medicine-men. The discussion of this subject among them was all-absorbing, and nearly all sincerely believed the great event would take place at the time appointed."[20]

It is no wonder that the people were in a ferment. Unable to grasp the fact of the extermination of the great buffalo herds, they believed that the animals upon which their old way of life depended had merely retreated into the cavern in the ground from which the first buffalo had long ago emerged. In a foreshadowing of the promises of the Ghost Dance nine years later, Patepte, or Buffalo Coming Out, son of the Fort Marion prisoner Chief Woman's Heart, announced that he would cause the buffalo to push up through a hole beneath his medicine tipi, bringing back with them all the old customs and ways of life. After four days of incantations, he declared that the time was not suitable for the ceremony. To bring back the buffalo, the people must first hold their annual Sun Dance. Then the diffused tribe, amalgamated by the Sun Dance, would be at the height of their powers. With the concerted help of his people, the Buffalo Medicine man would turn the buffalo out.[21]

The Sun Dance was normally held in the pleasant weather of June, but that year the Kiowas were induced to postpone it until after the close of school on June 30. It was July 12 when, in compliance with the request of some of the head men of the tribe, a military escort under Lieut. M. I. Eggleston, accompanied by interpreter E. L. Clark, joined the Sun Dance camp northwest of the agency, on the North Fork of the Red River. Here 1,400 Kiowas assembled, together with 160 Cheyennes, 44 Arapahos, and a few Comanches and members of other tribes. After moving up the river twenty miles, on July 18 the camp reached the site selected for the Medicine Lodge, some twenty-five miles east of the Texas border. Before any timber was cut for the lodge, it was necessary to find and kill the ceremonial buffalo—no easy task in 1881. Heap-o-bears loaded a pipe and tendered it to Bautigh, while the Buffalo Medicine man presented another to Sitbohaunt, thus authorizing the men to look for the buffalo bull. When they set out before daybreak on the twentieth, the tribe had already devised an escape clause. The interpreter explained to the agent, "In case they fail to find one I believe it is the intention to fold up something in a Buffalo robe as to appear as much like the natural Buffalo as posable [sic]." Clark added, "The fraud still keeps up his communication with the Great spirit who lives—beyond the Sun, and flatters the Indians, they really expecting plenty of Buffalo."

In three or four days the ritual hunting party killed two buffalo, a bull and a cow. The interpreter sounded less than convinced when he commented, "They claim that they did not go off their reserva-

tion or out of territory to find the Buffalo." Perhaps he suspected what was later told—that the hunters got their hides from a white Texan who raised buffalo.

Now the ceremony began. First came the sham battle ("I hope they don't shoot down this way.") On the 25th, "The Bull's Scalp...was decorated with such offerings as the Kiowas possessed. The Sacred Cotton wood fork was cut and Hoisted and the Bull Scalf [*sic*] on it in center of the camp." They completed building their lodge in four more days. Eggleston wrote on the thirtieth, "The Indians begin their four days medicine dance this evening and within two days thereafter [August 4], I think they will break up their camp and return to the agency."

To the Kiowas, after four to six weeks out on the hot plains in midsummer, suffering from a food shortage that would have been serious had not the military brought in supplies, and irritated by the encroaching white cattlemen, the failure of Patepte to bring back the buffalo was a crushing blow. The summer was memorialized in the Kiowa calendar as the summer of the Hot-sun Dance.

After a year of futile attempts, Buffalo Coming Out gave up, saying that someone had broken his medicine. Mooney says, "His pretensions were opposed by the younger men among the returned pris-

oners from the east, who used all their influence against him, but with little effect."

On the day the hunters had gone out after the ceremonial bull, Clark had made a comment to the agent which, in light of subsequent events, was heavy with implications. Seemingly apropos of nothing he had remarked, "Zo-tom got here to day he has not put on a G string yet." Ten days later Eggleston made a similarly significant comment: "I send this by the Kiowa Presbyterian preacher [Episcopalian, there being no other missionaries to the Kiowas], the orthography of whose name I am not able to master. He leaves for the agency to-morrow morning [July 31]."

Zotom's story continues as it was heard in Syracuse (italics mine): "Mr. Wicks found the Kiowas . . . about to assemble at one of their annual gatherings for medicine dance, and *after talking with the agent* and some of the people, he decided to put a Christian tent on the ground, and Paul in it as in his own home, to proclaim daily in their ears 'Him whom ye ignorantly worship declare I unto you.' Here morning and evening should be a gathering for prayer, with instruction through the day to as many as would assemble; Henry to be with Paul a part of the time."[22] Agent Hunt took a darker view of the proceedings:

The temptation to be present was too great, and

Zotom fell into the current, and was soon beyond the reach of any restraining influence [Hunt had obviously anticipated that Zotom would shed his clothes for the G-string], going out from the agency about 100 miles, and, if not taking part in the observance of the rites and ceremonies of the dance [unlikely, since he left after one night of the four-day Sun Dance proper], it was plainly evident that he still entertained a great reverence for the savage superstitions of his people, and I am much inclined to believe that during the summer, and especially during the six weeks out at the dance [actually eleven days plus travel time], he retrograded perceptibly. He is now [September 30], however, doing well, and we hope the disappointment and chagrin of his people over the failure of the promised results of the dance, and his own humiliation in taking part, will have a good effect, and he will profit by this experience, and be prepared to resist even greater temptations in the future.[23]

On this high moral note the matter might have rested, but for one thing. The agent's letter was written to Captain Pratt at Carlisle in reply to an inquiry on how the returned Florida Boys were doing. Hunt found it necessary to "write plainly," and Pratt apparently felt duty-bound to publish the negative report on the Kiowas and Comanches in the *Annual Report of the Commissioner of Indian Affairs*, along with Agent Miles's more generous account of the Cheyennes and Arapahos. When the letter "obtained some circulation at the East," two of Paul's white friends hastened to refute it. Deaconess Burnham called it "an inconsiderate letter containing mostly impressions and conjectures." Mr. Wicks wrote,

I wish you could have seen the *answer* to the Carlisle mistake which was right before me as I read the statement. It came to me at the Wichita School House, where I was spending the Sunday. Even as I read, Paul and Henry came in for the afternoon service. . . . Paul recounted his work in the morning among the Kiowas, where he had himself conducted the service, and afterward instructed the people, and then he added that he had gathered the boys every evening but one in the week and instructed them in the catechism, and right by his side, while he was speaking, sat his brother, neatly dressed, who is now faithfully working for the Agent, and who, when Paul reached home, was a lazy blanket Indian; the *right kind of going back*, we call this![24]

When Deaconess Burnham wrote to Paul about the report from the agent, his hurt bewilderment showed through his reply:

I am sorry that you hear about me that I have on Indian clothes. It is not so, dear House Mother, the white men tell you a lie. I thought myself I doing very well here. I teach them all the boys, and preach on

Sunday. I go and pray with the sick. Nobody here doing the good way; but I try. When I first came back, I saw my brothers' long hair, and not any do work. I gave my brothers talk. Now they cut off hair, and put on good clothes, and one go to school at Agency, and one work for Agent, and one go to Carlisle. . . . When I first came home, I see how all Indians live, and I think, myself, pretty bad way all that.[25]

Caught in the conflict between the cultures of white man and of Kiowa, he was firmly sustained by the staunch Mr. Wicks, whose reports are full of praise for his deacon's achievements:

Paul shows an admirable spirit. Our Sunday School yesterday was very satisfactory. . . . Paul is now telling them each evening the story of some part of our Savior's life. They enjoy it exceedingly.

Paul's influence has been excellent upon his whole family circle.

A prominent "medicine man," Paul's cousin, who scorned the idea of a *new* medicine when he was told a few months ago about the Savior of sinners, has since sought repeatedly for talks with Paul, and with Mr. Wicks. Recently he came again, to say he "was now convinced that the Kiowa road is all devil medicine, and he wished to put it away and become a Christian." He unbraided his long scalp lock, combed it out and had it cut off; he put on the dress of a white man and now stands before his people, a living exponent of the new medicine he has accepted. He will go to work as soon as work can be provided for him, and meanwhile he has chosen to go to school with the children; he has already learned the letters, and his influence for good is marked in all the school. Of him Paul writes: "I know it is God who has changed his heart, no man could have done it."[26]

By December the crisis was over. "When I think," said Wicks, "how bravely and firmly they have met the storm which has fairly beaten upon them, coming up out of the depths of the old, dark life, winning the victory inch by inch, I do just one thing, 'thank God and take courage.' "[27] In April Pratt published quite a different letter from that of six months before. He first quoted Wicks as reporting:

I can now safely say that in spite of all appearances to the contrary, David, Paul and Henry have been faithful. . . .

Paul surely holds all he had when he came out, and in spite of some trying obstacles has steadily gotten more. He stands very strongly against the medicine notions of his tribe, and is holding his own family with him, and even others. He will remain here during the summer teaching and instructing all he can. . . .

Of all I can truly say that they have proved as efficient and faithful as we had any right to expect.

Pratt added in his own words a veiled retraction

of the "Carlisle mistake," finally closing the incident: "More is expected, often, of those who are learning the right path, than of the weak who have always known the way; and so it is bandied about in the Territory and comes floating up to us that Paul and Ohet Toint [actually Taawayite] are gone backward, but when Mr. Wicks assures us that 'they have done better than could have been expected,' we believe him." The next year Pratt saw Paul at the agency and reported that he was doing especially well.[28]

Meanwhile, Wicks reported that Paul had begun to win the esteem of his skeptical agent. The erstwhile prison bugler was "sounding the Gospel Trumpet." He instructed a class of eighteen so that they might receive baptism. Mr. Wicks summarized the services rendered by his deacons in their first year:

The especial work of the Deacons was successfully inaugurated at the first. They told the story they had learned, by word of mouth in stated services at the school-rooms, and particularly by the camp fires of their people. They sought out the sick and the suffering and ministered to them constantly, giving much comfort to many sorely-burdened hearts. They persuaded many children to attend the schools, and steadily exerted a healthy influence upon all their people.[29]

Perhaps, in spite of Wicks's protestations, his confidence in the Kiowa deacon was not complete. Owen Yellow Hair returned from the East in July. The following month Paul sent his twelve-year-old brother Otto Zotom to Carlisle with Dr. J. A. Lippincott of Dickinson College and Dr. Horace Caruthers, husband of the Fort Marion teacher. Yet when the clergyman traveled to the East for the summer of 1882, although he left David in charge of the Cheyenne work, it was not Paul but the newly baptized white school-superintendent, George Hunt, who was entrusted with conducting the church services at the Kiowa reservation. When the bishop of the Missionary District of Arkansas and Indian Territory, Henry N. Pierce, made a visitation in the fall, the lone, cryptic comment in his journal regarding Paul said, "Called Rev. Paul Zotom, Deacon—at his room—saw his mother Sapoli."[30]

When Paul first arrived at the agency, he wrote to his brother who had gone off to Carlisle two years before, at the age of eighteen: "Now dear brother Yellow Hair our mother and other rest friends all pretty well and all want to see you very much. Only one cousin die last spring. Now this I am so sorry to tell, your dearwife got other young man, never mind brother good many other nice girl yet."[31]

Paul spoke from experience. Before he went off to

prison, he had been married to Prepared Meat (Keahpaum) and had a son, Otis (Toehay). In April, 1882, or shortly before, Paul, a one-quarter Crow, married Mary (Thrusting the Lance to Both Sides, Yeagtaupt), a Comanche, who bore him three children who did not live to maturity. Before her marriage, Mary had been employed briefly in the school dining room while she was a pupil. In 1883, after marriage, she worked for five years at the school as assistant cook, assistant matron, or assistant seamstress.[32]

Mr. Wicks continued to speak well of Paul and his work. In a speech to the benefactors of the Indians in Boston in the spring of 1884, Wicks paid "especial tribute to the Christian character of Paul" and requested financial support toward building a home for him. Then, three years after the beginning of the missions in Indian Territory, Mr. Wicks gave up the work, because of ill health. Zotom's advocate and prop was gone and he wrote:

Mr. Wicks, I am very very sorry you not come any more to Anadarko. When I read your letter make me feel very sorry and come down my tears a great deal, because I think I can't any man find like Mr. Wicks. I thought Mr. Wicks stay with me always and never go way anywhere. And now he is gone away off. I can't see him any more. Now, I say good-by. God bless you.

You say another man come here to Anadarko and preach. I know somebody stay with me. I mean our Father in Heaven. He stay with me. I thank you, Mr. Wicks, to stay with us and work together.[33]

The church did not soon send another man to Anadarko in place of Wicks. Twice in the next year Paul wrote to the Dakota League, which augmented its support with a pledge of two hundred dollars toward the building of his "three rooms and a porch." Although the national church continued his small salary, Paul is not known to have engaged further in their missionary endeavor. Indeed, before September of 1885, Tsaitkopeta, another of our artists, reported, "The Kiowas, Comanche and [Kiowa] Apaches have no missionaries nobody to teach them about God's ways." In the spring of 1887, Etahdleuh wrote, "There are no single man or woman here to tell the Indians about God. . . . A missionary is badly needing here." For a time Paul sent letters to a dedicated Fort Marion teacher, always beginning formally, as he had been taught: "I am well and hope when this letter reaches you it may find you the same." But by 1885 the correspondence with Mrs. Kingsley Gibbs had lapsed. Paul forgot the hard "lesson on gormandizing" taught by Captain Pratt. In 1882 young Mason Pratt wrote to his father from the agency that Paul "looks

even larger than he used to be, I hardly knew him." Twenty years later, the erstwhile perfect physical specimen of manhood was said to weigh 350 pounds. In 1888 a Presbyterian missionary whom Etahdleuh brought to Carlisle, Joshua Givens, son of the famed Satank, said Paul was doing no good. "After seeing Paul Zotom, I was at his home last night now occupied by my cousin Kiowa Billy and thought what a time wasted in Paul. He allowed his hair to grow long and is now a leading medicine man"—a healer who prayed for the sick.[34]

Putting into practice the precepts learned in the east was no easy matter for the Florida Boys who returned to the reservation. After the first several years, few opportunities for non-agricultural work were open to them, and these at wages so meager as to be negligible. Farming, hazardous at best because of the capricious rainfall, was impractical when livestock and implements were lacking. Yet the Indians were not free to seek work elsewhere; they could leave the reservation only with a permit. Government rations were skimpy, unreliable, and poor in quality, but the Indians could not go beyond their boundaries to hunt their own meat. Poor health conditions resulted in many deaths and widespread sickness. The white men brought in the crazing whisky, grazed their herds on reservation land, and stole the Indians' stock and timber. There was no title to property and no protection of law.

Even their fellow-tribesmen thwarted the returnees from the east. The elders of the tribe, who by long tradition held the reins of government, were jealous lest the educated young men supplant them. If a man prospered, the tribal ethic required that he share equally with all who had less. A society that since time out of mind had approved only warfare and hunting as work suitable for a man was quick to ridicule the man who turned his hand to such woman's work as agriculture or manual labor. The conservatives, with a love and respect for the ancient religion and government, laws and customs of the tribe, joined in resisting not only the missionaries who brought the white man's religion but also the Indians who upheld the agent's hand. Rare was the man whose integrity and steadfastness of spirit was strong enough to long prevail against the hazards besetting his journey on the white man's road.

In July of 1889, Paul's clerical superior, Bishop Henry N. Pierce of the Diocese of Arkansas and Indian Territory, made a tour of visitation in the Territory. He first called on Paul's Cheyenne counterpart, David Pendleton, who proved to be, after five years on his own resources, "a faithful and good man, and he has the confidence of all, both Indians and

whites. . . . I found that the Cheyenne Deacon had been faithful in performing such duties as he could." When the bishop moved on to Anadarko, he called on Agent Myers. The bishop's diary of July 12 records, "I talked with him about the Kiowa Deacon, Paul Zotom, of whom I have very unsatisfactory accounts." The agent sent a messenger "to bring him in," but it was five days before Paul complied, as told in a revealing passage of the diary for Wednesday, July 17:

Today the Rev. Paul Zotom, who has been since Monday afternoon in the neighborhood, made his first appearance, and his costume differed in no essential respect from that worn by the Indians in camp. It is true that his face was not painted, and this was about the only thing which distinguished him from the great body of the Kiowas. He has evidently left the "white man's road," and returned to the Indian path. I had a long and very unsatisfactory talk with him. I am more than afraid—I feel quite assured that his life is far from a correct one. I have strong evidence, not only of his having fallen into bad habits but of his having habitually made, during the past year and more, reports of services never performed by him. Indeed I have strong reasons for believing that he has done no missionary or ecclesiastical work for many months. The testimony received came from both Indians and whites. His reputation is very bad. Under these circumstances I have dropped his name from the list of Missionaries and expect ere long to have the evidence in regard to him in such shape as will lead to his deposition from the ministry. Perhaps Paul's position would be now quite different had he been under the direction and oversight of a Priest; that he has not been is no fault of mine. Let it rest where it should, and let those in fault answer for it before God.[35]

When Zotom was listed as "retired," retroactive to June 1, he no longer appeared on the roster of missionaries. Apparently his annual salary of three hundred dollars ceased with his retirement. Old and feeble, Bishop Pierce failed to take further action on Paul's case before the Indian Territory passed from his jurisdiction a year and a half later. Apparently the talk with the bishop had no lasting effect on Paul. His wife became very active in the new religion that came to the Kiowas in 1890. She composed a ghost-dance song for which she became well known. In 1892, Episcopal missionaries traveling through Anadarko found the Wicks mission work "practically abandoned." "Our Indian deacon, Paul Zotom, not having influence and godly advice of a white missionary to support and encourage him, is doing nothing to build up his red brethren in Christ." By 1893, Paul had been divorced and married to Mary Aungattay, or Standing in Track. They had no chil-

dren. In the same year, the new bishop, Francis K. Brooke, reporting on the two Indian deacons, found the Cheyenne still doing as much as he was able, "but the one at Anadarko, a Kiowa, I fear has been left to himself so long that he has retrograded too far to again be made useful."

Paul's formal severance with the Episcopal ministry occurred in 1894. The diary of the new bishop, Francis K. Brooke, has this entry for August 13: "At the home of Rev. H. C. Shaw, near Oklahoma City. In the presence of him and Rev. Dr. [D. Griffin] Gunn [Episcopal missionary at Oklahoma City] I deposed from the ministry Paul C. Zotom, deacon, he having in writing signified to me his renunciation of the ministry. This is another sad echo of the lost opportunity among the Indians at Anadarko Agency."[36]

The next month, Brooke corroborated Bishop Pierce's observation on the Kiowa's cessation of missionary work. "The poor fellow shd have been [deposed] some years ago. There has been no *Indian* work done at Anadarko for five or six years." A fellow Kiowa summed it up thus: "The Kiowas overpowered him and he gave up being a minister."[37]

In 1895, Paul had put behind him the religions of the Sun Dance, the Episcopal Church, and, presumably, the Ghost Dance and tried a new faith. He was baptized once more, this time by the Baptists, and was instrumental in the founding of yet another mission. On April 9, 1896, Miss Isabel Crawford was driven by Paul and his wife (whose name Miss Crawford translates as Stand-in-the-middle-of-the-road) in their wagon to the Saddle Mountain Creek area. Here, southwest of Anadarko, Miss Crawford was destined to stay as a missionary to the Kiowas. The Indians could not believe their eyes, and the Zotoms reassured them in sign language. " 'Is it true that the leetle Jesus woman from Elk Creek has come?' 'It is true,' signed Zotom and Stand-in-the-middle-of-the-road together."[38]

A few days later, when a "crazy" (drunken?) white man came to the camp in Saddle Mountain, Zotom invited him into the tipi to hear the "Jesus talk." At the close Zotom turned to him and said: "How is it that you are so bad when you can read the Bible for yourself?" He lectured the man and sent him off to the white settlement eighteen miles away.[39]

At the beginning of Miss Crawford's work Paul acted as her interpreter during prayer meetings and made frequent visits with her into the surrounding country. Through his influence many joined the church and were baptized. But in a few years he quitted Saddle Mountain for the agency once more.

In 1897, anthropologist James Mooney noted that Paul had "sadly fallen from grace" and was of less manly character than another of our artists, Tsait-kopeta. Perhaps this was a reference to Paul's weakness for drinking. In that year Zotom was painting model tipis at Anadarko for Mooney's Smithsonian exhibit at the Trans-Mississippi and International Exposition in Omaha in 1898 (Plate 12). This tipi-painting constitutes Zotom's only known art work since the Fort Marion days. He received his allotment with the Kiowas under the name Paul Zotum. As an officer in the Gourd Clan he blew the captured bugle—a skill he had learned at Fort Marion. He espoused still another religion, the peyote cult of the Native American Church. Before he died on April 27, 1913, the headstrong and heartstrong Paul had at least one more religious experience. As the Baptist missionary tells it:

Paul Zotom bought a buggy on credit. Later, when he had the money he paid for it, as he believed. At the Kiowa grass-payment, the white man who sold him the buggy was on hand to collect. Paul refused to pay, contending that he had already paid him. The man caught hold of his long hair and jerked him roughly, which so enraged Paul that he thought to twist the man's head off. Being a powerful Indian weighing 350 pounds, it would have been an easy thing to do. But he heard a voice behind him saying, "Zotone, don't get mad." The Voice kept saying softly, "Zotone, don't get mad." Not knowing an Indian was near, he thought it was the Lord speaking to him, and it quieted him and enabled him to control his anger. It was Wheton, a Mexican, a faithful member of Immanuel Church. Paul says if he had not heard that voice, he would surely have pulled the man to pieces.[40]

[1] "Ordination of Two Indians," *Churchman*, Vol. XLIII (June 18, 1881), 680.

[2] Pratt to Post Adjutant, Apr. 24, 1875, NA, WD, Letters Received, U.S. Army Commands, Department of the Missouri, 1875, S4/168/23; Nye, *Carbine and Lance*, 158.

[3] Pratt to Post Adjutant, Apr. 24, 1875, NA, WD, Letters Received, U.S. Army Commands, Department of the Missouri, 1875, S4/168/23; Nye, *Carbine and Lance*, 264; Nye, *Bad Medicine and Good*, 189.

[4] Cat. No. 20/6232, Sketchbook by Zotom, Museum of American Indian; #3, Sketchbook by Zotom, Mrs. Maurine M. Boles and James Jolly, a drawing which is reproduced with fifteen others of the set (six in color) in a recent article, "Rediscovery: An Indian Sketchbook," *Art in America*, Vol. LVII, No. 5 (Sept.–Oct., 1969), 82–87; Pratt, *Battlefield and Classroom*, 40; #3, Sketchbook by Etahdleuh, PP; Nye, *Carbine and Lance*, 192.

[5] Mrs. Caroline Doolittle, oral communication to author, Aug. 12, 1959; Pratt, *Battlefield and Classroom*, 185–86.

[6] Pratt, *Battlefield and Classroom*, 137, 94–98; *EKT*, Vol. II, No. 2 (Sept., 1881), [2]; Pratt, "Some Experiences with our Most Nomadic Indians," MS, PP.

[7] "Indian War-Dance," n.p., n.d., PP; "Indian Sports and War Dance," handbill, St. Augustine Historical Society, St. Augustine, Fla.; Pratt, *Battlefield and Classroom*, 188–189; "A-Take-e-ah-ome," handbill, PP.

8 [Ludlow], *SW*, Vol. VII, No. 5, 36.

9 Mary D. Burnham, "Florida Indians" (dateline, St. Augustine, Mar. 18, 1878), *Churchman*, XXXVII, No. 26, 720 n.

10 Zotom to Pratt, Aug. 6, 1878, PP; Paul C. Zotom to Pratt, Nov. 22, 1878, PP; Zotom, Journal, Sept. 15, 1879, enclosed in John B. Wicks to Commissioner, Sept. 18, 1879, NA, OIA, Letters Received, C&A Agency, W 2143-79. David, the former Making Medicine, was called David Pendleton Oakerhater, but signed himself David Pendleton. Henry, formerly Buffalo Scout, was Henry Pratt Taawayite, and John, formerly Shave Head, had become John Wicks Okestehei.

11 Mary D. Burnham, "First-fruits of the Kiowas, Comanches, and Cheyennes," *Churchman*, Vol. XXXVIII, No. 18, 527; Mrs. Caroline Doolittle, oral communication to author, Aug. 12, 1959; Arria S. Huntington, *Memoir and Letters of Frederic Dan Huntington*, 229; *Annual Report of the Dakota League of Massachusetts*, n.p., n.d., 1878, 13; 1879, 13; 1880, 4; 1881, 4; MMBWA, Sept., 1882, Dec., 1885.

12 Burnham, "First-fruits . . . ," *Churchman*, Vol. XXXVIII, No. 18, 527.

13 Rev. J. B. Wicks, "Indian Youths in Christian Families," *SM*, XLIV, 224. On the Plains, a strong heart connotes bravery.

14 *Annual Report of the Dakota League of Massachusetts*, n.p., n.d., 1880, 4; Bishop F. D. Huntington, "Educating the Indian," *Churchman*, Vol. XL, No. 5, 118, reprinted from Springfield *Republican*; Mrs. Caroline Doolittle, oral communication to author, Aug. 12, 1959.

15 Zotom to Hunt, Jan. 22, 1880, OHSIA, Kiowa–Indian Prisoners of War; NA, OIA, Carlisle School Records, Field Office Records No. 77, Owen Yellow Hair; "Indian School Notes," *Herald*, n.d., PP; Luther Standing Bear, *My People the Sioux*, 48.

16 Bishop Frederic D. Huntington, "Bishop's Address," 13th *Annual Convention of the Protestant Episcopal Church in the Diocese of Central New York, Journal*, 1881, 41; "Ordination of Two Indians," *Churchman*, Vol. XLIII (June 18, 1881), 680.

17 Rev. J. B. Wicks, "Work in the Indian Territory" (dateline, Anadarko, Dec. 1), *SM*, XLVII, 60.

18 Mooney, 17th *ARBAE*, 1895–96, Part I, 355–59; Rev. J. B. Wicks, "Story of the Indian Territory Mission," *OITC*, Vol. X, No. 1 (Feb., 1900), 6; [Mary D. Burnham], "Notes of our Indian Territory Mission," *GMCJ*, Vol. VI, No. 69 (Sept., 1881), 553–54.

19 Zotom to Bishop, May 13, 1881, GMCJ, Vol. VI, No. 66 (June, 1881), 531.

20 Hunt to Pratt, Sept. 30, 1881, *ARCIA*, 1881, 192.

21 The story of the attempt to bring back the buffalo combines these sources: Maj. Mizner to Agent Hunt, June 23, July 8, 1881; E. L. Clark to Hunt, July 14, 17, 20, 26, 1881; Clark to [Agent Miles], July 26, 1881; Lieut. M. D. Eggleston to Hunt, July 30, 1881—all in Kiowa–Dances, OHSIA; Clark to Miles, July 23, 1881, C&A–Dances; Hunt to Commissioner, June 9, 1881, Kiowa letterpress copy book, IX, 333—all in OHSIA; Mooney, 17th *ARBAE*, 1895–96, Part I, 219, 346–48, 350; Alice Marriott, *The Ten Grandmothers*, 150–52; James Mooney, "The Ghost-Dance Religion and the Sioux Outbreak of 1890," 14th *ARBAE*, 1892–93, Part II, 906.

22 "Notes of Our Indian Territory Mission," *GMCJ*, Vol. VI, No. 70 (Oct., 1881), 561.

23 Hunt to Pratt, Sept. 30, 1881, *ARCIA*, 1881, 192–93.

24 "Notes of Our Indian Territory Mission," *GMCJ*, VII, No. 74 (Feb., 1882), 592.

25 *Ibid.*, Zotom to White Mother [Burnham], Nov. 10, 1881.

26 "Notes of Our Indian Territory Mission," *GMCJ*, Vol. VII, No. 74 (Feb., 1882), 592; *ibid.*, Vol. VI, No. 71 (Nov., 1881), 566.

27 Wicks, *SM*, XLVII, 61.

28 Wicks to Pratt, Mar. 21, 1882, and Pratt's comment, "Rev. J. B. Wicks and His Work in the Territory," *MSt*, Vol. II, No. 9, [4]; Pratt to Hon. Daniel M. Fox, Dec. 1, 1883, PP.

29 "Notes of Our Indian Territory Mission," *GMCJ*, Vol. VII, No. 76 (Apr., 1882), 611; *EKT*, Vol. II, No. 2 (Sept., 1881), [2]; Rev. J. B. Wicks, "First Year's Work in the Indian Territory," *SM*, XLVII, 244.

30 NA, OIA, Carlisle School Records, Field Office Records, No. 77, Owen Yellow Hair, and No. 282, Otto Zotom; Sidney,

"Carlisle School for Indian Pupils," *Sights Worth Seeing*; Lippincott, *MSt.* Vol. III, 2, [1]; Hunt, Report, *ARCIA*, 1882, 71; Wicks, *OITC*, Vol. X, No. 1, 8; Bishop Henry N. Pierce, MS, Diary, Nov. 11, 1882, archives of Episcopal Diocese of Arkansas, Little Rock, as copied by Mrs. C. R. Moody and supplied by Archdeacon John Gordon Swope, Diocese of Arkansas.

31 NA, OIA, Carlisle School Records, Field Office Records, No. 77, Owen Yellow Hair; Zotom to Yellow Hair, *SN*, Vol. II, No. 1 (June, 1881), [3].

32 Allotment file No. 1403 Kiowa, Anadarko Agency, Anadarko, Okla.; George Zotom Otis to author, Feb. 16, 1965; MMBWA, Apr. 1882; OHSIA, Kiowa–K&C Boarding School, 1883–88 and Kiowa–Employees, 1881, 1883, 1885.

33 MMBWA, Nov., 1882, Mar. and Apr., 1884; "Among the Indians," *Saturday Globe*, Dec. 5, 1908.

34 MMBWA, Nov., 1884, Apr. and Sept., 1885; Bishop H. N. Pierce, "Annual Report of the Missionary Bishop of Arkansas and the Indian Territory." *DFMS, Reports*, 1885–86, 66; [Paul C. Tsaitkopte to Mrs. Amy Caruthers], "A Letter from an Earnest Kiowa Young Man Who Lived Several Years in an Eastern Family," *MSt*, Vol. VI, No. 2 (Sept., 1885), 8; "Etahdleuh Doanmoe," *MSt*, Vol. VII, No. 8 (May, 1887), 8; Mrs. Samuel Tyler, oral communication to author, Aug. 13, 1959; L. M. W. Gibbs to Agent, May 20, 1885, OHSIA, C&A–Indian Prisoners; Mason D. Pratt to father, July 8, 1882, PP; Rev. H. H. Clouse, "Rainy Mountain Kiowa Mission," *Baptist Home Mission Monthly*, Vol. XXIV, No. 7, 207; Pratt to Commissioner, Nov. 13, 1879, NA, OIA, Letters Received, Miscellaneous, P–1182–79, 13; Rev. Linn Pauahty, oral communication to author, Aug. 21, 1969; Joshua Given to Pratt, July 28, 1888, PP; For biographical data on Givens see Rev. J. J. Methvin, "Reminiscences of Life Among the Indians," *CO*, Vol. V, No. 2 (June, 1927), 173.

35 Bishop H. N. Pierce, "The Bishop's Annual Address," 18th *Annual Council of the Diocese of Arkansas, Journal of the Proceedings*, 31–38.

36 "Missionaries and Teachers among the Indians," *DFMS, Reports*, 1888–89, 38; Right Rev. Francis Key Brooke, "Ten Years of Church Life in Oklahoma and Indian Territory," *SM*, Vol. LXVIII, No. 5, 306; Mooney, 14th *ARBAE*, 1892–93, Part II, 907, 1085; Allotment file No. 1403 Kiowa, Anadarko Agency, Anadarko, Okla.; George Zotom Otis to author, Apr. 25, 1965; *OITC*, II, Nos. 3–4 (Oct.–Nov., 1892), [2]; Bishop Francis K. Brooke, "First Annual Report of the Missionary Bishop of Oklahoma," *DFMS*, Reports, 1892–93, 41; [Brooke], "The Bishop's Journal," *OITC*, Vol. III, No. 14, 1; Brooke to Langford, May 24, 1893, DFMS Papers, Domestic Committee, Correspondence of Rt. Rev. F. K. Brooke, Library and Archives of the Church Historical Society (Episcopal Church), Fort Worth, Tex. For a biographical sketch of Bishop Brooke, see Rev. H. J. LLwyd, "Right Rev. Francis Key Brooke, D. D., Bishop of Oklahoma," *CO*, Vol. XII, No. 1 (Mar., 1934), 52–54.

37 Brooke to Kimber, Sept. 6, 1894, DFMS Papers, Domestic Committee, Correspondence of Rt. Rev. F. K. Brooke, Library and Archives of the Church Historical Society (Episcopal Church), Fort Worth, Tex.; Bert Geikaunmah, oral communication to author, Oct. 23, 1960.

38 George Zotom Otis to author, Apr. 25, 1965; Crawford, *Kiowa*, 13.

39 Crawford, *Kiowa*, 20.

40 James Auchiah, MS, Statement of Fred Botone on Isabel Crawford, June 4, 1967, Fort Sill Museum, U.S. Army, Fort Sill, Okla., files; Mooney, 17th *ARBAE*, 1895–96, Part I, 216; Rev. Linn Pauahty, oral communication to author, Aug. 21, 1969; Neg. No. 55,755, Paul Zontum, BAEC; File No. 4336, James Mooney, MS, field correspondence, BAEC, quoted in letter, Mrs. Margaret Blaker to writer, Sept. 15, 1966; Allotment file no. 1403 Kiowa, Anadarko Agency, Anadarko, Okla.; George Zotom Otis to author, Apr. 25, 1965; Clouse, *Baptist Home Mission Monthly*, Vol. XXIV, No. 7, 207.

SQUINT EYES (Tichkematse), the Pan-Indian

Names on drawings: Squint Eyes; Tichkematse [Equivalent of Quchkeimus, below].
Names on Pratt's list: Squint Eyes [more accurate translation of Cheyenne name, Small Eyes], Quchkeimus.
Alias: John Squint Eye.
Tribe: Cheyenne.
Date of birth: 1857.
Charge listed against him: Ringleader.

Other incidents of early life: Fought against Osages, Utes, and the Army.
Dependents at time of arrest: None.
Rank at time of arrest: Warrior.
Place and date of arrest: Cheyenne Agency, Indian Territory, April 3, 1875.
Height and weight, July 9, 1877: 5′ 8½″; 134 lbs. 8 oz.
At Fort Marion, Florida: Arrived for imprisonment, May 21, 1875.
At Hampton Institute, Virginia: Arrived for schooling, April 14, 1878; baptized "Tichkematse" March, 1879; expenses of his education paid by Miss A. E. Prall of New York City; employed at Smithsonian Institution; did bird-collecting in Florida.
Departure for reservation: Early in 1880; collected for Smithsonian; went on expedition to Arizona Indians; was a farmer; was Indian Scout; acquired the name "John Squint Eye"; moved to Northern Cheyennes; served in Cavalry; was a policeman; was baptized in Mennonite Church.

Allotment number: 29.

Death: Died on November 7, 1932, at Lame Deer, Montana.

Relatives: Father, Crooked Arm(?) or Tall Bear(?). Mother, Crooked Nose. Brother, Rutherford B. Hays. Sisters, Shell and Holy. Wives, Hairy Face, died 1891; Nellie (Bigthigh or Elk), married 1891, died 1924; Josie Whistling Elk (Stronglefthand), married 1929, survived him. Children, (adopted) Bessie Americanhorse, born in 1905, and five or six who died young.

Number of pieces and location of extant art: 1 Hampton Inst.; 3 PP; 22 USNMC. Total, 26.

FOR A LIFE of high adventure after the years at Fort Marion, not another one of the Indians could match Squint Eyes, the Cheyenne. He was chosen for an arduous expedition to a semi-hostile Arizona tribe, because he was a light-hearted companion. He was taken on a mission to the watery fastness inhabited by the unfriendly Seminoles because he had a talent for taxidermy. Steadfastly he served with the United States Army for five years and saw action against obstreperous whites and Indians. Gregarious and adaptable, he joined forces with a young Aleutian to preside over an exhibit hall in a great scientific institution.

When Squint Eyes was arrested to be sent off to prison, no charge was listed against his name, since he was one of the eighteen "cut off from the end of the line" to fill out a pre-determined quota of prisoners. On the official lists, however, the vacant space after his name was filled with the ambiguous term, "Ringleader."[1]

At Fort Marion, his record is nearly as blank as his original charge. Nothing is known of his activities beyond the production of three pages of competent drawings (two in Plate 38). At Hampton Institute he distinguished himself little more. The vigilant eye of Captain Pratt must have detected certain potentialities in the youth, for before the 1879 term was out at Hampton, Squint Eyes was uprooted from his schoolroom and transplanted in the laboratory of the Smithsonian Institution, Washington, D.C., for the purpose of learning taxidermy. In the spring, at the suggestion of Secretary of War George W. McCrary, Pratt took some of his protégés to the White House to exhibit the progress they had made. He escorted four Cheyenne and Kiowa ex-prisoners and one young Sioux from Hampton, besides two Smithsonian employees—Squint Eyes and George Tsaroff, a native of the Aleutian Islands who had been brought to the States in 1873 and educated in Michigan. President Rutherford B. Hayes received the

party graciously, with compliments for the boys and congratulations for their mentor. The group stayed for several days at the Smithsonian.[2]

Squint Eyes proved to be an apt pupil in taxidermy. In June, in accordance with orders of the War Department, Pratt was instructed by Commissioner of Indian Affairs E. A. Hayt to investigate the condition of the Seminole Indians in Florida, to see what measures could be taken to "civilize" them. Spencer F. Baird, secretary of the Smithsonian and a life-long ornithologist, requested that Squint Eyes accompany Pratt in order to gather specimens of birds for the Institution's collections. The Indian's expenses would be taken from the fee paid regularly for his education by a generous patroness, Miss A. E. Prall of New York City. After leaving Washington on June 11, the men stopped for a few days in St. Augustine, where they were joined by Lieutenant Edward T. Brown, a friend from the Fort Marion years. The party traveled by rail across Florida, by steamer part way down the west coast, and by wagon from Fort Meade southeast through sandy, pine-sprinkled flats and alligator-infested waters in a vain search for a Seminole village. From a point west of Lake Okeechobee they went by boat down the Caloosahatchee to Fort Myers, where a parley with the Indians was to be held. A side trip thirty miles northeast from Fort Meade had taken them to an Indian village in the lake country, where the party slept on an unwalled, roofed platform as guests of the renowned chief Chipco, a reputed centenarian destined to die two years later.

Pratt failed in his mission to the Seminoles; the bitter Indians emphatically declined "to hear any Washington talk." He attributed his failure to a news-leak that preceded him to Florida. Squint Eyes, for his part, enjoyed considerable success in collecting birds. The pair returned by way of Hampton Institute, where they stopped off for a few days beginning July 19. Only four of the Cheyenne's former prison mates remained at the school.[3]

When Squint Eyes returned to Washington, he did not waste the rest of the month. Just that year the Bureau of Ethnology, as it was first called, had been organized within the framework of the Smithsonian Institution. Two of its earliest publications dealt with the Indian sign language, and to this study Squint Eyes made a unique contribution. He was the ideal informant for ethnologists: he grew up using the gestures as a second native language, and he now had mastered the rudiments of English. There was no need of an interpreter to interpose his own understanding between informant and recorder. In July, Frank H. Cushing, an ethnologist with the Smith-

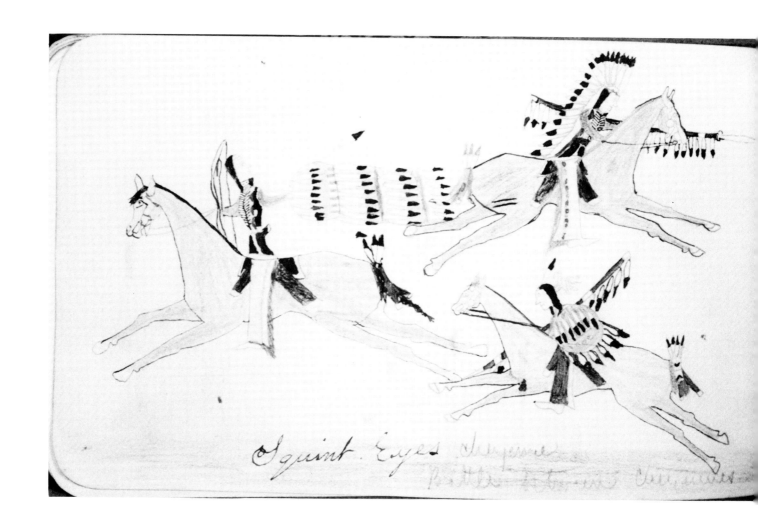

Squint Eyes Cheyenne

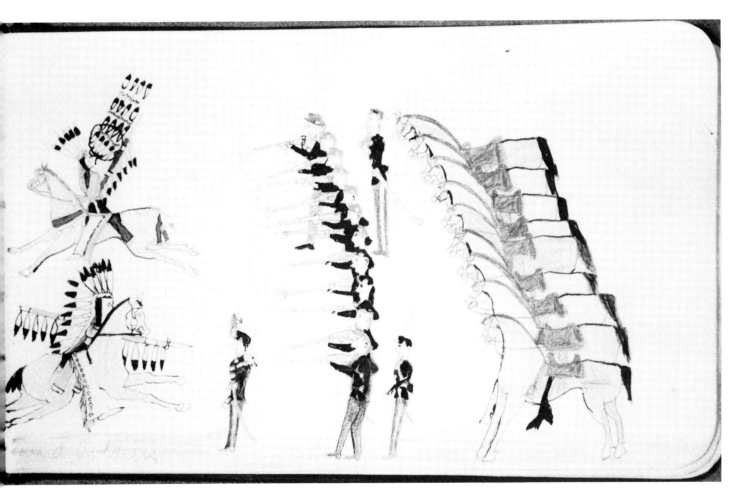

Plate 38. "Battle between Cheyennes and Soldiers," by Squint Eyes, Cheyenne, May 21, 1875–April 11, 1878 *(Courtesy of Yale University Library).* The scene dramatically contrasts two methods of warfare, the concerted volley of the rigidly disciplined cavalry versus the hit-and-run tactics of the highly individualistic tribesmen.

sonian, filled 161 cards with analyses of Squint Eyes' gestures, and he had the more generic signs photographed.[4]

In August, Miss Prall wrote that she was proud to hear good reports of her protégé. Two months later, however, the good lady was worried. She had received a letter from Squint Eyes complaining of his health and a shortage of funds. "I am afraid he is getting tired of civilized life," she confided to Pratt, "—else he is getting into bad company. I do not think that Washington is the place for him."[5]

Baird, too, had his doubts, as Pratt learned on consulting him about the Indian's complaints. "Nobody seems to know about the indisposition of Tichkematse," wrote Baird, "and he is running around as usual. He has quite recently had his pay for October. We can get along very well without him, as he is rather a fifth wheel to the coach; and if you want him in Carlisle, I will let him go to you."[6]

It is not clear whether or not Pratt brought him to his newly-opened school at Carlisle; Squint Eyes was never enrolled there as a student, although his young brother, called Rutherford B. Hayes, was in the first group of younger pupils to arrive from the west in October. Before leaving the Smithsonian, Squint Eyes apparently settled down to work in earnest. One of his drawings is dated November 8, 1879, just

three days after Baird offered to send him back. The youth produced the bulk of his art work here— twenty-two pictures—in many of them experimenting successfully with a new medium, water color (Color Plate 8). His curious photographic portrait (Plate 13) may have been made to illustrate a sign-language gesture. Or, it may date from the time when he is said to have dressed in Indian costume— here an oversized hide shirt fringed with scalps, dentalium and abalone earrings, bear claw necklace, and a wig somewhat askew—and acted as museum guide.

The Smithsonian Institution had two Indians, one named Tichkematse, a Cheyenne, and the other Geo. Tsaroff, a native of the Aleutian Islands, in charge of the ethnological hall. The presence of these Indians in the room attracted much attention, especially as they were able to explain intelligently the functions of many of the implements and other objects from a personal acquaintance with their use. . . . Tsaroff died of consumption in 1880, and Tichkematse returned to his tribe in the Indian Territory, where he exercised, in the interests of the Smithsonian Institution, his abilities as a taxidermist.[7]

Despite Squint Eyes' lapse of October, his contributions in a number of fields appear to merit the comment that at the Smithsonian "he was regarded as a great favorite on account of his willingness to

make himself useful and his knowledge of Indian life." Although he apparently remained in the east until after January 20, 1880, a month later his agent wrote from the Cheyenne and Arapaho Agency, " 'Titscomance' starts tomorrow to vicinity of Antelope Hills after Birds &c for the Smithsonian." That year Squint Eyes sent back birds and antlers of deer from the Indian Territory; the following year, a Cheyenne headdress and shield. On June 7, 1881, a wagon driven to Caldwell, Kansas, by another Fort Marion artist, Bear's Heart, took Squint Eyes on the first leg of an adventurous journey. At Fort Wingate, New Mexico, he was to meet Frank H. Cushing of the Smithsonion and begin a pack trip across the wilds of northern Arizona to the land of the legendary Coconinos.[8]

Cushing, who understood both the Zuñi tongue and the sign-language, had heard tales of the far-off place from the Zuñis, in westernmost New Mexico. He says:

Some Indian brothers told me of a most marvellous country toward the sunset, covered by waterless wastes and vast pine forests, and cut through by cañons as deep as the peaks of the Sierra Madre are high. "A veritable land of summer," they said, "deep down in a cold country, where sit our younger brothers, the Kuh-ni kwe....

"There are but few houses of them. They are wiser than the Navajos, and sit still in a cañon so deep that a little stone rolled from the top sounds like thunder ere it strikes the bottom. The road down is a whole day long, and only a little while in the middle of the day do you see the sun from below."[9]

For the Oz-like journey, Cushing received from Secretary Baird the services of his old informant Squint Eyes "as companion and assistant in the field." From General L. P. Bradley of Fort Wingate he obtained the use of pack animals—"two headstrong government mules, laden with beads and shells for trade, provisions and scientific apparatus"—and from the reluctant Zuñis a young man as guide who had journeyed to the land of the Coconinos before. Proceeding northwestward from Zuni, they traded for meat at a Navaho camp. To Squint Eyes the Plainsman, these sedentary Southwest Indians were an astonishment. "The strange, beehive-shaped, earth-covered hut, ... as well as the rude stick loom strung up in the shadow of a cedar-tree, at which a brightly dressed young squaw was diligently weaving, excited much curiosity and comment on the part of Tits-ke-mat-se."

Resuming their pilgrimage, the two Indians sped the miles through the country of flat-topped mesas with the telling of legends. "By such stories as this and dozens of folk-lore tales, often of great length,

was the journey enlivened or the camp entertained by my ever happy Indians." One day's end found them near a sandy Navaho cornfield studded with poles decorated with scarecrows of "worn-out dresses and blankets, deer-bones and clattering sticks." Cushing directed Squint Eyes to gather in some of the scarecrows to provide some needed camping equipment, intending to pay for them with beads later. This Squint Eyes proceeded to do, ignoring the singsong remonstrances of an outraged Navaho crone whose language he did not understand. After dark, tired as they were, they could not rest for a procession of curious Navaho visitors. "Tits-ke-mat-se was extremely suspicious of them. He called me a fool for entertaining them, and kept a close eye on the squaw of the party, who sat nearest the packages. He soon detected her secreting a bunch or two of bright red and blue beads, and silently informed me of it by sign language. I demanded of her, in the few Navaho words I could muster, the delivery of the beads, which so astonished the poor natives, ignorant as they were of signs, that they soon departed as they had come, one by one."

The next day began in an uproar when the mules were discovered in the Navaho cornfields, but a payment of trade-goods restored peace. On the trail once more, over a hot plain dotted with grotesque red erosion-carved monuments, Squint Eyes exhausted his horse chasing a fleet antelope. After a bargaining session with the Navahos, the worn-out mount was traded in on a new one.

Then Squint Eyes saw the pueblos of the Hopis, for the route lay through cliff-perching Walpi and age-old Oraibi. A third young Indian was added to the party as a guide. Midway across a hundred miles of the waterless Painted Desert, Cushing discovered at sunset that the Indians, relying upon the good omen of the dance which they had witnessed at Oraibi, had been careless with the supply of water. With drawn pistol Cushing protected the one scant waterbag and ordered a night march with all four men walking, to spare the animals. Squint Eyes quietly fell behind and mounted his horse. With sixty miles of desert yet to go, Cushing was desperate, and again Squint Eyes found himself looking into the barrel of the pistol. The three walking Indians gradually dropped behind, and at length Cushing discovered them sleeping—"all but Tits-ke-mat-se, who in despair was watching alone in the moonlight, faithfully mindful of the pistol I wore, yet not daring to disturb the less obedient sleepers." The night march continued into a glaring and thirsty day until water was found at last.

Presently the little party reached the land of the

Coconinos, who call themselves Havasupai, People of the Willows. The travelers found a perilous trail leading twenty miles down through the canyon of Cataract Creek, a tributary of the Colorado River. In a gorge seven miles south of the Grand Canyon was a spring-fed garden oasis—thirty wattled huts, occupied by the 235 people of the Havasupais, 3,000 feet below the level of the surrounding plain.

After four successful days of ethnographic research, Cushing sent his Hopi and Zuñi Indians back to their pueblos. In the company of Squint Eyes and a prospector taken on as guide, he proceeded 115 miles south to Whipple Barracks to investigate archaeological sites near Prescott and Fort Verde. Some thirty miles north of Prescott, the Cheyenne explored ancient dwellings of his race perhaps never before seen by the eye of a white man. "Between Camp Hua-la-pai (Walapai), in Western Arizona, and the cliff ruins of the Río Verde, [Cushing] discovered a remarkable series of mesa strongholds, exhibiting a crude form of what he regarded as incipient Pueblo architecture."

Secretary Baird commented that Squint Eyes that year "rendered very important service as an assistant in making ethnological collections under the direction of Mr. Cushing and of Mr. James Stevenson." Not only these two luminaries in the budding science of anthropology, but others such as Mathilda Stevenson, Cosmos Mendeleff, and Captain John G. Bourke were gathered to study the Zuñis concurrently with Tichkematse's stay there after the journey into Arizona. With his customary adaptability, the Cheyenne ethnographic assistant became a Southwest Indian pro tem. Captain Bourke's observant eye caught the irony of this bit of by-play at the close of an afternoon of pageantry attending the procession of the Little God of Fire. He recorded in his diary for November 26:

> The last rays of a golden sun were now flowing back from the sandstone battlements of Toyalani [the sacred mountain]; the bleating herds trotting slowly to their fields; children in swarms chasing each other across the streets; and lordly Navajoes, wrapped in blankets whose gorgeous hues rivalled those of the Sun God, squatted upon fences or housetops.
>
> It was a scene of savage beauty and savage characteristics. Tits-komatski, Cushing's Cheyenne Indian, educated at Hampton, Virginia, yielding to the fascination of the occasion, threw aside the habiliments of Civilization and appeared in the savage adornments of red paint and Navajo blankets.

Before he returned home, Squint Eyes once again threw aside, if not the habiliments, at least the approved customs, of civilization. The records do not

reveal whether by some happy coincidence he accompanied Colonel E. A. Carr's command from Fort Apache, Arizona, 150 miles southeast of Prescott, on the march to Cibecue that resulted in the fight with the Apaches on August 30, or whether on the following day he was by chance in the fort when the Apaches made a half-hearted attempt to take it. The newspaper at the Cheyenne and Arapaho Agency provides the only clue to what took place:

Titsecomanse, a Cheyenne Indian who went to New Mexico last spring in the interest of the Smithsonian Institution, has returned. He traveled along with a company of soldiers and relates the story of a shrap [*sic*] fight with the Apaches at White Mountain. In this encounter he forgot all about his bugs and went in for military glory. The battle resulted in the loss of several on each side. Our naturalist killed one Apache, whose scalp he brought home and now exhibits with great pride. He does not fancy bug hunting among hostile Indians and says he has explored New Mexico to his entire satisfaction.

Sometime in this decade he was married to Hairy Face, or Little Woman, by Indian custom. She bore him two or three children who did not live long. He tried farming awhile, and then he grasped an opportunity born of the travail of the Southern Cheyennes. The reservation was seized with a festering unrest that came to a head under an extraordinarily incompetent agent. The citizens of Kansas mobilized against an anticipated uprising and invasion by the Indians on their southern border. The President sent Philip H. Sheridan, Lieutenant General of the Army, to the Cheyenne agency. He arrived July 15, 1885, and on July 24 he reported, "The speedy and firm action of the President in redressing the grievous wrongs that had been done the Cheyennes and Arapahos, and the enlistment of a number of the young men of their tribes as scouts, obliterated a trouble which came near being very serious."[10]

On July 22, 1885, Squint Eyes enlisted in Company B of the Indian Scouts at Fort Reno. Six months later he was a sergeant, and was stationed at Fort Supply, where he spent his remaining three years as a scout. In 1886 he saw service in connection with trouble between the Chickasaw Nation and the cowmen. After an honorable discharge, he stayed on in the area at Cantonment, Oklahoma, and took his allotment lands there in 1890 or 1891. In the allotment files he was allottee number 29, John Squint Eye, the name by which he was thenceforth known. When his wife died in 1891, he moved among the Northern Cheyennes and never lived in Oklahoma again, although sometimes he returned to visit. In

1891 he married Nellie (Bigthigh or Elk Woman), a Northern Cheyenne, by Indian custom at Pine Ridge Agency, South Dakota. After living two years at Pine Ridge, Squint Eyes returned to Army service November 7, 1893, when he enlisted at Fort Keogh, Montana, in Troop L, Eighth United States Regiment of Cavalry. Before he was honorably discharged, December 12, 1894, he had seen service in a tragicomic phase of the famous Coxey's Army episode that culminated in a march on the nation's capitol.[11]

Hogan's Montana army, consisting mainly of unemployed miners, organized at Butte in 1894 and attempted to get railroad transportation to St. Paul, Minnesota, as the start of their trip to Washington. They at length made off with a Northern Pacific train. After a chase from city to city in the best traditions of the Keystone Kops, the civil authorities gave up and troops were ordered out from Fort Keogh. Lieutenant Colonel J. H. Page, with six companies of infantry, proceeded to Forsyth and surprised Hogan's army, taking 331 prisoners on April 26. When the men were tried, the only charge was contempt of court. With his talent for turning up where the action was, cavalryman Squint Eyes managed to take part in this infantry operation.[12]

From the time of his discharge until the year of his death, Squint Eyes gave his occupation as farmer or rancher. He lived for a while in a house at the Tongue River Agency, Lame Deer, Montana, and later on a ranch of his own a few miles out of town among the rocky, pine-dotted hills. In 1911 he applied for, and in the following year received, a patent in fee that would release him from the restrictions placed on Indians in handling their allotments. At this time he owned about sixty head of cattle and thirty-eight head of horses. He wanted to sell his land in Oklahoma and invest the proceeds in additional stock. Said his agent at Lame Deer, "John Squinteye . . . owns considerable property. He is, I believe, of all Indians living upon this Reservation the most competent to handle his own affairs. . . . Squinteye is industrious, and, to a reasonable extent, provident. He has a good appreciation of values, and . . . I recommend that favorable consideration be given his application.[13]

In 1905 Squint Eyes had a one-year term on the police force, as a private and then as second lieutenant. Nellie bore him two or three children who died while they were young. When one of them, a girl of eight or ten years, was suffering from tuberculosis in 1906, a Buffalo ceremony was pledged for her curing. In a special sweat lodge in the Rosebud River bottoms, six Cheyenne holy men conducted

the rite that culminated in the sprinkling of water on hot stones, both to purify the worshippers and to bring healing to Squint Eyes' daughter.

"She lived for about three years after these ceremonies and then died of tuberculosis. At her request her little dog and her saddle pony were killed at her grave, so that they might go with her"—up the Milky Way to Sehan, the Place of the Dead.[14]

Squint Eyes augmented his family by adopting as his daughter Bessie Americanhorse, who was born in 1905; but in 1924 or 1925 he again lost his wife by death. In 1929 he was married to Josie Whistling Elk or Stronglefthand, a Northern Cheyenne. This time there was a ceremony before Justice of the Peace A. J. Freeman at Forsyth. Squint Eyes received a military pension of fifty dollars a month for the last eight months of his life, granted because of advanced age. He died November 7, 1932, at Lame Deer, leaving his entire estate to his wife by a will he had signed himself, just as he signed all his papers.[15]

By virtue of a high degree of adaptability, intelligence, and steadfastness, Squint Eyes had solved the dilemma of reservation living—how to follow the white man's road and yet remain genuinely Indian. Few men of his day could boast of rubbing shoulders with Indians of as many tribes as Squint Eyes had known. He had worked with an Aleut from the northwesternmost tip of the United States and visited the Seminoles in the southeastern extremity. He had traveled with a Zuñi and a Hopi, and had married into the Northern Cheyennes. He had camped with the Havasupais and traded with the Navahos. He went to school with Arikaras, Mandans, Gros Ventres, and Sioux. He was imprisoned with Arapahos, Kiowas, Comanches, and a Caddo. He fought the Utes, the Osages, and the Apaches, and he took part in police action against the Chickasaws and the Southern Cheyennes.

He had warred with the white man, too, but there was no charge against him in the original list of prisoners of that war. For eleven of the Cheyennes there was good evidence of complicity in known raids. Yet, for the most notorious raid of all, only seven of the twenty-one participants had been apprehended, including the artists Bear's Heart, Chief Killer, Cohoe, and White Man. The raid took place in northwestern Kansas on the Smoky Hill River stage route on September 11, 1874. Five members of a family of emigrants named German were cruelly put to death and four girls were carried off into an ignominious captivity. Fifty years after the raid, the oldest sister, Catherine, gave an account of her captivity to her niece, who in 1927 published the story.

A copy of this book came into the hands of Mrs. Rodolphe Petter, wife of a Mennonite missionary who lived with the Cheyennes for fifty-six years. Mrs. Petter, long a resident of Lame Deer, can best conclude the story of Squint Eyes, whose Cheyenne name she spells phonetically as Tozcemazen:

He came to Montana and had some property so that a nice modern house was built for him in this Lame Deer valley, now used by John Woodenlegs, president of the Tribal Council. Tozcemazen always preferred a tepee to a modern house with several rooms.

He was a tame, meek Indian and became a Christian. One day he and another Indian by the name of Sweet medicine visited in my office. I had been reading Mrs. Grace E. Meredith's story, "Girl Captives of the Cheyennes," so began to tell that gruesome story. Tozcemazen became so distressed tho I had not indicated in any way that I suspected he was in the raid—perspiration poured out of his veins as he listened, and suddenly he got up and escaped outside. Sweetmedicine smiled and said, "He was really guilty. It is a true story" . . . Tozcemazen came and asked to be instructed for baptism which led him to confess his past sins and receive forgiveness and assu[r]ance of life eternal. It was an impressive service The records show that Squinteyes was baptized on April 7, 1929. We never questioned him about the raid.[16]

[1] List of Cheyenne Indians held as Prisoners, at Cheyenne Agency, Ind. Tr., OHSIA, C&A–Indian Prisoners; Pratt, *SMC*, XIX, 207.

[2] "The Seminoles," *DSP*, [1879], PP; Spencer F. Baird, Report, Jan., 1881, *ARSI*, 1880, 68; "Indian Students at the White House," n.p., n.d., PP; H. C. Roman Nose, "Experiences of . . . ," *SN*, Vol. I, No. 9, [1].

[3] Lt. R. H. Pratt, [Report on visit to Florida Seminoles], Aug. 20, 1879, 50 Cong., 1 sess., *Sen. Exec. Doc. No. 139* (Serial 2513), 10; "The Seminoles," *DSP*, [1879], PP; Pratt to wife, July 1, 1879, PP; Pratt, *Battlefield and Classroom*, 205–12; *CT*, Vol. III, No. 8 (Dec. 10, 1881), [4]; Pratt to Hayt, July 19, 1879, NA, OIA, Letters Received, Miscellaneous, P750–79. Pratt's original report, cited as NA, OIA, Letters Received, Union P872–79, is reproduced, annotated, and accompanied by the original drawings, several letters, and a bibliography in William C. Sturtevant, "R. H. Pratt's Report on the Seminole in 1879," *The Florida Anthropologist*, Vol. IX, No. 1 (Mar., 1956). For data on Baird, see David Starr Jordan and Jessie Knight Jordan, "Spencer Fullerton Baird," *DAB*, I, 513–15.

[4] Garrick Mallery, *Introduction to the Study of Sign Language among the North American Indians*, 17, 19–36, 58; *ibid.*, "Sign Language among the North American Indians," 1st *ARBAE*, 1879–80 (1881), 403; Mrs. Margaret Blaker to author, May 4, 1965. For data on Cushing, see Walter Hough, "Frank Hamilton Cushing," *DAB*, IV, 630.

[5] Miss E. A. Prall to Pratt, Aug. 23 and Oct. 27, 1879, PP.

[6] Spencer F. Baird to Pratt, Nov. 5, 1879, PP.

[7] Pratt to Commissioner, Nov. 13, 1879, NA, OIA, Letters Received, Miscellaneous, P1182–79, 14; Spencer F. Baird, Report, *ARSI*, 1881, 40.

[8] *CT*, Feb. 25, 1881, [5]; *CT*, June 10, 1881, [1]; Pratt to Miles, Jan. 20, 1880, OHSIA, C&A–Indian Prisoners; Miles to Pratt, Feb. 25, 1880, PP; Baird, *ARSI*, 1880, 125; birdskins, cat. nos. 79981–79984 (Division of Birds), and antlers (Division of Mammals); *ibid.*, 1881, 155: headdress, cat. no. MNH422C; shield—diameter 16 inches, rawhide, with buckskin cover painted yellow,

with personal and totemic designs, streamer of split buffalo hide dyed red and ornamented with flicker skin, eagle feathers and scalp locks wrapped with red flannel (Office of Anthropology).

[9] The following account of the trip is drawn from F. H. Cushing, "Nation of the Willows," *Atlantic Monthly*, L, No. 299, 362–74; *ibid.*, No. 300, 541; J. W. Powell, Report, 3d *ARBAE*, 1881–82, xviii–xix; Baird, *ARSI*, 1880, 40; *CT*, Jan. 10, 1882, [6]; Captain John G. Bourke, Diaries, MS, LIII (Nov. 26, 1881), 17, The United States Military Academy Library, Special Collections Division, West Point, N. Y.

[10] Military Pension Files, NA, Record Group 15B, Indian Scout 14,084; Sheridan to the President, July 24, 1885, in "Report of the Secretary of War," I, 49 Cong. 1 sess. *House Exec. Doc. No. 1*, Part II (Serial 2369), 60.

[11] Military Pension Files, NA, Record Group 15B, Indian Scout 14,084; Allotment file No. 29, John Squint Eye, Concho Agency, Concho, Okla.; Indian Census Rolls, NA, OIA, C&A Agency, Cheyennes, June 30, 1892, no. 675, 1893, no. 474.

[12] Donald L. McMurry, *Coxey's Army*, 199–204.

[13] Military Pension Files, NA, Record Group 15B, Indian Scout 14,084; Mrs. John Stands in Timber, oral communication to author, Sept. 11, 1968; Supt. J. R. Eddy to Supt. W. B. Freer of C&A Agency, Sept. 15, 1911, in Family Histories file, John Squinteye, Northern Cheyenne Agency, Lame Deer, Mont., Allotment file No. 29, John Squint Eyes, Federal Records Center, Fort Worth, Tex., BIA, Accession No. 69a111.

[14] Military Pension Files, NA, Record Group 15B, Indian Scout 14,084; Allotment file No. 29, John Squint Eye, Concho Agency, Concho, Okla.; Peter J. Powell, *Sweet Medicine: the Continuing Role of the Sacred Arrows, the Sun Dance, and the Sacred Buffalo Hat in Northern Cheyenne History*, I, 324–25; George Bird Grinnell, "A Buffalo Sweatlodge," *AA*, n.s. Vol. XXI, No. 4, p. 361.

[15] Allotment file No. 29, John Squint Eye, Concho Agency, Concho, Okla.; Military Pension Files, NA, Record Group 15B, Indian Scout 14,084.

[16] Mrs. Rodolphe Petter to author, Oct. 6, 1959.

WOHAW, the Warrior

Name on drawings: Wohaw.[1]

Names on Pratt's list: Beef [in the sense of a beef animal; translation of Kiowa name], Wohaw.

Tribe: Kiowa.

Date of birth: 1855.

Charges listed against him: Participated in the murder of Manuel Ortego and Lucien Munos [1874]. Was in the party killing Jacob Dilsey [1873].

Another incident of early life: Imprisoned at Fort Sill.

Dependents at time of arrest: Wife and child.

Rank at time of arrest: Warrior.

Place and date of arrest: Cheyenne Agency, Indian Territory; October 3, 1874.

Height and weight, July 9, 1877: 5′ 4½″; 133 lbs. 8 oz.

At Fort Marion, Florida: Arrived for imprisonment May 21, 1875.

Departure for reservation: April 11, 1878; there he was a pupil at the agency school, policeman, cavalryman, traditionalist, and warrior in pageant.

Allotment number: 2,537.

Death: Died on October 29, 1924, in the home of Hunting Horse (Tsatoke). Interred in a marked grave in Saddle Mountain Baptist cemetery.

Relatives: Father Tsokeahtine, a Kiowa-Apache. Mother, Tsokeahquodle? or Tsomah? Wives, Kodlemah, died 1875–78; Ahtoneah (Found), widow of Fort Marion prisoner Sun, married by 1879 or 1880, died 1923; Chahtabein, Mexican captive, divorced before 1900. Sons, Sawno, born 1881, died 1901; Gilbert (Ahdokobo), born 1883; and Siddonety, born 1886, died 1914. Daughter, Aukaupausy. Five other children died while small.

Number of pieces and location of extant art: 1 BAEC; 48 Missouri; 2 USNMC. Total, 51.

AT SIXTY years of age, Wohaw declared stoutly, "I am no coward; I'm a warrior." At eighteen years, as the chief Big Bow alleged, Wohaw "was in the party killing Jacob Dilsey on the North Fork of the Canadian River, below Camp Supply, near Cottonwood Grove I. T. Nov. 21, 1873." The prominent war-leader Bad Eye (Bird Chief) headed the party that included the chief Woman's Heart. Five of the seven participants, among them Wohaw, paid for this murder by incarceration at Fort Marion.

The story of the killing runs: "A party of 3 English gentlemen, with Tommy Levi [or Levi Thomas], scout [at Camp Supply], and Jacob Dilsen [sic], teamster, were hunting turkeys . . . , and Dilzen [sic] who was sent back for provisions with a wagon load of turkeys was killed and burned in his own wagon. . . . Levi says a party of seven Kiowas were encamped near them for several days, and that when Dilsen left, the Kiowas followed him."

The next year, testified Chief Kicking Bird, Wohaw "participated in the murder of Manuel Ortego and Lucien Munos near Dr. J. J. Sturms on the Little Washita Ind. Ty. Aug. 22 1874." Events leading up to this incident in the Anadarko Affair of August 22 were related above in connection with White Horse, the reputed leader in the killings.[2]

Following this incident, Wohaw appears to have abandoned White Horse, who shrewdly returned to the agency fold, and to have thrown in his lot with his former leaders and the irreconcilables, a large party of whom fled west. After a month of deprivation and apprehension the party split on a vote to continue to the Staked Plains of Texas. Some 150 people turned back near the Antelope Hills, including four famous chiefs—Satanta, Big Tree (out on parole), Woman's Heart, and Double Vision—and the war leader Bad Eye. These Kiowas, intent on surrendering en masse to the military, surprisingly chose to do so at the Cheyenne and Arapaho Agency at Darlington. Various explanations have been given for this gambit: that they hoped for greater leniency than at their own agency; that Satanta, Big Tree, and Woman's Heart were outlawed at Fort Sill; that the recollections of the fort, as the Kiowas themselves said, were not pleasant to them—"things were so mixed there." Big Tree was sent in as a feeler on September 29; on October 3 the others followed, gave up their arms, and became prisoners of war—among them the nineteen-year-old Wohaw. After a week of submitting to the detested daily roll-call, the Kiowas were sent to their own agency at Fort Sill after all. On December 22, 1874, "Who-haw" was removed from the ice house prison and joined the more notable miscreants, who were manacled

hand and foot in the basement of the Post guard-house. After seven long months of captivity, six of the prisoners from Darlington—Wohaw, Woman's Heart, Double Vision, Bad Eye, Bear in the Clouds, and Coming to the Grove—were among the twenty-seven Kiowas shipped off to Florida (Plate 6).[3]

In prison, Wohaw learned to write his name. He produced nearly all of his drawings in January of 1877. One of these efforts was purely and uniquely symbolic (Color Plate 9). It suggests that the artist had comprehended his position bridging two worlds, that he knew he must accept the situation, and that he foresaw a future of raising crops and livestock. Gone was the buffalo-chase of Plate 39. However, on his return to the reservation he proved unable to act on his knowledge for long at a time. He began to shuttle back and forth between his two worlds. In less than seven months, George Fox said of him, "Wo-han [sic] held up quite a long while, and even went to school with the children here, but he could not hold out; he got into a scrape which rather disgraced him, he left school, and now wanders around almost worthless; he wears his uniform [from Fort Marion], but also a blanket and G-string."[4]

Two months later the agent reported him in school again and showing a desire to learn. By July 25, 1879, he had transferred his efforts to the Agency Police, where he was listed as a private at five dollars a month. There is conflicting evidence on the reason for the termination of his service on September 30, 1881; he was discharged, "to reorganize the force," or he resigned, "tired of the service." Now for two years there were only negative reports on Wohaw's progress on the white road, and for eight years after that, silence.[5]

When a body of Indians were organized as Troop L, Seventh Regiment of United States Cavalry, Wohaw found a facet of the white man's culture that, like police work, appealed to a middle-aged warrior. He enlisted at Fort Sill November 10, 1891, and camped with other troopers. Injured in line of duty and honorably discharged February 9, 1895, at Fort Sill, Wohaw quitted the white man's road for good and moved back to his old home, west in Saddle Mountain community. The plain fact is that he and many of his people wanted to be not white but Indian—a fact so incredible to the whites that only today is it beginning to be comprehended. Wohaw was able to live the Indian life that he loved—Indian in customs, dress, and religion. He was one of the early members of the Ohoma Society, the Kiowa version of the Omaha Dance. He danced wielding a captured Army saber. He espoused the Ghost Dance faith that looked forward to a restoration of the

Indians' inheritance and a return of their departed friends and family members. He obviously intended neither to farm nor to raise stock, for when he took his allotment of 160 acres in 1900 (number 2,537), he chose rough, mountainous, boulder-strewn land. He never lived there, but first leased his land to a white farmer and then obtained official permission to sell half of it in order to improve his two-room, 14-by-28-foot box house, located on his son Gilbert's land. Such a house was built by the government for Indians who would pay fifty dollars for labor. When he made an application in 1918 for a pension of six dollars a month for the service injury, he was still able to sign his name. At the time of his death, October 29, 1924, he was living on Gilbert's allotment and visiting at the home of Gilbert's father-in-law, Hunting Horse (Tsatoke).[6]

Meanwhile, Wohaw's domestic status has been in a state of flux. This son of a Kiowa mother and a Kiowa-Apache father (not to be confused with Apache proper) had acquired a wife, Kodlemah, and a child before he went to Fort Marion in 1875. Kodlemah died while Wohaw was in prison. After he returned home he was married by Indian custom by 1879 or 1880 to Ahtoneah (Found), the widow of the first prisoner to die in St. Augustine, Sun (Coabotete). Wohaw thus became stepfather to Stephen

Kotay, Sun's child. By Ahtoneah, Wohaw had sons Sawno, 1881–1901, and Gilbert Wohaw (Ahdokobo), who was born in 1883. Wohaw took as a plural wife by Indian custom Chahtabein, a Mexican who had been captured as a child by the Kiowas and reared among them. By the time of their divorce by Indian custom, sometime before 1900, they had a daughter Aukaupausy and a son Siddonety, 1886–1914. Wohaw's other five children died when small. He survived Ahtoneah by eighteen months, after some forty-three years of marriage, and died unmarried but with Gilbert and Aukaupausy surviving him.[7]

Obscure as his life was, Wohaw probably had one claim to fame—that he was the last warrior from buffalo-hunting days to be wounded in a battle with United States troops. It came about in this way. During World War I, in 1917 or 1918, the authorities at Fort Sill decided to entertain the troops and the public by staging a free pageant in the form of a sham battle. At the site selected just below the Old Post Hospital, the wide bottom of Medicine Bluff Creek ran between high banks. Against the north bank the soldiers of the post built a stockade and barracks, with colors flying high above the tops of the trees that lined the banks. The sandy creek bed was dry and strewn with boulders, some bigger

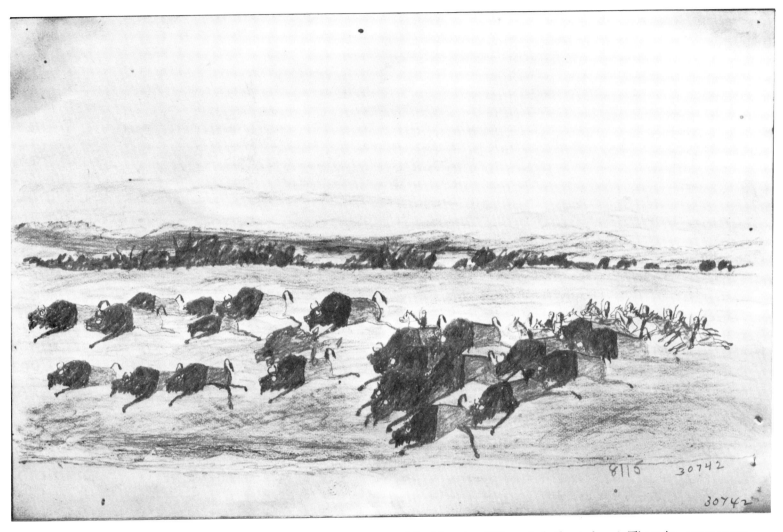

Plate 39. By Wohaw, Kiowa, June 30–July 21, 1877 (*Courtesy of Smithsonian Office of Anthropology*). There is a great sense of urgency in this scene representing the beginning of the chase. The hunters have overtaken the herd and are merging with the stampede to cut out their individual quarry.

than a man's head. Seats hewn out of the 150-foot-high south bank afforded a beautiful vantage point for the spectators to view the "fort" 250 yards away.

Many Kiowas were called in from the surrounding countryside to play the part of the attacking enemy. By the appointed hour in the afternoon, young men were eagerly thronging the brush thicket to the west that concealed them from general view. They were dressed in old-style war costumes with feathers, some almost naked except for body-paint, and carried shields, arrows, or spears. All were equipped with guns with blank shells or cartridges, like the soldier-defenders inside the fort.

The time drew near; a sentry in blue was walking his beat in front of the stockade, while the rest of the blue-coated troopers remained inside. Three or four thousand spectators filled the hillside seats or stood on the edges of the crowd. From the top of the bank, had they looked backward across the old quadrangle of Fort Sill, they might have glimpsed the Post Guardhouse where Wohaw and White Horse were confined in double chains some forty years before. Now Wohaw, an old man of more than threescore years, wanted to fight the soldiers in the sham battle. Some thought he was too old; it would be hazardous, dodging the shod hooves of horses, avoiding the swinging sabers of the troopers, and running over the

rock-strewn stream bed. But Wohaw insisted, "I am no coward; I want to fight." "All right," they said, "but stay in the back so you won't get hurt." So they dressed him up, complete with paint and an upstanding eagle feather.

Now some soldier-scouts come loping up to the stockade on horses and speak to the sentry. He throws open the gate so that they may give the alarm: Indians have been sighted. A bugle sounds and the men inside, preparing for attack, take their places at lookout points on the stockade. A lone Indian, undetected as he runs from tree to tree, scouts the fort. The charge of the main body of Indians follows and the battle begins.

A few soldiers fire. The Indians return the fire and run toward the stockade. Several soldiers fall and their places are taken by their comrades. One soldier slips out under cover of the gun smoke and rides eastward to summon help from another fort. The fight grows thicker. The stockade is on fire. Indians swarm to the wall and shoot in through the gun loops. A trumpet sounds—the cavalry is coming to the rescue, shooting as they ride. The Indians fall back to the middle of the creek bed and fight hand to hand with the blue-coats of the fort. Many from both sides fall. The cavalrymen, wielding sabers that flash in the sun, pursue the Indians who run to the timber for

cover. The fight is almost over. Soldiers are riding in every direction singling out Indians. There in the rocky creek bed the old man Wohaw is trying to get up, the eagle plume still on his head. He is bleeding.

Soldiers picked him up, carried him off, and took him by army ambulance to the Post Hospital. Three or four medical officers, after plucking off his eagle feather and washing away his face paint, examined a bloody gash on the side of his head near the crown. As they stood talking among themselves, the patient was trying to find out the cause of his wound. He asked the officers, "Is it bullet? maybe bullet," and one doctor answered, "No, no. Seems to me it's a cut from a cavalry horse's shoe heel after you were run over retreating. When you fell the horse may have stepped on the side of your head and cut it. It is not too deep. If the horse had stepped on your head he might have crushed it. You will be all right after treatment. It was no bullet, as they were all shooting blanks. It may be a cut from a horse shoe, but it is not a saber or bullet wound."

Wohaw never did believe it was done by a horse. He said, "It's a crazed bullet." Many persons said to him, "We told you that you were too old to take part. Now you are hurt." But Wohaw replied, "It's O. K. I'm a warrior. I got wounded by fighting United States soldiers."[8]

[1] From the first, Pratt called the prisoner Wohaw or Beef, and after Wohaw's return the translation persisted in the form of Cattle, at least through 1880. In 1897, while Wohaw was still living, Mooney rendered his name Wohate (-te being a personal suffix in proper names), Cow. Yet in 1943 the Kiowa Delos K. Lonewolf called him Wohate, Wolf-robe. Today the Kiowa Guy Quoetone refers to him as Wohaw (Goohaw, Goo Kaw), Wolf-hide. Other Kiowas consulted denied Beef, Cattle, or Cow as translations of the name. It might be concluded that the white men had foisted an erroneous translation upon the Kiowa in 1875, were it not for the name-symbol for Wohaw drawn by a fellow-Kiowa prisoner and reproduced at the beginning of this biography. It clinches the meaning that the word *wohaw* held for nineteenth-century Kiowas, and at the same time suggests why this meaning dropped out of the Kiowa language. The drawing bears out Mooney's thesis that *woha*, cow, was "a jargon word used between Indians and whites and supposed by the Indians to be the English name, from the fact of having heard it used so frequently, in the form of 'whoa haw!' by the early emigrants and Santa Fé traders in driving their teams. The proper Kiowa word is *tsenbo*." The modern *Dictionary of Americanisms* concurs in this explanation of the derivation of *wohaw* as a colloquial Western term for beef or beef cattle. Perhaps the original meaning of this universal word dropped out of the Kiowa language because of its hybrid origin. It may have been retained by the Comanches, however, for today James Auchiah says that Wohaw (Wohawta, Wohawte) means Wolf Robe in Kiowa and Beef in Comanche. Pratt to Post Adjutant, Apr. 24, 1875, NA, WD, Letters Received, U.S. Army Commands, Department of the Missouri, 1875, S4/168/23; Employees in Indian Police Force, third quarter, 1879, OHSIA, Kiowa–Police; Census, Kiowa, Comanche, and Apache, 1879–80, p. 20, OHSIA, Kiowa–Census; Mooney, 17th *ARBAE*, 1895–96, Part I, 215, 424, 429; Lonewolf, List of Kiowa Prisoners, [1943], PP; Quoetone to author, [Feb., 1967]; Picture Words by Koba, BAEC; Mitford M. Mathews, ed., *A Dictionary of Americanisms on Historical Principles*, II, 1883; Auchiah, MS, Statement on Wo-haw (Wo-haw-ta; Wo-haw-te), Fort Sill Museum, U.S. Army, Fort Sill, Okla., files.

[2] Emory to Gen. Mackenzie, Mar. 30, 1875, NA, WD, Letters Received, U.S. Army Commands, Department of the Missouri, 1875, S6/168/23; *ibid.*, Pratt to Post Adjutant, Apr. 24, 1875, S4/168/23.

[3] Nye, *Carbine and Lance*, 282; Lt. Col. Neill to AAG, Oct. 1, 4, 1874; Neill to Gen. Pope, telegram, Oct. 3, 1874, as quoted in R. Williams to Col. Drum, Oct. 7, 1874, both in NA, WD, AGO, AG's Letters Received, File 2815, 1874; Agent Haworth, Report, Sept. 20, 1875, *ARCIA*, 1875, 272; Agent Miles, Report, Sept. 30, 1874, *ARCIA*, 1874, 236; Pratt, *SMC*, XIX, 204, 209, 213; Miles to Commissioner Smith, Oct. 5, 12, 1874, NA, OIA, Letters Received, Upper Arkansas Agency, 1874, M1208, M1229; Post Guard Books, 1874–Apr. 13, 1875, Dec. 22ff. entries, Fort Sill Museum, U.S. Army, Fort Sill, Okla.

[4] Sketchbook by Bear's Heart and others, Massachusetts Historical Society, for script autograph; [Fox] to Pratt, Dec. 15, 1878, *SW*, Vol. VIII, No. 2 (Feb., 1879), 19.

[5] Agent Hunt to Pratt, Feb. 12, 1879, PP; Employees in Indian Police Force, third quarter, 1879; Receipt Roll, Indian Police, Feb. 3, Mar., June, 1880; Changes in Indian Police, Dec. 31, 1881— all in OHSIA, Kiowa–Police; Record of Indian Police, NA, OIA, Statistics Division, 1880–82; Mason D. Pratt to father, July 11, 1882, PP, Etahdleuh to Pratt, Sept. 14, 1882, *MSt*, Vol. III, No. 3, Oct., 1882, [4]; Pratt to Daniel M. Fox, Dec. 1, 1883, PP.

[6] Guy Quoetone to author, [Feb., 1967], June 15, 1967; Pension Records, NA; George Zotom Otis to author, Apr. 25, 1965; Allotment file No. 2537 Kiowa, Anadarko Agency, Anadarko, Okla.; Rev. Linn Pauahty, oral communication to author, Aug. 21, 1969.

[7] Allotment file No. 2537 Kiowa; Family Record Book, Kiowa, Camanche [*sic*] and Apache Tribes, 1901, 109; Probate records —all at Anadarko Agency, Anadarko, Okla.; Pension Records, NA; Pratt to AG, July 19, 1875, OHSIA, Kiowa–Indian prisoners of war; Census, Kiowa, Comanche, and Apache, 1879–80, 82–83, OHSIA, Kiowa–Census; Guy Quoetone to author [Feb., 1967]; Pratt, *SMC*, XIX, 201–14.

[8] Gillett Griswold, "Old Fort Sill: the First Seven Years," *CO*, Vol. XXXVI, No. 1, Pl. opp. p. 2. The author is indebted to Guy Quoetone, who interpreted for Wohaw in the hospital, for this lively and revealing reminiscence. Quoetone to author, June 15, 1967. Sham battles were a part of Kiowa culture in the old war days and persisted in conjunction with the Sun Dance.

Cohoe, the Industrious

Name on drawings: Cohoe.
Names on Pratt's list: Broken Leg [more accurate translation of Cheyenne name, Lame], Cohoe.
Aliases: Moose or Elk, Mapera-mohe or Mohe.
Tribe: Cheyenne.
Date of birth: 1853.
Charge listed against him: Accomplice (pointed out by Big Moccasin and Medicine Water) in Germain [*sic*] murder [1874].

Other incidents of early life: Fought with Crows and Pawnees.
Dependents at time of arrest: Wife.
Rank at time of arrest: Warrior.
Place and date of arrest: Cheyenne Agency, Indian Territory, January 9, 1875.
Height and weight, July 9, 1877: 5′ 8¾″; 131 lbs. 8 oz.
At Fort Marion, Florida: Arrived for imprisonment May 21, 1875; while there, produced drawings in Plates 40 and 41.
At Hampton Institute, Virginia: Arrived for schooling April 14, 1878; baptized "Cohoe" March 1879; acquired name "Nohnicas."
At Lee, Massachusetts: Arrived for work on farm early in June, 1879.
At Carlisle Institute, Pennsylvania: Arrived for education October 7, 1879.
Departure for reservation: March 2, 1880; was a mill hand, teamster, brick molder, baker, farmer, butcher, trader's clerk, Army Scout, delegate to Washington,

and head of War Dancers Society while there; acquired name "William Cohoe."

Allotment number: 1,936.

Death: Died of kidney trouble on March 18, 1924, at his home near Bickford, Oklahoma.

Relatives: Father, Sleeping Bear. Mother, Plain Looking (Dadadone). Sister, Shaking Herself. Wives, Small Woman, survived him; Pelican, divorced. Children, Charles (Walking Coyote), born 1882; Bruce (Black Bird), born 1885; and a daughter who died young. Wives' sister's husband, Little Chief, a Fort Marion prisoner.

Number of pieces and location of extant art: 2 Mass. Hist.; 16 Petersen; 3 PP. Total 21.[1]

[1] For full biography and twelve of his drawings in color, see Cohoe, *A Cheyenne Sketchbook.*

Plate 40. By Cohoe, Cheyenne, September, 1876 *(Collection of Karen D. Petersen).* In technique this drawing ranks with the similar scenes in Plates 15 and 23. Cohoe concentrates his talents on the horse, naturalistic and well drawn, and on the turkey hanging from the saddle.

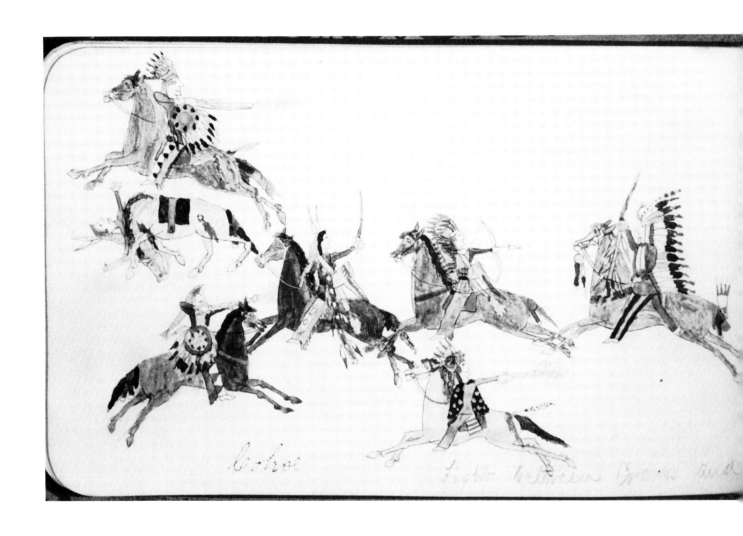

Cochise

Fight between Crow and

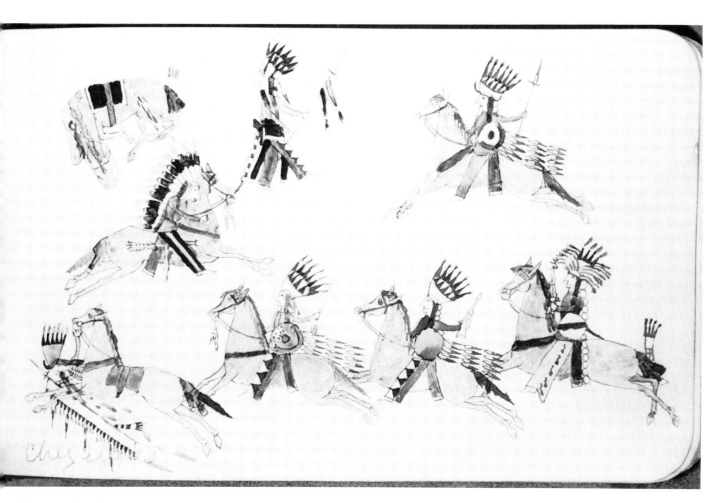

Plate 41. "Fight between Crows and Cheyennes," by Cohoe, Cheyenne, May 21, 1875–April 11, 1878 (*Courtesy of Yale University Library*). Most interesting is the central figure among the Crows (who are identifiable by their net-like hairdress). He well deserves the trailing shoulder-sash he wears as a recognition for bravery: he dares to ride into battle wielding only a saber. As he retreats, he defiantly flourishes the sword in one hand and a fresh scalp in the other. The abundant detail in this scene is characteristic of Cohoe.

Howling Wolf, the Nostalgic

Name on drawings: Howling Wolf.

Names on Pratt's list: Howling Wolf [translation of Cheyenne name], Honanistto.

Tribe: Cheyenne.

Date of birth: 1850.

Charge listed against him: Ringleader.

Other incidents of early life: Leader of raids; a dance director of Bowstring Society; fought with Osages.

Dependents at time of arrest: Wife and child.

Rank at time of arrest: Warrior.

Place and date of arrest: Cheyenne Agency, Indian Territory, April 3, 1875.

Height and weight, July 9, 1877: 5′ 9″; 161 lbs.

At Fort Marion, Florida: Arrived for imprisonment May 21, 1875; sent to Boston for treatment of eyes; became insubordinate; produced drawings in Plates 42 and 43.

Departure for reservation: April 11, 1878; was an employee at agency school, freighter, conservative, chief of "dog soldiers," malefactor, and entertainer there.

Allotment number: 2,102.

Death: Was killed in an automobile accident at Waurika, Oklahoma, on July 5, 1927.

Relatives: Father, Chief Minimic (Eagle Head), a Fort Marion prisoner. Mother, Shield (Hohanonivah). Brothers and sisters, Little Creek (Ohah) (male), Squirrel, Nistina. Wives, Bear, divorced; Magpie, divorced; Curly Hair (Mamakiaeh), died 1926. Sons, Red Bird (Maievis), born 1864, Little River (Ohah), born 1886, Jonathan, born 1900. Daughters, Shield

(Oakkinunnewa), born 1894, Feather. Six additional children died young. Stepsister Flying's husband, White Man, a Fort Marion artist.
Number of pieces and location of extant art: 28 Curtin; 8 Field Mus., jointly; 1 Mass. Hist.; 2 PP; 12 Richardson; 16 Yale U. Total, 67, including 8 jointly.[1]

[1] For full biography and twelve of his drawings in color, see Petersen, *Howling Wolf*, 21–64.

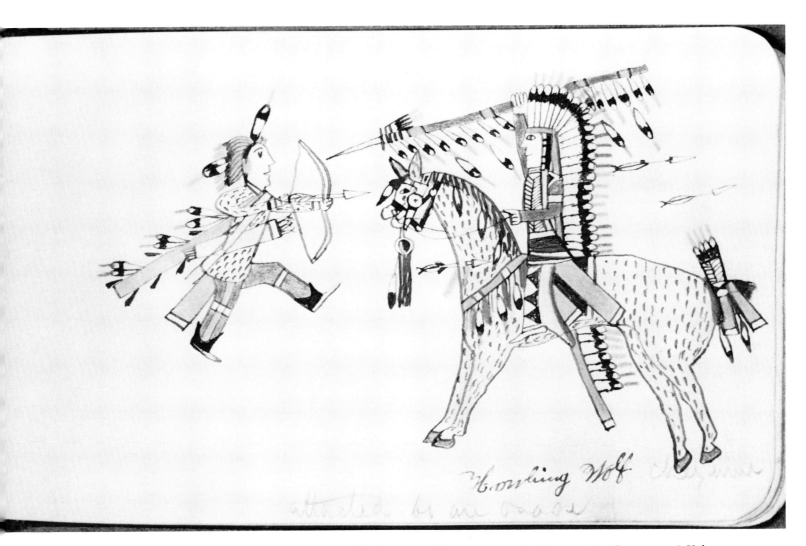

Plate 42. "attacted by an osage," by Howling Wolf, Cheyenne, May 21, 1875–April 11, 1878 *(Courtesy of Yale University Library).* The Osage at first glance appears to be weak in marksmanship. However, in accordance with the artistic conventions for distance, he is probably much further from his target than he appears to be. This drawing only hints at the technical proficiency that Howling Wolf was to manifest later.

Plate 43. By Howling Wolf, Cheyenne, July 13?, 1877 *(Courtesy of Massachusetts Historical Society).* "Letter from Howling Wolf to his father, Mininic [*sic*], describing his voyage from Fort Marion. It was written at sea, after leaving Savannah." Numbers on the drawing were identified as follows: 1, Fort Marion (striped lighthouse, watchtower, and cleated flagpole on ramparts); 2, Minimic, with his totem, the eagle; 3, 3, 3, 3, Fernandina, Port Royal, and other places at which the steamer touches; 4, Savannah, the dots indicating a great number of houses. There was a change of steamer, and the marks (–) are meant for footsteps to show that Howling Wolf walked from one steamer to the other; and 5, the Savannah steamer, "with Lieut. Zalinsky [*sic*] and Howling Wolf on board, the latter indicated by his totem."

Making Medicine, the Faithful

Name on drawings: Making Medicine.

Names on Pratt's list: Making Medicine [more accurate translation of Cheyenne name, Sun Dancer], Okuh-hatuh.

Alias: Bear Going Straight, Noksowist.

Tribe: Cheyenne.

Date of birth: 1844.

Charge listed against him: Ringleader.

Other incidents of early life: Officer of Bowstring Soldier Society; war leader; fought Osages, Utes, Otos, and Missouris.

Dependents at time of arrest: Wife and child.

Rank at time of arrest: Warrior.

Place and date of arrest: Cheyenne Agency, Indian Territory, April 3, 1875.

Height and weight, July 9, 1877: 6′ ¼″; 145 lbs.

At Fort Marion, Florida: Arrived for imprisonment May 21, 1875; was first sergeant in the company; taught archery; produced drawings in Color Plate 1 and Plates 14–21.

At Syracuse, New York: Arrived for orientation for education about April 17, 1878.

At Paris Hill, New York: Arrived for education in clergyman's home about May 20, 1878; expenses paid by Mrs. George Pendleton and daughters, Cincinnati, Ohio; baptized "David Pendleton" October 6, 1878 ("Oakerhater" sometimes added after this name); confirmed October 20, 1878; traveled to agency and brought back Carlisle recruits, his wife, and child;

ordained deacon June 7, 1881.

Departure for reservation: June 7, 1881; assisted in founding Episcopal mission at agency; active minister of Episcopal Church for fifty years.

Allotment number: 522.

Death: Died August 31, 1931, and was interred at Watonga, Oklahoma.

Relatives: Father, Sleeping Wolf. Mother, Mother Pendleton. Brothers, Wolf Tongue (Veokeih), Little Medicine (Mangositomai), a Fort Marion prisoner. Wives, Thunder (Nomee), married 1872, died 1880; Taking Off Dress (Nanessan), married and divorced by 1875; Smoking (Susie Anna Bent, Nahepo), married 1882, died 1890; White Buffalo (Minnie), married in 1897 or 1898. Children, Frank Pendleton, born 1905, and seven who died young.

Number of pieces and location of extant art: 45 BAEC; 19 Mass. Hist.; 3 PP; 1 St. Augustine Hist. Total, 68.[1]

[1] A full biography of Making Medicine is in preparation by the author.

VI. MINOR ARTISTS

THE artists have been classified as major or minor largely on the basis of quantity rather than quality of work. The minor artists are those with only two to five drawings to their credit, except for Packer, who did eleven of a quality that tipped the scales against him. The 15 minor artists made 6 per cent of the 749 identified drawings.

Most of the artists were either Cheyenne or Kiowa, both tribes among those well known for their traditional pictorial Plains art. But two of the minor artists, Packer and White Bear, were Arapaho. One of their drawings (Plate 50), was a joint effort.

Of the fifteen so-called minor artists, four died in the East or immediately following their return home. Two of the eleven survivors lived out their lives on the white man's road. Four others, after a few years' trial of the new way, returned to the Indian path. Two slipped out of the realm of recorded history immediately upon their return from Fort Marion.

Two fluctuated from one way of life to the other. The fifteenth man, after seven years on the white man's road, became the recognized leader of his people. In the usual pattern of people everywhere, the minor artists at Fort Marion ranged from progressive to conservative, with the majority well distributed between the extremes.

BUFFALO MEAT

Names on drawings: Buffalo Meat, Buffalo Meet.[1]
Names on Pratt's list: Buffalo Meat [translation of Cheyenne name], Oewotoh.
Tribe: Cheyenne.
Date of birth: 1847.
Charge listed against him: Ringleader.
Other incidents of early life: Fought the Osages.
Dependents at time of arrest: Wife and child.
Rank at time of arrest: Warrior.
Place and date of arrest: Cheyenne Agency, Indian Territory, April 3, 1875.
Height and weight, July 9, 1877: 5′ 8″; 152 lbs. 8 oz.
At Fort Marion, Florida: Arrived for imprisonment May 21, 1875; produced drawings in Plates 44 and 45 while there.

Departure for reservation: April 11, 1878. There he was a head chief of tribe, policeman, laborer for agent, worker at commissary, teamster, delegate to Washington, worker and deacon in Baptist Church; he took a mission-trip through East; he was adjudged competent to handle his own business affairs.
Allotment number: 444.
Death: He died of tuberculosis on October 2, 1917, at his home near Kingfisher, Oklahoma, and was interred at the Indian Mission at Kingfisher.
Relatives: Brother, Colt (Mookemewemiss). Wife, Earrings (Cooeveenoseaeh), married about 1867, survived him. Children, Raymond B. Meat (Black Eagle, Maker), born 1878; adopted daughter, Bull Woman (Lelie or Emma Jones, Otropiveahek), taken in 1870; and five who died young.
Number of pieces and location of extant art: 16 BAEC attributed to him but probably the work of three other artists; 3 Mass. Hist.; 2 Okla. Hist.; list, "Price Current," PP. Total, 21, including 16 of doubtful origin, plus "Price Current."

[1] The symbol above the name shows meat drying on a rack.

Plate 44. "Price Current," by Buffalo Meat, Cheyenne, May 21, 1875–April 11, 1878 *(Courtesy of Yale University Library)*. Buffalo Meat made a pictographic price list for articles that the prisoners could purchase in town. Pratt added the translation of some of the more obscure items.

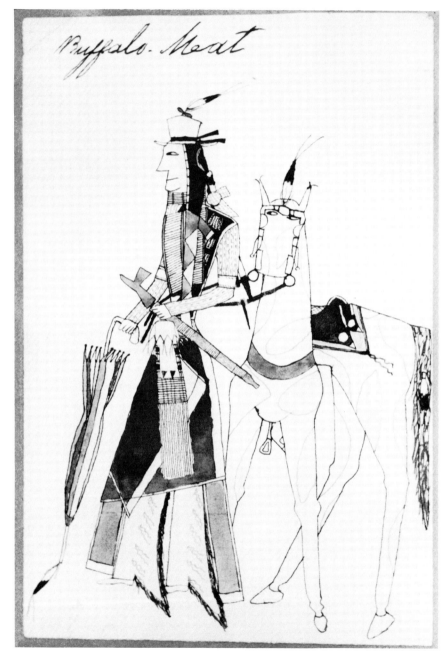

Plate 45. "Buffalo Meat (in his Sunday
clothes)," by Buffalo Meat, Cheyenne,
shortly before March 12, 1878 *(Courtesy
of Oklahoma Historical Society).* The
contrasts in this ludicrous scene are the
source of its humor. The imposing pipe
and pipe-bag contrast with the huge gaily
striped umbrella and the tiny hat. The
horse is reminiscent of a two-man comedy
act on skates, with the component parts
heading in different directions. The at-
tempt to employ a newly learned skill—
drawing the horse's head from the front—
heightens the impression of a synthetic
animal, but for the hindquarters the artist
reverts to tradition.

Buzzard

Name on drawings: Buzzard.

Names on Pratt's list: Buzzard [translation of Cheyenne name], Mohhewihkio.

Aliases: Black Lodge, Moqtaruhiyumeni.

Tribe: Cheyenne.

Date of birth: 1855.

Charge listed against him: Ringleader.

Dependents at time of arrest: None.

Rank at time of arrest: Warrior.

Place and date of arrest: Cheyenne Agency, Indian Territory, April 3, 1875.

Height and weight, July 9, 1877: 6' 1"; 172 lbs.

At Fort Marion, Florida: Arrived for imprisonment

May 21, 1875; while there he produced the drawing in Plate 46.

At Hampton Institute, Virginia: Arrived for schooling April 14, 1878; baptized "Howard Charlton" March, 1879; expenses paid by Mrs. Howard Charlton, New York City, and Mrs. Sara E. Charlton, Hamilton, Ontario, Canada.

At Lee, Massachusetts: Arrived for work on farm early in June, 1879.

At Carlisle Institute, Pennsylvania: Arrived for education October 7, 1879.

Departure for reservation: January 26, 1880.

Death: Died about 1881.

Relatives: Brother, Whirlwind.

Number of pieces and location of extant art: 1 Okla. Hist.; 2 PP. Total, 3.

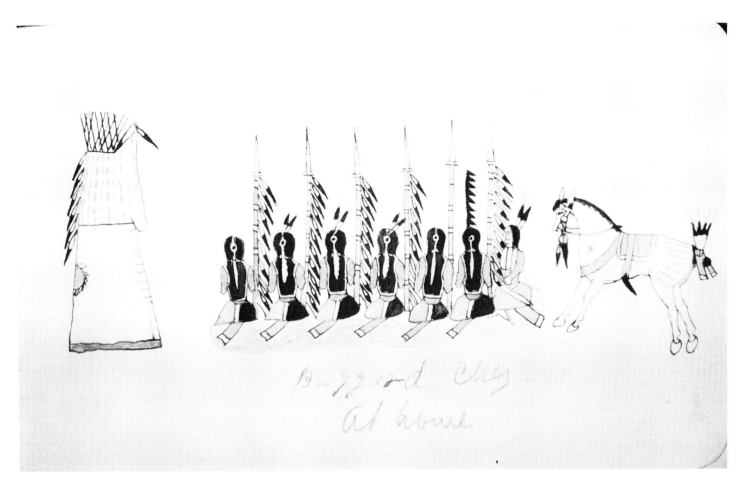

Plate 46. "At home," by Buzzard, Cheyenne, May 21, 1875–April 11, 1878 *(Courtesy of Yale University Library).* The feathered lances and the horse's accoutrements of war suggest that this is a meeting of members of a soldier society—perhaps its officers—taking instruction from an older member.

CHIEF KILLER

Name on drawings: Chief Killer.

Names on Pratt's list: Chief Killer [translation of Cheyenne name], Nohhunahwih.

Tribe: Cheyenne.

Date of birth: 1849.

Charge listed against him: Participated in the killing of the Germain [*sic*] parents and son and daughter, and in the carrying away into captivity of the four sisters [1874].

Other incidents of early life: Captured by Captain Pratt; imprisoned at Fort Sill.

Dependents at time of arrest: Wife and child.

Rank at time of arrest: Warrior.

Place and date of arrest: Staked Plains, Texas, Sept. 24, 1874.

Height and weight, July 9, 1877: 5′ 5½″; 131 lbs.

At Fort Marion, Florida: Arrived for imprisonment May 21, 1875; while there he produced the drawing in Plate 47.

Departure for reservation: April 11, 1878; there he was a brick-molder, butcher, policeman, herder, and teamster.

Allotment number: 2,084.

Death: Died on July 24, 1922, and was interred in the cemetery at Concho, Oklahoma.

Relatives: Father, Fast Wolf. Mother, Nearly. Uncle, Chief Counting Coup. Stepfather, Medicine Water, a Fort Marion prisoner. Brother, Bald Eagle. Wife, Old Coffee, died in 1912. Children, Maude (Feather), born 1868; Naomi (Lame), born 1878; and a son who died young.

Number of pieces and location of extant art: 2 PP. Total, 2.

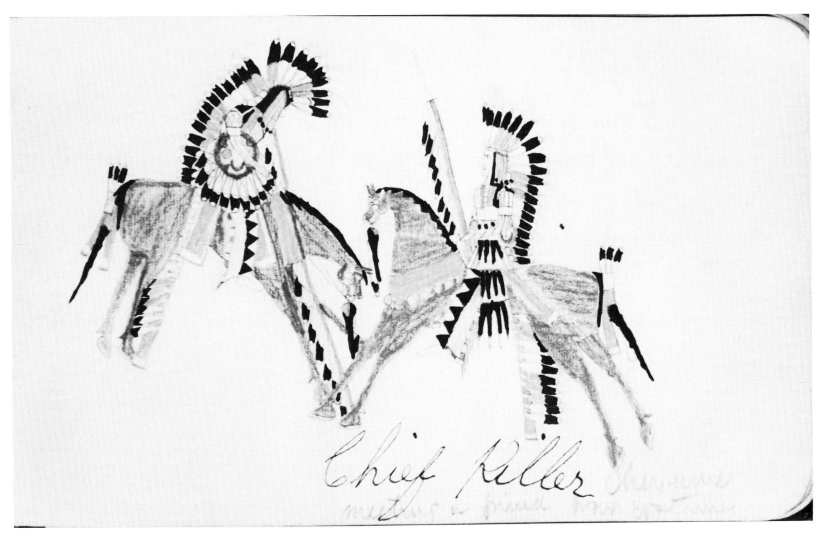

Plate 47. "meeting a friend war costume," by Chief Killer, Cheyenne, May 21, 1875–April 11, 1878 *(Courtesy of Yale University Library).* The treatment of costume material is strongly reminiscent of the Contemporary school of Indian art.

LITTLE CHIEF

Name on drawings: Little Chief.
Names on Pratt's list: Little Chief [translation of Cheyenne name], Koweonarre.
Tribe: Cheyenne.
Date of birth: 1854.
Charge listed against him: Ringleader.
Other incidents of early life: Fought the Osages.
Dependents at time of arrest: None.
Rank at time of arrest: Warrior.
Place and date of arrest: Cheyenne Agency, Indian Territory, April 13, 1875.
Height and weight, July 9, 1877: 5' 10"; 144 lbs. 8 oz.
At Fort Marion, Florida: Arrived for imprisonment May 21, 1875; while there he produced the drawing in Plate 48.
At Hampton Institute, Virginia: Arrived for schooling April 14, 1878; while there he adopted the name "William Little Chief."
At Lee, Massachusetts: Arrived for work on farm early June, 1879.
At Carlisle Institute, Pennsylvania: Arrived for education October 7, 1879.
Departure for reservation: January 26, 1880. While there he was a physician's apprentice and interpreter, Army Scout, policeman, interpreter for a preacher in the Dutch Reformed Church at Colony, member of the War Dancers Society, member of Mennonite Church, farmer, and stock raiser.
Allotment number: 880.
Death: He died on December 24 or 25, 1923, at Clinton, Oklahoma.
Relatives: Father, Chief Little Chief. Mother, Lightning. Foster father, Star, a Fort Marion prisoner. Uncle, Chief Heap of Birds, a Fort Marion prisoner. Wives, Standing Twenty, married and died 1880; Anna Gentle Horse (Ape Walker), married 1881, survived him. Daughter, Richanda (Magpie), born 1882, and one who died young. Anna's sisters' husband, Cohoe, a Fort Marion prisoner.
Number of pieces and location of extant art: 2 PP. Total, 2.

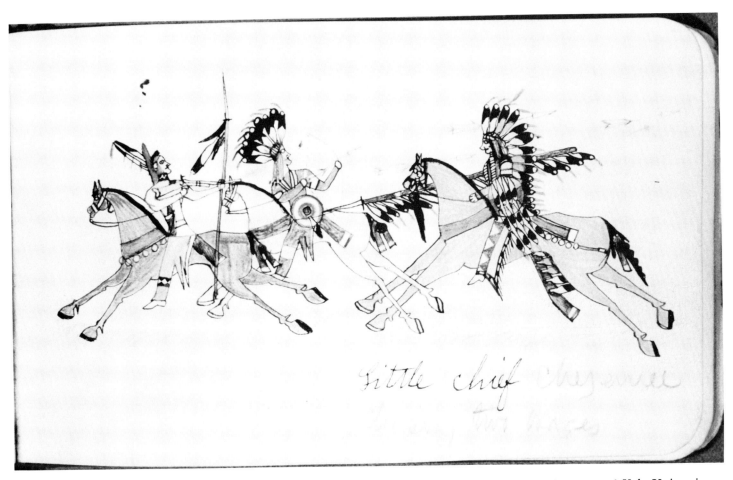

Plate 48. "Chasing two osages," by Little Chief, Cheyenne, May 21, 1875–April 11, 1878 *(Courtesy of Yale University Library).* One of the Osages makes a gun rest of his heavy lance, to steady his aim as he and his target jounce along the plain.

237

NICK

Name on drawings: Nick.
Names on Pratt's list: Big Nose [translation of Cheyenne name], Paeyis.
Tribe: Cheyenne.
Date of birth: 1855.
Charge listed against him: Ringleader.
Dependents at time of arrest: None.
Rank at time of arrest: Warrior.
Place and date of arrest: Cheyenne Agency, Indian Territory, April 3, 1875.
Height and weight, July 9, 1877: 5′ 6¾″; 135 lbs.
At Fort Marion, Florida: Arrived for imprisonment May 21, 1875; while there he produced the drawing in Plate 49.

At Hampton Institute, Virginia: Arrived for schooling April 14, 1878; expenses paid by Annie S. Larocque, New York City; added surname "Pratt" to "Nick."
Death: He died May 31, 1879, at Hampton Institute, Virginia, from congestion of the lungs. He was interred in a marked grave in the cemetery of Hampton Institute.
Relatives: Brother, William Fletcher.
Number of pieces and location of extant art: 2 PP. Total, 2.

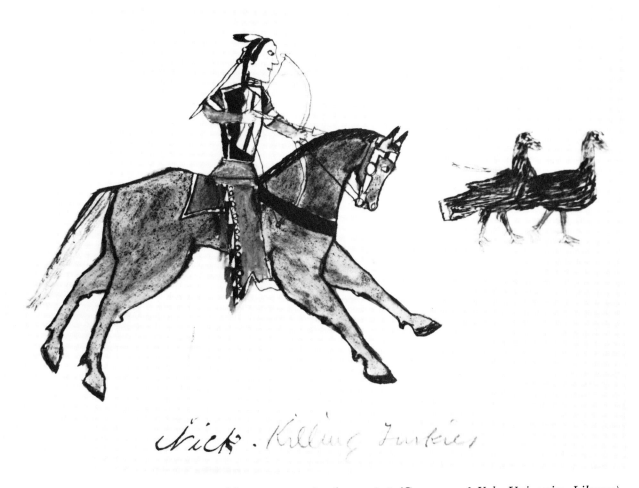

Nick. Killing Turkies

Plate 49. "Killing Turkies," by Nick, Cheyenne, May 21, 1875–April 11, 1878 *(Courtesy of Yale University Library).* The Cheyennes did not scorn small game, as this scene shows. Any addition to the larder picked up on the hunt was welcome. Nick reverses the traditional right-to-left flow of action.

PACKER

At Fort Marion, Florida: Arrived for imprisonment May 21, 1875; while there he produced the drawing in Plate 50.

Departure for reservation: April 11, 1878; he was a policeman there.

Death: He died after 1883.

Relatives: Brother, Left Hand.

Number of pieces and location of extant art: 11 Hampton Inst., including 2 jointly. Total, 11, including 2 jointly.

Names on drawings: Packer, Backer, Backei.

Names on Pratt's list: Packer, Nunnetiyuh.

Tribe: Arapaho.

Date of birth: 1851.

Charge listed against him: Willful murder. Killed Leon Williams, a Mexican herder in the employment of the United States Government, at Arapaho and Cheyenne Agency [1874].

Dependents at time of arrest: Wife and child.

Rank at time of arrest: Warrior.

Place and date of arrest: Cheyenne Agency, Indian Territory, March 5, 1875.

Height and weight, July 9, 1877: 5′ 9½″; 143 lbs.

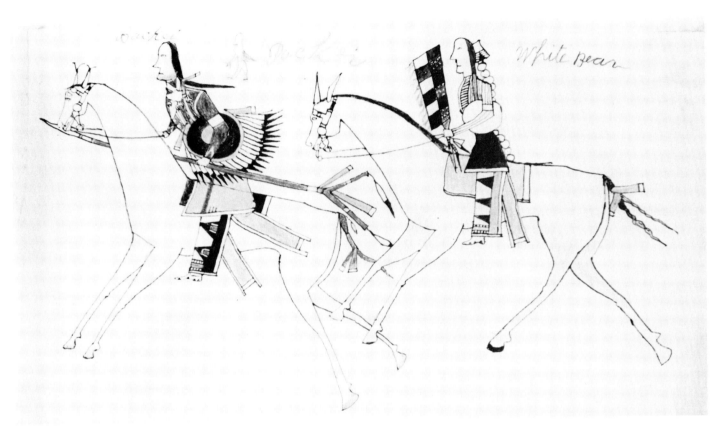

Plate 50. By Packer and White Bear, Arapahos, May 21, 1875–April 11, 1878 *(Courtesy of Hampton Institute).* These two artists were the only Arapahos at Fort Marion and therefore were able, at least at first, to communicate orally only with each other. Understandably, they collaborated on drawing. Packer adds his name-symbol to his signature. White Bear's rider carries a feathered insignia identifying him as one of four Arapahos to hold the Second Degree rank of the First Dance men.

ROMAN NOSE

Name on drawings: Roman Nose.
Names on Pratt's list: Roman Nose [translation of Cheyenne name], Wouhhunnih.
Tribe: Cheyenne.
Date of birth: 1855.
Charge listed against him: Ringleader.
Dependents at time of arrest: None.
Rank at time of arrest: Warrior.
Place and date of arrest: Cheyenne Agency, Indian Territory, April 3, 1875.
Height and weight, July 9, 1877: 5′ 9¾″; 154 lbs. 8 oz.
At Fort Marion, Florida: Arrived for imprisonment May 21, 1875; while there he produced the drawing in Plate 51.
At Tarrytown, New York: Arrived for education in a doctor's home April 22, 1878.

At Hampton, Virginia: Arrived for schooling late in the summer of 1878; was baptized "Henry Caruthers" in March of 1879; education was paid for by a fund raised by Mrs. Horace Caruthers, Tarrytown, New York.
At Lee, Massachusetts: Arrived for work on farm early in June, 1879.
At Carlisle Institute, Pennsylvania: Arrived for education on October 7, 1879, and again on May 7, 1883. While there the first time he learned tinning, and visited the agency to help recruit pupils for Carlisle. He studied tinning the second time he was there.
Departure for reservation: March 15, 1881, and September 18, 1883. While there he was a sawmill worker, Army Scout, policeman, agency tinner, Chief of the Southern Cheyennes, delegate to Washington, and owner of land leased by a gypsum company.
Allotment number: 2,071.
Death: He died on June 13, 1917, on the allotment of William Cohoe, a Fort Marion prisoner, near Watonga, Oklahoma. He was interred at Baptist Indian Mission near Watonga.
Relatives: Father, Naked Turkey (Shot Nose). Mother, Day. Wives, Red Paint, married 1881, died by 1886; and Standing, married by 1887, survived him. Children, Amanda (White Head), born 1887; John (Head Bear), born 1891; and several who died young.
Number of pieces and location of extant art: 2 PP. Total, 2.

a cheyenne Roman Nose. his friend White Bird

Plate 51. "a cheyenne Roman Nose. his friend White Bird," by Roman Nose, Cheyenne, May 21, 1875–April 11, 1878 (*Courtesy of Yale University Library*). This remarkable example of duplication indicates the Plains Indian's mastery of the figure of the mounted warrior.

SHAVE HEAD

Name on drawings: Shave Head.

Names on Pratt's list: Shave Head [translation of Cheyenne name], Ouksteuh.

Tribe: Cheyenne.

Date of birth: 1854.

Charge listed against him: Ringleader.

Dependents at time of arrest: None.

Rank at time of arrest: Warrior.

Place and date of arrest: Cheyenne Agency, Indian Territory, April 3, 1875.

Height and weight, July 9, 1877: 5′ 9″; 124 lbs. 8 oz.

At Fort Marion, Florida: Arrived for imprisonment May 21, 1875; while there he produced the drawing in Plate 52.

At Syracuse, New York: Arrived for orientation for education about April 17, 1878.

At Paris Hill, New York: Arrived for education in a clergyman's home about May 20, 1878; expenses paid by Episcopal Diocese of Central New York; baptized "John Wicks" October 6, 1878; confirmed October 20, 1878.

Departure for reservation: September 10, 1880.

Death: He died of tuberculosis on November 10, 1880, at the Cheyenne Agency. He was interred in Sand Hills near Darlington, in a marked grave in cemetery named Otoomoist, Resting Place.

Relatives: Father, Little Bull. Mother, Pizen. Brothers, Standing on the Sky, Iron Jacket.

Number of pieces and location of extant art: 2 PP. Total, 2.

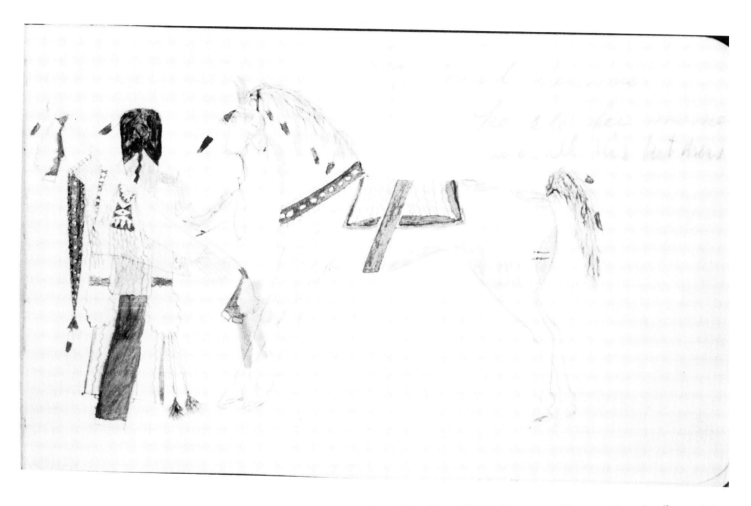

Plate 52. "okesteheimeme [Shave Head] and all his best dress," by Shave Head, Cheyenne, May 21, 1875–April 11, 1878 *(Courtesy of Yale University Library)*. The magnificent quiver and bow-case that obscure the wearer constitute the youth's "best dress." Among the appendages are some requisites for a journey: a slender awl-case and a bag for fire-steel, flint, and punk. The artist's name-symbol appears below his signature.

SOARING EAGLE

At Fort Marion, Florida: Arrived for imprisonment May 21, 1875; while there he produced the drawing in Plate 53.

At Hampton Institute, Virginia: Arrived for schooling April 14, 1878.

At Lee, Massachusetts: Arrived for work on farm early in June 1879.

Departure for reservation: October, 1879.

Death: Died after 1886.

Number of pieces and location of extant art: 8 Field Mus., jointly; 2 PP. Total, 10, including 8 jointly.

[1] The symbol above the name represents simply "bird."

Names on drawings: Soaring Eagle; Soarung Eagle.[1]

Names on Pratt's list: Soaring Eagle [more accurate translation of Cheyenne name, Soaring Bird], Ouho.

Tribe: Cheyenne.

Date of birth: 1851.

Charge listed against him: Brown murder, near Wallace [1874]. Had Brown's pistol when captured by Lieutenant Hinkle.

Dependents at time of arrest: None.

Rank at time of arrest: Warrior.

Place and date of arrest: Fort Wallace, Kansas, December 25, 1874.

Height and weight, July 9, 1877: 5' 7"; 128 lbs. 8 oz.

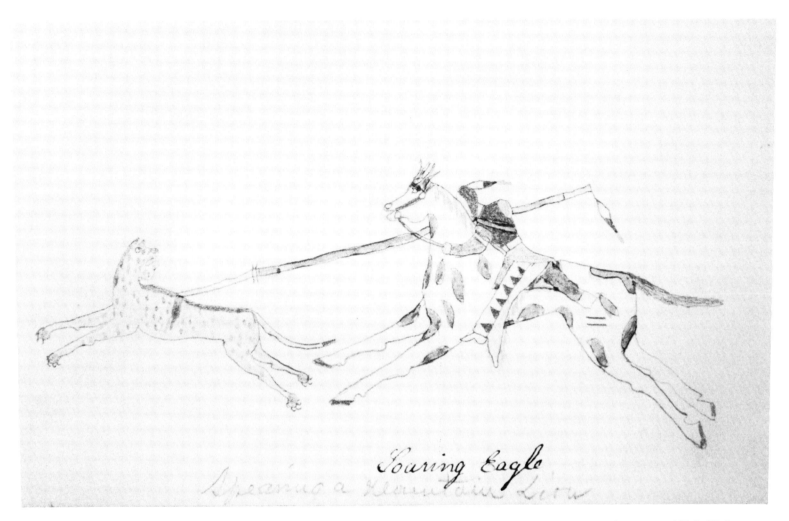

Soaring Eagle

Spearing a Mountain Lion

Plate 53. "Spearing a Mountain Lion," by Soaring Eagle, Cheyenne, May 21, 1875–April 11, 1878 *(Courtesy of Yale University Library)*. The skin of the mountain lion (cougar, panther, puma) was highly prized for quivers because it was both beautiful and powerful. Although the artist has given this young cat the lines of a conventionalized horse, he manifests fine skill in composition.

TOUNKEUH

Name on drawings: Tounkeuh.[1]

Names on Pratt's list: Good Talk [translation of Kiowa name], Tonakeuh.

Tribe: Kiowa.

Date of birth: 1858.

Charges listed against him: Stealing in Salt Creek Valley, Texas, in late 1871. Was with Lone Wolf killing Dudley and Wallace, buffalo-hunters [1874].

Other incidents of early life: Stole horses in Texas; surrendered to Asa Habba and to Captain Pratt.

Dependents at time of arrest: None.

Rank at time of arrest: Warrior.

Place and date of arrest: Salt Fork, Red River, Indian Territory, February 18, 1875.

Height and weight, July 9, 1877: 5′ 6″; 145 lbs.

At Fort Marion, Florida: Arrived for imprisonment May 21, 1875; while there he produced the drawing in Plate 54.

At Hampton Institute, Virginia: Arrived for schooling April 14, 1878; baptized "Tounkeah" in March, 1879.

At Lee, Massachusetts: Arrived for work on farm early in June, 1879.

At Carlisle Institute, Pennsylvania: Arrived for education October 7, 1879.

Departure for reservation: March 2, 1880; while there he worked as a laborer; he took the name "Paul Tounkeuh."

Death: He died between 1889 and 1912.

Number of pieces and location of extant art: 2 PP. Total, 2.

[1] The symbol above the name represents simply "talk."

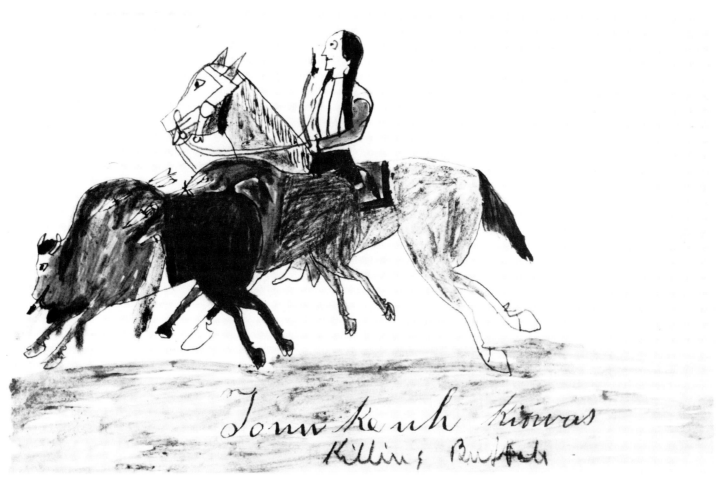

Plate 54. "Killing Buffalo," by Tounkeuh, Kiowa, May 21, 1875–April 11, 1878 *(Courtesy of Yale University Library).* This drawing lays to rest the old cliché that all Indians drew alike. Compare Plates 19, 32, and Color Plate 8 on the same theme.

TSADELTAH

Name on drawings: Tsadeltah.

Name on Pratt's list: White Goose [alternate translation of Kiowa name, Swan], Tsahdletah.

Tribe: Kiowa.

Date of birth: 1847.

Charges listed against him: Was with Lone Wolf, killing two men, buffalo-hunters, Wallace and Dudley [1874]; was prominent in the attack on troops at the Washita, August 22, 1874; helped to kill the white men Modest, Osborne, and others [1874].

Other incidents of early life: Stole horses in Texas; surrendered to Asa Habba and to Captain Pratt.

Dependents at time of arrest: Wife and child.

Rank at time of arrest: Warrior.

Place and date of arrest: Salt Fork, Red River, Indian Territory, February 18, 1875.

Height and weight, July 9, 1877: 5′ 10″; 156 lbs.

At Fort Marion, Florida: Arrived for imprisonment May 21, 1875; while there he produced the drawing in Plate 55.

At Hampton Institute, Virginia: Arrived for schooling April 14, 1878; baptized "Tsadletah" in March, 1879.

At Lee, Massachusetts: Arrived for work on farm early in June, 1879.

Death: He died of paralysis October 6, 1879, at the home of Alexander Hyde, Lee, Massachusetts. He was interred in a marked grave in the Hyde family plot, Fairmount Cemetery, Lee, Massachusetts.

Relatives: Daughter, Kahakuh.

Number of pieces and location of extant art: 3 Hampton Inst. Total, 3.

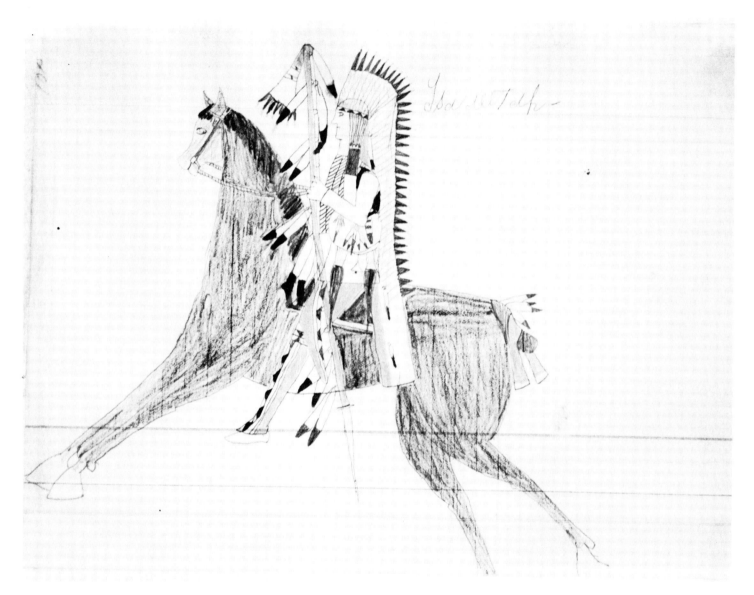

Plate 55. By Tsadeltah, Kiowa, May 21, 1875–April 11, 1878 *(Courtesy of Hampton Institute).* In spite of mediocre artistic ability, the rich details of the war-dress romanticize the warrior.

TSAITKOPETA

Name on drawings: Tsaitkopeta.

Names on Pratt's list: Bear Mountain [translation of Kiowa name], Tsaitkopeta.

Tribe: Cheyenne father, Pawnee mother; lived with Kiowas fourteen years before imprisonment.

Date of birth: 1852.

Charges listed against him: Helped rob Shirley's store [1874]. Stole horses. Was with Lone Wolf killing Dudley and Wallace [1874].

Other incidents of early life: Lived in camp attacked by Kit Carson and troops in Texas; participated in Lost Valley fight in Texas, 1874; surrendered to Asa Habba and to Captain Pratt.

Dependents at time of arrest: Wife.

Rank at time of arrest: Warrior.

Place and date of arrest: Salt Fork, Red River, Indian Territory, February 18, 1875.

Height and weight, July 9, 1877: 5′ 9¾″; 166 lbs. 8 oz.

At Fort Marion, Florida: Arrived for imprisonment May 21, 1875; while there he produced the drawing in Plate 56.

At Tarrytown, New York: Arrived for education in a doctor's home April 22, 1878; was supported by money raised by Mrs. Horace Caruthers; was baptized "Paul Caruthers" on February 1, 1879; made trip to St. Augustine with Carutherses.

Departure for reservation: July 1, 1882; there he was an employee at government school, wood cutter, Army Scout, informant for anthropologist James Mooney, assistant to Rev. J. J. Methvin, and farmer.

Allotment number: 307.

Death: He died April 7, 1910, at Anadarko, Oklahoma, and was interred in a marked grave in the cemetery south of Anadarko.

Relatives: Father, Chief Little Bear (Nakwakit), or Loud Talker (Tonekoneky)?, a Cheyenne. Mother, Pawnee Woman (Koegamah), a Pawnee captive. Mother's father, Chief White Horse (a Pawnee). Sister, Iheaddlety. Wives, Catch Herself (Aunggotay), married 1875, divorced 1876; Amy (Standing Between, Domegatty), married 1882, survived him. Susie (Going to Name and Bring In, Ahkaun), married about 1888, divorced about 1906. Children, Julia (Ahtokoiah), born 1884; Joseph (Coming under Water, Tanedomah), born 1886; Minnie, born 1895; and fourteen others who died young.

Number of pieces and location of extant art: 2 Mass. Hist. Total, 2.

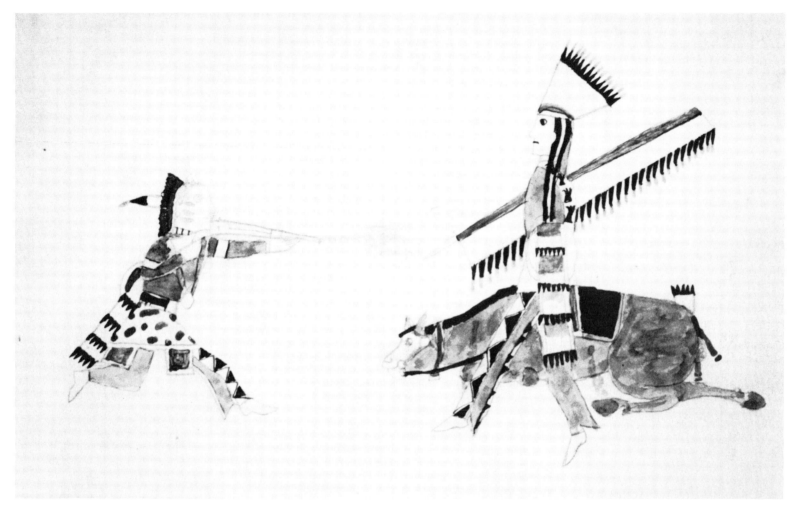

Plate 56. "Osage," by Tsaitkopeta, April 18–July 21, 1877 *(Courtesy of Massachusetts Historical Society).* The Osage, whose tribe customarily went to war on foot, has downed the Kiowa's horse, leaving the rider helpless before the long range of the carbine. Nevertheless, the Kiowa is making a last effort to rush the Osage with his spear before a bullet stops him.

WHITE BEAR

Name on drawings: White Bear.[1]

Name on Pratt's list: White Bear [more accurate translation of Arapaho name, Albino Bear], Huhnohuhcoah.

Tribe: Arapaho.

Date of birth: 1852.

Charge listed against him: Attempt to kill. Did shoot at, with intent to kill, F. H. Williams, an employe of the United States Government, at the Arapahoe and Cheyenne Agency [1873].

Dependents at time of arrest: Wife and child.

Rank at time of arrest: Warrior.

Place and date of arrest: Cheyenne Agency, Indian Territory, March 5, 1875.

Height and weight, July 9, 1877: 5′ 4¾″; 126 lbs. 8 oz.

At Fort Marion, Florida: Arrived for imprisonment May 21, 1875; while there he produced the drawing in Plate 50.

At Hampton Institute, Virginia: Arrived for schooling April 14, 1878.

At Lee, Massachusetts: Arrived for work on farm early in June, 1879.

At Carlisle Institute, Pennsylvania: Arrived for education October 7, 1879.

Departure for reservation: March 2, 1880; while there he was farmer, Army Scout, and herder.

Allotment number: 1,540.

Date of death: 1891.

Relatives: Father, Chief Old Crow. Mother, Ole Son. Brothers and sisters, Black Lodge, Curly, Pawnee, James Pawnee, White Bear Woman, Ponca Woman, Yellow Hair, Lone Woman, and Bean Niel. Wives, Mrs. White Horse, married 1871, divorced 1875; Red Woman (Hicibai), married 1878, survived him. Children, Nancy North, born 1873; Luther Reed, born 1874; Ida, born 1882; Little Man (Bird, Henanukada), born 1889; and three who died young.

Number of pieces and location of extant art: 2 Hampton Inst., jointly. Total, 2, jointly.

[1] The symbol above the name, although drawn by Koba to represent White Bear, cannot be taken seriously. The white monstrosity combines a buffalo's horns, a mule's ears, a moose's head, a deer's tail, and cloven hoofs.

WHITE MAN (Ahsit)

Names on drawings: White Man; Ahsit [equivalent of Owussait below].

Names on Pratt's list: White Man, Owussait [translation, Hail Stone].

Tribe: Cheyenne.

Date of birth: 1853.

Charge listed against him: Accomplice in Short and Germain [*sic*] murders [1874]; pointed out by Medicine Water.

Dependents at time of arrest: Wife and baby.

Rank at time of arrest: Warrior.

Place and date of arrest: Cheyenne Agency, Indian Territory, March 5, 1875.

Height and weight, July 9, 1877: 5′ 11¼″; 174 lbs.

At Fort Marion, Florida: Arrived for imprisonment

May 21, 1875; while there he produced the drawing in Plate 57.

At Hampton Institute, Virginia: Arrived for schooling April 14, 1878; was baptized "Ahsit" in March, 1879; expenses paid by T. H. Faile, New York City.

At Lee, Massachusetts: Arrived for work on farm early in June, 1879.

At Carlisle Institute, Pennsylvania: Arrived for education October 7, 1879.

Departure for reservation: January 26, 1880; while there he was a farmer, stock raiser, laborer, teamster, and herder; and took the name "Hail."

Allotment number: 1,901.

Death: He died November 23, 1931.

Relatives: Father, Bull Telling Tales. Mother, Grief. Brothers and sisters, Standing Twenty, Cape, Big Nose, and Head Woman. Father-in-law, Chief Minimic (Eagle Head), a Fort Marion prisoner. Wife, Flying, died in 1897. Children, Oliver Hail, born 1875; Minnie Hail (Fan), born 1884; and one who died young. Wife's stepbrother, Howling Wolf, a Fort Marion prisoner.

Number of pieces and location of extant art: 1 American Mus.; 1 Hampton Inst.; 2 PP. Total, 4.

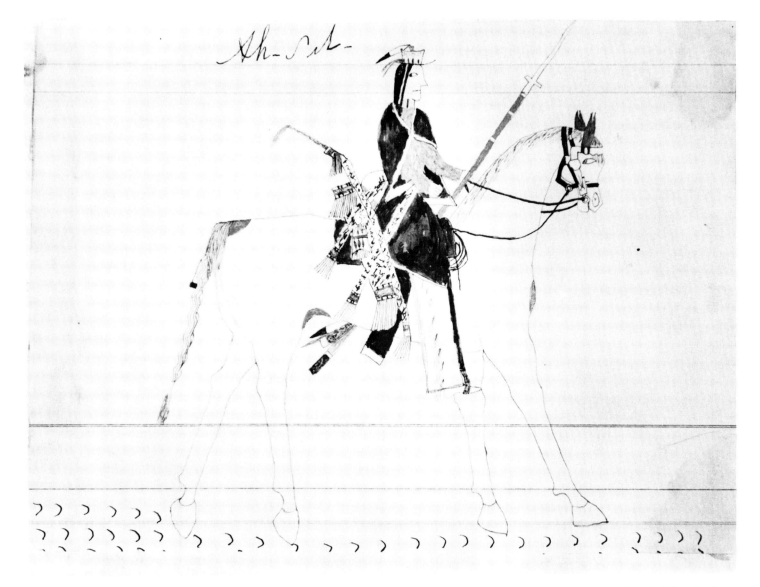

Plate 57. By Ah-sit [White Man], Cheyenne, May 21, 1875–April 11, 1878 *(Courtesy of Hampton Institute)*. The classic rider is reversed.

ZONEKEUH

Name on drawings: Zonekeuh.

Names on Pratt's list: Teeth [more accurate translation of Kiowa name, Tooth Man], Zonekeuh.

Aliases: Green Shield Man, Kinasahekia.

Tribe: Kiowa.

Date of birth: 1857.

Charges listed against him: Was with Mahmante [Man Who Walks above the Ground] killing the two colored men [1871]. Was with Lone Wolf killing two buffalo-hunters, Dudley and Wallace [1874].

Other incidents of early life: Raided for horses in Mexico and Texas; surrendered to Asa Habba and to Captain Pratt.

Dependents at time of arrest: None.

Rank at time of arrest: Warrior.

Place and date of arrest: Salt Fork, Red River, February 18, 1875.

Height and weight, July 9, 1877: 5′ 7″; 150 lbs.

At Fort Marion, Florida: Arrived for imprisonment May 21, 1875; while there he produced the drawing in Plate 58.

At Tarrytown, New York: Arrived for education in a doctor's home April 22, 1878.

At Hampton Institute, Virginia: Arrived for schooling late in the summer, 1878; was baptized in March, 1879.

Death: He died of consumption on April 27, 1880, at Carlisle Institute, while en route to the reservation. He was interred in a marked grave in Carlisle Barracks Cemetery.

Number of pieces and location of extant art: 4 PP. Total, 4.

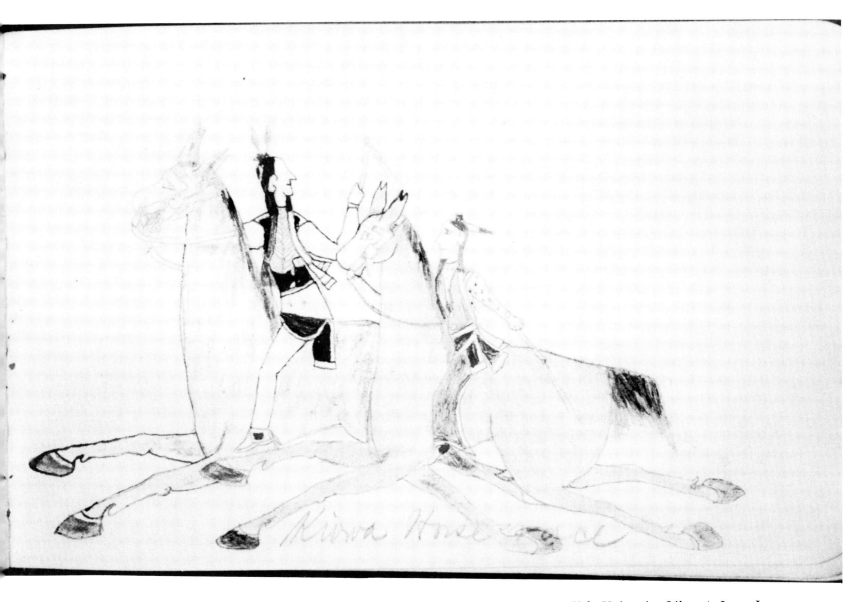

Plate 58. "Kiowa Horse race," by Zonekeuh, May 21, 1875–April 11, 1878 (*Courtesy of Yale University Library*). In an Indian race the stakes are high; the second rider is lashing his horse. The man in the lead turns to taunt his competitor, brandishing his quirt in derision.

VII. ART AFTER FORT MARION

OUR Indian youth are encouraged to practice and improve in their native art. Painting on paper, fans, and on pottery, brings them pocket money which keeps them cheerful.

"The negro has the only American music; the Indian has the only American art.

"I believe it to be a duty to preserve, and in a wise and natural way to develop both. The latter is curiously suggestive of ancient Egyptian or oriental styles. There is an oriental expression in the Indian's countenance.

"Our Indian paintings are much sought after, and are doing good in many places, as reminders of the needs of a noble but wronged people."[1]

So spoke the great-souled principal of Hampton Institute, Virginia, a year after he opened the doors of his negro school to seventeen of the Indians from Fort Marion. The school for freedmen, which General Samuel C. Armstrong founded soon after the Civil War, was the only one willing to risk the education of Indian warriors which at the same time fulfilled Pratt's vision of a combined academic and vocational education for his charges. Subsequently, many younger pupils from Plains tribes were enrolled, and the Florida Boys offered the hand of friendship to the homesick youngsters. Pratt was detailed to duty at Hampton for the school year of 1878–79. Discernible in Armstrong's statement on art is Pratt's own concept of the three-fold function of picture-drawing: recreation, the satisfaction of earning money, and good public relations. General Armstrong, from his own rich background, adds still another concept: Indian drawing is art, it is uniquely American, it should be fostered and preserved. His school faculty was of the same persuasion. He was quoted as telling a Northern audience, "It has also been the aim of their instructors to prevent their painting being Anglicized, but rather to

bring it out, to make it distinctive, and typical of themselves and their race. . . . There is a bright, a lively, and a life-like appearance about many of [the drawings] which redeem many seemingly bad faults."[2]

On the first day at Hampton, Pratt related in an address to the student body, "A lady here has showed one of [the Indians], since they have been here, a picture which he painted for her little son two years ago. He laughed to see it. He can do better now, a great deal; his pictures are Indian pictures still, but he has improved." Just as they had done at Fort Marion, the Florida Boys fell to drawing upon their arrival. An influx of visitors for the anniversary celebration five or six weeks later found the artists prepared with a supply of painted pictures and fans. The proceeds brought in by the brisk sale of mementos were used for the purchase of clothing.

Only seven specimens of the art of the Florida Boys at Hampton are known to have survived. Four of them can with certainty be dated 1878–79, the only year in which their creators were in residence at Hampton. Fans by Koba and White Man, a vase by Etahdleuh, and a plaque by Koba show scenes of combat, hunting, and life at home, as well as a warrior dressed in the regalia of his soldier-society. No wonder the fans were said to be "decorated in a way to keep a whole congregation awake through a hot Sunday sermon." Curiously, the pottery was not made by the Indian pupils according to some traditional technique, but in a northern factory. Large quantities of what is variously spoken of as Cambridge or Beverly (Massachusetts) pottery or Albert ware (New York?) were sent to Hampton to be painted. Some of the pottery and fans were the gift of Mrs. Larocque, patroness of the Fort Marion archery class.

The decoration of this bric-a-brac was a popular fad of the day.

The fashionable rage for "Keramics" has found its way to Hampton—not from the fashionable world, but by way of the wilderness. A very attractive corner of the Industrial Room shop is that devoted to the pottery painted by the Cheyennes and Kiowas whose untutored art bears a very curious resemblance to the Egyptian. Compare the colored illustrations of Egyptian frescoes in Edward Clark's handsome work on The Homestead of the Nations, with these painted braves in wild chase after the buffalo, or riding in full feather and stately grace around the vases, and you cannot but be struck by the similarity in type of feature and management of lines.[3]

Specimens of Hampton art found their way back to Massachusetts. Some were exhibited at Spring-

field, in the spring of 1879. Soon afterward, Bear's Heart sent a "pretty little vase" to the aged Lydia Maria Child of Wayland, Massachusetts, an ardent abolitionist, Indian sympathizer, and friend of Hampton. She graciously reciprocated by knitting him a scarf. Bear's Heart also made two drawings on paper still extant from the Hampton period. For one of his sympathetic teachers, Cora M. Folsom, he drew a galloping scene candidly entitled Stealing Horses (Color Plate 4). The beautiful drawing, apparently the last produced by any of the Florida Boys in the East, was done at the pinnacle of Bear's Heart's technical skill.[4]

It was the practice of Hampton Institute to send specimens of the pupils' art as a bonus to each subscriber to the school paper (at a dollar a year) and to individuals or Sunday-schools in Virginia contributing to the education of the Indians. This practice very likely was the origin of the hunting scene, signed "Bears Heart" and dated 1880, that is reproduced in a recent monograph.[5]

Meanwhile, Tsaitkopeta was making craftwork for sale at Tarrytown, New York, where he lived in the home of Dr. and Mrs. Horace Caruthers. His teacher from the Fort Marion days, Mrs. Amy Caruthers, sent a package to the Kiowa agent, accompanied by a letter saying, "Tsait-kope-da made a few dollars by painting jars and has spent it in getting these things for his mother, sister and little brothers, going without things he needed himself to do so. He is afraid his mother and the others may suffer from cold this winter." He also made bows for three dollars and decorated sea-beans by polishing, mounting, and cutting designs such as stars on them. At Carlisle Institute in 1880, Ohettoint made a book of drawings for Captain Pratt in a distinctive style that employed water colors (Plate 36). At the United States National Museum in Washington, Squint Eyes in 1879 and Etahdleuh in 1880 between them produced a folio of sketches (Color Plates 5 and 8 and Plate 35).[6]

After five years of acculturation, how much of his background of Plains drawing traditions did Etahdleuh retain? Plate 35 and Color Plate 5 show many of the traits of early painting: horse and man in action; horse with long, arching neck, small head, and legs spread when speed is indicated; elongated man in profile with shoulders broadside and rigid straight posture; stylized costume details; distant objects usually placed higher on the page; figures outlined, filled in with colors, and mostly two-dimensional in line and color; action from right to left. Later refinements in the matter of clothing, proportions, details, sureness of line, care in applying color,

and lack of crudeness are all to be found. The principal divergencies from tradition lie in the media used, a composition that exceeds the unity incidentally contributed by the confinement of the page, abandonment of pictographic symbols in favor of realism, background appropriate to the subject, diminution of distant objects in size and clarity, and scenes sometimes done in neutral tones, like Plate 35. Although the subject-matter has changed from war to peace, the mood remains a glorification of masculine prowess.

Etahdleuh, then, like his fellow-artists at Fort Marion, carried on the Plains tradition. At the same time he continued the process of refinement which had begun about 1850 by adding elements that heightened the decorative quality or the meaning of his drawings.

It is profitable to compare his work of February to April, 1880 (Plate 35 and Color Plate 5), with that of April to July, 1877, at Fort Marion (Plates 31 through 34). None of the earlier drawings can measure up to the handsome Color Plate 5 of three years later. Otherwise, all show an equally advanced over-all technical skill, such as in the drawing of figures and the handling of perspective. However, the 1877 drawings, except for the panorama, are weak in originality of theme and of composition.

They resemble the treatment given by some of Etahdleuh's comrades to the same subjects—two men making peace, entertaining friends at home, and the buffalo-kill. In the fourth drawing of 1877 (Plate 33), the artist finds his forte. The fine composition of this panorama states the subject clearly and, incidentally, achieves distance without employing the conventional forty-five degree angle of viewing. This flair for panoramas culminates in the later Plate 35. Its contemporary, the water-color Color Plate 5, is his most sophisticated. It ranks with Bear's Heart's Color Plate 4 in technique, composition, and decorative quality. Parenthetically, it is probably no coincidence that both have in common the old favorite theme of Plains art—man and horse.

WITH THE RETURN of the last of the Florida Boys to Indian Territory, the drawings in this volume end (except for the Dohasan tipi done on the reservation —Color Plate 6). Only those portraying life on the Plains are included here. The drawings showing the white man's world are so foreign to traditional techniques as to suggest a separate treatment. Similarly, work done after the artists had turned to reservation living implies new influences on their art that are beyond the scope of this book. Howling Wolf produced at least one sketchbook within three years after

his return home. It was annotated by the interpreter and scout, Ben Clark, and collected by the anthropologist and writer, Captain John G. Bourke. Some of the drawings resemble in technique several in a set signed by Howling Wolf and Soaring Eagle which was recently reproduced and described. It is uncertain whether the latter book originated at Fort Marion or on the Plains. Cohoe collaborated with friends in painting on small hides for children. Ohettoint and Zotom decorated miniature tipis with traditional painted patterns for display at the Omaha Exposition of 1898. Ohettoint later reproduced his miniature tipi in full size (Plate 11).[7]

Why did the flood of drawings that poured forth from Fort Marion so soon diminish to a mere trickle? Not from lack of a market: army officers and civilian employees at the agencies stood ready to supply drawing materials and to purchase the completed books for souvenirs, as public and private collections attest today. Not because the memories of prison life evoked by the act of drawing were painful: returnees regaled their friends with many a tale of Fort Marion, now grown into legend. It seems more plausible that the outpouring of artistic impulse subsided for two reasons: the intellectual aridity of life in the Western concentration camps and the absence of a wide-eyed audience to whom a homesick artist

could say with authority, This is the way it was on the Great Plains.

[1] S. C. Armstrong, "Report," May 21, 1879, *Reports of the Officers of the Hampton Normal and Agricultural Institute, Hampton, Virginia, for the Academical and Fiscal Year, Ending June 30, 1879*, 13.

[2] J. M. T., Jr., "The Indian Problem," *Friends' Intelligencer*, Vol. XXXVI, No. 44 (Dec. 20, 1879), 693.

[3] [Ludlow] *SW*, Vol. VII, No. 5, 36; "Anniversary Day at Hampton," *SW*, Vol. VII, No. 6 (June, 1878), 46; fan by White Man, American Museum of Natural History; fan by Koba, vase by Etahdleuh, plaque by Koba, Hampton Institute: [Ludlow], *SW*, Vol. VIII, No. 5, 55; "A Notable Anniversary" (dateline, Hampton, May 23, 1879), *Daily Advertiser*, n.d., PP; A. L. Larocque to Pratt, Jan. 14, 1880, PP. Miss Ludlow's reference is to Edward L. Clark, *Daleth; or, the Homestead of the Nations* (Boston, Mass., 1864).

[4] "A Notable Anniversary" (dateline, Hampton, May 23, 1879), *Daily Advertiser*, n.d., PP; L. Maria Child to Bear's Heart, Sept., 1879, *SW*, Vol. VIII, No. 12 (Dec., 1879), 123–24; "Lydia Maria Child," *SW*, Vol. IX, No. 12 (Dec., 1880), 126; "Stealing Horses," by Bear's Heart, Hampton.

[5] "Indian Education," *SW*, Vol. VIII, No. 10 (Oct., 1879), 99; *SW*, Vol. VIII, No. 5 (May, 1879), 52; Rodee, "Stylistic Development of Plains Indian Painting . . . ," *Plains Anthropologist*, Vol. X, No. 30, 218–32; drawing by Bear's Heart, Howard D. Rodee.

[6] Mrs. Caruthers to Hunt, Dec. 17, 1879, OHSIA, C&A–Indian prisoners; Setkopti, Diary, in Mooney, MS, Field notebooks, II, 10 *passim*, Jan. 8, 17, 20, Sept. 19, Oct. 24, 25, 29, 1879, Oct. 30, 1880; sketchbook by Chas. Ohet-toint, PP; drawings by Tich-ke-matse and Etahdleuh Doanmoe, USNMC.

[7] Sketchbook by Howling Wolf, Mrs. A. H. Richardson; Petersen, *Howling Wolf* (with twelve drawings in color); sketch-

book by Howling Wolf and Soaring Eagle, Field Museum, reproduced in George I. Quimby, "Plains Art from a Florida Prison," *Chicago Natural History Museum Bulletin*, Vol. XXXVI, No. 10 (Oct., 1965), 1–5; Mrs. Richanda Little Chief Stone Calf, oral communication to author, May 22, 1959.

PICTOGRAPHIC DICTIONARY

PICTOGRAPHIC DICTIONARY:
Conventions Used by Fort Marion Artists, 1875-1880

THE dictionary that follows is intended as a key to assist in unlocking the meaning of drawings that are based on the pictographic conventions of nineteenth-century Plains Indian art. It may be said of many of these drawings that the whole is greater than the sum of its parts. To arrive at the complete meaning, two steps should be taken.

First, identify the items that make up the picture. Here the column in the dictionary called Explicit Meaning may be of assistance.

Second, account for the presence in the picture of each item. The column called Connotation may provide clues, but even more useful is a large stock of curiosity, intuition, resourcefulness, and knowledge of Plains Indians culture. The true pictograph was selective in the items shown, including only those with significance for the message conveyed. The most heavily stressed item, the most puzzling one, or the one not usually found in similar drawings may

be the key to the interpretation of the whole. Conversely, a single item takes its meaning from its relation to the other items in the drawing; it must be studied in context.

To illustrate the process of interpretation from some of our plates originally lacking in captions: when checked for explicit meanings of costumes, Plates 20, 34, 42, and 56 each show one Cheyenne or Kiowa and one Osage. In Plates 20 and 34 the connotation of the outstretched hands and the weapons held vertically is peace. Explicit parts of Plates 42 and 56—wounded horses, charging enemies, horizontal weapons, and discharged bow and gun—add up to the greater whole of a desperate encounter. The shield in Color Plate 3, reinforced by the led horse and the array of weapons, indicates the war path. In Plate 22 the horse's warlike trappings and its rider's peaceful accouterments are reconciled by the rarely seen sham weapon of a mock, but ceremonial, warfare. As for

Plate 26, the combination of clothing can only mean an Indian Scout, while the horse's head and the forward-thrown dust are the clues to what is taking place.

Meanings may vary contextually, and they may also vary in accordance with the tribal origin of a drawing or its date of execution. The Dictionary applies strictly only to the Fort Marion artists of the Cheyenne, Arapaho, and Kiowa tribes for the years 1875–80. Thus the connotation of the blanket coat and capote in a Dakota drawing is not "winter" but "on the warpath," because the Dakotas wore these garments on war expeditions. Similarly, after the wane of warfare, the fringed buckskin shirt and the crown of eagle feathers came into general use and no longer proclaimed, "This is a very brave man."

VIII. ABSTRACTIONS, MISCELLANEOUS

EXPLICIT MEANING CONNOTATION

1. Costume symbol Costume symbol for White Horse
 a. Headdress of White Horse
 b. Face paint of White Horse
 c. Shield of White Horse
2. Defensive position in battle
3. Figure above or behind another of Distance in depth
 same size
4. Figures, partial Whole figure
5. Figures unduly close Distance in width compressed
6. Figures unduly few Many figures

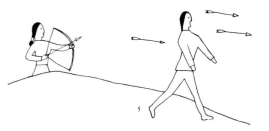

EXPLICIT MEANING CONNOTATION

7. Flesh puncture and blood Wound
8. Footprints, consecutive Action in past tense
9. Footprints, grouped Many men, or standing in one spot a long time
10. Hand elevated, palm forward I have nothing; surrender
11. Hand reaching out, palm up Friendly intent
12. Hero glorified, enemy belittled A man's prowess
13. Smoke and noise Impact of discharged gun
14. Leg distorted Lameness

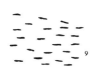

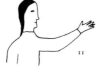

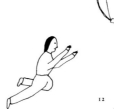

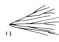

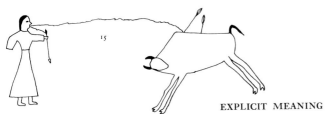

EXPLICIT MEANING	CONNOTATION
15. Object connected to mouth by line	Subject or object of the speech
16. Movement right to left	Flow of action
17. Movement shown by extended legs	Speed
18. Musket ball with its power	A fired ball
19. Name symbol	Name symbol for Roman Nose
a. Glyph denoting a Roman nose	
b. Line denoting possession	
c. Stereotyped man	
20. Moccasin unsupported between two people	Object or impact passed to receiver while in hand of sender
21. Pipe across waist	Chief
22. Pipe bag (not an abstraction)	

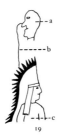

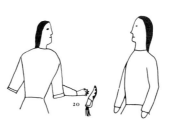

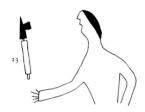

EXPLICIT MEANING	CONNOTATION
23. Pipe elevated and unsupported	Leader of war party
24. Pipe elevated and extended	Peaceful intent shown by a leader
25. Route taken by something sacred	Sacred; mysterious
26. Vocal sounds	
27. Weapon in harmless position and woman in the delegation	Peaceful intent
28. Weapons relinquished	Surrender

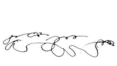

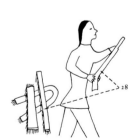

274

IX. ANIMALS

1. Short ears ⎫
2. Stubby tail ⎪
3. Teeth ⎬ Bear
4. Dark body ⎪
5. Long, curved claws ⎪
6. Footprints with long, curved claws ⎭
7. Heart
8. Blackbird, yellow-headed (buffalo bird)
9. Curved horns ⎫
10. Hump ⎪
11. Short, arched tail ⎪
12. Extended tongue ⎬ Buffalo (bison)
13. Dark body ⎪
14. Divided hoof ⎪
15. Divided-hoof prints ⎭

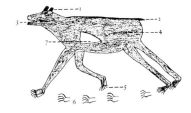

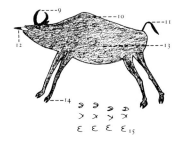

EXPLICIT MEANING CONNOTATION

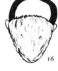

16. Buffalo head

17. Buzzard

18. Horns
19. Long, ropy tail }Cow, beef
20. Spots

21. Deer, mule

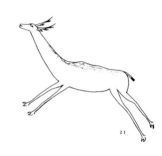

22. Antlers
23. Dark on back of neck and back
24. Long tail raised in flight
25. White rump }Deer, white-tailed
26. White under-belly
27. Divided hoof

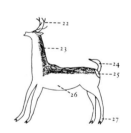

28. Teeth
29. Recurving tail }Dog
30. Claws
31. Spotted dog

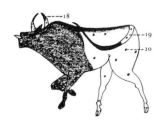

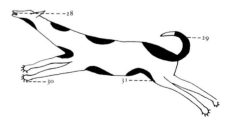

EXPLICIT MEANING CONNOTATION

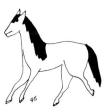

32. Eagle, bald

33. Antlers
34. Dark neck and front
35. Hair on neck and breast } Elk
36. Short tail
37. Light rump

38. Fox, grey

39. Goose, snow

40. Small head
41. Long, arching neck
42. Long body
43. Front and hind legs extended in } Horse, domesticated
 running
44. Undivided-hoof prints
45. Spotted horse

46. Long tail and mane Horse, wild (feral)

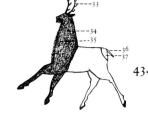

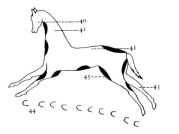

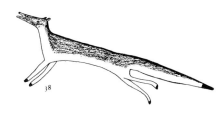

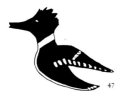

EXPLICIT MEANING CONNOTATION

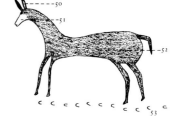

47. Kingfisher, belted
48. Lion, mountain (cougar, panther, puma)
49. Moose
50. Large ears ⎫
51. White face ⎬ Mule
52. Dark body ⎪
53. Undivided-hoof prints ⎭
54. Owl
55. Pronged horns ⎫
56. Banded breast ⎪
57. Short tail ⎬ Pronghorn (antelope)
58. White rump ⎪
59. Divided hoof ⎪
60. Divided-hoof prints ⎭

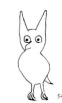

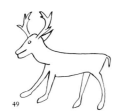

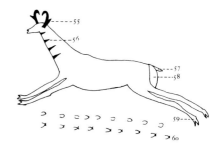

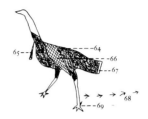

EXPLICIT MEANING CONNOTATION

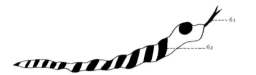

61. Forked tongue ⎫
62. Diagonal stripes ⎬ Snake

63. Thunder bird

64. Dark body ⎫
65. Wattles ⎪
66. Barred wings ⎬ Turkey
67. White-banded tail ⎪
68. Tracks ⎪
69. Three or four toes ⎭

70. Turtle

71. Wolf

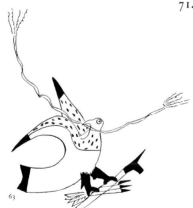

X. COSTUMES, ACCESSORIES, AND FIGURES:
Cheyenne, Arapaho, Kiowa

EXPLICIT MEANING	CONNOTATION (A man unless otherwise noted)
1. Headdress with buffalo horns and dropper	
2. Cape	
3. Breechcloth looped up	Strenuous activity
4. Buggy whip	Man or woman
5. Headdress with stripped quills	
6. Ornament for hair	
7. Bow case and quiver	
8. Strap for quiver	
9. Cloth drape on quiver	
10. Blanket wrapped around hips for riding	Man or woman
11. Scalp lock with circular hair-part	
12. Fan made from a wing	
13. Robe of buffalo hide, decorated	

EXPLICIT MEANING CONNOTATION

14. Robe with white selvedge up back
and worn over head
15. Blanket strip
16. Legging
17. Moccasin with fringe at heel
18. Capote Winter
19. Rifle case with fringe
20. Coat made from blanket Winter
21. Bag for fire steel
22. Staff
23. Breechcloth, long
24. Coat from Army uniform
25. Case for awl
26. Bow case and quiver with lion paws,
in position for walking
27. Blanket wrapped around hips for
walking
28. Trousers from Army uniform
29. Otter turban with horn
30. Scalp lock
31. Choker of dentalium shells Man or woman
32. Cone earring with drops
33. Umbrella Man or woman

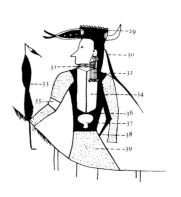

EXPLICIT MEANING CONNOTATION

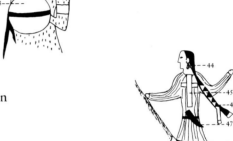

34. Breast plate of hair pipes
35. Arm band of German silver
36. Vest
37. Pectoral ornament of German silver
38. Braid wrapping of animal skin
39. Shirt of cloth
40. Feather from eagle
41. Army epaulets with fringe
42. Breast plate of hair pipes
43. Shield with otter skin binding War

44. Earring Man or woman
45. Ornamental cross of German silver
46. Braid wrapping of cloth
47. Knife sheath under belt

48. Umbrella, open Man or woman; sunny day
49. Head roach of animal hair, with eagle feather
50. Fan of eagle feathers
51. Hair plates of German silver
52. Robe, a woven blanket, enveloping body Man or woman
53. Hide legging in "forked" pattern with fringe

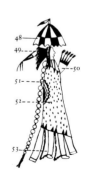

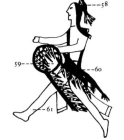

EXPLICIT MEANING CONNOTATION

54. Hat from white man
55. Earring Man or woman
56. Bow case and quiver of mountain lion
skin and tail
57. Bandolier of hair pipes
58. Mounted bird
59. Shield with cloth drape and feathers War
60. Bow case and quiver of otter skin
61. Legs extended Running
62. Crescent ornament with fringe
63. Breath feather of eagle
64. Hair part for scalp lock
65. Ornament on scalp lock
66. Vest
67. Mounted rodent
68. Bone pipe with wrapping

EXPLICIT MEANING CONNOTATION

69. War bonnet of eagle feathers with weasel tail dropper	Very brave man
70. Face shown in profile	Man or woman
71. Shoulders shown broadside	Man or woman
72. Earring of dentalium shells and abalone	Man or woman
73. Elongated torso	Man or woman
74. War shirt of buckskin with fringe	Very brave man
75. Shield with feathered dropper	War
76. Posture rigid and straight	Man or woman
77. Foot shown turned toward the side	Man or woman
78. War bonnet with feathers and buffalo horns	
79. Hair unbound	Man or woman
80. Stylized costume	Man or woman
81. Nose but no eye or mouth	Man or woman
82. War bonnet of eagle feathers with full tail	Very brave man
83. Necklace of hair pipes	Man or woman (Cheyenne)
84. No hands	Man or woman

EXPLICIT MEANING CONNOTATION

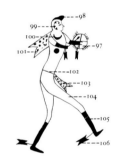

85. Shako with plume, from Army uniform
86. Epaulets with fringe
87. Silver medal on ribbon
88. Frock coat of an Army officer

⎫
⎬ A leader rewarded by Government
⎭

89. Feathers with band
90. Whistle of bone
91. Moon painted on bare torso
92. Bandolier of mescal beans or brass beads
93. Paint on body
94. Medicine wheel
95. Long breechcloth
96. Blanket wrapped around hips and legs

⎫
⎬ Sun Dancer
⎭

97. Hand drum and stick
98. Hair combed toward front
99. Paint with triangles on face
100. Moon, painted
101. Drape of cloth
102. Waist cord
103. Short breechcloth
104. Body nearly naked
105. Paint on lower legs and forearms
106. Symbol representing a man

⎫
⎬ Massaum participant (Cheyenne)
⎭

EXPLICIT MEANING CONNOTATION

107. Headdress of crow feathers sur-
mounted by eagle feathers
108. Shoulder sash worn by very brave
men } Dog Soldier (Cheyenne)
109. Belt
110. Rattle with dewclaws
111. Body nearly naked

112. Paint on face
113. Hair unbound
114. Full feathered lance
115. Paint on nearly naked body } Bowstring (Wolf) Soldier (Cheyenne)
116. Rattle, doughnut shaped, with
weasel tail fringe

117. Whip painted in rectangles, hung First Dance Man, Second Degree
with feathers, buffalo tail, and bell (Arapaho)
118. Hair ornament Man or woman
119. Earring in crescent shape Man or woman
120. Braid, plain Woman
121. Belt of German silver with dropper Woman
122. Bag, fringed Man or woman
123. Panel set into side of skirt Woman
124. Legging top turned down and Woman
fringed
125. Legging Woman

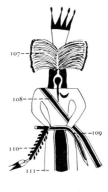

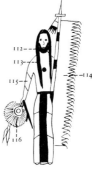

EXPLICIT MEANING CONNOTATION

Explicit Meaning	Connotation
126. Hair part	Woman
127. Cone earring following edge of ear	Man or woman
128. Tab on shoulder	Woman
129. Elk tooth ornaments	Woman
130. Cape sleeves	Woman
131. Blanket wrapped from waist to knee	Man or woman
132. Skirt with side panels	Woman
133. Moccasin with legging attached	Woman
134. Hair unbound	
135. Breechcloth short	Boy
136. Body nearly naked	

XI. COSTUMES AND ACCESSORIES, FOREIGN:
Traits Distinguishing Those Not Belonging to the Foregoing Tribes

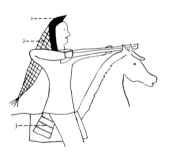

EXPLICIT MEANING	CONNOTATION (A man unless otherwise noted)
1. Hair brushed forward	
2. Hairdo a net-like wig	Crow tribe
3. Breechcloth with stripes	
4. Jacket	
5. Trousers with pinstripes	Mexican Guides Corps
6. Holster	
7. Shako with pompon	Mexican Presidial Cavalry
8. Poncho	

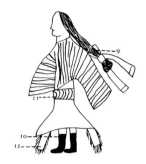

EXPLICIT MEANING CONNOTATION

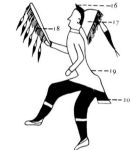

9. Hair "clubbed"

10. Leggings black } Navaho female

11. Belt of German silver conchas?

12. Skirt with side panels of fringed leather

13. Hair "clubbed"

14. Breechcloth short } Navaho tribe

15. Leggings black

16. Ridge of hair above shaved head

17. Head roach (alternately—head dress with feathers)

18. Dance whip (alternately—a conventional weapon) } Omaha Dance Society member

19. Dance posture of body bent forward at waist, hips back

20. Breechcloth short

21. Dance whip

22. Ridge of hair above shaved head

23. Bars of paint on face

24. Scalp lock } Osage tribe

25. Choker with design

26. Silver medal on ribbon

27. Breechcloth short

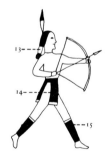

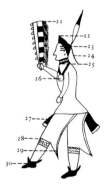

EXPLICIT MEANING CONNOTATION

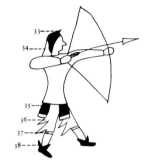

28. Garter with design
29. Tabs with points behind thighs
30. Moccasin with flaring cuff } Osage tribe
31. Necklace of bear claws
32. Necklace of bead rope

33. Hair coming to a point on crown
34. Pigtail
35. Breechcloth short } Pawnee tribe
36. Tabs with points behind thighs
37. Garters
38. Moccasin with flaring cuff

39. Shako with plume
40. Hair short
41. Saber
42. Epaulet
43. Coat with buttons and contrasting cuffs } U.S. Army officer
44. Belt
45. Scabbard
46. Trousers with stripe up the side
47. Shoes with heels

48. Clothing of fringed leather
49. Hair tied at end } Ute tribe
50. Breechcloth short

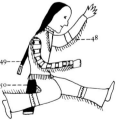

EXPLICIT MEANING CONNOTATION

51. Hat

52. Hair at collar-length

53. Beard

54. Shirt with collar ⟩ White civilian, Eastern dress

55. Coat

56. Trousers

57. Shoes with heels

58. White civilian, Western dress

59. Wichita woman

XII. HORSE GEAR

EXPLICIT MEANING	CONNOTATION
1. Head stall with silver mounting	
2. Ornament for tail	
3. Riding pad	
4. Crupper	
5. Tail tied up with cloth strips	War
6. Breast strap with bells	
7. Girth	
8. Paint for protection	War
9. Tether tied to vegetation	
10. Ears with slits	
11. Bridle made commercially	
12. Reins of braided leather	
13. Scalp	
14. Saddle cloth from U.S. Army	
15. Brand made by white man	
16. Tail braided	
17. Paint for protection	War
18. Hobble	

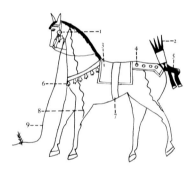

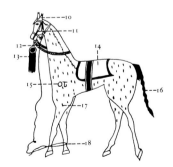

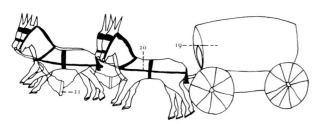

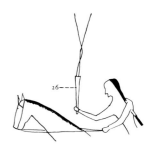

EXPLICIT MEANING	CONNOTATION
19. Wagon with cover	White man
20. Harness	White man
21. Tug hanging slack	Grade down hill
22. Ears with slits	
23. Rein, single	
24. Quirt of wood with pendant animal skin	
25. Case for war bonnet	Travel
26. Quirt of bone	
27. Quirt	
28. Quirt of woven leather with twisted lashes	

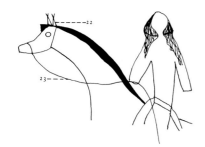

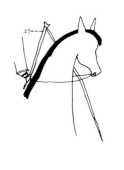

EXPLICIT MEANING CONNOTATION

29. Saddle of horn and antler
30. Saddle bag Travel
31. Three-point blanket on saddle
32. Saddle of curved antlers
33. Saddle with pronged antler
34. Saddle for pack
35. Parfleche Travel
36. Saddle for woman
37. Saddle with stirrup, commercial
38. Canteen from U.S. Army Travel
39. Stirrup
40. Stirrup, tapadero (Mexican)

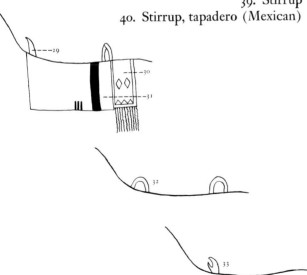

XIII. MAN-MADE OBJECTS, MISCELLANEOUS

EXPLICIT MEANING CONNOTATION

1. Barrel
2. Bed with tripods and willow back-rests
3. Bugle of U.S. Army
4. Cloth
5. Coffee pot
6. Cooking devices
a. Kettle with chain
b. Kettle with chain and pot-hook
c. Kettle with wooden pot-hook

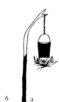

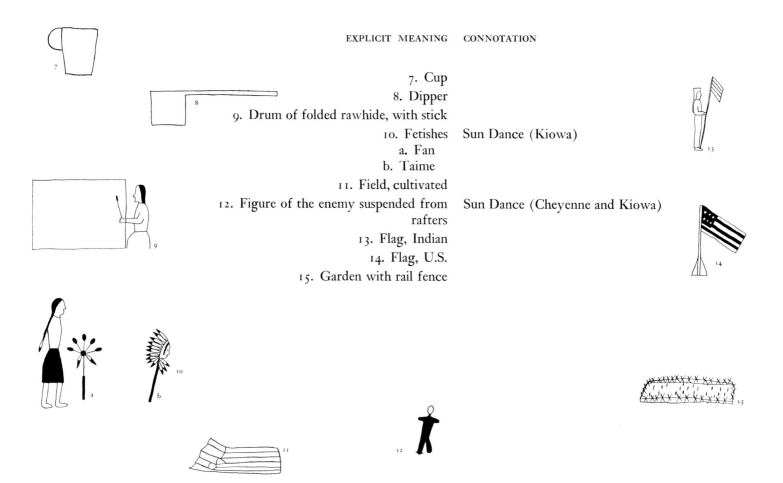

EXPLICIT MEANING	CONNOTATION
7. Cup	
8. Dipper	
9. Drum of folded rawhide, with stick	
10. Fetishes	Sun Dance (Kiowa)
a. Fan	
b. Taime	
11. Field, cultivated	
12. Figure of the enemy suspended from rafters	Sun Dance (Cheyenne and Kiowa)
13. Flag, Indian	
14. Flag, U.S.	
15. Garden with rail fence	

EXPLICIT MEANING CONNOTATION

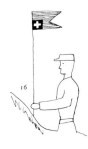

16. Guidon of U.S. Army

17. Hatchet, utilitarian

18. Hide for tanning, leaning against tipi

19. Mark to shoot at for recreation, with arrows shot

20. Matches

21. Offerings of robes and cloth on poles and willow bundle Sun Dance (Cheyenne and Kiowa)

22. Rack with drying meat

EXPLICIT MEANING CONNOTATION

23. Shinny equipment
a. Goal marked with colored cloth
b. Stick
c. Ball in doughnut shape
24. Travois carrying sticks
25. Tripod carrying shield

XIV. NATURAL OBJECTS

EXPLICIT MEANING **CONNOTATION**

1. Hail
2. Hills
3. Hole with dust
4. Lightning
5. Meteor
6. Moon

EXPLICIT MEANING CONNOTATION

7. Mountain
8. Pond with trees
9. Rainbow
10. Shower with cloud
11. Smoke
12. Star
13. Star, morning

EXPLICIT MEANING CONNOTATION

14. Stream with trees
15. Summit of a slope
16. Sun
17. Swamp
18. Tree, dead
19. Trees
20. Undergrowth

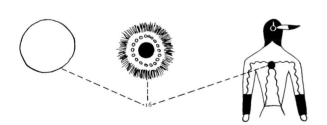

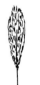
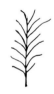

XV. STRUCTURES

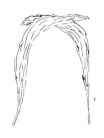

EXPLICIT MEANING CONNOTATION

1. Arbor Summer season
2. Barracks of U.S. Army
3. Dog Soldier lodge Cheyenne tribe
4. Grass house Wichita tribe
5. House of white man
6. Omaha Dance house Osage tribe
7. Sun Dance lodge Cheyenne, Arapaho, Kiowa tribes

EXPLICIT MEANING	CONNOTATION
8. Sun shade of blankets	Summer season
9. Tent, Army "A"	
10. Tent, Army wall	
11. Tent, Army wall with wall partially rolled up	Hot day
12. Tipi with smoke flaps	
13. Tipis	A man of substance (plural wives)
a. Elaborate painting	Hereditary pattern; distinguished family (Cheyenne or Kiowa)
b. Wall partially rolled up	Hot day

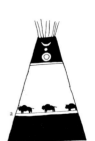

XVI. WEAPONS

1. Bayonet, Army
2. Bow and arrow
3. Cannon and ammunition, Army
4. Carbine
5. Coup stick Kiowa
6. Knife used in scalping

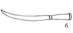

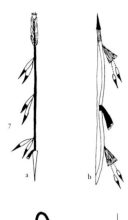

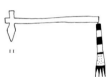

EXPLICIT MEANING CONNOTATION

7. Lances
a. Arrow lance Cheyenne or Kiowa
b. Bow lance with feathers suspended Bowstring Soldier Society (Cheyenne)
by twisted cords
c. Crooked lance with otterskin Very brave man
wrapping
d. Full-feathered lance of eagle
feathers
e. Lance wrapped with otter fur
f. Padded lance Sham battle before Sun Dance (Kiowa)

8. Revolver
9. Rifle, brass or silver mounted, with
wiping sticks as rest
10. Saber with otterskin streamers
11. Pipe tomahawk with ornamental tab
12. Powder horn and musket ball pouch

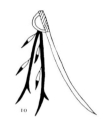

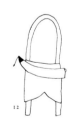

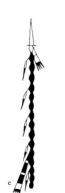

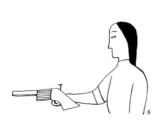

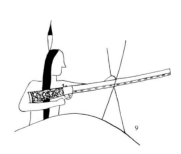

APPENDIX

CHRONOLOGICAL CATALOGUE OF THE ART OF THE FORT MARION INDIANS

DATE	ARTIST AND FILE NUMBER	NO. OF ITEMS	LOCATION
1875 (Aug.)	Making Medicine (Cat. No. 39a)	23	BAEC
1875 (Sept.)[1]	Anonymous	1	Sidney Lanier, *Florida: Its Scenery, Climate, and History*, 53
1876 (Feb. 12)	Koba	17	Mrs. Karen D. Petersen, West St. Paul, Minn.
1876 (June 13)	Zotom	23	PP
1876 (July 31)	Bears Heart and Ohettoint	26	Roy H. Robinson, Evanston, Ill.
1876 (Sept.)	Bears Heart	25	Roy H. Robinson, Evanston, Ill.
1876 (Sept.)	Etahdleuh	32	Roy H. Robinson, Evanston, Ill.
1876 (Sept.)	Ohettoint	31	Roy H. Robinson, Evanston, Ill.
1876 (Sept.)	Cohoe	16	Mrs. Karen D. Petersen, West St. Paul, Minn.
1876 (Oct.)	Howling Wolf	16	Western Americana Collection, Yale University, New Haven, Conn.
1875 (May 21)–1876 (Nov. 30)[2]	White Horse (Acc. No. 1949, 165)	19	Joslyn Art Museum, Omaha, Neb.
1876 (Nov.)	Bears Heart (20/6231)	24	Museum of the American Indian, Heye Foundation, New York, N.Y.
1876[3]	Ohettoint	26	Mrs. D. W. Killinger, Greencastle, Ind.
1877 (Jan.)[4]	Wohaw	48	Pictorial History Department, Missouri Historical Society, St. Louis

NOTE: A page is counted as one item. All are original drawings on paper unless specified otherwise. Reproductions are listed only if originals are not extant. Listing is in order of latest possible date of completion or sale. Unless a date appears on a work, a footnote gives the basis for dating it. Variation in capitalization of a name or in its division into syllables by use of spaces, hyphens, or periods is ignored.

DATE	ARTIST AND FILE NUMBER	NO. OF ITEMS	LOCATION
1875 (May 21)–1877 (Mar. 26)[5]	Buffalo Meat(?) (Cat. No. 4656)	16	BAEC
1876 (May 18)–1877 (Mar. 26)[6]	Making Medicine (Cat. No. 39b)	22	BAEC
1877 (Apr. 26)[7]	Etahdleuh	27	PP
1876 (July 26)–1877 (May 24)[8]	Zotom	37	Mrs. Maurine M. Boles, St. Augustine; James Jolly, Daytona Beach, Fla.
1877 (July 13?)[9]	Howling Wolf	1	Francis Parkman Papers, Massachusetts Historical Society, Boston
1877 (Apr. 18–July 21)[10]	Bears Heart and others	43	Francis Parkman Papers, Massachusetts Historical Society, Boston
1877 (June 30–July 21)[11]	Bears Heart and Wohaw (Neg. Nos. 363b–1 and 2) (photographs)	2	BAEC
1877 (June 30–July 21)[11]	Wohaw (Cat. Nos. 30747 and 30750)	2	USNMC
1877[12]	Zotom	29	L. S. M. Curtin, Santa Fe, N. M.
1877[12]	Howling Wolf	28	L. S. M. Curtin, Santa Fe, N. M.
c1877[13]	Making Medicine (and Little Medicine?) (fan)	1	Library, St. Augustine Historical Society, St. Augustine, Fla.
1878 (Feb. 28–Mar. 3)[14]	Etahdleuh	1	Miss Frances Malone, Greenfield, Mass.
1878 (shortly before Mar. 12)[15]	Buffalo Meat and Buzzard	3	Museum, Oklahoma Historical Society, Oklahoma City
1875 (May 21)–1878 (Apr. 11)[16]	Koba (Cat. No. 39c)	31	BAEC
1875 (May 21)–1878 (Apr. 11)	Making Medicine and others	50	PP
1875 (May 21)–1878 (Apr. 11)	Tsadeltah and others	88	Huntington Library, Hampton Institute, Hampton, Va.
1875 (May 21)–1878 (Apr. 11)	Zotom (20/6232–6241)	15	Museum of the American Indian, Heye Foundation, New York, N. Y.
1875 (May 21)–1878 (Apr. 11)(?)[17]	Howling Wolf and Soaring Eagle (83999)	8	Field Museum of Natural History, Chicago, Ill.
1878 (Apr. 13)–1879 (June 7)[18]	Ahsit (White Man) (1.4616) (fan)	1	American Museum of Natural History, New York, N. Y.
1878 (Apr. 13)–1879 (June 7)	Etahdleuh (1926) (vase)	1	College Museum, Hampton Institute, Hampton, Va.

DATE	ARTIST AND FILE NUMBER	NO. OF ITEMS	LOCATION
1878 (Apr. 13)–1879 (June 7)	Koba (1923) (plaque)	1	College Museum, Hampton Institute, Hampton, Va.
1879 (Jan. 1–June 7)[19]	Koba (1925) (fan)	1	College Museum, Hampton Institute, Hampton, Va.
1880 (Jan.)	Chas. Ohettoint	56	PP
1879 (Mar.)–1880 (Feb. 21)[20]	Tichkematse (Cat. No. 290,844)	22	USNMC
1880 (Feb. 21–Apr.)[21]	Etahdleuh Doanmoe (Cat. No. 290,844)	4	USNMC
1880	Bears Heart	1	Howard D. Rodee, New York, N. Y.
1875 (May 21)–1881 (Mar. 31)[22]	Bears Heart and anonymous (4 of them transparencies)	14	PP
1878 (Apr. 13)–1881 (Mar. 31)[23]	Anonymous	1	Huntington Library, Hampton Institute, Hampton, Va.
1880 (Dec.)–1881 (Mar. 31)[24]	Jas. Bears Heart	1	Huntington Library, Hampton Institute, Hampton, Va.
1878 (Apr. 27)–1881 (May 16)[25]	Howling Wolf	12	Mrs. A. H. Richardson, Omaha, Neb.
1893 –1898[26]	Ohettoint (Cat. No. 245,001) (tipi)	1	USNMC

[1] A letter of Sidney Lanier to Lt. A. H. Merrill, Aug. 26, 1875, PP, forwarded to Pratt Sept. 2, asks for drawings for Lanier's book.

[2] Several factors indicate a very early date. White Horse did not sign this work, as he could have done by July, 1877. Only Making Medicine, in August, 1875, drew in a book identical to this one. The inscription speaks of "Sign Language," just as Lanier spoke of "sign writing" in August, 1875. The book includes no views of life at Fort Marion, as most books did after the first year. It was taken to the Philadelphia Centennial between May and November, 1876. Collection data in Joslyn Art Museum.

[3] A letter of Mrs. Killinger to author, Sept. 20, 1966, furnishes this date from the book.

[4] Mrs. Jensen, *Bulletin of the Missouri Historical Society*, Vol. VII, No. 1, 76–77, establishes the date on unassailable circumstantial evidence.

[5] The catalog card for Cat. No. 4656, BAEC, establishes the writer of an inscription in this book as George Fox, from a comparison with handwriting in book No. 39b. The citation for the Mar. 26 date, given in footnote 5, applies equally here.

The writer believes that Buffalo Meat, the Cheyenne, was not the creator of these drawings, for the following reasons: His name was not inscribed by himself but, presumably, by George Fox, although Buffalo Meat could write his name by July of 1877. The drawings are obviously by several men, judging by the degrees of proficiency. Kiowa traits, not found in the Fort Marion representations of Cheyennes and Arapahos, are used in these drawings, such as fringe at moccasin-heels, medals, wom-

en's crescent earrings, bear-paw designs on clothing, and streamers on quivers.

[6] The inspection here pictured took place on or by May 18, 1876.—Col. H. J. Hunt to AAG, NA, WD, Inspec. Gen's. Office, # S79 (1876). A memo by Mrs. S. H. Burnside, BAEC files, names the writer of an inscription in the book as George W. Fox. "Affairs at Home," FP, Mar. 31, 1877, gives Mar. 26, 1877, as the date of interpreter Fox's separation from Fort Marion.

[7] A memo by Mason Pratt in PP supplies the date formerly attached to the drawings but now missing.

[8] Pratt set about getting an organ, shown in a drawing, July 26, 1876; the day for prayer meeting, said to be Sunday in one caption, was changed to Monday by May 24, 1877. Pratt to Bishop Whipple, July 26, 1876, Minnesota Historical Society, St. Paul, Minn., Bishop Henry B. Whipple Papers; J. D. Wells, "A Company of Christian Indians," The Christian at Work, May 24, 1877.

[9] Howling Wolf left St. Augustine July 12, 1877, and made the drawing after leaving Savannah. NA, WD, AGO, Returns from U.S. Military Posts, St. Augustine, Fla., July, 1879.

[10] The book has a roll call of the prisoners which omits two Kiowas released April 18, 1877, but includes Nadawitht, who died July 21, 1877. Pratt, Report of Indian Prisoners Confined in Fort Marion, St. Augustine, Florida, April, 1877, PP; Pratt to Post Adjutant, July 22, 1877, PP.

[11] The originals of the BAEC photographs were formerly in the USNMC and were accessioned consecutively with the Wohaws now at the USNMC, other Fort Marion drawings, and a picture-letter that is dated June 30, 1877. These were presumably the drawings which Clark Mills was taking to Washington on July 21. "Curiosities for the Smithsonian Institute," News, July 27 [1877].

[12] A letter of Mrs. Curtin to author, July 13, 1964, supplies this date of collecting the sketchbook.

[13] The display label at St. Augustine Historical Society gives this date.

[14] Sketches preceding and following this one, which is inter-

polated in a sketchbook by James Wells Champney, are dated Feb. 28 and Mar. 3, 1878.

[15] F. H. T. [Frank Hamilton Taylor], Daily Graphic, Apr. 26, 1878, and DSP, Mar. 12, 1878, together date the collector's visit to the fort.

[16] All under this date are undated but are known to have originated in the Fort Marion era.

[17] There is room for doubt as to whether this book was made at Fort Marion or in the West. Since conclusive internal evidence or documentation is lacking, the three pictures of the captivity were the deciding factor in favor of the earlier date.

[18] All under this date are undated but are known to have originated during the year at Hampton.

[19] The fan was dated 1879, but Koba's Hampton year ended June 7.

[20] Tichkematse's dates at the U.S. National Museum are deduced from "Indian Students at the White House," n.p., n.d., PP; Denison, The Congregationalist, Vol. XXXI, No. 21, 162; Annie S. Larocque to Pratt, Apr. 6, 1879, PP; Pratt to Miles, Jan. 20, 1880, OHSIA, C&A–Indian Prisoners; Miles to Pratt, Feb. 25, 1880, PP. One drawing is dated Nov. 8, 1879.

[21] Etahdleuh's dates at the U.S. National Museum are deduced from SW, Vol. XVII, No. 7, 81; Doanmoe to Pratt, Feb. 24, 1880, enclosed in Pratt to agent, Feb. 27, 1880, OHSIA, Kiowa–Carlisle Indian School; Doanmoe to Miles, Mar. 22, 1880, CT, Vol. I, No. 8 (Apr. 24, 1880); Pratt to Commissioner, May 7, 1880, NA, OIA, Letters Received, P649–80.

[22] The drawings might have been done in either the Fort Marion or the Hampton years. Since Pratt saw little of Bear's Heart in the latter period, the drawings will be attributed to Fort Marion.

[23] The note with the drawing locates it at Hampton. It would therefore fall between the arrival of the prisoners and the departure of the last one.

[24] Cora M. Folsom, for whom the drawing was made, arrived at Hampton in Dec., 1880, as she says in her manuscript, "Indian

Work at Hampton," in Hampton Institute. Bear's Heart left Hampton Apr. 1, 1881. [Folsom], in *Twenty-two Years' Work*, 329.

[25] Miles to Commissioner, May 2, 1878, NA, OIA, Letters Received, C&A Agency, 1878, gives Apr. 27, 1878, for Howling Wolf's arrival at the agency. The sketchbook identifies him as Minimic's son, and Minimic died May 16, 1881. *CT*, Vol. II, No. 19 (May 25, 1881), [5].

[26] James Mooney, in MS, Field notebooks, I, pp. 50a and 51a, says that the original tipi was no longer renewed after 1892. James B. Haynes, in *History of the Trans-Mississippi and International Exposition of 1898*, 226, states that by 1898 Mooney had worked on the display of model Kiowa tipis for five years.

NOTE: A recent book attributes one of its illustrations to "Kiowa year count by Bird-Tied-on-Top-of-His-Head, Ft. Marion, Florida, 1871 [*sic*]—Plate 20. Fairfield [*sic*] Museum and Planetarium, St. Johnsbury, Vermont." Except that the Plains drawing book in the collections of the Fairbanks Museum and Planetarium bears the name of Bad Eye, a Kiowa, there is no evidence to suggest that the book was made by a Fort Marion prisoner. Indeed, there is good reason to believe that no drawings were made at the fort by the prisoner Bad Eye (whose Kiowa name could be rendered Bird Tied on Top). Examination of the drawings precludes any possibility that this is a "year count."

BIBLIOGRAPHY

ARCHIVAL MATERIALS

American Museum of Natural History (New York), Anthropology—Fan with drawings.
Anadarko Agency (Anadarko, Okla.)—Allotment files.
Castillo de San Marcos National Monument (St. Augustine, Fla.)—Indian drawings.
Church Historical Society (Episcopal Church) (Fort Worth, Tex.)—Bishop Brooke's correspondence.
Concho Agency (Concho, Okla.)—Allotment files.
Episcopal Diocese of Arkansas (Little Rock)—Bishop Pierce's diary.
Episcopal Diocese of Massachusetts (Boston)—Records of the Dakota League.
Field Museum (Chicago, Ill.)—Indian drawings, Mooney tipi collection data.
Fort Sill Museum, U.S. Army (Fort Sill, Okla.)—Files, Post Guard Books, 1874–Apr. 13, 1875.
Hampton Institute (Hampton, Va.):
 Library—Indian drawings.

Museum—Fan, plaque, and vase with Indian drawings.
 Records—Records of returned Indians.
 Vault—MS by Cora M. Folsom, "Indian Work at Hampton."
Historical Society of Pennsylvania (Philadelphia), Manuscript Room—Autograph Collection.
Joslyn Art Museum (Omaha, Neb.)—Indian drawings.
Massachusetts Historical Society (Boston)—Indian drawings.
Minnesota Historical Society (St. Paul)—Bishop Henry B. Whipple Papers, Letters received, 1876, 1878.
Missouri Historical Society (St. Louis)—Indian drawings.
Museum of the American Indian, Heye Foundation (New York)—Indian drawings.
New York Public Library (New York)—Photograph collection.
Northern Cheyenne Agency (Lame Deer, Mont.)—Family Histories file.

Oklahoma Historical Society (Oklahoma City):
 Indian Archives
 Card index.
 Cheyenne and Arapaho—Deaths, Hampton Institute, Indian murders, Indian prisoners.
 Indian warfare.
 Kiowa—Carpenters, Carlisle Indian School, Census, Employees, Indian houses, Indian prisoners of war, Kiowa School, Military relations, Police.
 Kiowa Agency letterpress copy book, 1882.
 Museum—Indian drawings.
 Photographs—Collection.
St. Augustine Historical Society (St. Augustine, Fla.)—Census, Indian drawings, typescript by Mrs. G. W. Gibbs.
Smithsonian Institution:
 Divisions of Birds and Mammals—Collection data.
 Office of Anthropology Archives
 Bureau of American Ethnology Collection
 Correspondence files.
 Indian drawings.
 MS field notebooks and correspondence of James Mooney.
 Photograph and negative collections.
 U.S. National Museum Collection
 Collection data.
 Indian drawings.
 Photograph collection.

Tipi collection by Mooney.
The United States Military Academy (West Point, N. Y.), Library, Special Collections Division, Capt. John G. Bourke Papers—Diaries.
United States National Archives and Records Service:
 Office of Indian Affairs
 Carlisle School Records.
 Field Papers, Central Superintendency
 Cheyenne and Arapaho Agency, 1874, 1875.
 Kiowa and Comanche Agency, 1875.
 Indian Census Rolls, C&A Agency, Cheyenne, 1892, 1893.
 Letters Received
 1880, 1881, 1886.
 Central Superintendency, 1875, 1876.
 Cheyenne and Arapaho Agency, 1875, 1878, 1879.
 Kiowa Agency, 1874, 1875.
 Miscellaneous, 1878, 1879.
 Upper Arkansas Agency, 1874.
 Statistics Division
 Record of Indian Police, 1880–82, 1888–1904.
 Roster of Agency Employees, 1880–81.
 War Department
 Adjutant General's Office
 File 2815—1874.
 ACP file 6238—1878.
 Letters Received, U.S. Army Commands, Department of the Missouri, 1874, 1875.

Military Pension Files.

Yale University (New Haven, Conn.), Beinecke Rare Book and Manuscript Library, Western Americana, Gen. Richard H. Pratt Papers:

 R. H. Pratt

 Indian drawings and accompanying memos.

 Letterpress copy books.

 Letters received.

 MS data on prisoners.

 MS memoirs.

 MS, Some Experiences with our Most Nomadic Indians.

 Mrs. R. H. (Anna Laura) Pratt—Scrapbooks.

 Miss Longstreth—Scrapbook.

 Mason Pratt—Notes on drawings and photographs.

 Delos K. Lonewolf—List of Kiowa prisoners.

OFFICIAL REPORTS

ARBAE, 1881–82 (1882).

ARCIA, 1872, 1874, 1875, 1881, 1882, 1888, 1889, 1890.

ARSI, 1880 (1881), 1881 (1883).

Congressional:

 Howe, Albert. "Notes on the Returned Indian Students of the Hampton Norman and Agricultural Institute, Dec., 1891," 52 Cong., 1 sess., *Sen. Exec. Doc. No. 31* (Serial 2892) (Washington, D.C., 1891).

 Joint Special Committee Appointed under Joint Resolution of Mar. 3, 1865. "Condition of the Indian Tribes," 39 Cong., 2 sess., *Sen. Report No. 156* (Serial 1279) (Washington, D.C., 1867).

 Henely, Lt. Austin, to Post Adjutant, in 44 Cong., 1 sess., *House Exec. Doc. No. 1*, Part II (Serial 1674) (Washington, D.C., 1876).

 Pratt, Lt. R. H. [Report on visit to Florida Seminoles], 50 Cong., 1 sess., *Sen. Exec. Doc. No. 139* (Serial 2513) (Washington, D.C., 1888).

 Sheridan, Gen. P. H., to the President, in "Report of the Secretary of War," I, 49 Cong., 1 sess., *House Exec. Doc. No. 1*, Part II (Serial 2369) (Washington, D.C., 1886).

Denominational:

 [Brooke, Bishop Francis K.]. "The Bishop's Journal," *OITC*, Vol. III, No. 14 (Sept., 1894).

 Brooke, Bishop Francis K. "First Annual Report of the Missionary Bishop of Oklahoma," *DFMS Reports*, 1892–93 (New York, n.d.).

 Huntington, Bishop Frederic D. "Bishop's Address," 13th *Annual Convention of the Protestant Episcopal Church in the Diocese of Central New York, Journal*, 1881.

 "Missionaries and Teachers among the Indians," *DFMS Reports*, 1888–89 (New York, n.d.).

 Pierce, Bishop H. N. "Annual Report of the Missionary Bishop of Arkansas and the Indian Territory," *DFMS Reports*, 1885–86 (New York, n.d.).

———. "The Bishop's Annual Address," 18th *Annual Council of the Diocese of Arkansas, Journal of the Proceedings* (Little Rock, 1890).

Educational:

Armstrong, S. C. "Report," *Reports of the Officers of the Hampton Normal and Agricultural Institute, Hampton, Virginia, for the Academical and Fiscal Year, Ending June 30, 1879* (Hampton, Va., 1879).

Miles to Romeyn, "Bears Heart's Return," in Hampton Normal and Agricultural Institute, *Report of the Principal for 1881* (Hampton, Va., 1882).

ARTICLES

Adams, Adeline. "Clark Mills," *DAB*, XIII (1934).

Adeler, Max [Charles Heber Clark]. "Negro and Indian," *Evening Bulletin* (Philadelphia), May 25, 1878.

Bass, Althea. "James Mooney in Oklahoma," *CO*, Vol. XXXII, No. 3 (Autumn, 1954).

Brooke, Rt. Rev. Francis Key. "Ten Years of Church Life in Oklahoma and Indian Territory," *SM*, Vol. LXVIII, No. 5 (May, 1903).

[Burnham, Mary D.]. "An Evening at San Marco," *GMCJ*, Vol. III, No. 29 (May, 1878).

———. "Notes of Our Indian Territory Mission," *GMCJ*, Vol. IV, No. 69 (Sept., 1881).

———. "Our Indians at Paris Hill," *GMCJ*, Vol. IV, No. 48 (Dec., 1879).

Burnham, Mary D. "First-fruits of the Kiowas, Comanches, and Cheyennes," *Churchman*, Vol. XXXVIII, No. 18 (Nov. 2, 1878).

———. "Florida Indians," *Churchman*, Vol. XXXVII, No. 26 (June 29, 1878).

Caruthers, Mrs. Horace. "The Indian Prisoners at St. Augustine," *The Christian at Work*, Vol. XI, No. 554 (Aug. 23, 1877).

"Champ" [James Wells Champney]. "Home Correspondence," *Weekly Transcript* (Boston), Apr. 2, 1878.

Champney, Lizzie W. "The Indians at San Marco," *The Independent*, Vol. XXX, No. 1541 (New York, June 13, 1878).

Clouse, Rev. H. H. "Rainy Mountain Kiowa Mission," *Baptist Home Mission Monthly*, Vol. XXIV, No. 7 (July, 1902).

Crayon, Porte [David Hunter Strother]. "Sitting Bull. —Autobiography of the Famous Sioux Chief," *Harper's Weekly*, Vol. XX, No. 1022 (July 29, 1876).

Cushing, F. H. "Nation of the Willows," *Atlantic Monthly*, Vol. L, No. 299 (Sept., 1882); No. 300 (Oct.).

Davis, Curtis Carroll. "Tardy Reminiscences: Some Recollections of Horace Caruthers 1824–1894," *Westchester County Historical Bulletin*, Vol. XXIV, No. 3 (July, 1948).

[Davis, Theodore R.]. "A Summer on the Plains," *Harper's New Monthly Magazine*, Vol. XXXVI, No. 213 (Feb., 1868).

Denison, Rev. John H. "A Supplement to the last Smithsonian Report," *The Congregationalist*, Vol. XXXI, No. 21 (Boston, May 21, 1879).

Doanmoe, Etahdleuh. "Communicated," *EKT*, Vol. I, No. 9 (March, 1881).

Ediger, Theodore A., ed. "Chief Kias," *CO*, Vol. XVIII, No. 3 (Sept., 1940).

Ewers, John C. "The Blackfoot War Lodge: Its construction and Use," *AA*, n. s. Vol. XLVI, No. 2, Part I (Apr.–June, 1944)

———. "Plains Indian Painting: The History and Development of an American Art Form," in *Howling Wolf: A Cheyenne Warrior's Graphic Interpretation of His People*, by Karen Daniels Petersen, Palo Alto, 1968.

Faulkner, Ethel Webb. "Joel Dorman Steele," *DAB*, XVII (1935).

Filipiak, Jack D. "The Battle of Summit Springs," *The Colorado Magazine*, Vol. XLI, No. 4 (Fall, 1964).

[Folsom, Cora M.]. "Instantaneous Views," *Twenty-two Years' Work of the Hampton Normal and Agricultural Institute at Hampton, Virginia* (Hampton, Va., 1893).

Grinnell, George Bird. "A Buffalo Sweatlodge," *AA*, n. s. Vol. XXI, No. 4 (Oct.–Dec., 1919).

———. "Coup and Scalp Among the Plains Indians," *AA*, n. s. Vol. XII, No. 2 (Apr.–June, 1910).

Griswold, Gillett. "Old Fort Sill: The First Seven Years," *CO*, Vol. XXXVI, No. 1 (Spring, 1958).

Hough, Walter. "Frank Hamilton Cushing," *DAB*, IV (1930).

Huntington, Bishop F. D. "Educating the Indian," *Churchman*, Vol. XL, No. 5 (Aug. 2, 1879).

Jensen, Mrs. Dana O. "Wo-Haw: Kiowa Warrior," *Bulletin of the Missouri Historical Society*, Vol. VII, No. 1 (Oct., 1950).

Jordan, David Starr and Jessie Knight Jordan. "Spencer Fullerton Baird," *DAB*, I (1928).

Lippincott, Dr. J. A., to Pratt, Sept. 5, 1882, "Dr. Lippincott's Report," *MST*, Vol. III, No. 2 (Sept., 1882).

Llwyd, Rev. H. J. "Right Rev. Francis Key Brooke, D. D., Bishop of Oklahoma," *CO*, Vol. XII, No. 1 (Mar., 1934).

[Ludlow, Helen W.]. "An Indian Raid on Hampton Institute," *SW*, Vol. VII, No. 5 (May, 1878).

———. "Indian Education at Hampton and Carlisle," *Harper's New Monthly Magazine*, Vol. LXII, No. 371 (Apr., 1881).

———. "Record of Indian Progress," *SW*, Vol. VIII, No. 5 (May, 1879).

McKay, Robert J. "Biography," *James Wells Champney, 1843–1903* (Deerfield, Mass., 1965).

Mallery, Garrick. "Pictographs of the North American Indians," 4th *ARBAE*, 1882–83 (1886).

———. "Picture-writing of the American Indians," 10th *ARBAE*, 1888–89 (1893).

———. "Sign Language among the North American Indians," 1st *ARBAE*, 1879–80 (1881).

Methvin, Rev. J. J. "Apeahtone, Kiowa—A Bit of History, *CO*, Vol. IX, No. 3 (Sept., 1931).

———. "Reminiscences of Life Among the Indians," *CO*, Vol. V, No. 2 (June, 1927).

Mooney, James. "Calendar History of the Kiowa Indians," 17th *ARBAE*, 1895–96, Part I (1898).

———. "The Cheyenne Indians," *American Anthropological Association Memoirs*, I (Lancaster, Pa., 1905–1907).

———. "The Ghost-Dance Religion and the Sioux Outbreak of 1890," 14th *ARBAE*, 1892–93, Part II (1896).

———. "The Indian Congress in Omaha," *AA*, n. s. Vol. I, No. 1 (Jan., 1899).

Murphy, John. "Reminiscences of the Washita Campaign and of the Darlington Indian Agency," *CO*, Vol. I, No. 3 (June, 1923).

Nute, Grace Lee, "Henry Benjamin Whipple," *DAB*, XX (1936).

Pilling, James C. "Catalogue of Linguistic Manuscripts in the Library of the Bureau of Ethnology," 1st *ARBAE*, 1879–80 (1881).

[Pratt, R. H.]. "Rev. J. B. Wicks and His Work in the Territory," *MSt*, Vol. II, No. 9 (Apr., 1882).

Pratt, R. H. "Catalogue of Casts Taken by Clark Mills, Esq., of the Heads of Sixty-four Indian Prisoners of Various Western Tribes and Held at Fort Marion, Saint Augustine, Fla., in Charge of Capt. R. H. Pratt, U.S.A.," *Proceedings of the United States National Museum*, 1878, I, *SMC*, XIX (1880).

Quimby, George I. "Plains Art from a Florida Prison," *Chicago Natural History Museum Bulletin*, Vol. XXXVI, No. 10 (Oct., 1965).

Rodee, Howard D. "The Stylistic Development of Plains Indian Painting and its Relationship to Ledger Drawings," *Plains Anthropologist*, Vol. X, No. 30 (Nov., 1965).

[Roman Nose, H. C.]. "Experiences of . . .," *SN*, Vol. I, No. 7 (Carlisle, Pa., Dec., 1880).

Roman Nose, H. C. "Experiences of . . . ," *SN*, Vol. I, No. 9 (Carlisle, Pa., Feb., 1881).

[Romeyn, Capt. Henry]. "The Hampton Institute Cadets at the Inauguration," *SW*, Vol. X, No. 4 (Apr., 1881).

Sidney, Margaret. "The Carlisle School for Indian Pupils," *Sights Worth Seeing. By Those Who Saw Them* Boston, 1886.

[Steele, J. Dorman]. "An Indian Picture-Letter," *The Leisure Hour*, Vol. XXVI, No. 1351 (London, Nov. 17, 1877).

Steele, Mrs. J. Dorman. "The Indian Prisoners at Fort Marion," *The National Teachers' Monthly*, Vol. III, No. 10 (Aug., 1877).

Stirling, Matthew W. "Three Pictographic Autobiographies of Sitting Bull," *SMC*, Vol. XCVII, No. 5 (1938).

Stowe, Harriet Beecher. "The Indians at St. Augustine," *The Christian Union* (New York), Apr. 18 [1877], as quoted by *FP* [May, 1877].

[Taylor, Frank H.]. "Indian Chiefs as Prisoners," *Daily Graphic* (New York), Apr. 26, 1878.

Townsend, E. [Ed.] R. "A City of the South," *Daily Graphic* (New York), Mar. 30, 1876.

Wells, J. D., "A Company of Christian Indians," *The Christian at Work*, May 24, 1877.

West, G. Derek. "The Battle of Adobe Walls (1874)," *Panhandle-Plains Historical Review*, Vol. XXXVI (Canyon, Tex., 1963).

Wicks, Rev. J. B. "First Year's Work in the Indian Territory," *SM*, Vol. XLVII (July, 1882).

———. "Indian Youths in Christian Families," *SM*, Vol. XLIV (June, 1879).

———. "Obituary," *CT*, (Darlington, I.T.), Feb. 10, 1882.

———. "Story of the Indian Territory Mission," *OITC*, Vol. IX, No. 12 (July, 1900).

———. "Story of the Indian Territory Mission," *OITC*, Vol. X, No. 1 (Aug., 1900).

———. "Work in the Indian Territory," *SM*, Vol. XLVII (Feb., 1882).

Books

Armstrong, Samuel C. *Indian Education in the East, at Hampton, Virginia, and Carlisle, Pennsylvania . . .* Hampton, Va., 1880.

Battey, Thomas C. *Life and Adventures of a Quaker among the Indians.* Boston, 1875.

Bent, George. *Life of . . . Written from his Letters*, by George E. Hyde, ed. by Savoie Lottinville. Norman, 1968.

Berthrong, Donald J. *The Southern Cheyennes.* Norman, 1963.

Betzinez, Jason. *I Fought with Geronimo*, ed. by Wilbur Sturtevant Nye. Harrisburg, 1959.

Boas, Franz. *Primitive Art.* Cambridge, 1927.

Catlin, George. *North American Indians* 2 vols. Edinburgh, 1926.

Cohoe. *A Cheyenne Sketchbook*, commentary by E. Adamson Hoebel and Karen Daniels Petersen. Norman, 1964.

Crawford, Isabel. *Kiowa, the History of a Blanket Indian Mission.* New York, 1915.

Dodge, Col. Richard I. *Our Wild Indians.* Hartford, 1882.

Dunn, Dorothy. *American Indian Painting of the Southwest and Plains Areas.* Albuquerque, 1968.

Ewers, John C. *Plains Indian Painting.* Stanford University, 1939.

Garrard, Lewis H. *Wah-to-yah and the Taos Trail.* Cincinnati, 1850.

Grinnell, George Bird. *The Cheyenne Indians*, 2 vols. New York, 1962.

———. *By Cheyenne Campfires*. New Haven, 1926.

Hardy, Lady Duffus. *Down South*. London, 1883.

Hassrick, Royal B. *The Sioux: Life and Customs of a Warrior Society*. Norman, 1964.

Haynes, James B. *History of the Trans-Mississippi and International Exposition of 1898*. St. Louis, 1910.

Huntington, Arria S. *Memoir and Letters of Frederick Dan Huntington*. Boston, 1906.

James, Edwin, comp. *Account of an Expedition from Pittsburgh to the Rocky Mountains, Performed in the Years 1819 and '20 . . . under the Command of Major Stephen H. Long*, 2 vols. Philadelphia, 1823.

Keim, De B. Randolph. *Sheridan's Troopers on the Borders: a Winter Campaign on the Plains*. Philadelphia, 1870.

Kennedy, Mary Selden. *The Seldens of Virginia*. New York, 1911.

Lanier, Sidney. *Centennial Edition of the Works of . . .*, ed. by Charles R. Anderson, 10 vols. Baltimore, 1945.

———. *Florida: its Scenery, Climate, and History*. Philadelphia, 1875.

McMurry, Donald L. *Coxey's Army*. Boston, 1929.

Mallery, Garrick. *Introduction to the Study of Sign Language among the North American Indians*. Washington, 1880.

Marquis, Thomas B., ed. *Wooden Leg: A Warrior Who Fought Custer*. Lincoln, 1957.

Marriott, Alice. *The Ten Grandmothers*. Norman, 1945.

Mather, Horace E. *Lineage of Rev. Richard Mather*. Hartford, 1890.

Mathews, Mitford M., ed. *A Dictionary of Americanisms on Historical Principles*. Chicago, 1951.

Methvin, Rev. J. J. *In the Limelight or History of Anadarko and Vicinity from the Earliest Days* [Anadarko, Okla., 1926?].

Mishkin, Bernard. *Rank and Warfare Among the Plains Indians*. New York, 1940.

Nye, Wilbur S. *Bad Medicine and Good*. Norman, 1962.

———. *Carbine and Lance: The Story of Old Fort Sill*. Norman, 1938.

———. *Plains Indian Raiders: The Final Phases of Warfare from the Arkansas to the Red River*. Norman, 1968.

Parsons, Elsie Clews. *Kiowa Tales* (Memoirs of the American Folk-lore Society, XXII). New York, 1929.

Petersen, Karen Daniels. *Howling Wolf: A Cheyenne Warrior's Graphic Interpretation of His People*, introduction by John C. Ewers. Palo Alto, 1968.

Petter, Rev. Rodolphe. *English-Cheyenne Dictionary*. Kettle Falls, Wash., 1913–15.

———. *Reminiscences of Past Years in the Mission Service among the Cheyennes* [Newton, Kans., 1936].

Powell, Peter J. *Sweet Medicine: the Continuing Role of the Sacred Arrows, the Sun Dance, and the Sacred Buffalo Hat in Northern Cheyenne History*. 2 vols. Norman, 1969.

Pratt, Brig. Gen. Richard Henry. *Battlefield and Class-*

room: Four Decades with the American Indian, 1867–1904, ed. by Robert M. Utley. New Haven, 1964.

Richardson, Rupert N. *The Comanche Barrier to South Plains Settlement.* Glendale, 1933.

Seger, John H. *Early Days among the Cheyenne and Arapahoe Indians,* ed. by Stanley Vestal. Norman, 1934.

Service, Elman R. *Profiles in Ethnology.* New York, 1958.

[Sheridan, Gen. Philip H.]. *Record of Engagements with Hostile Indians within the Military Division of the Missouri from 1868 to 1882.* Chicago, 1882.

Smith, De Cost. *Indian Experiences.* Caldwell, Id., 1943.

Standing Bear, Luther. *My People the Sioux.* Boston, 1928.

Sunshine, Silvia [Abbie M. Brooks]. *Petals Plucked from Sunny Climes.* Nashville, 1885.

Talbot, Edith Armstrong. *Samuel Chapman Armstrong.* New York, 1904.

Tatum, Lawrie. *Our Red Brothers.* Philadelphia, 1899.

Tixier, Victor. *Tixier's Travels on the Osage Prairies,* ed. by John Francis McDermott. Norman, 1940.

Tousey, Lt. Col. Thomas G. *Military History of Carlisle and Carlisle Barracks.* Richmond, 1939.

Wied-Neuweid, Maximilian, Prince of. *Travels in the Interior of North America.* Vols XXII, XXIII, and XXIV in Reuben Gold Thwaites, ed., *Early Western Travels, 1748–1846,* 32 vols. Cleveland, 1906.

NEWSPAPERS

Argus, Tarrytown, N. Y.
Cheyenne Transporter, Darlington, Indian Territory.
Daily Advertiser, Boston, Mass.
Daily Call, Washington, D. C.
Daily Courant, Hartford, Conn.
Daily Florida Union, Jacksonville, Fla.
Daily Graphic, New York, N. Y.
Daily National Republican, Washington, D. C.
Daily Sun and Press, Jacksonville, Fla.
Daily Times, Hartford, Conn.
Daily Union, Springfield, Mass.
Evening Bulletin, Philadelphia, Pa.
Evening Transcript, Boston, Mass.
Florida Press, St. Augustine, Fla.
Florida Sun, Jacksonville, Fla.
Herald, Carlisle, Pa.
Journal, Boston, Mass.
Mirror, Carlisle, Pa.
News, Savannah, Ga.
Public Ledger, Philadelphia, Pa.
Republican, Springfield, Mass.
Saturday Globe, Utica, N. Y.
Tri-Weekly Florida Sun, Jacksonville, Fla.
Weekly Floridian, Tallahassee, Fla.
Weekly Transcript, Boston, Mass.

INDEX